CONTEMPORARY
STONE SCULPTURE IN
ZIMBABWE

CONTEXT, CONTENT AND FORM

CONTEMPORARY STONE SCULPTURE IN ZIMBABWE

CONTEXT, CONTENT AND FORM

CELIA WINTER-IRVING

CRAFTSMAN HOUSE

Dedicated to the artists of Zimbabwe

This edition first published in 1993 by Craftsman House BVI Ltd., Tortola, BVI
Distributed in Australia by Craftsman House,
20 Barcoo Street,
East Roseville, NSW 2069, Australia

Distributed internationally through the following offices:

USA
STBS Ltd.
PO Box 786
Cooper Station
New York
NY 10276

UK
STBS Ltd.
5th Floor, Reading Bridge House
Reading Bridge Approach
Reading RGI 8PP
England

ASIA
STBS (Singapore) Pte Ltd.
No. 25 Tannery Road
Singapore 1334
Republic of Singapore

ISBN 976 8097 37 X

Design *Sue Edmonds and Craftsman House, Sydney*
Typesetter *Craftsman House, Sydney*
Colour photographs *Peter Fernandes*
Printer *Kyodo, Singapore*

CONTENTS

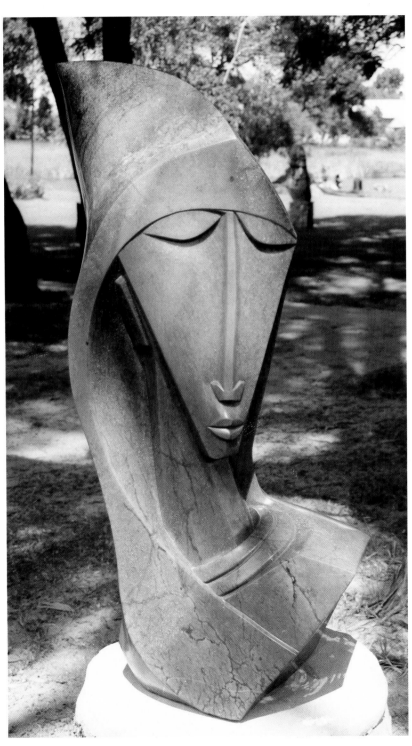

Nicholas Mukomberanwa

ACKNOWLEDGMENTS

In January of 1987 I came to Zimbabwe to write a commissioned article on stone sculpture in Zimbabwe for the British art journal *Studio International*. This was published in June, 1988. My interest in stone sculpture in Zimbabwe had been brought about by six exhibitions held in Sydney, Australia, by the Irving Sculpture Gallery (of which I was director) and The Gallery Shona Sculpture of Harare. While writing the article, I thought of writing a book, which would complement the existing publications by F. Mor and Marion Arnold, but be broader in scope, and focus more closely on the artists themselves, rather than be limited only to their art.

My initial concept was a book in which the sculptors would be encouraged to express themselves, to provide the reader with information about the thoughts and processes that brought their art into being, and in particular the cultural origins of the subject matter of their work, bearing in mind its multicultural dimension. The fact that this book has grown far beyond that original conception, and has become a study of a variety of traditions of the visual arts in Zimbabwe and the visual culture of the nation, has been because of the lack of restriction in its writing, and because of the accessibility of a variety of people in Zimbabwe and the freedom with which they have provided information. My research has often been field work, because of the comparative lack of published material, and interviews with artists and others who support the art of Zimbabwe. The support of many people for this book has added a professional and personal dimension, and there are indeed many to thank.

I would like firstly to sincerely thank Professor Cyril Rogers, Director of the National Gallery of Zimbabwe, and the Board of Trustees of the Gallery for appointing me an Honorary Research Fellow of the Gallery in March, 1988. This appointment has given me an office in the Gallery and the professional environment necessary for writing a book of this scope and kind. I have been able to meet, in a professional capacity, many people who have been invaluable to my research and excellent informants. The support of the Gallery staff has been a great stimulus to my enthusiasm for writing the book.

I would like to thank Tom Blomefield and the artists of the Tengenenge Sculpture Community for offering me the hospitality of the community as its guest, in particular during my initial time in Zimbabwe. It was here that the concept of the book as it first stood developed, and it was here that I had my first introduction to the artists of Zimbabwe. It would be appropriate to thank the community as a whole, and each artist and its Director as individuals. Tom Blomefield has given me much personal support and encouragement, and his fluency in the languages of his artists, in particular the Malawian Chewa, has been invaluable to my research.

For their early offers of support for the book, I would like to sincerely thank Patrick Dumont, Managing Director of Nestle's (Pvt) Ltd, and Mr Alistair Carlyle, Chairman of Barker McCormac Advertising and Marketing (Pvt) Ltd, in Harare. I see these offers as an extension of the strong degree of patronage being given to the arts by the corporate sector in Harare, and would like to show my public appreciation for their offers. I would like to thank Mr Alan McAuley and Mrs Bridie McAuley for their practical support of the book during various stages of its writing.

I would like to express my appreciation to Professor Thomas Huffman, Professor of Archaeology at the University of Witwatersrand, South Africa, for the significant information he has provided me with in interview, and also access to his published work. Professor Huffman's views on Great Zimbabwe have a decidedly human dimension. I would like also to thank Dr David Beach and Peter Garlake for the

8

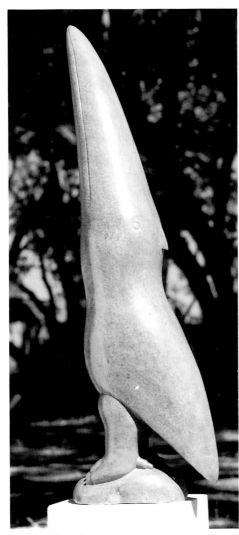

Ephraim Chaurika

information they have provided, through their published work, for Chapter Eight.

The infrastructure for support of the visual arts in Zimbabwe encourages free expression and allows the artist a marked degree of self-development. I would, therefore also like to express my appreciation to Dr Tafataona Mahoso, Director of the National Arts Council, Mr Cuthbert Musiwa, Deputy Secretary for Culture in the Ministry of Education and Culture, and Mr F Mutakonyi, Under-Secretary for Cultural Education in the Ministry of Education and Culture, for the time they have given to me for the research and writing of Chapter Eleven. In the same sense I would like to show my appreciation to Professor Cyril Rogers who has spent much time in interviews to allow me to present an in-depth study of the workings of the National Gallery of Zimbabwe, which are so vital to the development of the arts.

I would like to thank the private gallery directors in Harare for their appreciation of the book and for the information they have given me. Regrettably, Gallery Delta in Harare closed during this book's final stages of preparation. It is hoped that it will reopen at another location in the city in the future.

I would like also to thank the following individuals in their official or professional, and also their personal, capacities for their support and encouragement of my work: His Excellency Mr Alexander Atanassov, former Ambassador of the People's Republic of Bulgaria in Zimbabwe; Mr Roy Guthrie, Director of Chapungu Village and the Gallery Shona Sculpture in Harare for making available important works from the permanent collection at Chapungu and for assisting Peter Fernandes with staff, transport and the siting of major works; His Excellency, Dr Werner Kilian, Ambassador of the Federal Republic of Germany in Zimbabwe; His Excellency Mr Philip Peters, former High Commissioner for Australia in Zimbabwe; Mr Neil Mules, Deputy High Commissioner for Australia in Zimbabwe; Mr Walter Bazar; Miss Ruth Chard, The British Council, Harare; Mrs Barbara Collins, The National Gallery, of Zimbabwe; Mr Jerry Collins, Sydney, Australia; Dr Trevor Coombe; Mrs Elspeth Court; Mr Philip Darby, Reader in Political Science, University of Melbourne, Australia; Mr Richard Franklin; Mr Ian Grosart, Senior Lecturer in Political Science, University of Sydney, Australia; Mr Paul Gwichiri, National Gallery of Zimbabwe; Mrs Otilia Kadenge, National Gallery of Zimbabwe; Mrs Angeline Kamba, Director, National Archives of Zimbabwe; Mr Phebian Kangai,

Instructor, BAT Workshop, National Gallery of Zimbabwe, and the students of the BAT Workshop; Mr Robert Kilian; Mr Haydon Leson; Mr Harrie Leyton, Director, Tropen Museum, Amsterdam, The Netherlands; Mr Ernest Mukuwapasi, University of Zimbabwe; Mr Joseph Muli, National Gallery of Zimbabwe; Mr Kenneth Mutunga, National Gallery of Zimbabwe; Mr Philip Myrick; Mr John Povey, Editor, Arts Africa; Professor Terence Ranger, Professor of Race Relations, Oxford University, UK; Mr Nigel Ross, Director, British Council, Harare; Mr Norman Strachan, Sydney, Australia; Mrs Freida High Tesfagiorgus, Professor of Afro-American Studies, Department of Afro-American Studies, University of Wisconsin-Madison, USA; Mr Paul Wade, Director of Educational Services, National Gallery of Zimbabwe; Mr David Walker, Honorary Research Fellow, National Gallery of Zimbabwe; Ms Rose West, National Gallery of Zimbabwe; Mrs A Winter-Irving, Sydney, Australia; Mr Jonathan Zilberg, University of Illinois, Illinois, USA; the many Zimbabwean artists to whom I am grateful for the accessibility of their information, and their conviction of the importance of this book. I am also grateful to the Director and staff of the House of Humour and Satire, Gabrovo, Bulgaria, and the members of the Board of the Foundation, Beelden op de Berg, Wageningen, Holland.

For the photographs used in this book, my thanks to Roy Cook, Alan Gray, Roy Guthrie, Derek Huggins, Gordon Macpherson, Ministry of Information Photographic Section, National Archives of Zimbabwe, National Gallery of Zimbabwe Library, Ernst Schade, and Clive Wilson. Sincere thanks to Peter Fernandes of Harare who has photographed stone sculpture in Zimbabwe since its beginning in the late '50s. His love of the work is reflected in professional photography of great clarity and sensitivity.

Without the support of all these people, and of many others, it would not have been possible for the book to embrace its current scope. I would like to thank Nevili Drury and Caroline de Fries from Craftsman House Publishers, for their assistance with the revised edition of this book.

It is to be hoped that this book will give the support to the artists of Zimbabwe that they have given to its preparation.

Celia Winter-Irving

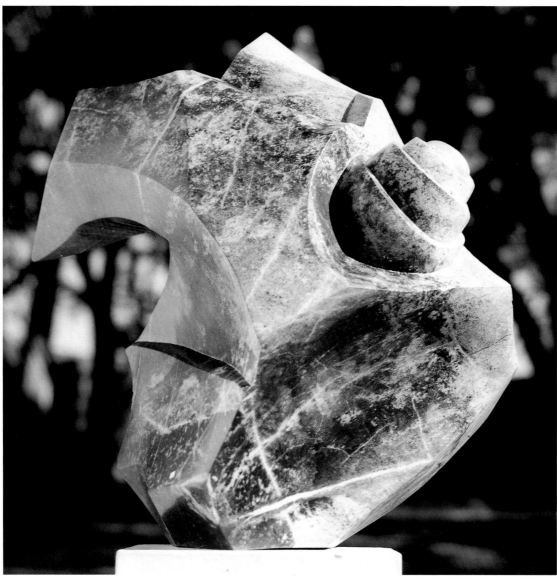

Brighton Sango

FOREWORD

A most succinct definition of culture was given by the Governor General of New Zealand, the Right Reverend Sir Paul Reeves, when he opened the Zimbabwe Heritage Exhibition in Auckland on 31 January, 1990: 'Culture is all about the way people behave.'

Having established a definition of culture, he went on to illustrate how the arts of a people flow from that culture — the literary arts, the performing arts, and the visual arts.

It is the visual arts that this fascinating book by Celia Winter-Irving is all about. Even though one can classify the arts through a Linnaean hierarchical system, they are inextricably intertwined. The visual arts naturally touch upon the literary arts and the performing arts, and any taxonomic shift in classifying them is for convenience, rather than for reality.

The intertwining nature of the arts, as they spring from the culture of a people, can be classed in another way: intellect, knowledge and emotion, or as the classical psychologist would put it, cognition, conation and affect.

In Celia Winter-Irving's book, endeavour is challenged on all three fronts: intellectual stimuli, knowledge of the visual arts in general and the emotional satisfaction in witnessing a lofty work in tune with the infinite.

Zimbabwe, like all other countries, has a rich and sustaining share of mythology. It is necessary to cite but two examples. In the heart of the country, not far from the town of Masvingo, stand the impressive remains of the ancient city that is now known as Great Zimbabwe. It is heroic in size, and even though the levelling hand of time has reduced its glory Great Zimbabwe still stands as a monument to a distant culture. It is enveloped in mythology.

In the colonial era of this country, many hypotheses attempted to explain the origin of Great Zimbabwe. Surely it must have been built by the Phoenicians, or the Romans, or the lost tribe of Israel, or the Moors, or the Indians, or even the Martians? Any of these myths could be acceptable as long as the Africans were not involved.

In the same colonial era the genesis of today's remarkable stone sculpture must surely have been from the outside; inspiration must have come from Europe and from the National Gallery, or from Tengenenge or from Vukutu or from some of the intrepid explorers from South Africa. It is true that many Europeans understood the power of this spontaneous sculpture movement, and encouraged it, but they did not commence it. There really should be no myth about who commenced this unique flowering of artistic talent. It was a humble Agricultural Conservation Officer, by the name of Joram Mariga. The nation, and the world, owe much to him.

It is appropriate to speculate from whence comes the remarkable artistic talent of Zimbabwean and other artists who have made their home in this caring country. The bushmen were the sole inhabitants of Zimbabwe before about one thousand BC, and have left a visual account of the culture of their era. The forms and colours of the rock paintings of Zimbabwe have survived over the millennia and will continue to do so if man does not desecrate this heritage.

It is clear, too, that stone carving and metal work was carried on at Great Zimbabwe. Yet the talents of six hundred years ago have remained latent since then. It strains credibility to insist that the stream of consciousness in men stretches all the way from the bushmen to Great Zimbabwe to present day Zimbabwe.

There must be, of course, diverse cultural influences that bear on the artistic genius of today and these are described with skill and sensibility by Celia Winter-Irving. Whatever its cultural antecedents may be, Zimbabwe's contemporary artistic achievements must be acclaimed.

As a movement of today, the visual arts spring from the nurturing influence of the culture of the region, and from

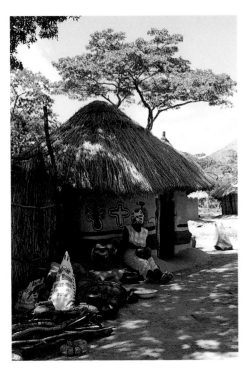

Village at Tengenenge

the sympathetic climate afforded by the government and the people of Zimbabwe. So far the artistic genius of Zimbabwe has expressed itself mainly through stone but there is much evidence to establish that this talent is not a specific one. Increasingly the talent is manifesting itself not only in stone sculpture, but in metal and wood, in paintings and in graphics, in exciting brilliant textiles, and in graceful and beautiful, but still fragile, ceramics.

As Celia Winter-Irving maintains, if the encouragement of excellence continues, and there is no reason why it should not, the artistic achievements of this part of Africa, predictably, will bring an acclaim not accorded elsewhere.

With such a short, totally contemporary history, it is not surprising that the scholarly literature on the visual arts of Zimbabwe is so sparse. Marion Arnold's book *Zimbabwean Stone Sculpture* stands as a recognised classic. Of more popular appeal, and eminently readable but less researched, is the work on Shona Sculpture by the former Italian Ambassador to Zimbabwe, His Excellency Mr Ferdinand Mor. In the National Gallery's various publications — such as *Zimbabwe Insight* and elsewhere — sensitive and critical articles have appeared which deepen our knowledge of this remarkable home-grown movement in stone. The daily and periodic press, radio and television all play important roles in making known the exceptional artistic gifts of the people of Zimbabwe. Even so, the literature is scanty.

Celia Winter-Irving's book *Contemporary Stone Sculpture in Zimbabwe* is an important scholarly addition to research and publication and to the analysis and appreciation of Zimbabwe's cultural flowering. She is eminently suited to write on Zimbabwe's sculpture and other forms of art and visual culture. She is a sculptor of note in her own right, and she has faced the task of running The Irving Sculpture Gallery in Sydney, Australia. Her Gallery in the Antipodes was devoted largely to sculpture, and her critical writing in the scholarly journals in Australia illustrates that she has the right background and sensitivity to move from the arts of one country to those of another.

Not only has Celia Winter-Irving won for herself wide respect among the artists of Zimbabwe, she has helped inspire them to higher levels of creativity. If Henry Moore and Ivan Mestrovic are to have successors in this century it is most likely that they will spring from the soil of Zimbabwe. I have no doubt that Celia Winter-Irving will have spent much time with these successors, encouraging them in their pursuit of excellence.

Professor Cyril A. Rogers
Director, National Gallery of Zimbabwe.

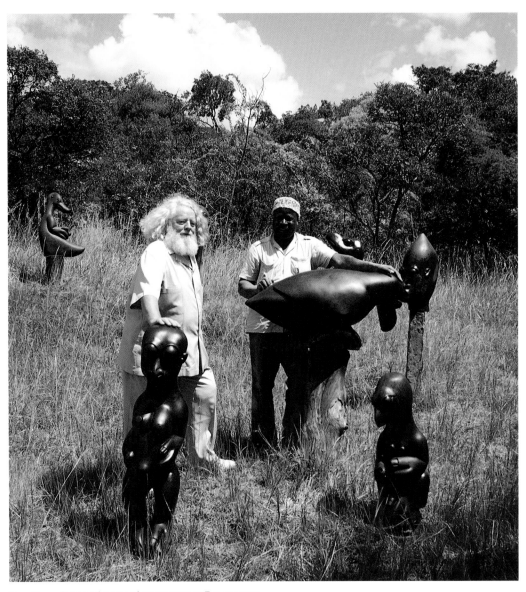

Tom Blomefield and Bernard Matemera at Tengenenge

INTRODUCTION

The stone sculpture in Zimbabwe, dating from 1956 until today, is easily the best-known manifestation of Southern African contemporary art. It has no overt historical roots in Zimbabwe, and is not derived from any recognisable indigenous tradition of object making. The sculpture's credibility as serious sculpture, as opposed to 'airport art' or tourist art produced during the same period within other African countries, was enhanced by its early presence in public art museums, the Musée Rodin in Paris in 1971 and the Musée d'Arte Moderne in Paris in 1972. Here the sculpture was presented with appropriate conditions of connoisseurship through Frank McEwen, first Director of the National Gallery of Zimbabwe (1957–1973) and initial catalyst to the sculpture through his establishment of the National Gallery Workshop School.

The sculpture has never been considered naive or primitive, or as folk art stemming from a vernacular source. Expressively charged and conceptually based, rich in imagery, symbolism and association, it shares the properties of much of the best contemporary sculpture outside the Third World.

However, it is also essentially African. Its African qualities include its vitalism, and distortion of form, its use of bulk, its monumentality, and truth to a natural material, stone. But most importantly its African qualities do not have exclusively formal parameters. The sculpture is the collective expression of the historic beliefs of the societies represented by the artists (with culturally determined variants) in a spiritual rationale or explanation for the workings of the real or natural world. Largely, its subject matter is expressive of the general African belief, again with societally and culturally determined differences, that African man is part of a larger plan than that devised for Western man. It links the living and the dead, the visible and invisible universe, and the mortal and spiritual realm. Unlike African tribal art, the sculpture performs no ritualistic or ceremonial function, nor does it have any place in the material culture of the societies represented by the artists. Yet it is far from art for art's sake. Its aesthetic origins largely lie in the artists' realisations of the spiritual dimensions of their traditional cultures. Form and content have a similar genesis.

Although all the artists live and work in Zimbabwe, the sculpture is a multi-cultural and multi-ethnic phenomenon. The sculptors, mostly rural-born Africans are of the Shona, indigenous to Zimbabwe. They are also of the Chewa and Yao of Malawi, and the Mbunda of Angola, as well as people from Mozambique and Zambia who came to Zimbabwe seeking work in the 1960s, and who were encouraged by their employer, Tom Blomefield, to become artists as a means of employment during economic sanctions against Rhodesia.

The sculpture of the Shona emerged initially through the work of Joram Mariga, and at the National Gallery Workshop School under the direction of Frank McEwen. The early sculptors and indeed many of the later sculptors, limited in formal education had, and have, a developed knowledge of the traditional beliefs of their parent cultures, prior to their becoming artists. These beliefs are a composite of myth, folklore, oral history, customs and rituals, and belief in the power of ancestral spirits and deities to influence everyday events. Although initially encouraged by European catalysts, Frank McEwen and Tom Blomefield, the sculptors' subject matter was largely their personal reading of the traditional ontologies and cosmologies of their parent cultures.

This is still the case today, although some of the younger sculptors explore the human dimension of social relationships, the relationship of the family, the relationship of, for example, mother and child, or make a personal statement expressing their own world

view, and on occasions their feelings about social change, political change and acculturation.

The book looks at the sculpture as a contemporary manifestation of the rich national tradition in Zimbabwe of expressing in visual terms, aspects of cultural practice. It is significant that stone plays a major role in the two most famous examples of Zimbabwe's visual culture, the rock art and the ruins of Great Zimbabwe. The sculpture may be seen as the Renaissance of the stone of Zimbabwe, imparting to it a new function and a new aesthetic, but respecting its properties in the same way they were respected previously by those involved in painting the caves and constructing Great Zimbabwe.

Zimbabwe's visual culture has always had a close relationship with the country's physical environment and natural attributes. The most expressive aspects of Zimbabwe's historic visual culture are non-portable, accessible cultural sites which lose their meaning and significance if not seen in situ. Great Zimbabwe, 319 km from Harare, the country's most powerful polity, and its most culturally significant (AD 1250–1450), was constructed by the Shona from stone, which was the material from which the famous Zimbabwe birds were made. Although no connection can be established between the birds and the stone sculpture — and the birds have a meaning outside their objecthood which has not yet been established — their sculptural qualities are unmistakable.

The paintings of the San (bushmen) found on the walls of caves on the Zimbabwe plateau, predate the people now called the Shona.

Once viewed Eurocentrically and in purely aesthetic terms, these paintings are now viewed by scholars, and in particular by archaeologists and anthropologists, in terms of the cosmologies of the societies represented by the artists and societies of the San in Southern Africa. Some authorities consider the paintings to be observations of people in a physically induced trance, who possessed an energy and potency which was channelled into rainmaking and healing. Both Great Zimbabwe and the rock art (and here a similarity to the sculpture can be noted) are valuable references to other aspects of cultural practice of the societies represented by the artists.

The cultural dimension of Zimbabwean life is currently becoming more important to Zimbabweans, and of greater interest to visitors to the country and those outside the country. Zimbabwe's music, poetry and novels are well known in Zimbabwe and subject to much study outside the country.

Zimbabwe's culture is not institutionalised and confined to the catalogue and classified by check list.

It is not a coffee table culture to be seen in books and brochures appealing to the mind's eye rather than the mind. It is a culture which can be experienced and participated in; one with an historic presence and also one which keeps pace with the social change and economic growth which contributes to the nation's development. Since Independence, Zimbabwe's culture has been seen as part of the nation's heritage. It has appropriately been conserved and preserved by National Museums and Monuments, and well documented by the National Archives. The flourishing of the visual arts in Zimbabwe, despite a lack of art education in schools, speaks for the remarkable intuitive talent of the artists of Zimbabwe. The self-direction that has established Zimbabwe's artists will not be discouraged by the Regional School of Art and Design soon to be established in Harare for SADCC countries. Artists then might change their direction, if they choose to do so, but still will be taught with the traditional encouragement and example that has given Zimbabwe art, in particular its sculpture, its originality and expressive quality.

This book aims to present the

sculpture within the overall context of a variety of traditions of visual arts practices in Zimbabwe, some of which have existed since colonial times, such as white Zimbabwean painting, and others which have emerged since Independence, and show innovation and experiment within established parameters of practice, such as welded metal sculpture.

The visual arts in Zimbabwe have flourished because of, and despite, colonial rule, and their directions have stemmed from the spiritual, social and cultural traditions which have shaped the lives of both black and white Zimbabweans. Equally influential have been the economic climate of the country, the issues and events which led up to Independence in 1980, and the geographical position of the country in Africa and the world. Since Independence, the visual arts have been allowed a freedom of expression unusual in a socialist country, and artists have been allowed to explore their own personal direction without ideological constraints.

Reputable commercial galleries are seen by government as part of a flourishing private sector which brings valuable foreign exchange into the country. The government sees progress in the visual arts as part of the nation's rapid development. It is to the credit of Zimbabwe's artists, black and white, that

they sustained their practice through the social and political transition of the society up to and after Independence; a long period of colonial rule, followed by economic sanctions against Rhodesia, the Independence War, comparative isolation from the rest of the world, and the emergence of Independent Zimbabwe as a socialist state.

The book presents what might be termed an aerial view of Zimbabwe's visual culture. Much can be learned from the links and connections between a variety of art practices, and from the ideologies, policies and activities of those institutions, organisations and individuals who have provided enlightened official, institutional, commercial, philanthropic, personal, and informal support for the visual arts in Zimbabwe since colonial times. Not one aspect of the visual arts or visual culture of Zimbabwe can be seen in isolation. The sculpture must be regarded as a contemporary art movement, with the subject influenced by historic cultural traditions linked to historic aspects of object-making through a commonality of material, stone, and a commonality of means, hand carving — an executional skill which has been in practice for hundreds of years.

The success of the sculpture may prove the maxim that 'art can speak for itself', because the international

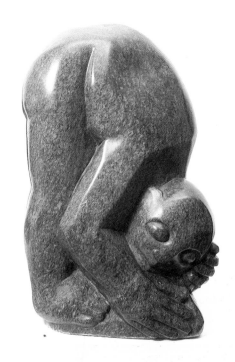

Joseph Ndandarika

recognition given to the sculpture was not always supported by the scholarship and well-researched literature which usually accompanies and enhances significant 'movements' in art. This is particularly important when a knowledge of the cultural backgrounds of the artists is necessary for their art to be fully understood. While the development of the sculpture has been accompanied by numerous essays in journalism and photo-journalism, which have effectively 'romanced the stone' and created for it African qualities based on essentially European expectations and sensibilities, serious writing in book form has been confined to two texts only. In neither

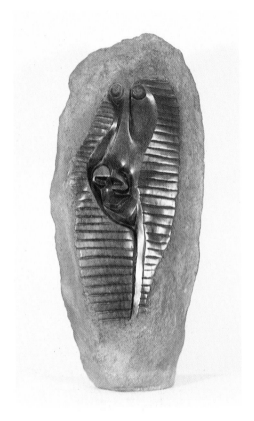

Nicholas Mukomberanwa

has the artist been effectively allowed to speak for himself or herself. One book is Marion Arnold's academic dissertation, *Zimbabwean Stone Sculpture*, published by Books of Zimbabwe in 1981, which looks at the spiritual and cultural origins of the sculpture of the Shona only. F. Mor's book, *Shona Sculpture*, published by Jongwe Printing and Publishing House in 1987, also looks at the sculpture of the Shona only from the viewpoint of a Western critic and aesthetician, and ignores the cultural origins of subject matter. Scant attention has been paid in either book to the thoughts and processes which have directed the artists' work.

Much media coverage has been given to the colourful personal histories of Frank McEwen and Tom Blomefield. The influence of their personalities on artists with whom they came in contact cannot be ignored. However, little written attention has been given to either man's distinct way of encouraging those new to the concept of making art, to their mentorship without hint of paternalism or colonisation of the art, or their very different experiments in informal art education.

While the history of stone sculpture in Zimbabwe can be firmly and chronologically established, it is not yet time to create an art history for the sculpture. The majority of the artists are still alive and working, their future being as important as their past. It is significant that the word 'retrospective' is used for a large corpus of work with an historical base for a living artist. An art historian would be daunted by the fact that many works are not dated, and it is difficult to establish an accurate chronology for the work of even a major artist. There has been little assessment of the development of an artist's work in terms of formal analysis, changes in style, and treatment of material. Scholars, which include anthropologists and sociologists as much as art historians, are attracted by the cultural strength of the artists' statements. To these scholars, the sculpture appears to have a genuine ethnographic dimension. It is significant that some of the work selected for an exhibition organised by the National Gallery of Zimbabwe in June, 1989, in Wageningen in Holland at the Foundation Beelden op de Berg was by an ethnographer and anthropologist, Harrie Leyton, Director of the Tropen Museum in Amsterdam.

A book which focuses on the stone sculpture in Zimbabwe, and presents it in the broader context of the visual culture of the country cannot be just an 'art book'. Because the sculpture is multi-cultural, and for other reasons, the book must approach the sculpture from perspectives outside art history. The aesthetic origins of the visual culture of Zimbabwe, of which the sculpture is the best known manifestation, lie within a variety of social and cultural practices, rather than within traditions of art practice. An exception to this might be white Zimbabwean painting (discussed in Chapter Nine). In as much as the book focuses upon these practices as much as it does on the art which stems from them, it is hoped that it will be of interest not only to art lovers, and collectors, but also to art educationalists, teachers and administrators, to persons involved in African studies, to cultural and social anthropologists, ethnographers, sociologists and historians, and also to

anyone generally interested in the culture of Zimbabwe. It is hoped that it will add a cultural dimension to the experience of many visitors to Zimbabwe and that it will contribute to the serious scholarship on Zimbabwean culture which is still in its infancy. While the text should be acceptable to the interested layman, there is enough substantive text to satisfy the interests of the specialist. While the visual material is important, the photographs accompany the text rather than the text the photographs.

Chapter One establishes the origins of the sculpture and puts its development into an historical framework which is not complete without detailed discussion of the human dimension of Frank McEwen and Tom Blomefield, and their approach to the encouragement of artists. This is treated in greater depth in two later separate chapters. It also places the sculpture in the overall context of the development of the visual arts in Zimbabwe. It looks at the sculpture before and after Independence, and the way in which younger sculptors, subject to education, acculturation and urbanisation express their world view through their art.

Chapter Two looks at the unique properties, formal and conceptual, of the stone sculpture in Zimbabwe. It considers the affinities and differences between the sculpture and historic and contemporary aspects of Western sculptural practice, Western religious art and African tribal art.

Chapter Three deals with the cultural origins of the subject matter of the sculpture, and stresses the multi-cultural dimension of the movement. It discusses how the cultural differences of the artists determine distinct differences in subject matter, and treatment of the approach to subject matter. It also disputes the name 'Shona Sculpture' as a generic term.

Chapter Four is devoted to the work of Frank McEwen with the artists of the National Gallery Workshop School, and his highly individualistic approach to art education.

Chapter Five deals with the current role and activities of the National Gallery of Zimbabwe. While its work and activities are the result of acceptable policy making by the Board of Trustees, there is still the presence and the personal vision of the Director, Professor Cyril Rogers, as there was of the first Director, Frank McEwen. While the Gallery maintains the traditional functions of preservation and conservation suited to a public art museum, its main concern is a holistic approach to the life and work of the living artists of Zimbabwe, serving through its market, their economic needs and through its school, the BAT Workshop, their educational needs.

Chapter Six is concerned with the historic and current importance of the Tengenenge Sculpture Community. In both this chapter, and Chapter Four, there is a focus on the very different approaches to art education that each mentor felt was applicable to the cultural and educational background of the sculptors with whom they were concerned. Tengenenge is looked at in depth in terms of its informal governance, and the highly personal approach of Tom Blomefield to the running of his community. Tengenenge is also considered in terms of its success as a rural development project, improving, without aid or donor funding, the quality of life of over seven hundred rural-born Africans.

Chapter Seven presents stone sculpture in Zimbabwe in a manner which allows the artists to speak for themselves. It contains twenty two essays on sculptors from a wide variety of backgrounds. These essays are based on taped interviews in which artists speak about their understanding of art in respect of their own culture and education, and the origins of the subject matter of their work.

Chapter Eight is devoted to historic

aspects of Zimbabwe's visual culture, the richness of which is often ignored at the expense of the presence of the sculpture. The sculpture is linked conceptually to the visual culture, in that the visual culture of Zimbabwe is often the visual realisation and symbolic representation of beliefs, and the spiritual dimension of a world view. Research into the meaning and function of the rock paintings, and the structures and the birds at Great Zimbabwe is still very much work in progress. The chapter rather than arriving at conclusions, puts forward theories of recent and current scholars with appropriate reference and recognition.

Chapter Nine discusses other traditions of the visual arts in Zimbabwe. In part it is concerned with the impact of colonialism on the visual arts of Zimbabwe, representing it through tracing the development of white painters since the nineteenth century, from Thomas Baines and other explorers, hunters and botanists who used the canvas in a manner that the photographer would have used the camera. It also looks at the way later painters have used the landscape, which presented its challenges to the European in pre-independent Zimbabwe. It discusses the way that, since Independence, young black Zimbabwean sculptors working in other media, and painters, express their

thoughts in a visual language which is easily understood by black Zimbabweans.

Chapter Ten examines the criticism of some that the stone sculpture has been over-commercialised, and that its attraction to almost an exclusively European audience creates doubts about its cultural specificity. It looks at the notion that the sculpture has become more of an industry than an art form, being seen as a product by dealers, and income-producing objects by the artists. Various questions come to mind; for example, whether its cultural relevance speaks on the part of the artists, or whether it has been imposed by private gallery directors in the cause of capturing a market. In this chapter, the gallery directors speak for themselves and present their case. While the chapter appreciates their considerable achievements, it presents an objective assessment of their operations. This chapter also looks at another aspect of private patronage of the art of Zimbabwe — corporate patronage — and is a study of the philanthropic dimension of four large Zimbabwean companies, Nedlaw Investment and Trust Corporation Ltd, Mobil Oil Zimbabwe (Pvt) Ltd, Cairns Holdings Ltd (Mukuyu Wines) and BAT (Zimbabwe) Ltd.

Chapter Eleven examines the role of government vested in the Ministry of

Education and Culture; the National Arts Council, the parastatal which funds and administers a number of arts organisations; and ZAVACAD the Zimbabwe Visual Artists, Craftpersons and Designers, recognised in 1983 as the organisation supporting the visual artists of Zimbabwe.

The Conclusion discusses Zimbabwean art within the context of a debate about art education in Zimbabwe. It is concerned with the future of Zimbabwean art in terms of the Regional School of Art and Design for SADCC countries soon to be established in Harare, and the consequences of a shift from formal and non-formal art education to substantial opportunities for formal art education in the country.

The visual arts in Zimbabwe and, in particular, the stone sculpture are currently at a watershed. The Regional Art School may steer Zimbabwean art away from an ideology which is largely economic. It may develop a more contemporary ethnicity, a greater and more genuine African content and consciousness and a sense of international direction.

Today the stone sculpture in Zimbabwe is better known outside than inside the country. There are those in government who feel that the sculpture reflects largely academic cultural

traditions, and that it has little relevance to contemporary Zimbabwean society. Yet government is also keen to preserve Zimbabwe's cultural heritage, and the sculpture is surely part of that heritage. It may be said that the stone sculpture is repeating its own history, and that sculptors work towards a successful commercial formula and that there is little sense of development as is appropriate for a tradition of art. However, many young sculptors are moving away from a traditional cultural stance to explore the potential of sculptural form as an end in itself, and those using the green and gold Chiweshe stone are developing for their material a new and more decorative aesthetic. Many artists are using new materials, natural and man-made. Through these new developments, in particular welded metal sculpture, and experimental ways of working with wood, is Zimbabwean art losing its character and becoming part of the mainstream of international art? Or, on the other hand, does the character of Zimbabwean art need redefinition, and is a more international direction a sign of its development?

A problem today is the proliferation of stone sculpture in Zimbabwe, and the lack of a true and critical assessment of standards to determine what is sculpture and what is merely carving. It is to be hoped that among the scholars of many disciplines who are coming to Zimbabwe to research and write about the sculpture, there are those who can attempt, within an art-historical discourse, a critique of the art and the work of individual artists, taking into account the cultural and social parameters within which the development of the sculpture has taken place. Whatever criticisms may be levelled, the stone sculpture in Zimbabwe is the result of awesome intuitive talent on the part of the artists. It is a talent which is, and has been, fostered with sensitivity and which, latent, continues to emerge, and which has nothing to do with education or the economic status of the artist.

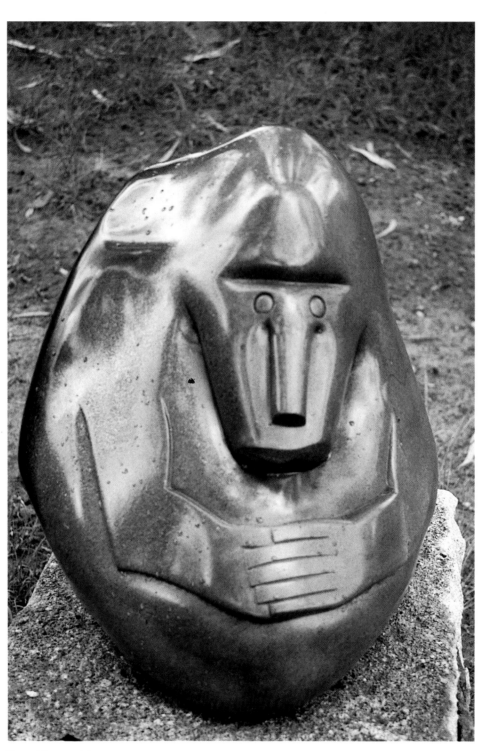

Henry Munyaradzi

CHAPTER ONE

THE STRENGTH OF ITS PRESENCE

Stone sculpture in Zimbabwe largely reflects the sculptors' conceptual-isations of the customs and observances which sustain traditional beliefs, and the spiritual dimension these beliefs give to the natural world. However, the enormous social and spiritual changes which are taking place today in Zimbabwe, and have taken place since Independence, must also be recognised. It is realistic to say today that on the part of the sculptors, attitudes to beliefs vary, and these variations are apparent in the artists' work. On the part of the older and well-established sculptors, strong associations with the rural areas remain through extended families and kinship ties. Despite their urban lifestyle many older sculptors have beliefs which are personally held and empirical in that they can believe that the experiences and circumstances of their life are the result of spiritual intervention. Such artists may depict this intervention in terms of their own life and make highly personal statements. On the other hand older sculptors may subscribe to the collectively held beliefs of their society, and observe their practice without consideration of the effect of them on him or her personally. Without actually believing or subscribing to practices associated with beliefs, an older artist may have respect for the traditional beliefs of his or her

society, and for their value in preserving moral and social order.

Younger sculptors might well stand back from their traditional beliefs and objectify them, critically evaluate them and question their relevance today. They may well wish to be known as inter-national artists rather than Zimbabwean artists. Some younger artists working in Harare are exploring more the human dimension of life, looking at the family relationships and the relationship between man and woman, and mother and child, in non-culturally specific terms. Younger artists in the rural areas, for example Guruve, near Tengenenge, have attitudes to beliefs similar to those of many of the older artists, and the beliefs have a reality to them that is lacking in the lives of the younger town artists.

Movements in art generally arise in countries with established artistic traditions, in which the artist's place and role in society has been determined by centuries of patronage from church or state, or private individuals. Historically, movements in the visual arts have been associated with painting: expressionism and impressionism, fauvism, whereas movements in sculpture are few. Sculpture is largely associated with the work of individuals, and its history is built around their achievements. To many, sculpture means the works of Michelangelo,

Brancusi and Henry Moore, and they look for no more.

Stone sculpture in Zimbabwe has also had its patronage, mostly that of individuals supporting the art with a remarkable lack of self interest. The patronage of stone sculpture in Zimbabwe stems today from the overall patronage of the visual arts, in terms of policy making, from the Ministry of Education and Culture, and at a more practical level from the National Arts Council and the National Gallery of Zimbabwe. Private patronage comes from the reputable private galleries, the corporate sector, the Tengenenge Sculpture Community, and those individuals whose purchase of Zimbabwean art brings so much valuable foreign exchange into the country.

The word 'movement', as applied to stone sculpture in Zimbabwe, has been misused. Its use implies that the sculptors all come from the same cultural back-ground and they have undue influence on each other, and possibly work together. Traditions of informal and non-formal art education in Zimbabwe have discouraged influence, and encouraged sculptors to think of themselves as individuals rather than as part of a movement. It is significant that, outside structured communities such as Tengenenge, sculptors prefer to work in isolation rather than together. A trend

today is for master sculptors to assist younger sculptors through example and encouragement. If the sculpture is considered to be a movement its multi-cultural dimension must be recognised. If it is a movement it is one which has in-built cultural variations, change, innovations, experiment and new ideas, factors which have not been limited by the use of a common material (stone), and a consistency of means (carving).

It is remarkable that such a phenomenon as stone sculpture could emerge in Zimbabwe, a developing country in Africa with no recognisable tradition of art or long history of support for the arts. The spiritual beliefs of the main tribal groups in Zimbabwe — the Shona and the Matabele — have little collective ritual or ceremony requiring the use of associated objects now assigned the name of tribal art. Such countries as Angola, Nigeria and the Congo are known as African countries famous for their rich tribal art. However, despite its recent origin, stone sculpture in Zimbabwe has, through its subject matter, a sense of origin and evolution which is couched in the traditional beliefs of the major African societies. This cultural relevance has helped the rapid establishment of its international respect and presence, and the accolades it has gained from critics and collectors, which

has seldom been achieved by an art form of its duration.

While the international presence of the sculpture was initially established through the influence of Frank McEwen, a major recession for its local and international market took place during the international economic sanctions against Rhodesia, and the Independence War which, in itself, forced the closure of the Tengenenge Sculpture Community. Both situations escalated export costs, forced people to leave the country, and diminished the tourist trade. The period since Independence has seen the presence of the sculpture consolidated both inside and outside of Zimbabwe.

A strength behind this presence, in particular since the appointment of Professor Cyril Rogers as Director in 1986, has been the National Gallery of Zimbabwe. The Gallery is known locally and internationally for its distinctly Zimbabwean identity, for its exhibition and promotion of the indigenous art of this country, and its recognition of the international community in Harare through its showing of work by distinguished expatriate artists. The Gallery has a democratic approach to the art it exhibits, purchases and sells. Its permanent and overseas collections contain the work of established and emerging artists, with the emphasis on

sculpture. The Gallery Market in which work is sold adopts a similar approach. The sculptors and artists of Zimbabwe see the National Gallery as a major source of encouragement to their work, a feeling underpinned by the accessibility and human dimension of the Director and staff. The National Gallery, under Professor Rogers, has a local and international outreach programme. Exhibitions from the Gallery travel to the Gallery at Bulawayo and the Mutare Museum. In 1989 an exhibition of significant Zimbabwean sculpture, selected by the National Gallery of Zimbabwe, was held in Wageningen in Holland, organised by the Foundation Beelden op de Berg. Parts of this exhibition travelled to Stuttgart in Germany and to other European countries. In January, 1990, an exhibition comprising works from the Zimbabwe Heritage Exhibition of the National Gallery in 1989 was shown in Auckland, New Zealand, during the Commonwealth Games, and four distinguished Zimbabwean sculptors Nicholas Mukomberanwa, Bernard Takawira, Locardia Ndandarika, Bernard Matemera and one painter, Helen Lieros, travelled to Auckland to attend the exhibition and participate in workshops. While the Gallery is keen to further the inter-national presence of the sculpture, it

is sensitive to the need to retain some of the best works in Zimbabwe. It is significant that it has purchased the winning work of the Director's Award of Distinction, and the Overall Award of Distinction in the Annual Exhibition of the National Gallery in 1989, Nicholas Mukomberanwa's *Street Beggar* for its permanent collection, with the proviso that it will never leave Zimbabwe.

The Gallery's work for the artists of Zimbabwe has an overall human quality. Their educational needs are met through a semi-formal art education at the BAT Workshop, funded by a major company in Harare, and staffed by the National Gallery. Here young artists, selected on the basis of aptitude, work towards their O and A level examinations with considerable success. The Gallery Market allows young sculptors, many from the rural areas, to sell their work in a manner that provides for them a reasonably regular income.

Independent Zimbabwe has seen private galleries in Harare consolidate their operations and work increasingly towards the promotion of individual artists. The Gallery Shona Sculpture, one of the earliest galleries, has a large open air sculpture garden, Chapungu Village, which allows large-scale work to be seen in its natural setting. The work of the Director, Roy Guthrie, assumes an

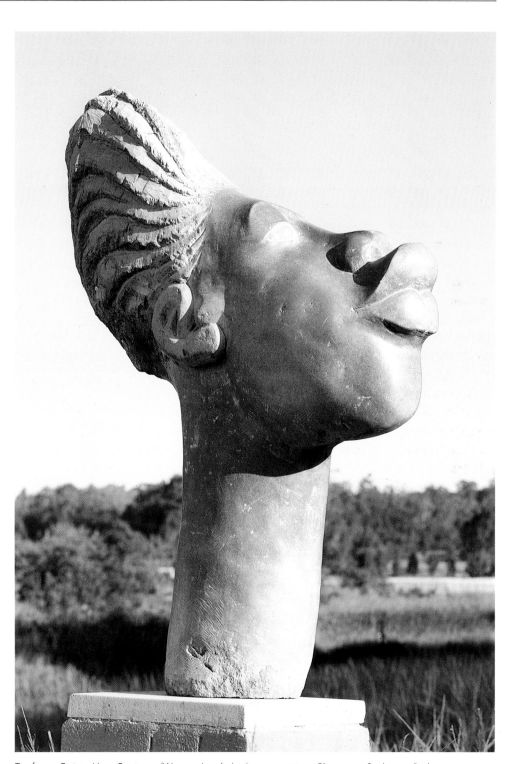

Tapfuma Gutsa, *Ya-a-Sentewa (Woman Leader)*, picture courtesy Chapungu Sculpture Park

increasingly philanthropic dimension and his building up of an impressively historic permanent collection provides the viewer with a sense of the development of the sculpture. This has been documented by Professor Helene Nelkin, a Polish art historian.

The Matombo Gallery and the Stone Dynamics Gallery have a strong presence in Harare. Stone Dynamics has held exhibitions outside the capital, at Victoria Falls. Matombo Gallery has exhibited at international art fairs, and in 1988 held an exhibition in Dublin of the work of Shona sculptors. This is indicative of the current interests of the National Gallery, and the private galleries, to hold individual exhibitions. The Gallery Shona Sculpture, over the past three years, has had individual exhibitions for Henry Munyaradzi, Bernard Takawira and Nicholas Mukomberanwa.

The tangible support of the diplomatic missions and cultural organisations in Harare for the art is strong and ever present. The former Ambassador of the People's Republic of Bulgaria in Zimbabwe, Cde Alexander Atanassov, combined his official support of Zimbabwean culture and cultural exchanges between Bulgaria and Zimbabwe with a strong personal interest and commitment to the art. His purchase of work from the Tengenenge Sculpture

Community resulted in a major exhibition 'The Lighter Side of Stone' held in May 1989 for the Biennale of Humour and Satire at the House of Humour and Satire in Gabrovo in Bulgaria. An exhibition of Tengenenge sculpture on the theme of 'Mother and Child', arranged by the Ambassador of Bulgaria and opened by the Executive Chairperson of the Child Survival and Development Foundation, the First Lady, Amai Sally Mugabe took place in December, 1989. Exhibitions of the work of young artists took place during 1988 and 1989 under the auspices of the French Embassy at Le Forum in Harare, and a major exhibition of Tengenenge sculpture, 'The Spirit of Tengenenge', was organised by the Zimbabwe-German Society in Harare in July, 1989.

In 1987, African Influence Gallery was opened in Boston for the exclusive presentation of stone sculpture in Zimbabwe with emphasis on individual exhibitions. The Reece Galleries Inc. in New York, are focusing strongly on the sculpture. The African Heritage Gallery in Hong Kong has held major exhibitions and, in conjunction with The Gallery Shona Sculpture, the Irving Sculpture Gallery in Sydney has held six highly successful exhibitions.

The promotion of the sculpture, both locally and outside Zimbabwe,

is gaining an increasingly scholarly approach. The promoters of the sculpture are realising that a sophisticated art-public's appreciation is often formed from what they know about the art, which directs their ideas of what to look for and how to look. There is increasing interest in Harare in the presentation of symposiums and forums on Zimbabwean art, in particular allowing artists to express their views on their own work and the state of the art generally. A series of lectures and forums was organised at the National Gallery of Zimbabwe in 1988, as was a series of lectures by the French Embassy at Le Forum. Africanists, curators and directors of public art museums are visiting Zimbabwe with frequency, to study the art, meet the artists, and elevate its status once more to exhibitions in public art museums. Freida High Tefasgiorgis, Professor of African and Afro-American Studies at the University of Wisconsin, is arranging for the sculpture to be exhibited in an overview of African modernism which she will curate for her university. This is indicative of a trend to present the sculpture in a broader context of African or Southern African art.

In 1990 an exhibition '10 years Zimbabwe' took place at the Ubersee Museum in Bremen, Germany, coordinated by Dr Erica Kammerer-Grothaus. This

exhibition defined the nation's identity in the light of its history, and traditional and contemporary culture. Zimbabwean stone sculpture featured prominently in this exhibition as did paintings from the children at the Tengenenge Sculpture Community. This was possibly the broadest based and most ambitious display of Zimbabwean life and heritage ever held — its parameters being far beyond those of the ordinary exhibition. Its catalogue was more of a handbook to Zimbabwe with over thirty essays on a variety of topics, including art, by leading Zimbabwean and expatriate writers.

Grace Stanislaus of the Studio Museum in Harlem, New York, arranged for an exhibition of the work of Henry Munyaradzi, Nicholas Mukomberanwa and Tapfuma Gutsa, in January of 1990. The exhibition, Zimbabwe op de Berg, at the Foundation Beelden op de Berg in Wageningen, in Holland in June, 1989, benefited from the consultation of Harrie Leyton, anthropologist and ethnographer, Director of the Tropen Museum in Amsterdam. Interpretation of the exhibition 'The Lighter Side of Stone', in the House of Humour and Satire in Gabrovo in Bulgaria, benefited from the presence of Tom Blomefield, Director of the Tengenenge Sculpture Community.

The Yorkshire Sculpture Park, near Sheffield, England also included many pieces of Zimbabwe's stone sculpture in a very successful exhibition in September of 1990.

Film-makers are coming to Zimbabwe and making important documentaries on the sculpture which allow artists to present their work through their own eyes and words.

The current emphasis on contextualisation, interpretation and education in terms of the sculpture is long overdue. It does however underpin the international realisation of the cultural respectability of the art. The impetus is not coming so much from the promoters of the sculpture as from scholars themselves, which lends credence to a genuine appreciation of the cultural value of the work from an academic viewpoint. Such an approach complements the commercial aspect of the promotion of the work, and heralds stone sculpture in Zimbabwe to be recognised as one of the most important cultural statements to come out of contemporary Africa.

Visitors to Zimbabwe who purchase the sculpture for exhibition overseas are often people with considerable professional and academic skills, who lend a different dimension to the promotion of the sculpture outside the country. It is to be hoped that the sculpture will soon take its rightful place in the public art museums of the world and be considered as one of modern Africa's most valuable aspects of cultural property.

Zimbabwe today offers the visitor a variety of experiences. It is one of Africa's five-state countries, and it caters lavishly for the tourist. Visitors to Zimbabwe are becoming increasingly aware of the nation's cultural richness.

Since Independence in 1980, the stone sculpture in Zimbabwe has been the most important, visible and internationally recognised aspect of a lively and flourishing visual arts practice, the physical environment of Zimbabwe, and events which have taken place as a result of social and political change. While Zimbabwean art cannot yet be seen to have a cohesive national identity, its cultural specificity may be recognised in terms of its representation of the traditional and contemporary cultures of both black and white Zimbabweans. Yet some well-known expatriate and white Zimbabwean painters' work is reflective of directions in international art which cross cultural boundaries.

From colonial times artists in Rhodesia had to fight against the geographical isolation of the country, the pedestrianism and parochialism of certain white Rhodesians, the amateurism of art societies, and the economic and political difficulties of the country which

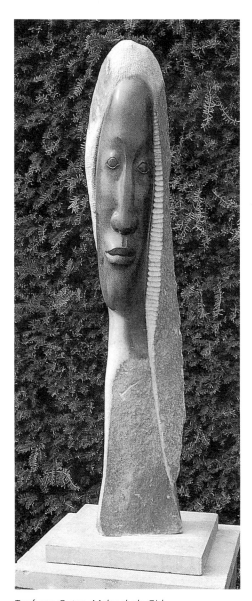

Tapfuma Gutsa, *Melancholy Girl*

established priorities other than the fostering of the visual arts. From the onset, the National Gallery had to fight against the problem of an 'uneducated art public' and at the same time try to develop an appreciation of art within the local community. In encouraging Zimbabwean artists to take themselves seriously, and to consider their work in terms of professional standards, it drew public attention to a serious appreciation of the worth of art and of the artist as a professional.

In 1958 the first Annual Exhibition was held at the National Gallery, an exhibition which may have had its origins in the competitions arranged by the suburban art societies, but one which subjected the work of black and white Zimbabweans to rigorous and selective judgment, and the pursuit of standards of excellence which have always been the Gallery's criteria. Today the Annual Exhibition, known as 'Zimbabwe Heritage', is judged by a panel of international jurists who judge the art by standards which have nothing to do with its commercial appeal and instil notions of quality in Zimbabwe's artists which have nothing to do with the saleability of their work.

The state up until the present time has not tried to control the direction of the visual arts of Zimbabwe, nor the nature and content of the art. Prior to Independence, apart from the National Gallery there was no direct government support for the arts until the establishment of the National Arts Foundation in 1971. The foundation, in the words of its director Derek Huggins 'was a recognised coordinated and responsible body to serve as an acceptable means of channelling finance from the government and from the private and industrial and commercial sectors to stimulate and promote the arts'. Since Independence, direct government support for the arts has increased. In 1985 the Ministry of Youth, Sport and Culture, today the Ministry of Education and Culture, was established as part of the First Five-Year National Development Plan of Zimbabwe. The National Arts Foundation has been reconstituted as the National Arts Council, and in keeping with post-Independence thinking has an indigenous Shona-speaking Zimbabwean staff. The council looks after the interests, financial and otherwise, of the various Zimbabwean arts organisations including the Zimbabwean Association of Visual Artists, Craftpersons and Designers' (ZAVACAD), an organisation officially recognised by the Ministry of Education and Culture. Run by artists to serve the interests of artists, ZAVACAD is not so much a political voice for the artists of

Zimbabwe as an organisation with a human dimension which tries in a practical way to serve the needs of its members — largely young sculptors working in rural areas with problems of transport, materials and market outlets.

It is relevant here to establish the origins of the stone sculpture in Zimbabwe and to look at the influences that have governed its direction. The sculpture is chronologically contemporary, and it may well have a legitimate place in what is acceptable as African modernism. The earliest recognised exponent of the stone sculpture as we know it today was Joram Mariga, who is considered one of Zimbabwe's master sculptors, and who had a one-person exhibition at the National Gallery of Zimbabwe in 1989.

While Frank McEwen is still considered the catalyst for the early sculptors, Mariga's historic position is now firmly consolidated through his encouragement of many of the early sculptors. Joram Mariga carved originally in wood, and then turned to soapstone. Working in Nyanga in his spare time, as an employee of Agritex, his work was discovered by Mrs Pat Pearce, who brought it to Frank McEwen at the National Gallery. McEwen was impressed by the way that Mariga explored the parameters of his traditional culture through his art, and this was the origin

of his interest in discovering other manifestations of intuitive talent in Africans, initially in painter and sculptor Thomas Mukarobwa, and developing its potential through encouragement at the National Gallery Workshop School. Similar encouragement was given to untutored Africans by Tom Blomefield through the establishment of the Tengenenge Sculpture Community in 1966. While the artists in the main were new to the notion of art (apart from those who had been to mission schools), they were familiar with the material they were to use, stone, and had observed hand carving within the rural areas in Zimbabwe, Mozambique, Malawi and Angola from where they came. These previous associations with the material and the executional skill assisted them quickly to develop the basic skills, and explains the early quality of their work.

Seminal to the work of Frank McEwen and Tom Blomefield, but important to the development of Zimbabwean art, was the encouragement given to black African artists at Cyrene Mission and Serima Mission. Cyrene Mission was established by Canon Edward Paterson in 1939, Serima Mission by Father John Groeber in 1948. Both clergy encouraged their artists to make art in accordance with Christian beliefs rather than making reference to their

African beliefs, and instilled into their students a Western understanding of art. The influence of the teaching at both these missions on the future of Zimbabwean art cannot be discounted.

Frank McEwen, first Director of the National Gallery of Zimbabwe, was born in Britain in 1912, and attended the Sorbonne in Paris, studying there under Henri Fucillon and painting with Lucien Pissarro. At the Art Academy in Toulon in Southern France, he experimented with the teaching methods of Gustav Moreau, which had a great influence on his encouragement of Zimbabwean artists. From 1945–1955 he was Fine Arts Representative of the British Council in Paris. He arrived in Rhodesia with a knowledge of the European art world and its art that was as formidable as his connections within that art world. He was responsible for bringing many exhibitions from Europe to the National Gallery, including the opening exhibition drawn from the collection of the Louvre, and the national galleries of Holland, England and Belgium. He also had a wide knowledge of African art, in particular the art of the Niger basin and the Congo. He did not consider that art to be primitive or naive, but art which represented the strength of the culture of the areas. He saw Africa as a world where for generations faith, magic,

music and dance and object-making had interacted with each other to profoundly express an understanding of the relationship between the physical and the metaphysical, and the spiritual and mortal realm. He felt that art by Africans living in Rhodesia whose cultural expression had undergone suppression during colonial times should be capable of similar expression and depth.

In 1957 he encouraged some of his Gallery attendants to paint. These included Thomas Mukarobwa, whose expressive and painterly vision of the physical make-up of Nyanga gave him a marked intuitive talent as a painter, and today his work is well-known. Shown the work of Joram Mariga, working in Nyanga in soapstone in a way that expressed the reality of his Shona beliefs, he also gave his attendants tools and stone and encouraged them to sculpt. These aspiring artists were formed into a loose association known as the National Gallery Workshop School. The school had no formal headquarters (although its base was the National Gallery), but the artists were given tools and stone and the necessary stimulus and critical encouragement. These men were largely rural born, of limited education but steeped in the beliefs and cultural traditions which made their traditional Shona culture a living culture. McEwen

believed that the spiritual depths of these men were equal to those who made what was now called tribal art, and he encouraged them to tap these depths through their sculpture. No direction was imposed upon them, no one style was considered acceptable, and no specified relationship with their material was expected. The original Workshop School, since disbanded, will be treated in depth in a later chapter. Many of the best artists working today began to sculpt at the school, and the far-reaching influence of McEwen is still evident in their work today.

While the Workshop School continued during the l960s and gained considerable international prestige outside of Rhodesia, in 1966 a new momentum was given to the sculpture. Tom Blomefield, a South-African-born farmer and chrome miner of English and Irish descent, established a tobacco farm at Tengenenge, 140km north of Harare, in the Horseshoe Block, near the mountains of the Great Dyke which reach down to the Zambezi Valley. His workers were immigrants from Malawi, Mozambique and Angola, and had come to Rhodesia seeking employment. He became fluent in one of the languages of his workers, the Malawian Chewa, and thus interested in their cultures, developed a sympathetic understanding

in their wish to retain links with their traditional cultures through upholding customs and observances associated with spiritual practice, for example the dance societies associated with initiation of young men. During the time of international sanctions against Rhodesia, he was forced to find alternative employment for his workers. It was his initial idea to establish a craft school, where his employees could revive the traditional crafts of their parent cultures. While this idea was germinating an itinerant sculptor, Crispen Chakanyoka, arrived at Tengenenge with some of his work. Crispen Chakanyoka had worked with Joram Mariga in Nyanga.

Initially artists worked from a model, Lemon Moses, one of their number. However Tom Blomefield, sculpting with his employees, encouraged them to reach into the traditional beliefs of their parent cultures for inspiration. Thus the stylistic origins of much of the early Malawian and Angolan sculpture from Tengenenge were the masks and costumes of the secret dance societies.

In the beginning sculpture was taken and sold from the National Gallery, and for some time Tengenenge was loosely affiliated with the Gallery and seen as an extension of the Workshop School. Tengenenge's fluctuating fortunes have always been linked with

events that have affected the country. During the Independence War in Rhodesia, Tengenenge was closed for security reasons, and outlets for the work were established in Harare.

Today Tengenenge flourishes again, under the direction of Tom Blomefield, and benefits from the present political and social stability of post-Independent Zimbabwe. Tengenenge is not only a community of artists, it is a community of families and friends. It can be seen as a successful social experiment as much as an economic success. By 1980, over 500 artists had been given the opportunity for the expansion of their human potential, far in excess of that of the average rural African with limited means and education. Tom Blomefield's provision of a place and space for artists to work has allowed them to retain their traditional way of life and at the same time make contact with the outside world through many visitors to the community. At its most meaningful, Tengenenge is a successful experiment in art education, community arts and development, and rural development. It has been a departure point for some of Zimbabwe's leading sculptors, such as Henry Munyaradzi, Fanizani Akuda and Ephraim Chaurika. Through exhibitions which have been held outside of Zimbabwe Tengenenge has become world-known,

yet the community remains the same with its cluster of huts, open fires and plough discs, and sculpture around as far as the eye can see.

Both Frank McEwen and Tom Blomefield, from different positions and perspectives, had a developed and sensitive understanding of their artists' cultural backgrounds, and their need to make art in response to what was culturally most important to them — the beliefs and observances of their parent cultures. Both men realised that the educational and economic limitations of rural Africans did not limit their understanding of their cultural heritage, and their already existing spiritual development. It was a confidence in the potential source of subject matter and its scope, and a faith in the artists' knowledge of and access to that source, which gave both men confidence in the cultural value of the art that they were encouraging.

It was the philosophy of both men to encourage rather than to directly influence the artists, and thus stone sculpture in Zimbabwe has been able to shape its own future. Although it was initially vocational, its directions were not established by existing market forces or an already established clientele. The artists had few expectations imposed upon them but they were helped in

reaching an understanding of the value and worth of an object with no spiritual or material function. They were also encouraged to arrive at their own conclusions as to why they were making art, what their art was about and who their art was for. They were not forced to conform to the Western stereotype of the artist, to see the artist as other than self-supporting, or isolated from society. They were not exposed to other art forms, or reproductions of art, nor were they asked first to draw before they started to sculpt. Hence they had no desire to copy or reproduce images. There was no style or genre which they had to consider acceptable, and no conformity imposed upon them through institutionalisation or classes. Each artist reinforced his individuality through working in his own time, place and space, and thus discipline came from within. This approach to making art has become an established tradition for stone sculptors in Zimbabwe, and it is a paradigm for the way in which these sculptors work today.

The National Gallery of Zimbabwe's Workshop School and the Tengenenge Sculpture Community were established at a time when historic African societal and cultural values had been undermined by colonialism. However they had not been entirely replaced by the values established

by urbanisation, further education and acculturation characteristic of post-Independent Zimbabwe. At the Workshop School, and in particular at Tengenenge, a large number of artists were encouraged to reclaim and reinforce traditional cultural values. Art was not introduced to them as the product of education or the synthesis of established ideas. For the artists, art was a new way of expressing their traditional social role as contributors to society and supporters of the family. It helped them care for the older members of their family as tradition decreed, to improve living standards and provide medical assistance and education for their children. The environment in which sculpture was created, out-of-doors, and often in the family and domestic surroundings, meant they were not cut off from a familiar way of life by their art.

Today the work of the older sculptors such as Nicholas Mukomberanwa and Henry Munyaradzi remains culturally authentic and genuine in statement. These Harare-based artists retain a profound respect for their cultural heritage, and pay that respect through their sculpture. However, a number of younger artists in Harare are deliberately 'romancing the stone'. There is little opportunity for art education in Zimbabwe in secondary schools. Lacking in any form of art education and developed under-standing of the meaning and function of art, these younger artists are becoming increasingly manipulated by market forces. Because of severe unemployment, they see the artist as a self-employed member of the work force, and are making income-producing objects rather than art. They do not see the artist as enriching the society in which she or he lives. This notion is supported by some private galleries that purchase work outright from artists. Young artists are thus often encouraged to make more art rather than better art. Distanced by time and circumstances from their traditional cultures, many young artists respect their traditional beliefs but, inevitably, they see them as a prescribed formula for selling their work to their European clientele both inside and outside Zimbabwe.

An artist's relationship with his or her own culture may be consolidated through art. Indifference to the cultural relevance of his or her art can make an artist produce what is alien to his or her own culture. It is possible because of the indifference of the Shona people of Zimbabwe to the art of their own culture, the sculpture of the Shona, that Zimbabwe's Shona sculptors, in particular young sculptors, do not make sculpture which reflects the social and cultural forces at work in Zimbabwe today. While little has been done to attract the Shona people to the sculpture of the Shona, the Shona historically have not had a developed level of visual awareness or literacy. This has been partially the product of a lack of art education in schools. The cultural expression of the Shona has been in music, dance, and more recently, poetry, drama and the novel. Their association of the three-dimensional object has been with their material culture, the functional object which has assisted the operation of their daily life. If younger artists commented on the issues and events in contemporary Zimbabwe through their art, they may establish communication with an audience of their own culture. Zimbabwean painters, young Africans such as Fidgie Ngombe, who have no tradition of a European marketplace to support their art, are entering into the area of social comment and using a visual language which is realistic and easily read by other young Zimbabweans. However, it must also be realised that young sculptors have the educational and economic limitations of the older artists, particularly young sculptors working in remote rural areas. Many have seldom gone beyond Form Four, and few have attained O levels. They are not always politically or socially aware and their knowledge of the outside world can be confined to the 'messages' they receive from radio,

television and film. Hence they have little opportunity for development within their own contemporary cultural matrix.

There are, however, exceptions to that rule. Tapfuma Gutsa is a Zimbabwean sculptor who has had a formal art education at the City and Guilds School in London. His work has international influences, and reflects his critical attitudes to Shona culture, in particular the efficacy of certain Shona beliefs. He sees art as having a social as well as a material and economic function, is not afraid to take issue through his work, and urges younger sculptors to do the same. Brighton Sango is another sculptor who feels that being Shona is not necessary to his art. His abstract sculpture explores the possibilities of pure form and while doing so conveys a universal message, and recognisable human emotion.

The prospect of a Regional School of Art and Design for SADCC countries to be based in Harare, will open up many possibilities for Zimbabwean artists. Here artists will be sensitively accommodated into a variety of courses suitable to their needs, developed skills, potential skills and intuitive abilities. It is to be hoped that the effects of an institutional structure will be minimal, and artists, while being exposed to influences outside of their art, will be encouraged

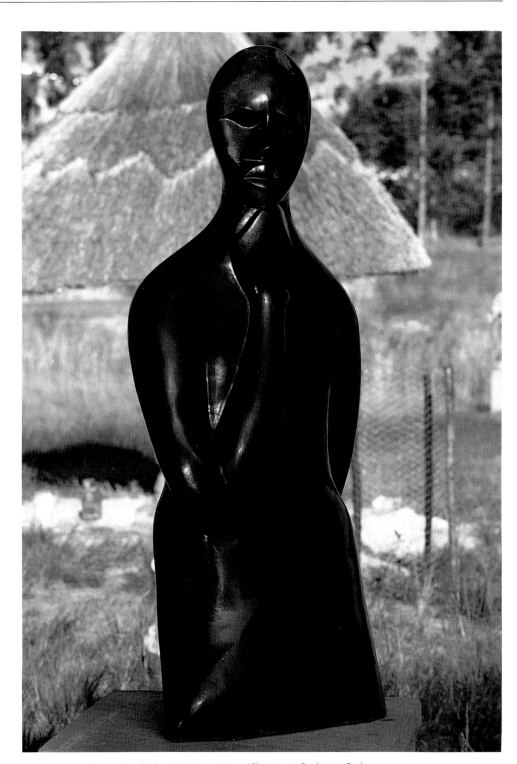

Agnes Nyanhongo, *The Thinker*, picture courtesy Chapungu Sculpture Park

to make art with the freedom that they have always known. Introduction to new materials, new concepts of art and ways of making art may break down what might seem to be traditional barriers to the development of Zimbabwean art and, in particular, the stone sculpture in Zimbabwe. The establishment of the School may mean the introduction of new ways of expressing age-old ideas, and new ideas expressed in age-old ways. While encouraging young sculptors to conceptualise new ideas in their work and make sculpture which is relevant to their societies today, the School, through a process of more formal education, may also encourage them to explore their traditional cultures more formally than before, and to make a study of their beliefs and observances so that they might be more accurately documented in their sculpture. The School will perhaps prevent younger artists from repeating a formula which has been tried once too often and broaden the development of Zimbabwean art. It might be that Zimbabwe, through the School, will not only be recognised for its stone sculpture but for its sculpture.

Today Zimbabwe is no longer isolated from the rest of the world. The achievements of the government are recognised outside Zimbabwe, and donor agencies and diplomatic missions from many countries are assisting in economic, cultural and social development. Economic development in Zimbabwe is measured by a series of growth points, areas which are thought to be achieving maximum economic efficiency and productivity. They are used as role models for the development of other areas.

Many young Zimbabweans are benefiting from cultural exchanges, and receiving tertiary education outside Zimbabwe. Zimbabwe's musicians, poets, and writers are responding in their work to experiences outside of their own culture and broadening their cultural horizons. It is inevitable that the arts in the country will begin to express an African consciousness, and international consciousness and sculpture should not be left behind. Sculptors are now travelling outside Zimbabwe with exhibitions and are exposed to art forms and cultural values other than their own. Opportunities are now provided for sculptors to use images and symbols in their work with a more general application and universal significance. But the traditions they reflect in their work are living traditions and they should not lose sight of them.

There is a great deal of intuitive talent among stone sculptors in Zimbabwe: a facility for carving, an understanding of the properties and potential of stone that has never been taught, and an ability to solve formal problems of great complexity. This talent must be directed and guided towards standards of excellence rather than exploited for commercial gain. But commercialisation cannot stop this talent or limit its development, and for this reason alone stone sculpture in Zimbabwe has an assured future.

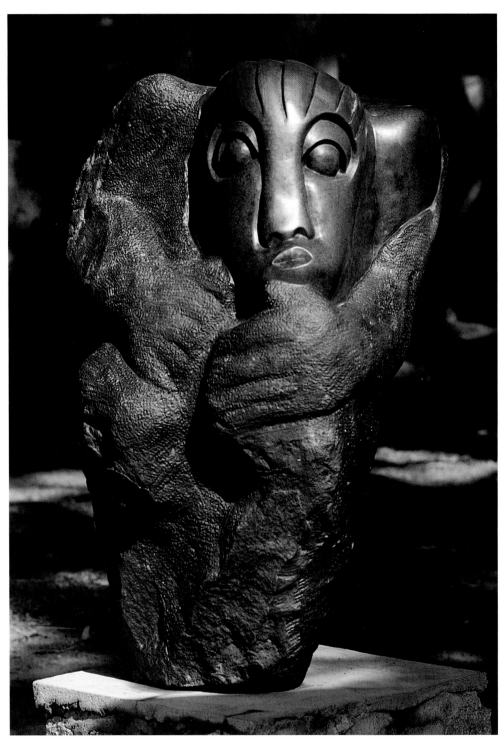

Bernard Takawira, *Looking to the Other Side*, picture courtesy Chapungu Sculpture Park

CHAPTER TWO

UNIQUE ARTISTIC PROPERTIES

The difference and affinities between the sculpture and historic and contemporary aspects of international sculptural practice must be recognised. It is necessary to know how the sculpture differs from Western 'religious' art. It is necessary to understand the African quality of the sculpture, and its relationship to African tribal art.

In Western countries, sculpture historically has had a closer connection with the world outside art than art itself. Sculpture for centuries was public art and generally reflected the interests of the general public. Sculpture's history has not so much been its own history but the history of church and state, of cities and leaders and heroes, of exploration, human achievement and of death. Churches, buildings, civic squares and the recognition and honouring of leaders have been the reason for sculpture's existence. Sculpture's historic home has been outside the gallery or the museum and in the street, the square or the plaza.

For centuries, sculpture's public has not necessarily been an art-loving public but a heterogeneous crowd interested in sculpture, not because of its artistic properties, but because of the people, incidents and deeds it represents. Historically in Western society, sculptors were under the patronage of church and state and the commitments manifested in their work were largely religious, political or civic. The presence of a sculpture underpinned the permanency and efficacy of a system, an ideology or a belief. Today when systems, ideologies and people come and go before they are considered memorable, sculpture has lost its historic associations. Television, film and the biography have taken over sculpture's commemorative role.

Abstraction and modernism removed sculpture from its representational associations and established autonomous objecthood as the reason for its existence. After the 1920s, sculpture no longer had to be about something, or of someone or something, to be understood. It became valued for its artistic properties; for its formal values and for considerations on the part of the artists of mass and space; and on a more personal basis, what it made its viewers feel. With its genesis in the work of Picasso and Gonzales — cubism and constructivism — abstract sculpture moved from the base onto the floor, later the table and more recently the wall, thus creating a physical intimacy rather than a distance between the work and the viewer. Sculpture began to take its place in galleries, becoming an art commodity rather than a commissioned item. Sculptors could now say what they wanted to say rather than what they were told to say. Sculpture, like painting, became subject to conditions of connoisseurship; works were bought and sold and provenance established. If sculpture was no longer a monument to human endeavour, it established for itself a new value as art.

Post-modernism again posed challenges to accepted notions of sculpture. It established a discourse about the nature of objecthood, its meaning and its ramifications. The object had become considered as more than a thing in itself, with cultural and social significance. In the 1970s, the thinking or concept behind the work of art became as important as the work of art itself. The definition of sculpture was opened out to include conceptually-based new and ephemeral art forms: performance art, video art, installations, and body art — all three-dimensional and often all three taking place together. If these works negated the artists' hand and denied their materials the truth, they were filled with the artists' presence and often ritualised the work process, giving it a sense of theatre. Hence sculpture became an inclusive and overwhelming set of activities of which object-making was one.

The 1980s saw the concept of the sculptural object become more inclusive. Found objects from the real world, with already culturally assigned significance

and meaning, were culturally redefined through placement in a fine art context. Hence sculpture regained its link with the real world but in a very different way to before. These links were also established through environmental sculpture, when artists worked with the natural environment, used natural materials and explored the sculptural properties of natural form.

As performance art, video art, installations and other ephemeral art forms became art forms in their own right, there was among sculptors a return to object-making, sometimes through the releasing of materials from traditional expectations and the mixing of media with culinary skill. On the other hand, some artists re-established the traditional relationship of the artist to his materials and once more engaged in the heroic sweaty tussle with their work characteristic of Michelangelo. This relationship now included what was thought about subject and was largely a conceptual rather than a perceptual understanding of subject. The statement of the new object sculpture included the statement about the artist's relationship to society, his or her own culture and other cultures. Often the natural properties of the material were highlighted in the cause of realising its truth, and had an influence on the subject.

Stone sculpture in Zimbabwe has a strong affinity with this direction in object sculpture. It has a traditional treatment, hand carving of an age-old material — stone. The historic sweaty tussle remains, while a more heady exercise takes place at the same time. The mind becomes shaman, the idea becomes the driving force and part of the means. Stone sculpture in Zimbabwe at its best arises from the need of the artist to express himself or herself, from the need to make permanent his conception rather than a perception of things and to do so with total honesty to the material.

However, stone sculpture in Zimbabwe has little in common with historic aspects of sculptural practice. It has seldom been intended or considered to be public sculpture. Its development has never accompanied the building of cities. Stone sculpture in Zimbabwe does not depict individuals, nor is it commemorative or emblematic. It is seldom representational.

Although the matrix of stone sculpture in Zimbabwe is the spiritual beliefs of the societies represented by the artists, it is not 'religious art' in the Western sense, or the generally accepted African sense. Its spiritual dimension is markedly different. Unlike Western religious art, its imagery is not already established or collectively understood as

religious imagery. The subject does not come from religious narrative or from the written word such as the Bible. Religious traditions among the societies represented by the artists are largely oral, passed down by word of mouth from generation to generation and made concrete by observance. Unlike Western 'religious' art, stone sculpture in Zimbabwe does not depict familiar religious figures. The religions of the artists' societies have no saints or prophets. The stone sculpture does not depict religious incidents or events and it does not have moral overtones.

Unlike African religious art, it does not play any part in spiritual observances. Nor does it have any ritualistic or ceremonial role, and artists are not ascribed any religious or spiritual powers by the societies they represent. However, among Shona artists, some feel that they are possessed by a *shave*, a wandering ancestral spirit which bestows a talent on a human host.

The African quality of stone sculpture in Zimbabwe does not just lie in its vitalism and its preoccupation with mass at the expense of space. In common with more traditional African artists, the stone sculptors' reason for making art is not bound up with a sense of selfhood or an interest in expressing individuality in their work. Collectively the sculpture

expresses the African belief in the cosmological link between the mortal world and the spiritual realm, between the living and the dead.

In this expression the sculptors seem to have a sense of oneness which lies far deeper than the relationship of artists within a prescribed movement or tradition of art. The sculpture seems to spring from a shared memory on the part of the artists in a Jungian sense. As much as it presents the artists' societally based and culturally determined beliefs, it presents the collective unconscious of a culture, both specific and African. Some commonalities of iconography, the large head, the protruding eyes, the Janus head and the concept of metamorphosis are shared by the art of more than one African culture and by cultures outside of Africa.

The African quality of the sculpture is pervasive, its essence does not have to be referred to or described and it is obvious where the sculpture is from.

Yet located within the discourse of African art, the sculpture has little in common with African tribal art, for example, the art of the Congo, or the Niger Basin. Historically in Africa, the significance of the carved object has been the material or spiritual function it has had outside its objecthood, and its association with ritual, ceremony, or material culture. Often such objects were made out of wood, a durable material. Once the ritual or ceremony was over, the object had outlived its usefulness and there was no need to preserve it. The power of stone sculpture in Zimbabwe lies in its autonomous objecthood, it has never been regarded as an ethnographic specimen. As much as Shona sculpture is related to Shona ontology, it has no place in the few ceremonies held by the Shona to propitiate or venerate ancestral spirits. The sculpture of the Chewa and Yao of Malawi and of the Mbunda from Angola has a more specifically tribal origin and contains images from the masks worn by dancers in secret societies which establish a relationship with the spiritual realm.

Historically, what is now known as African tribal art was disenfranchised from its functional role but located within an ethnographic discourse by nineteenth century ethnographers. Once removed from their context, put in a glass case, and housed in an ethnographic museum, these objects were almost scientifically regarded as cultural specimens which served as a departure point for a wider study of the cultures represented by their makers. These objects were often thought to define the meaning of African religious practice. In ritualistic terms, they often possessed a channelling function and influenced spiritual powers to act in the interests of the real world. Objects thus assisted the preservation of the relationship of the spiritual realm and the natural world and reinforced its links. Hence a mask might honour a spirit in a particular dance and encourage the assumption that the dancer had taken on the guise of the spirit. The fetish figures such as those found in the Congo contain ingredients which it is believed allow the fetish to operate as a benevolent or destructive force on the owner's behalf.

It was the early 20th century artists, Picasso, Derain, Matisse, Leger and others who began to see African carved objects as possessing artistic properties rather than merely being minders of tribal culture as they were to the ethnographers. Picasso in his well-known painting *Les Demoiselles d'Avignon* incorporated the images of three African masks as the faces of his demoiselles. Similarly the Fauvists, Cubists, Dadaists and Surrealists employed African imagery in their paintings and African volumetric concerns into their sculpture.

Prior to the First World War, art historians began to formalise what to look for and how to look at these objects within a fine arts discourse. Rather than ethnographic specimens they were

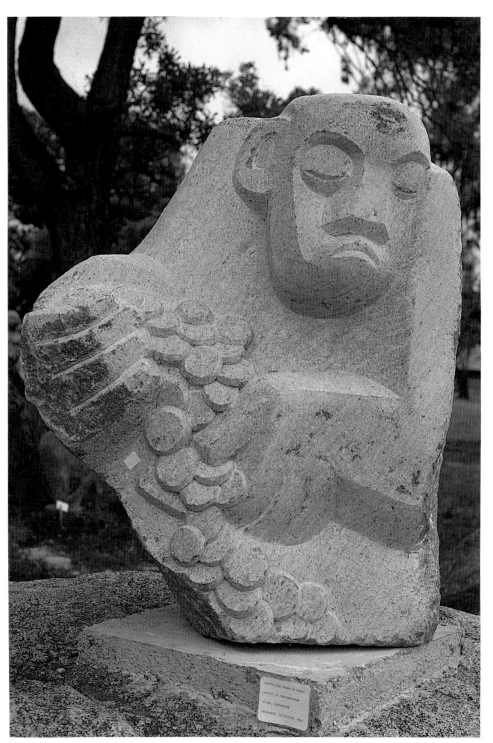

Nicholas Mukomberanwa

re-classified as tribal art. Without consideration of the purpose of the object, or even who the artist was, objects from different cultures were ascribed common properties with no distinction between their widely different functions and intentions, either on the part of the artist, or the society in which he lived. Fetishes, masks and statuary became collectively known as sculpture and inscriptions on bark became known as paintings.

Slowly in European eyes, these carved objects acquired a power which resided in their autonomous objecthood rather than one related to their function outside that objecthood. Meaning became lodged in the appearance and presence of the work rather than its wider cultural application, and content appeared inherent in form rather than function. Hence began the taxonomic shift of objects from ethnographic museums to fine art museums. The generic term 'tribal art' was given to these objects with a lack of regard for their place and role within the spiritual structure of the society represented by the artist. Within these museums, objects were categorised, often geographically, in accordance with their style and form rather than assigned their cultural significance. The terminologies of ethnography, science and anthropology

gave way to the terminology of art. Objects were removed from their glass cases. placed on bases and lit from above, below and occasionally inside, and their artistic properties were emphasised by their display and labelling. Rather than being valued for their content and meaning they were valued for their authenticity (if the artists could be established), their provenance, and their rarity. Their function became unimportant; their merit lay solely in their artistic merit which was ascribed to them by museum directors, curators and collectors from outside their culture.

As a commodity, these African carved objects today have become part of our material culture but they are a little short on spirit. Rather than being recognised for their African quality, these objects are assigned properties and attributes which they ostensibly share with Western sculpture. Without any intention on the part of their makers to make art, these objects have become the means by which we discover art and sculpture. Hence the Western perception of African art as something that has become art rather than something that was created to be art. However today, thankfully, cultural and social anthropologists are trying to restore the original meanings of such objects and once more using them as a departure point for an investigation of their makers' cultures.

Stone sculpture in Zimbabwe is acknowledged to have relevance to other aspects of cultural practice of the societies represented by the artists. What to look for in the sculpture and how to look at it includes these references. Although the sculpture is intended to be art, it tells us a great deal about the historic cultural practices of the societies represented by the artists. These artists are living artists; we know them as artists who are aware that they are artists, and we can establish from these artists the meaning of their work. We can learn as much from stone sculpture in Zimbabwe about the cultures represented by the artists' societies as we can about the cultural practices of those societies represented by the makers of what we now call African tribal art. Considerations of African tribal art cannot devalue the cultural association of stone sculpture in Zimbabwe.

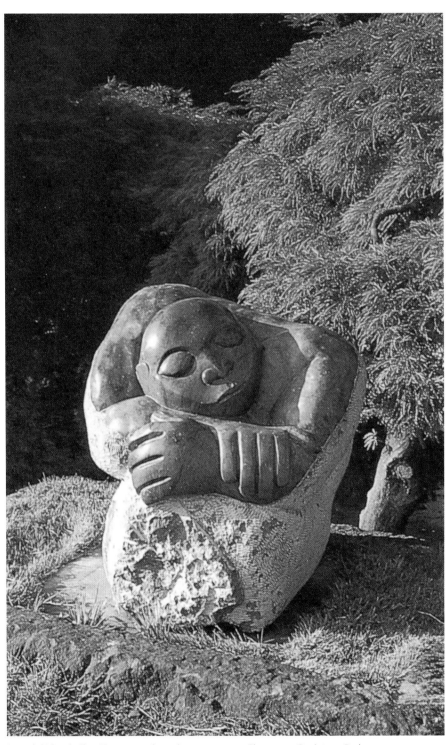

Joseph Ndandarika, *Farmer resting*, picture courtesy Chapungu Sculpture Park

CHAPTER THREE

CULTURAL ORIGINS

The stone sculpture in Zimbabwe and the influences which have shaped its directions raise many issues which concern disciplines outside of the fine arts, for example art education, cultural and social anthropology, sociology, ethnography and history. It also raises questions about the role of European 'catalysts' in colonial and post-colonial Africa. The sculpture, its origins, influences, subject matter and commercial dimension are of interest to those professionally involved in art education, art practice, community arts, arts administration and the economies of the visual arts. Within a developmental context the initial phases of the sculpture, the National Gallery Workshop School, and the Tengenenge Sculpture Community can be seen as successful community development projects for rural Africans.

Stone sculpture in Zimbabwe cannot be explained through the formal analysis that is applied to Western sculpture. Each object cannot be viewed as an art object alone with purely aesthetic values and properties. To be fully understood the sculpture must be placed in a cultural context. For the last 30 years the consistent use of the term 'Shona sculpture' has been misleading and puts severe limitations upon our understanding of the subject matter and the derivation of the subject matter in

terms of the artists' intentions. The term 'Shona sculpture' implies that all the artists are Shona, and implies a collective societal and cultural allegiance on their part. The sculptors are from different societies, indigenous and immigrant to Zimbabwe, with differing ontological and cosmological perspectives, which determine subject matter, treatment of subject and treatment of material. To date, little serious attention has been given in writing to the multi-ethnic sculptors at Tengenenge, the Chewa and Yao from Malawi, the Mbunda from Angola and those from Mozambique. Their sculpture differs greatly from Shona sculpture. No generic term has yet been found to replace Shona sculpture, and the issue was raised at the first Nedlaw Sculpture Forum at the National Gallery of Zimbabwe in 1984, and tabled in Resolution 7: 'The name "Shona sculpture" should be dropped forthwith and a more unifying terminology adopted, without obscuring the specific identity of the work involved.' What is required is a name that highlights the societal differences of the artists and even the currently used 'Stone Sculptors' of Zimbabwe fails to achieve this. Hence the title of this book, *Contemporary Stone Sculpture in Zimbabwe*.

To be fully understood the sculpture cannot be divorced from its context.

Art attributes of the sculpture are best judged as to how effectively they convey the subject. The subject must be judged by how clearly it makes a cultural statement. It is only when an understanding of the beliefs of the societies represented by the artists is reached that the sculpture can be fully understood. For example in a Shona sculpture, a primary reading of a man changing into a baboon is easily made. However, unless the significance of metamorphosis in Shona society is understood, a secondary reading cannot be attempted. Images may be recognisable but the meaning behind the images must be known if the sculpture is to be correctly interpreted.

When questioned, the sculptors will discuss their sculpture in terms of its cultural statement rather than as an art object, and naturally so, as their ideas about their culture are more fully developed than their ideas about art. What may be thought to be a discussion with an artist about art will be in reality a discussion about his culture and his relationship to it.

Each society represented by the artist has a different concept of the Deity. The Shona believe in *Mwari*, the Great One in the Sky, historically a disinterested philosophical principle, reached only by ancestral spirits. The Yao believe in *Mulungu*, a personal

God, and the Mbunda of Angola believe in *Kalunga*, a highly personal God interested in the daily life of each Mbunda. Each society has a range of ancestral spirits of differing makeups and powers. Each has a different way of establishing a collective and individual relationship with the spirits, and each realm of spirits has its own way of communicating with the Deity. Shona belief is based on a personal relationship between the mortal Shona and the spiritual realm established through the intercession of spirit mediums, the *mhondoro* and the *svikiro*. The Chewa and Yao have a more exclusive relationship with their spiritual realm. This relationship is largely confined to members of a secret dance society, the Nyago and Ben of the Yao and the Nyao of the Chewa. All Mbunda have a personal relationship with *Kalunga*, which is celebrated in the inclusive Mkishi dance. Hence the structure of beliefs and their observances varies widely within the societies represented by the sculptors.

It is relevant to look at the derivation and origin of the subject matter of the sculpture. Much of it comes from beliefs which are articulated through myth and folklore. Myth is common to all cultures with culturally-determined variants. Through its presentation of archetypal situations, myth establishes moral truths and the differences between good and evil. Folklore is the means by which myth is perpetuated. Through folklore archetypal situations are individualised and given a reality to ensuing generations. Both myth and folklore are part of the rich oral history of all the societies represented by the sculptors. If beliefs are based on myth and folklore rather than couched in reality they are none the less real to those who believe, and they determine perceptions of physical phenomena and animal and human behaviour.

Collectively, the subject matter of much of the sculpture has its genesis in a mystical conceptualisation of the societies represented by the artists. This conceptualisation is the strongest influence on subject matter although it is personalised in terms of the artists' beliefs and attitudes to beliefs. Despite the changes that have taken place in the recent history of the country, subsequent movement of established artists from rural areas to Harare, and improvements in material culture, the subject matter of the sculpture has hardly changed accordingly. Despite observation of and participation in the changes which have taken place in Zimbabwe since Independence, sculptors have seldom chosen to represent these changes in their work. If it is agreed that at least the work of the older and well-established artists is culturally authentic, this would indicate that on the part of these artists, despite the effect of the change, traditional beliefs have been retained. Even among most urbanised artists, the 'real world' depicted is that of the rural African. An explanation for this may be that the changes which have taken place in the lives of the older artists have not been accompanied by educational development and political awareness which would make them more sensitised to the new social and political situation in Zimbabwe and there has been nothing to replace their traditional allegiances.

Because of the societal differences among the artists, the sculpture has no collective symbolic language. Regional differences between the Shona sculptors can determine different beliefs and different observances of beliefs. Hence there is no overall language for Shona sculpture alone.

Common to all Zimbabwean sculptors is the primacy of their relationship with their material, the locally-mined stone: serpentine, springstone, steatite, fagamaso and fagamanzi which is largely found in the mountains of the Great Dyke at Tengenenge, and the decorative Chiweshe Stone. Some artists, in particular Shona artists, feel that there is

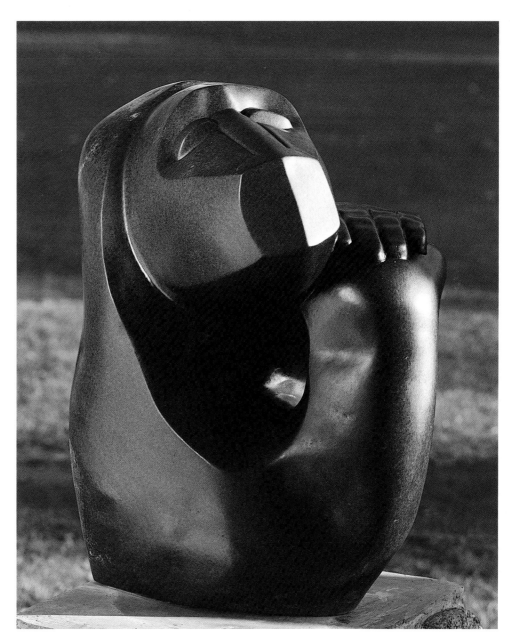

Damien Manuhwa, *Thinking Baboon Chief*, picture courtesy Chapungu Sculpture Park

a presence within the stone, a material truth which must be respected and preserved, and a spiritual force which guides them through the work. The stone before it is carved has a highly sculptural quality. Some stone it seems was sculpted before it became sculpture, and requires little working. The use of stone by the sculptors speaks of the long historical association of stone with Zimbabwe, and of the depth of the country's historical roots. The stone, which is millions of years old, imparts a sense of history to the sculpture. It conveys the feeling that the sculpture is as old as the material, and is part of a centuries-old continuity of art practice among the societies represented by the artists. Some sculptors find the subject indicated by the shape and form of the stone, others predetermine the subject and arrive at it independently of the material. However, even if the shape and form of the stone has no indication of the subject, surface, texture and colour are essential aspects of the finished sculpture. Part of the stone can be left uncarved, colour within the stone or the grain of the stone can be used to highlight the three-dimensional quality of the work.

Solutions to formal problems are largely intuitive and usually arrived at while carving, resolved prior to the commencement of work or at the conclusion. Initially the subject is blocked out and detail then inserted. Finish is achieved by a highly-polished surface.

In the stone sculpture of Zimbabwe, matters of style are determined by matters of culture. Artists have distinctly recognisable styles often achieved early in their careers. A distinctive style does not indicate a repetition of subject matter but confidence in a certain way of expressing subject and a control over the

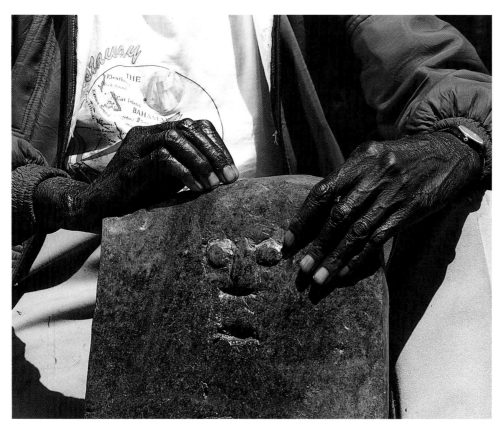

Kakoma Kweli's hands

material. There is a broader sense of style which is distinctive to artists from their parent societies which is determined by subject, approach to and treatment of subject and approach to and treatment of material.

Although the Yao and Chewa artists had not made sculpture in their parent countries before coming to Tengenenge, they were familiar with objects associated with their traditional cultures. Their sculpture is strongly imagist and the matrix of the image used stems from the richness of Yao and Chewa culture, in particular from the objects used by the dancers in their secret societies. While the masks worn by the dancers had no

function outside their objecthood, they were part of the ritual of the dance. They hid the identity of the dancer, and disguised his human attributes. Often the dancer represented a caricature of those who were socially undesirable in society, in particular a European, and the mask he wore was naturalistic to convey a recognisable character. Historically, the dances occupied a central position in Chewa and Yao society. They were performed at rites of passage such as the initiation of young men, and at funeral services. The dances thus served as instruments of social control, and a means of communicating with ancestral spirits.

Yao and Chewa sculpture often assumes the shape and form of the masks used in the dances, and figures follow the shape and form of the dancers. There is in Yao sculpture such as that of Josia Manzi at Tengenenge a sense of the caricature in the Yao dance. Often human and animal forms are exaggerated to become a parody of reality and a fantasy of the perceptual. It is apparent from Yao and Chewa sculpture that the Yao and Chewa view of the world contains the presence of spiritual beings and things exclusive to the Yao and Chewa, which assume far more importance than the creatures and beings of the natural world and natural phenomena. In some Yao sculpture, the tools seem to have taken their own course rather than having been guided by the human hand. In some Yao and Chewa sculpture, the imagination of the artist seems to have visited a fantastic dream world, to return to the real world, spent, exhausted and in need of revival. Often Yao sculpture seems in a state of formal turmoil, there is a chaotic realisation of statement, and no recognisable notions of sculptural propriety. Central to Yao beliefs and the traditional structure of Yao society are animal fables with moral overtones handed down by the Yao elders. Here animals of all kinds engage in social

relationships and find themselves in essentially human predicaments, sometimes with a spiritual dimension. Yao sculpture speaks of the strange couplings and amazing consorts which result from these relationships, such as that of the late Wazi Maicolo at Tengenenge. Many sculptures are composite animals, rather than distinctive and recognisable creatures and individuals of a species.

These animals share each other's features and borrow each other's limbs and are creatures from a surreal world. In Yao and Chewa sculpture, subject matter is not so much influenced by shape and form of the stone so much as it is by the imagination. Space breaks up the mass and plays a major part in defining the form and nature of the subject. There is little use of the curved form of the stone; angular properties and sharper edges convey a tension in the work which is seldom present in Shona sculpture. In Yao and Chewa sculpture the imagination of the artist plays tricks with our notions of reality, and makes the surreal world believable. In fact it becomes the real world and we enter this world and leave it with reluctance.

The sculpture of the Mbunda from Angola, such as that of the late Makina Kameya, and Kakoma Kweli at Tengenenge, is stylised and static and has a sense of the exclusively ritual function and service of the mask of the Mkishi dancer. Outside this service, the mask has no meaning, as the dancer has no spiritual role to play. There is no hint of human expression in the heads and there is no presence of the man behind the mask. Features are indicated minimally, depicted by cuts — simple incisions which create facial forms without individualising them. These sculptures speak of the dancer passing into another state of consciousness. The eyes roll back into the head as if avoiding contact with the real world. They seem to see things we cannot see, but fail to recognise what we ourselves observe.

The sculpture of the Shona artists varies in style, evidence of the fact that Shona beliefs are not collectively held or formally expressed but are matters of the individual's relationship with the spiritual realm. The stylistic differences among the artists reflect the fact that Shona beliefs are open to interpretation by the individual. Although Shona sculptors may have a shared perception of the observance of beliefs, treatment of the subject is highly idiosyncratic. To many Shona sculptors, what matters is the allowance in Shona beliefs for a personal relationship with the spiritual realm, and the use of the word 'spirit' in the title of a sculpture is indicative of this relationship. A common stylistic feature of Shona sculpture is respect for the stone. Often the original form of the stone is retained, and the subject is often seen as inherent in that form. Mass is seldom broken up by space, and the form of the sculpture is monolithic. In Shona sculpture the natural surface of the stone is often left uncarved, highlighting the importance of the natural properties of the material.

In Shona sculpture, the spirit world is usually represented in terms of its effect upon the natural world and presented in anthropomorphic terms. Presentation of subject is usually literal rather than fantastic or allegorical, as it is in Yao and Chewa sculpture. Because of the personal nature of Shona beliefs, there is little collective imagery in Shona sculpture, and there is no imagist recourse made to the few objects associated with spiritual practice. For example, in a Shona sculpture by Lazarus Takawira titled *Spirit Hare*, a hare will be represented as a hare with spiritual attributes rather than a spirit with the attributes of a hare. In a sculpture depicting metamorphosis, the subject is not presented in a trance-like state, but as an ordinary man or animal undergoing metamorphosis. Often the metamorphosis takes place before our eyes, so that the subject becomes a mixture of man and spirit. Shona sculpture often depicts creatures from the real world whom the Shona believe

are invested with spiritual powers. The bataleur eagle is the bearer of spiritual messages, and the dendera bird announces the coming of rain. If these themes recur in the work of a number of artists, it is an indication of their importance in Shona beliefs. Shona sculptors such as Nicholas Mukomberanwa also depict those who hold institutional positions of power in Shona society: the old aunt (*vatete*), the medium, the chief, and the mediator. Despite the highly individual character of each sculpture, individuals are seldom depicted, which represents the traditional unimportance of individual achievement in Shona society.

Like the sculpture of the Yao, the Chewa and the Mbunda, Shona sculpture is conceptual rather than perceptual. The artists do not depict the subject as they literally see it, but as they imagine it to be.

It is seldom possible to get close to animals in Africa, and the artists' impression of them is usually from a distance and in movement. Hence a representational treatment of subject based on close observance is difficult. Within Shona sculpture, the features of an animal or bird may be distorted to convey the emotions or mood of the subject, for example, agitation or excitement. The Shona's conceptualisation of the subject is based on the power of the

imagination of the artist, possibly his personal association of the subject with its spiritual significance, his particular style and the shape, weight and hardness of the stone and the tools he uses.

As the majority of the artists are Shona and, although urbanised, draw their subject matter from their traditional beliefs, it is necessary to have some knowledge of these beliefs in order to fully understand the meaning of Shona sculpture.

The name 'Shona' today collectively embraces the descendants of people who settled on the Zimbabwe plateau from about 900AD in the south and 1200AD in the north. The history of the Shona is largely oral, and findings to date have been established by archaeologists and linguists, together with oral historians, rather than historians. Traditionally the Shona, known earlier as the Karanga, lived in chiefdoms, the term conceptualised for those linked by patrilineal lineage living in one area. A series of dynasties or states have brought them together under one rule or the concentration of political power for periods of time. The actual polities of the Shona are known as *zimbabwes*, the best known of which is Great Zimbabwe near Masvingo.

At the apex of Shona spirituality is *Mwari*, the Great One in the Sky,

variously known as *Nyamatenga* (He who lives in his own heaven), *Muwanikwa* (He who was found already in existence), *Dzivaguru* (The Great Pool) and *Chikara* (The Beast). Although *Mwari* is not a personal God and is not worshipped as such (apart from by members of a *Mwari* cult in the Matopos Hills and further afield), it is believed that he created the universe and is the source of all creation. Although *Mwari* is considered a disinterested philosophical principle by the majority of Shona his name is taken in various situations.

Outside of the *Mwari* cult, links with *Mwari* are established by the ancestral spirits of the Shona, who in turn establish relationships with the mortal Shona through the intercession of possessed spirit mediums, the *svikiro* and the *mhondoro*. The ancestral spirits represent the various interests of the Shona, who believe that they have the power to intervene in the interests of family and tribe, to shape destiny, dictate behaviour and affect physical phenomena such as weather patterns. The *mhondoro*, the spirit of royal ancestors, is honoured by those of the territory and will represent that territory's interests which are largely rural and include the fertility of the land, and the benevolence of natural phenomena such as weather. The *mudzimu* or family spirits are honoured

by members of the patrilineal family. They are called upon to guarantee the continuous well-being of that patrilineal family, to protect its members from illness and witchcraft and when travelling. In addition to benevolent spirits, there are vengeful spirits such as the *muroyi* and the *ngozi*. The *ngozi* is the spirit of a murdered person who demands compensation from the patrilineal family of the murderer in the form of a woman who has to marry into the family of the murdered person. The *muroyi* or witch is either hereditary or voluntary. The hereditary *muroyi* or witch kills for no reason at all, the voluntary *muroyi* for a human motive.

Within the context of the *Mwari* cult in the Matopos Hills, the spirit medium, the *svikiro*, follows a line of succession. Outside the cult, ancestral spirits choose their own mediums. Possession of a medium is usually presaged by illness or sickness and possession is indicated by a trance-like state. The moral standards of a medium must be impeccable as they set a precedent for the rest of the Shona society. The *mhondoro* spirit medium historically determined the choice of king and today he determines the choice of chief. During the war leading up to Independence, spirit mediums played a highly significant role. Rather than acting

in the interests of the individual, which is the role of the *svikiro*, the *mhondoro* acts in the interests of the tribe or those living in a particular territory. He is responsible for the ecological stability of the territory and he determines certain areas of the environment sacred. He also determines the day of the rain ceremony — in certain areas, if a black cloth is put out to the *mhondoro* it is believed that rain will fall. In rural areas, the spirit mediums still exercise a degree of social control.

The *mhondoro* in Guruve near Tengenenge is particularly influential. In a news programme on Zimbabwe television on January 27, 1988 it was reported that there was a reluctance among local residents to use an anti-worm pesticide until the *mhondoro* of the area had sanctioned its use.

Many of Zimbabwe's Shona sculptors attribute their ability to induction by a *shave*, a special skill or talent handed on to a Shona by members of his patrilineal family or from an alien spirit outside of his lineage. Traditionally the skills of the Shona such as pottery-making or iron-working or hunting are considered the result of induction by the *shave*. While the alien *shave* is concerned only about being host to an individual, the ancestral *shave*, in bestowing talent upon the individual, acts in the interests of the patrilineal family as a whole.

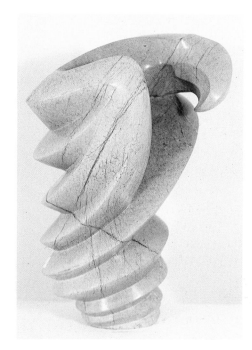

Brighton Sango, Chapungu

Shona religion has little observance or practice which requires the use of related objects with power or function outside their objecthood. Exceptions are the ritual objects used by diviners or healers such as the *n'anga*, whose approach to medicine is traditional yet holistic and involves the use of natural herbs in the course of treatment of mind and body. Other objects are walking sticks or *tsvimbo* used by spirit mediums, often the property of ancestors whose spirits possessed the mediums and were

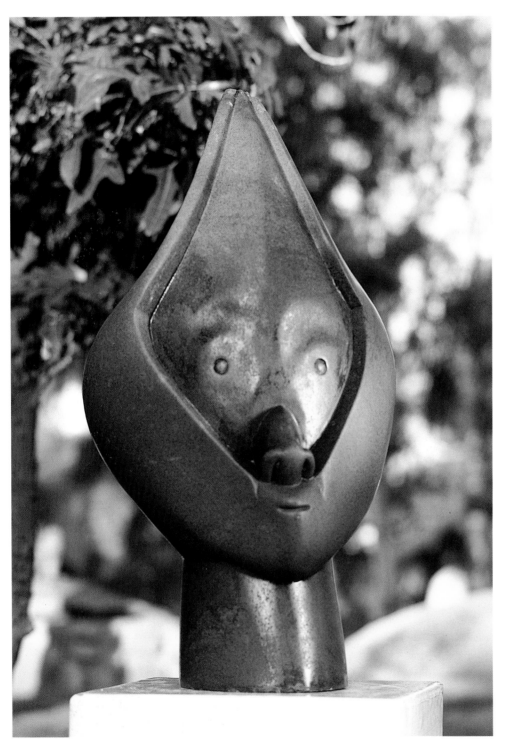

Ephraim Chaurika, *Man Emerging from Plant*, picture courtesy Chapungu Sculpture Park

given to the mediums by the ancestors' families.

In addition to belonging to their chiefdom or lineage, the Shona belong to their clan or totem. This is an association similar to the membership of a club. It has nothing to do with chiefdom or tribe or genealogical association but expresses similar allegiances and claims similar loyalties. The clan or totem is named after an animal, for example the rhinoceros totem, or the elephant totem. Members of a clan or totem are supposed to have been descended from an unspecified ancestor, although they have no traceable kinship ties. Totem or clan membership has a strong association with geographical region. When a Shona woman marries, she takes on the clan or totem of her husband and if divorced she returns to the clan of her father. Clan membership is exogamous — persons may not marry a member of their clan or totem. Punishment is also given to those who eat the meat of their clan or totem. There is no ritual or ceremony attached to belonging to a clan or totem. However, members of a clan or totem experience a relationship similar to that of kinship and lineage. The clan or totem often provides subject matter for Shona sculptors, for example, a woman can be depicted turning into a rhinoceros, the punishment for eating rhinoceros meat.

Shona ontology does not include the structured worship of spirits, and their presence is seldom recognised or observed from the occasional propitiation ceremony or veneration ceremony. There are no collective public displays of belief or places of worship apart from the *Mwari* shrine in the Matopos Hills. There are no prophets, priests, clergy or saints. There are no people assigned special spiritual powers apart from the *svikiro* and *mhondoro*. There is no theology as such, and no persons in positions of religious authority to determine what is to be believed. Shona religion is not doctrinal, although it is responsible for the establishment of moral order. The importance of fertility to the ancestral spirits shows that Shona beliefs are important to the lives of rural people. To date there has been no modification of Shona beliefs or reconstruction to meet the needs of urbanised Shona. Shona beliefs have no written laws or commandments. Belief is not institutionalised; it is a highly personal matter between the living and the dead, the mortal and spiritual realm, inclusive of all.

Traditional Shona beliefs have taken their toll from the effects of the teaching of some Christian missionaries. Some missionaries have forced their Shona converts to completely renounce their traditional beliefs which at worst have been considered devil worship. The importance of these beliefs to the Shona today is shown by the proliferation of independent churches in Zimbabwe which, taking a syncretic approach, have modified Christian forms of worship and doctrinal standpoints to accommodate Shona traditional beliefs with little or no conflict of interest. These churches realise the importance of lineage, clan and totem, communication with ancestors and the relationship between the living and the dead to the Shona people. The growth of independent churches means that many Shona today are exploring more fully their traditional beliefs and sustaining their efficacy in contemporary society in Zimbabwe.

At a grass roots level, there is a developed perception of traditional cultural observances and values, particularly among rural Shona. Traditional beliefs among both urban and rural Shona are living beliefs. Hence stone sculpture produced by the Shona has a cultural significance which is to a degree empirical and must be treated as such.

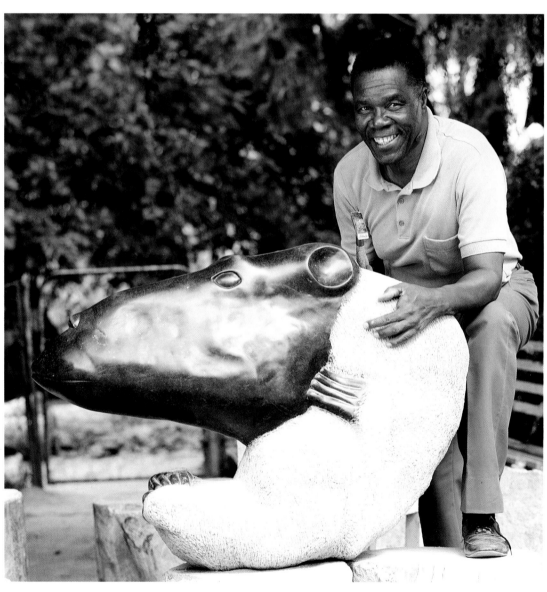

Joram Mariga

CHAPTER FOUR

FRANK McEWEN AND OTHER EARLY MENTORS

To encourage creative potential when it is already established is one thing, as it is to broaden the base of a creative potential that already exists. To develop hitherto undeveloped creative potential, in particular, in Africans, largely untutored in Western notions of art is another, and far more difficult. There is no educational framework in which to place this development, no historical association, and nothing to build on.

Frank McEwen came from the United Kingdom and Europe, where art has been an expression of culture, and often the major one for hundreds of years. He felt it essential to encourage or at least to lay the foundation for a living art in this country. When he arrived in 1957 he was horrified at the colonial suppression of genuine indigenous cultural expression in the country, and appalled at the existing proliferation of mechanistically produced art for the tourist trade which he called 'airport art'. When Frank McEwen introduced sculpture into the National Gallery Workshop School he had recognised, through the work of Joram Mariga, the intuitive and untutored talent that lay within the Shona. He was aware of the rural born Shona's familiarity with carving in their villages as a known or observed skill, and of their understanding of the significance of stone in the history and culture of

their country. He may have also been aware of the prestige of those who carved in traditional Shona society, the *vavezi*. With remarkable insight he commandeered these associations together with the Shona artists' understanding of their traditional culture to the making of art, first through painting and then to the more natural African expression of three dimensional form. It might be thought that if encouraged to make three dimensional objects, rural born Shona might have resorted to making objects associated in shape, form or design, with the objects of their material culture. If the sculpture in Zimbabwe had followed this pattern, it would have been essentially folk art, drawing on existing vernacular traditions. It was to Frank McEwen's credit that he was able to steer his artists away from recognised traditions of object-making and towards a conceptual, rather than perceptual direction.

It has become currently fashionable to regard Frank McEwen not only as the initial dynamic of stone sculpture in Zimbabwe but virtually as the creator of the art itself. The sculpture seems in the minds of many to have emanated from his personal magnetism and his charisma, almost to be a product of his mind rather than of the considerable intuitive ability of the artists. His personality was such

that the artists were inclined to consider their work as an extension of his dream and his vision rather than their vision of what African art should be. However while the debt to Frank McEwen must readily be acknowledged it must not be forgotten that it was an artist, Joram Mariga, who drew McEwen's attention to the talent of the African, and in his expression through his work that his beliefs established the world around him, made McEwen realise the closeness of the African to his traditional culture. It was Thomas Mukarobwa, one of the earliest members of the Workshop School, who recounted to him much Shona folklore and took him to Nyanga to see the bush where that folklore established the relationship between animal, man and nature.

It has never been established that Frank McEwen took into account the European expectation of African art as a composite of myth and magic, or whether or not on his part there was an exploitation of subject matter to meet the needs of the European market place. The earliest sculptors arrived at their own subject, and the most effective way they thought to express it. The style for example of Thomas Mukarobwa, and the way in which he essentially raises the animal out of the stone, could not have possibly come from a Western perception

of sculpture. While McEwen's influence was all pervasive it stopped short at the artists making what he wanted them to make, and in the cause of the establishment of a truly indigenous form of African cultural expression, he allowed them complete conceptual freedom. Lacking education in a Western sense, their art revealed them as extremely well educated in their cultural traditions and it was this education that was seen by Frank McEwen as the education that mattered, and was necessary to their art. No other education was necessary. The Workshop School developed in the artists the importance of self expression, which remains one of the strengths of the stone sculpture in Zimbabwe today. At the Workshop School, education took place through criticism, rather than the imposition of ideas, and criticism was never levelled at the way the artists expressed themselves.

The importance of Frank McEwen to stone sculpture in Zimbabwe lies also in his credentials in the European art world through which he was able to establish the sculpture as an art form which could take its place among the best of European art, and was accorded similar prestige. The placement of the work in exhibitions at the Musée d'Art Moderne in Paris and the Musée Rodin in 1971 and 1972 and the Museum of Modern Art in New York in 1969, established, for the sculpture, credentials of seriousness and quality. It might be thought that this was solely because of McEwen but these credentials have remained with the sculpture for many years after his departure, and vouch for its historic standards and quality. In a sense the work has inherited McEwen's credentials but since, and even before Independence, it has established its own, inside and outside Zimbabwe. Initially it may have been Frank McEwen himself who established the standards of Zimbabwean sculpture but now those standards are being realised as innate work long after McEwen's departure from Zimbabwe.

While many of the artists of the Workshop School were new to art and the notion of art, some had attended mission schools where they were introduced to a Western perception of art and the opportunity to experiment with materials, if not to explore subject matter in relationship to their own cultures. While McEwen's ideas on art education were not in keeping with those of the mission schools, these must be seen as seminal developments to the Workshop School and further developments in Zimbabwean sculpture and art.

Cyrene Mission was established by Canon Edward Paterson in 1939, south of Bulawayo. Canon Paterson saw the making of art by young Africans as developing skills and an awareness of things outside of art and of building disciplines useful for adult life. The matrix of painting and sculpture at Cyrene was not derived from the cultural backgrounds of the artists, but from the beliefs of Christianity and, in particular, the biblical narrative. Cyrene art has lacked the essential African quality of stone sculpture in Zimbabwe. It is doubtful if a painting of a black Good Samaritan striding down the road lined with msasa trees is more African than a mechanistically produced black African rhinoceros. However the paintings of Cyrene have the suffused glow of the African landscape, a landscape which seems to change its colours at the whim of the sun, the light and the seasons, and have the sense of restless movement that underpins the feeling of the African bush. A fostered awareness of their natural surroundings by young artists led to a close observation of detail in the paintings which on occasion seem too crowded with subjects. Similarly the wooden sculptures in the Chapel of Cyrene have the bold outline, the dismissal of space and the solidarity of form which characterises the carving of African objects, in particular those associated with Shona material culture. It was at Cyrene that some artists, who

later made stone sculpture, learned to carve, and developed at least a rudimentary understanding of art which was further developed by Frank McEwen.

Father John Groeber, a Swiss-born priest who initially studied architecture, came to Africa in 1939. In 1948 he was commissioned by his Bishop to start a new mission in Serima Central Reserve, 20 kilometres from Fort Victoria (now Masvingo) in Mashonaland. As both priest and head of the school, he was able to establish his own art curriculum and he himself taught art. He exposed his pupils to West African masks, and the early sculpture of Nicholas Mukomberanwa, one of Zimbabwe's leading sculptors who went on to the Workshop School, builds on the broken planes and cubes which form the composition of these masks. Groeber's intention was to invest art of Christian content with African expression. While the content of the art may be Christian, the sculpture, in particular at Serima, is African in form — exaggerated heads and with outsized hands. In the African sense, the carvings in the Serima Chapel are expressive rather than depictive of subject. The prophets are realised as totemic figures, and the Bible scenes are full of emotion, and feeling. While Frank McEwen did not admit to building on the ideas formulated by Father Groeber, it is

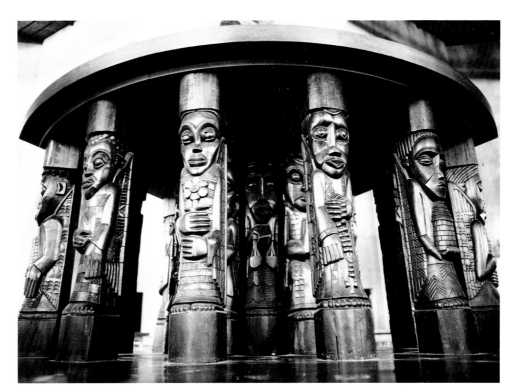

Photograph courtesy Ministry of Information, Zimbabwe

significant that Nicholas Mukomberanwa had commenced carving at Serima Mission before he joined the Workshop School.

Frank McEwen came to Africa feeling that European art was on the decline. In an article written for *African Arts* he commented: 'Western international modern art has become little more than a reflection of a reflection of a reflection, a hair-splitting devolution from the great aesthetic explosion in Paris at the turn of the century'.[1] He felt that the African mind had not yet been compartmentalised to recognise art as something outside the parameters of daily existence.

He believed African art to be an extension of other facets of cultural expression, both spiritual and worldly, traditional and contemporary. To develop in the artists an understanding of Western art only, would be to take them

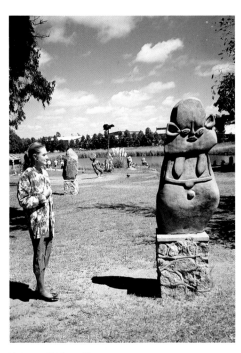

Vukutu Gallery, Harare

away from their own culture which he felt should be the basis of their artistic expression. He wanted to encourage an art form which was indigenous and truly of the black Africans of Zimbabwe. He thought the way to bring these artists to their own unique understanding of art, was to develop in them a fuller awareness and understanding of their own culture, and to encourage them to realise this in visual terms. Rather than merely accepting their culture, they were encouraged by McEwen to think about it,

which made them more aware of the richness of their cultural heritage.

Through making sculpture the artists were encouraged to think of their evolutionary development rather than their contemporary development. McEwen saw myth and folklore as interpreted by the artists as providing an explanation for them for the interaction between the mortal and spiritual realm. His ideas which he thought best suited to the needs of the artists were based on the educational theories of Gustav Moreau in Paris in the nineteenth century. In these theories free expression was considered the best means of self expression. McEwen believed that the artists would best understand art if it was presented to them as an extension of daily life. He believed that their way of making art should be as unplanned and spontaneous as their lives already were. He did not want to make them feel that art was restrictive, and that it should be made in a particular place at a particular time. While many artists worked at the School, others brought their work in from the rural areas in which they had always lived.

When the Workshop School artists began to make art they established themselves as professional artists. Art was not introduced to them as a leisure activity or a hobby. From economic

necessity it was vocational. As an income producing activity the art had a value and function outside of its objecthood in keeping with the historic notions of usefulness of the object within Shona society. At the same time there was no commercial pressure brought to bear upon the artists, as the market for their work still had to be created to meet the supply. While the School was inclusive, and all artists were encouraged to bring in their work, it was subject to McEwen's scrutiny and this scrutiny was highly selective. From the start, strict quality control was imposed upon the work by McEwen before it was exposed to public view. If an artist's work became repetitious, it was not selected. It was through criticism by McEwen that the artists improved their work, developed their styles and refined their techniques. This was vastly different from Tom Blomefield's policy of encouragement alone. Artists were encouraged by McEwen to work in a style which best suited their expression of subject and to establish this style early in their careers. They were encouraged to see their cultural traditions as living traditions, to be explored by each artist with fresh insight. If more than one artist was exploring the meaning of a myth or legend, they would do so in a highly personal way and thus their work would

be different. Much attention was paid by McEwen to the source of subject — perhaps a dream or meditation.

It was Frank McEwen's highly personal relationship with the artists and his encouragement of them as individuals rather than as members of a movement which assisted the early development of their work. The School was also seen by McEwen as a group of individuals with individual attitudes about their own culture. This is the way the collectors, gallery directors and curators are looking at the sculpture today.

In 1969, Frank McEwen's wife Mary, established Vukutu, a rural area where artists could work, and submit their work to the National Gallery. Vukutu, in mountainous Nyanga, is an area of jutting rocks which might tumble to the ground, appearing to have almost mythic significance, and to speak of the myths and folklore which sustained life in the days of Shona prehistory. Here artists felt more at home with their past and with the forces of nature which determined the pattern of everyday events. Artists at Vukutu, such as the late John Takawira, abandoned their conscious will to some kind of guiding force which made them sculpt, and they experienced the primacy of their relationship with their material and subject.

Frank McEwen not only thought about the education of the artists but the education of the public. It was in his time that appropriate conditions of connoisseurship which apply to any art were applied to the sculpture: good catalogue introductions, well curated exhibitions and scholarly promotion. It was after his departure from Zimbabwe that the commercial dimension of the promotion became dominant, sometimes at the expense of everything else. However, what the stone sculpture in Zimbabwe is gaining today is the stress on the individual, the quality control, selectivity and scholarly promotion which was provided by McEwen. The National Gallery of Zimbabwe, the best private galleries and Tengenenge are living up to his ideals at last.

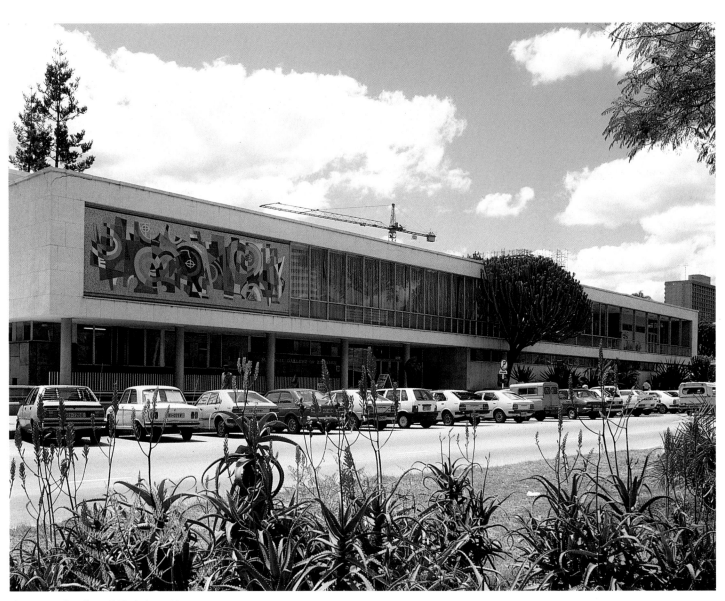

The National Gallery of Zimbabwe, Harare

CHAPTER FIVE

THE NATIONAL GALLERY OF ZIMBABWE

The National Gallery of Zimbabwe is recognised as the major public art museum in black Africa. The Gallery, established in 1957, fulfils the traditional role of an art museum in that 'it collects, preserves, exhibits and interprets the traditional arts of its region of Africa and, more generally, the world at large'. But it is far more than a repository for the institutionalisation of culture. In practical terms, one of the Gallery's most important aims is to serve the needs of the living artists of Zimbabwe, which in accordance with the needs of a Third World country are both economic and educational. The Gallery has provided both economic and educational support for artists in Zimbabwe in the absence of a formal art education structure and a lack of scholarships, grants or endowments.

The Gallery is a functional contemporary space which appears far more modern than a building conceived and constructed more than 30 years ago. It is a two-storey building in the middle of Harare, with a number of flexible spaces on both levels which, when devoid of art, appear to be inclusive and flow into each other, but when housing an exhibition develop a suitable self-containment and autonomy. The fact that exhibitions are frequently changing, sustains and develops public interest in the Gallery,

and also infuses it with an energy and dynamism seldom found in a public art museum. Low ceilings and an abundance of light create an immediacy between the works of art and the viewer. In keeping with the Zimbabwean's approach to art, there is little separation of art from life at the Gallery, and indeed art is part of the life of the Gallery's public, rather than something to be viewed on a particular occasion. A sculpture garden allows large sculptures to be displayed as they were conceived by the artist in an outdoor setting and in natural surroundings.

Gillian Wylie, past curator, comments: 'Although prior to Independence the Gallery had been a very liberal institution in terms of the then administration, after Independence we had to be very much in tune with the thinking of the new government. The focus changed, we had a lot of new embassies who gave us exhibitions, so our international presence differed greatly from that established by Frank McEwen. At the same time we struggled hard to get exhibitions from local sources, which were very relevant to a black Zimbabwean public. I feel very much that the Gallery should have exhibitions linked to the Zimbabwean environment, and which create a dialogue with the Zimbabwean public.'

This is a Gallery suited to the needs and aspirations of a developing country,

a Gallery with a space that is resilient to change and to the display of new approaches to art, a Gallery which welcomes innovations in art. Although the Gallery today is concerned with the preservation of the past, at the same time it is very much involved with the present and looking towards the future.

In his speech to open the Annual Exhibition at the Gallery in 1985, Mr David Karimanzira, the Minister of Youth, Sport and Culture, said: 'Let us make this a people's Gallery.' This comment is in keeping with the prevailing ideology in Zimbabwe; it is also in keeping with the personal philosophy of the current Director, Professor Cyril Rogers, a New Zealander, who was appointed in August, 1985. He is a distinguished academic in the field of education and, as a university administrator, was 'invited back to Zimbabwe to change the Gallery which had a colonial image not in keeping with Independent Zimbabwe'. He sees himself responding to the 'demands of a government which sees its own conscience more clearly than that of ten years ago, and a government in tune with its own culture'. He sees the Gallery's administration achieved as much by human contact as by paperwork, and he is always accessible to his staff and to the public. His presence in the Gallery, each day, is constant and felt.

Professor Rogers sees the dynamic of the Gallery as growth, change and development, of maintaining the cultural traditions of Zimbabwe as living traditions, rather than historical achievements. He sees his role as Gallery Director partly as developmental — to build into the structure of the Gallery new projects, and into its aims and objectives, new goals. He has opened the Gallery's doors to an ever-increasing, wider and more democratic public, and cemented the friendships of foreign governments by consolidating their relationships with the Gallery. He also wishes to establish a permanent presence for the National Gallery in Bulawayo by moving it from its present temporary premises to Douslin House, a former mining headquarters now under reconstruction and renovation. Of the Gallery's years under Frank McEwen, Professor Rogers comments: 'The Gallery then tended to be a reflection on what was the best in Europe. This European-isation was the social demand of the time, and Frank McEwen was working within the bounds of political possibility.'

The National Gallery of Zimbabwe is a parastatal institution set up by an Act of Parliament, with support received from its parent Ministry, the Ministry of Education and Culture. Professor Rogers comments: 'The Ministry has provided the Gallery with its recurrent budget, but it has not given the Gallery any significant capital support over the tenure of my office. However, the recurrent budget has increased considerably since I have been here, and we have gone from a position of being on a care-and-maintenance basis to managing comfortably on the recurrent side. However, the Ministry has recently indicated strong support for capital development. Funds for develop-ments such as the Bulawayo Gallery are being raised from other governments and international bodies. When I was a university Vice-Chancellor I was always looking for resources which gave my institutions a measure of independence from the state. While learned institutions exist to serve the state, they also need freedom to experiment — something which the state cannot always sanction. I am trying to build up resources for the Gallery in the form of grants rather than loans, so that exciting new challenges can be accepted and new directions embarked upon without necessarily waiting for statal fiat.'

Professor Rogers is entitled, with the agreement of his Board of Trustees, to change Gallery policy and he considers that, up until now, he has made practical changes as well as policy changes. 'Prior to my coming here, the Gallery doors provided a threshold of resistance to the outside world. I hope I have been able to democratise that situation. One change I have made is in the area of education. As a former Professor of Education, I feel we have to link what we do with what we teach. I want the experience of the Gallery, for all who come to it, to be a learning experience. Indeed, if one witnesses the number of people looking at a video of the work of Henry Moore, ranging from ambassadors of foreign governments to black and white school-children, this experience is open to all. Frank McEwen did not believe that you could, or should, teach anything to anyone. If we did away with all the great art schools in the world, the world would decline into barbarism. Frank was possibly a far better teacher than he would admit. He was very authoritarian, and the law was his word. If he said an artistic work was good, it was good and if he said it was junk you put it in the stone crusher.'

The Board of Trustees, together with Professor Rogers, make decisions on Gallery policy, and there is a government representative on the Board. The Director considers it his role to see that government thinking is articulated to the Board of Trustees and that the thinking of the National Gallery is made clear to the government. He feels that there is insufficient government representation on the Board and that, for example, there should be representation from the

Ministry of Foreign Affairs, Information and from Treasury. He is expected, by the Board of Trustees, to generate policy on which judgments and sensible decisions can be made. The Gallery's relationships with outside donors vary. 'Sometimes we have a limited artistic choice from foreign governments and diplomatic missions attached to Zimbabwe. Under the cultural agreements, which are more symptomatic of socialist countries than others, we are sometimes offered exhibitions which are not genuinely art exhibitions, but which often pave the way for the more serious art exhibitions. Some grants obtained by the Gallery are totally untied, and untied money at the moment is being put into the fund for the new gallery at Bulawayo. Today the budget of the Gallery is over one million dollars per year (mainly recurrent) as compared to $80 000 five years ago.'

Under the direction of Professor Rogers the private sector, and diplomats in Harare, are playing a positive role that they did not play before.

Professor Rogers feels strongly that the National Gallery belongs to the nation's people and that it is beneficial for the artists to have a relationship with the National Gallery.

The National Gallery has fraternal links with the private galleries in Harare. The Gallery's relationship with the private galleries is informal, and it is natural that a number of the galleries will compete with the commercial operations of the National Gallery. One gallery director had, however, said to Professor Rogers: 'You represent a watershed and you can do so many things that we have tried to do.' This gallery director has supplemented the National Gallery's permanent collection with work that will make it an historically valuable collection. These works fill many gaps in the collection which was built up by previous directors.

Professor Rogers feels that the political changes in Zimbabwe have dictated social and cultural changes. In a sense, the changes that have taken place in the Gallery over the past thirty years have been sensitive to the changes that have taken place in Rhodesia and Zimbabwe, and it is this sensitivity which has led to the Gallery's successful and ongoing support for the visual arts in the country. 'In the past, we worked on the assumption that Africans could not paint or draw, but today we realise that unlike the sculptors they have not had the opportunity to do so, or the education, or the resources. People today say that the standard of education has gone down, that the child in Form Four is not educated in the way that he was before Independence. The truth is that in those days there was an educational elite, whereas today there are so many more people being educated. Here among black Africans the broader interest in art and art teaching at primary level is commendable.' It is currently Professor Rogers' aim to focus more attention on black and white Zimbabwean artists who work in media other than sculpture, and to establish a presence of Zimbabwean painters outside Zimbabwe comparable with that of the sculptors.

The ground floor entrance and foyer to the Gallery has been turned into an exhibition space, at the suggestion of the Gallery's present Head of Exhibitions, Rose West, where two-dimensional work by both black and white Zimbabweans is shown. Professor Rogers comments: 'Part of the essence of nation building is to give people heroes — military, civic — and their dignity; art is an essential medium in identifying national heroes who set the nation apart from other nations. Zimbabwe's heroes come from the arts as well as from other fields. In this country you have a public climate peculiarly sympathetic to the artist. The artist is a fairly honoured person in Zimbabwe who meets and talks with presidents and kings, and the National Gallery and the government ensure that he or she does so. Our head attendant and leading sculptor, Thomas Mukarobwa, recently returned from London where he

fascinated Prince Charles.'

Professor Rogers believes that it is still necessary for the Gallery to have its international connections but that they should be reviewed. International exhibitions are provided by the embassies of foreign governments, and Sir Richard Attenborough, who is a patron of the National Gallery, suggested that the Gallery should build up its collection of lithographs of European masters donated by foreign embassies within Zimbabwe.

Rose West is a well-known painter herself and she is able to look at the role of the Gallery from the point of view of the artists it serves as well as a member of staff: 'I think that when the current Director came here he saw a very large gap between the black African artists and the Gallery. Today these artists are not hesitant about coming here. The Director is an educationalist, and even if some of the black African artists have little formal education, they are certainly getting an art education through the National Gallery. As a painter I am particularly interested in the presence of two-dimensional works, both in the Gallery and as represented by the Gallery overseas. It is possible in Europe that two-dimensional works from Zimbabwe are harder to promote than our sculpture because of the competition from two-dimensional works by artists from

European countries. Our sculpture is so different from anything Europe has seen. However, we have had requests for paintings and graphics from India and Poland, and exhibitions have been held in over twenty major countries. The embassies often send works such as stamps, posters and other items, initially, to introduce their countries rather than their art, but we then request that they send an exhibition of contemporary fine arts.'

Ms West also says that it is easier to get works from abroad than other African countries: 'African countries present problems of communication, and transport inefficiency.' She feels that the Gallery's permanent collection is interesting from an historical point of view, but it should now contain more works by black African painters. 'The Director is frequently quoted in the press, and thus he establishes a presence for the Gallery, outside the Gallery. He has made people from all walks of life aware of the Gallery's existence, and even if they get tired of it, they never forget it.'

The Market on the ground floor of the National Gallery appears crowded rather than cluttered and bears witness to the amazing proliferation of sculpture, craftwork and other forms of art in Zimbabwe. Indirectly, the Market is part of the educational outreach of the

Gallery, which works in the interests of young and aspiring artists of talent. Work submitted to the Market is subjected to a rigorous selection by a panel of artists: members of the staff of the National Gallery. Once offered for sale the work is exposed to impartial public scrutiny.

The Market was established at the time of the Non-Aligned Conference in Harare in 1986. Until that time, the Gallery was not generating resources of its own. All profits from the Market go towards the expansion of the Gallery's permanent and overseas collections. Apart from being a valuable source of foreign currency, it has brought forth artists of exceptional and previously unrecognised talent, such as Edward Chiwawa, who has exhibited in Hungary.

Professor Rogers feels that it is impossible to establish absolute standards of excellence in art. Some of his colleagues feel that there are abstract and immutable standards which apply to all the arts, but he feels that when one moves into the area of aesthetics and judgments by the mind and the heart one is treading on delicate ground. He believes that evaluation of standards is a matter of opinion and taste. He considers that at the moment there is a great deal more sculpture than ever before. The permanent sculpture collection is not a partial historical record of excellence,

but a partial historical record of carving in stone. There are no established conditions of judgment for the Annual Exhibition at the National Gallery, rather the work is allowed to speak for itself and quality determines the judges' decisions. As the judges do not know the artists, their assessments are impartial. Initially, it was amateur painters who submitted their work to the Annual Exhibition, and through this submission the artists began to take their work more seriously. With the assistance of the Annual Exhibition it has been possible for a number of amateur artists to reach professional standing. Experiment and innovation have become a hallmark of the Exhibition and it is significant that the winner in 1988 was Tapfuma Gutsa, of whom Professor Rogers has said: 'To say to Tapfuma that he should disassociate himself from his relationship with European culture would be a pity, he is not so much reaching into his own culture but into a vast storehouse of universal approaches to art.'

Each year forums are held, in association with the Annual Exhibition, where the judges discuss their decisions and comment on the state of art in Zimbabwe. Here artists are encouraged, as are artists throughout the world, to objectify their feelings about their work and face public scrutiny. The Annual Exhibition is sponsored by captains of industry from the private sector of the economy, a notable patron being Mr Norman Walden of Nedlaw.

The Annual Exhibition for 1989, although exclusively Zimbabwean, had a sense of internationalism in some of its entries, while others showed new ways of expressing Zimbabwean sensibilities and Zimbabwean identity. It appears that young Zimbabwean painters, perhaps benefiting from better education and consequently a more informed perception of the world around them, had developed the social skill of art to communicate simply and effectively their feelings about social problems. The presence of much welded metal sculpture must be attributed to the generous sponsorship by Oxyco of the 'Weldart Exhibition', and to Professor Melvin Edwards, Head of Fine Arts at Rutgers University, USA and a distinguished metal sculptor who spends some time teaching in Zimbabwe each year.

In much of the sculpture, metal appeared as if a new material to artists, full of fresh possibilities and far removed from the academic traditions of welded metal sculpture in the international ambience. Women from the Weya group of artists seem to reach back into the traditional female techniques of needle-work to make strong statements about

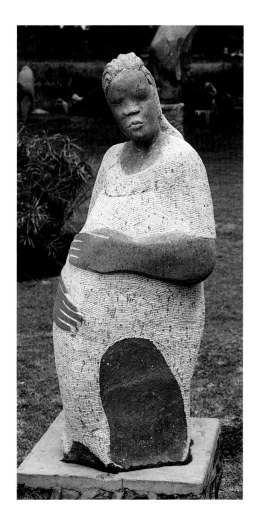

Tapfuma Gutsa

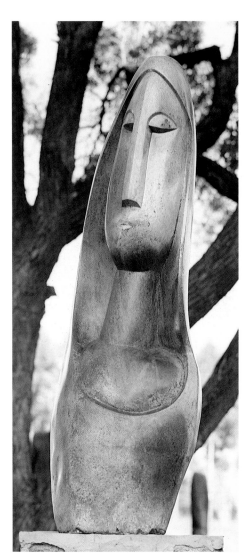

Nicholas Mukomberanwa, *Woman of Wisdom*, picture courtesy Chapungu Sculpture Park

the role of women in Shona society, and the traditional cultural ties which determine their activities. The stone sculpture developed a new aesthetic through the use of Chiweshe stone by many young artists, and by master sculptor, Nicholas Mukomberanwa, the winner of the Director's Award of Distinction in any Category, and the Award of Distinction in the Nedlaw Sculpture Exhibition. This stone, light green flecked with gold, relieves the massiveness of some of the sculpture, and lends itself to an Italianate ornateness which is being put to good use in many young artists' work. It is commendable that the new directions in Zimbabwean art which were evident in the exhibition are not the result of the process of education, or outside influences, but some kind of internal dynamic which must have some relationship to the rapid development and maturity of the new country. Artists, possibly feeling more secure, are not sheltering behind the ideas and notions of others, but speaking as individuals, with a strength of statement that demands a hearing.

The educational outreach of the National Gallery, in conjunction with its parent, the Ministry of Education and Culture, will be soon extended to a Regional School of Art and Design for the SADCC countries, to be based in Harare. On taking up his appointment, Professor Rogers was requested by the Board of Trustees to assess the needs of the country's artists. He felt that there was a need for a national or regional art school. The Ministry of Education and Culture has been encouraged to think regionally about the school. Three consultants for the school were invited to Zimbabwe supported by the Ministry of Development Co-operation in the Netherlands, the British Council and the Australian government. They have prepared a feasibility study for the school, costing out the project in terms of its various needs. The view of the Board and the consultants is that the school will flourish best if given that kind of operational freedom suitable to a parastatal. Professor Rogers has brought together all of the ministries who have a vital interest in the school: the Ministries of Education and Culture, Women's Affairs, Higher Education, Foreign Affairs and the Treasury, the University and last, but strategically first, the office of the President. He feels that the staff and students of the school will have a regional cultural impact on each other. Zimbabwean artists will come into contact with such areas of art as painting in Mozambique, and at the same time Mozambicans will challenge Zimbabwean painters and graphic artists to produce

something which is very much their own: 'The influence of the school will be Africa on Africa rather than international.' It is the intention of the school to offer hospitality to artists whether they are formally trained or untrained, experienced or inexperienced, schooled or unschooled, working in all kinds of media, including traditional media. Within the context of the variety of courses artists will be given opportunities, and will be able to conserve and refine skills, develop new skills and further their general education in art and design. The school, in collaboration with the University's Department of Education, will also provide in-service training for teachers of art and design. Only one secondary teachers' college, Hillside, in Bulawayo, offers such training and there is no such course currently offered at the University of Zimbabwe. Many of Zimbabwe's best artists do not have the required O levels for further education in art. Leading artists will become indispensable resources for the school, in the capacity of teachers, students and artists in residence. Many international donors have expressed positive interest in the school, and the Australian government has already donated one million Australian dollars for scholarships.

The BAT Workshop is the official teaching institution of the National Gallery of Zimbabwe. The Workshop was established in 1982, both to continue the educational role of the National Gallery, established by the earlier National Gallery Workshop School, and at the same time to revise the process and broaden the scope of art education for the students.

At the Workshop, students are offered a foundation course with the opportunity to specialise in their second and third year. While the scope of the National Gallery Workshop School's activities was narrowed to a focus on sculpture, in part because of the shortage of materials other than stone, the generous support of the British African Tobacco Company (BAT) for the School has allowed students to work in a variety of media. A limited number of disadvantaged young Africans are provided with art education (and possibly more education than they have ever previously received). Here the development of artistic skills is part of a formal learning process, and the making of art the product of teaching.

The Instructor of the Workshop School is Paul Wade, a British citizen of Bermudan background. He believes that it is from art that we can learn about art, he feels that the only way his students can withstand influences of other art is to expose them to such influences, and he pursues this confrontationist policy with vigour. Art history is taught in the second year as 'slides in the dark' (as it was taught to Paul Wade) and the reading of books in the National Gallery library, and through the writing of essays. At first, all Wade's students wanted to sculpt, now many want to paint. 'It is a matter of availability of opportunity. Anyone can get a piece of stone and sculpt, but painting is something that has to be taught.' Wade considers that the ethnicity of stone sculpture in Zimbabwe has been imposed upon it and created by Western expectations of African art. He believes that if education is strong enough to withstand that expectation, his sculptors can find a universal aesthetic, and that Zimbabwean sculpture can be truly Zimbabwean art, not in a naive tribalistic sort of way — 'but art that can compete in the international arena that now contains it'. He feels that the movement of stone sculpture is in danger of collapsing in on itself, that the name Shona is used as a selling device, giving it false links with African tribal art, with its associations of myth and magic to satisfy European expectations. He considers that without this imposed ethnicity, Zimbabwean art could still remain Zimbabwean and yet hold its own in an international context.

Wade considers that this might take

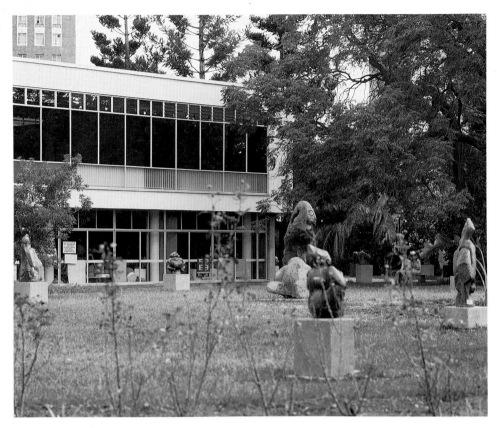

The National Gallery

the cultural origin of Zimbabwean art, and point to the fact that ethnicity is not the only factor which contributes to these origins. Students at the Workshop have successfully attained their O levels in art (the last four years has produced a 100 per cent pass rate), and in keeping with the vocational nature of Zimbabwean art these students are looking towards careers as artists. Paul Wade sees education in Zimbabwe as giving more emphasis to vocational subjects, usually taught in Western countries, but befitting to a developing country such as Zimbabwe: 'The actual policy from government is very positive, giving dignity to vocational areas.'

Today the National Gallery of Zimbabwe is the home, not only of stone sculpture, but of Zimbabwean art. The exhibitions which take place, and the permanent collection when it is on display, reflect the variety of media and aesthetic and conceptual approaches which are currently characteristic of the art of the country. While the sculptors working in stone constantly pursue the standards of excellence inborn in them, and initially encouraged by Frank McEwen, the overall impression gained by a visit to the National Gallery is of a nation of individual artists. These artists appear to establish their own departure points for their work. Assimilated

place if there was a revision of Western expectations of Zimbabwean art; if those interested in America and Europe expected more of Zimbabwean art than stone sculpture. Wade's students used to be found in a disused warehouse in the industrial suburbs of Harare. They now temporarily occupy the Penthouse Studio in the National Gallery of Zimbabwe. They may be sitting at easels painting a 'still life' in which the life is far from still and which radiates with the light and colour of the African outdoors, rather than the muted tones of the interior. A rigorously British method of teaching, life drawing, life modelling, drawing and easel painting cannot suppress the

Africanness from what is produced. While the form and context of the art produced may be international, its aesthetic origins are undeniably African. The paintings are subject to unpredictable mood changes within one painting, shifts of opposition in colour, paint applied to canvas with vigour. The Workshop appears to emphasise the point that however much the African is disassociated from his or her cultural origins through education, his or her culture will remain apparent in art. This expressiveness in itself has a cultural origin and is to be found in music and dance. In a sense it controls the social dynamics of African society. The paintings at the Workshop broaden

influences may be part of those departure points, but they seem to be developing very much their own processes and responses to being in Zimbabwe, and being in Africa.

The Gallery's holistic approach to its fostering of the artists of Zimbabwe, looking after their economic and educational needs as well as their promotion, is in keeping with the requirements of artists in a developing country. As the artists are very much to the forefront of Zimbabwean society, the Gallery is very much in the public eye, receiving much attention from the local and international media. The international dimension of the Gallery is twofold, the holding of exhibitions of Zimbabwean art outside of Zimbabwe, and the presentation of exhibitions of art from outside the country in Zimbabwe.

Professor Rogers acknowledges traditions of art such as the stone sculpture but he does not see tradition as necessarily arresting progress, growth and development. The National Gallery of Zimbabwe keeps up with the pace and momentum that the fame and recognition of Zimbabwean art is developing both inside Zimbabwe and within the international art scene. In a sense it sets this pace and monitors this momentum, through its changing exhibitions, and its entrepreneurial and educational outreach. As much as it upholds its role to preserve and conserve the art and culture of the past, it looks forward to the future art of the nation, and actively supports that art through exhibitions which are innovative and experimental.

The National Gallery of Zimbabwe may be an institution as are all public art museums, but the human dimension of this institution is evidenced through its holistic care of the nation's artists, and the welcome it gives to visitors whatever their colour, race or creed.

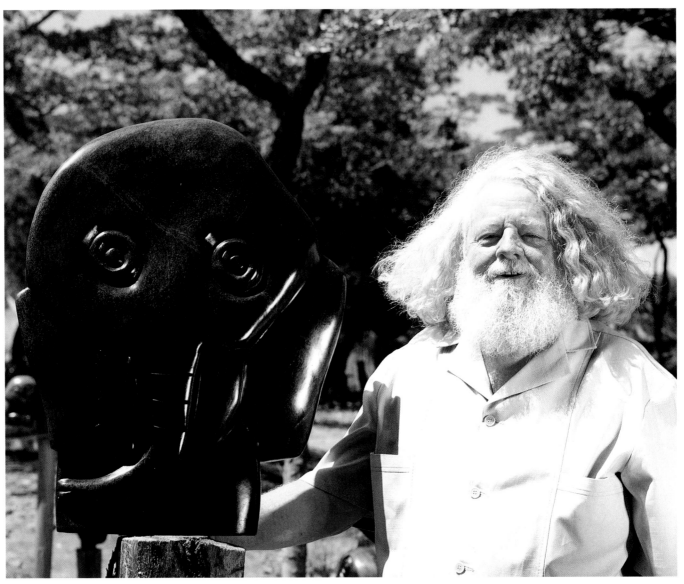

Tom Blomefield with Davison Chakawa's *Elephant* at Tengenenge

CHAPTER SIX

TENGENENGE

The Tengenenge Sculpture Community 150km north of Harare is a central dynamic of stone sculpture in Zimbabwe. Today over seventy sculptors from various countries in Southern Africa are working at Tengenenge, some resident with their families, others coming from the nearby farm compound. The constant influx of new artists brings new and innovative ideas into the sculpture, while the presence of the recognised sculptors such as Bernard Matemera and Josia Manzi, who have been with the community since its early days, provides the necessary sense of history for a sculpture community which has been a vital force for stone sculpture in Zimbabwe since 1966.

Today Tengenenge sculpture is considered to have its own direction, perhaps to be a movement in its own right, but a movement with room for individuality, and definite cultural and aesthetic parameters of style, form and approach to subject. Tengenenge will not only go down in the annals of Zimbabwean art, but in the annals of Zimbabwe cultural history, and possibly in the annals of Southern African cultural history.

Tengenenge's geographical isolation has not cut it off from the rest of the world. The presence of the community is well established in Harare and abroad through frequent well documented exhibitions, and serious writing by well established art writers and journalists. Tengenenge is regarded by many people in Zimbabwe, and outside the country, as one of the nation's most important cultural sites, as necessary to visit as Great Zimbabwe and the rock art. As with Great Zimbabwe and the rock art, Tengenenge is a valuable resource for an understanding of the social, cultural and spiritual parameters of the operation of those who live there. However, while Great Zimbabwe and rock art now have only historical value, Tengenenge is a living community, a community with a past of vital historical value to the art of Zimbabwe, and a community with an ongoing future, pioneering new directions in the art of Zimbabwe.

Tengenenge is absorbing to people of many interests. The art historian can appreciate the way in which many pieces in the Director Tom Blomefield's permanent collection allow the evolution of Tengenenge sculpture to be traced through developments in form, style and content over thirty years. Traditions of oral history, with the artists as informants, have been established in the community, which also provide information about the evolution of the art. To an anthropologist, Tengenenge is a multi-cultural community with an unusual degree of successful assimilation, which establishes its social dynamics. This is particularly the case with the multi-cultural dimension of the families who live at Tengenenge, and family life is a key factor in keeping the community together. The sociologist may be interested in the human relationships which develop at Tengenenge between persons of the same and different cultures which form the substructure which binds the community together.

People find their own way to Tengenenge, sometimes with the aid of a map. To each visitor it is a journey of exploration of the kind expected in Africa, with dirt roads, deceptive turn offs and the possibility of getting lost. A significant development for those who want to go to Tengenenge, is the building of a tar road by local farmers wishing to bring their produce to town, which leads almost to the boundaries of the community. This road was officially opened on November 25, 1989 by Dr Joshua Nkomo, Vice-President of Zimbabwe. The new road is particularly important to Tengenenge, which is now visited by museum directors and curators from all over the world, writers and journalists, artists, members of diplomatic missions and donor aid organisations, and interested Zimbabweans. The arrival of some visitors is anticipated, others unplanned. All are offered the hospitality of the community, to walk among

the acres of sculpture, to bring their refreshments into the cool of the rondavel, to meet and talk with Tom Blomefield and the artists. Rather than being found, Tengenenge waits to be discovered and takes one by surprise. Tengenenge is sheltered from the real world by the mountains of the Great Dyke which stretch across the country to the Zambezi Valley. Here there are vast repositories of stone, which appear to have been created to be made into sculpture, and some seem to be sculptures in their own right. Tom Blomefield has the mining rights to much of this stone, which is purchased by most of the sculptors working in Zimbabwe. Thus, in addition to being a thriving community of some of Zimbabwe's leading artists, Tengenenge is a valuable resource for the art of Zimbabwe. The area is located in the heart of Zimbabwe's Horseshoe Block, a rich tobacco farming area. On approach to Tengenenge, clusters of msasa trees, huge rocks, and fields of tobacco turn without warning into a landscape of sculpture. Here sculpture seems like a force of nature, a random growth, each day spreading further through the bush and up the mountain where the resident sculptors live, and display their sculptures outside their houses. Tom Blomefield's home is an old mining shed, with rooms redolent of

history, which are now an office, bedroom, and spare rooms. The shed is the home of much art which is housed on the verandah. Although sculpture is sold, Tengenenge has never had an overtly commercial dimension, and visitors appreciate the cultural as much as, if not more than, the commercial aspect of the art.

In a physical sense Tengenenge remains unaffected by the changes which have taken place in Zimbabwe. Music is played on the mbira; open fires, pole and daga huts, plough discs and chickens speak of a traditional way of African life, which is also sustained by the retention of age old customs by the artists. Tom Blomefield himself becomes personally involved in these, for example giving gifts to the spirit medium to appease or placate ancestral spirits, and putting out a black cloth to the *Mhondoro* for the bringing of rain. Yet the community life at Tengenenge cannot be seen as retro-gressive or a throw back to a traditional way of life which does not provide for progress. It is the preservation of a traditional way of life which keeps alive the spiritual heritage of the artist's cultures, a heritage which in itself is not static and which allows for experiment, innovation and startling originality in art. The voluntary retention of spiritual customs and values and observances

sustain daily life at Tengenenge. On the compound nearby, every Sunday, a composite of Chewa and Yao dances, joined by the few Shona in the community, takes place. Here the identity of the sculptors is lost under masks and animal costumes, emphasising the traditional secrecy of the Yao and Chewa dances. Cut off from the real world and its assumed resources: (until recently) electric light, running water and a telephone, Tengenenge's material survival and well-being, although achieved through the sale of art and stone, is sustained successfully by a spiritual dynamic, which relates to the unseen spirit world, not easily documented in writing. To the visitor this dynamic can be Tengenenge's most palpable presence — and as long as this dynamic is there, sculpture will be made.

Tengenenge was not conceived as a development project, but despite its retention of a traditional way of life it has succeeded as one without outside aid or endowment. The aim of Tom Blomefield has been to make the artists self-supporting, to improve their quality of life without taking away their cultural heritage or destroying their cultural values. Unlike some development projects it has not changed the life of its people to a pace which they find bewildering. It has not forced them to

change their identity for the sake of an imposed one, or to have their lives run by bureaucracy. The changes that have taken place at Tengenenge and the changes which will take place will occur in terms of the artists' understanding of the measure of time, and their ideas of progress. There have been those who have wished to change Tengenenge but they have wished to change it in terms of their own wants and needs rather than the wants and needs of the community.

It is difficult to judge whether Tom Blomefield is an extension of Tengenenge or whether Tengenenge is an extension of Tom Blomefield himself. He is a profound and humble man, and he has not always seen Tengenenge in terms of the way that the outside world sees it, with broader implications than that of a community of artists or a group of individual artists. Tom Blomefield modestly underplays his role in the enormously successful story of Tengenenge. While he knows that Tengenenge has helped to meet the social and cultural needs as well as the economic needs of the artists, he does not himself sometimes realise the contribution he has made to the progress of the community. Like all good characters in an African adventure, Tom Blomefield has shot many leopards, climbed many mountains and crossed many rapids, but this is not what makes one want

to turn the page. His is a story of charting, exploration and development, development of people as much as of land, a story of endurance, of sacrifice, and hardship. It tells the story of the development of Africa by its own people, rather than by those who came to colonise it. However the reward is not an adventurous narrative in this remarkable story but an appreciation of human achievement which encourages our own need for self development, and puts us in touch with our own potential.

Over the past thirty years Tom Blomefield has spent much of his time at Tengenenge, at first as a wealthy tobacco farmer, with, in contrast to many other tobacco farmers, an interest in his farm workers as individuals, in particular as African individuals with links with their parent cultures from outside of Zimbabwe. While not attempting to adopt his workers' cultures or their way of life, speaking fluent Chewa he has shared in their cultural preoccupations and in particular their belief in the invisible universe as a source of creative energy. In a physical and a cosmological sense Tom Blomefield feels that perhaps he is part of the larger plan devised for African man, and his views are far from anthropomorphic. It is possible that he has got closer to the African way of life than many anthropologists, who expect that

it must fall into some already existing system, fit into an existing theory or an already determined role model. He does not come to this way of life from a position outside of the artists' cultures, and his living alongside the Africans is not in the nature of a social experiment to be documented, statistically evaluated and presented as data.

However, Tom Blomefield has not become 'African' and his tastes and sensibilities have remained European. Living at Tengenenge today he has adapted to the artists' cultures whilst not adopting them. His kinship with his artists is deep, and indeed as a distinguished sculptor in his own right, he is one of them, yet he remains very much their mentor, as well as their friend. His mentorship had little sense of the paternalism of white supremacy. Unlike many European catalysts living and working in Africa, ostensibly for the good of the African, he has not employed strategies of cultural imperialism, political action or colonialism to establish his position, all in the cause of their 'development'. Nor has he imposed his European way of life and its values upon the artists. The traditional way of life at Tengenenge is part of the natural order of things. It has never been exploited or contrived to suit the interest of the European visitor. While Tom Blomefield

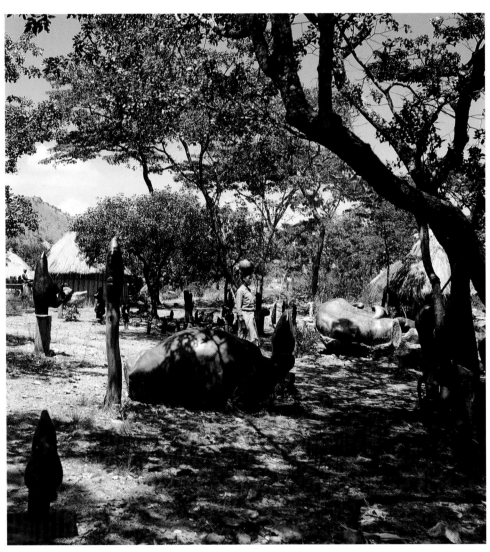

View of Sanwell Chirume's outside studio and gallery

guides his artists by example and in a manner to which they can easily relate, he respects the advice of his fellow artists and in particular that of his master artists, Bernard Matemera and Josia Manzi. He comments on the establishment of Tengenenge: 'Added to the circumstances of international sanctions and our need to find alternative employment, we were also undergoing at Tengenenge historical and evolutionary changes. During this time of transition we needed something to ease ourselves into, something very positive to occupy us and to channel our thoughts, something to dream for, to stop our sense of direction from being split into so many paths. At this time we were all trapped in restrictions of our experience, and the limitations on our lives. We needed something to expand our conceptual vision which was so very narrow at the time.' Hence the establishment of Tengenenge had a philosophical as well as a practical and economic rationale.

The fortunes of Tengenenge and those of Tom Blomefield have fluctuated with those of Rhodesia and Zimbabwe. In 1973 Tom Blomefield sold his farm and lived for some time in suburban Harare, constantly visiting Tengenenge and establishing outlets for the work in self-owned galleries in Harare. Initially informally affiliated to the National

Gallery Workshop School, a divisive and unhappy relationship with Frank McEwen forced Tom Blomefield to dissociate the community from the National Gallery prior to 1970. In 1979 when the country surrounding Tengenenge was occupied by guerillas fighting for Independence, the community was closed for security reasons. Only the Manzi family were left. Many of the artists who left at that time were bought houses by Tom Blomefield, and well-known ex-Tengenenge artists, today working in town, include Henry Munyaradzi, Fanzani Akuda, Ephraim Chaurika and Edward Chiwawa.

Since Independence under more stable and secure economic and political circumstances the community has been strongly restored. Encouraged by his family and Professor Cyril Rogers, Director of the National Gallery of Zimbabwe, Tom Blomefield returned to live at Tengenenge in 1985. The decision attracted some of the former artists to rejoin, and many new artists to join the community. Thus the community recommenced its activities with its identity firmly associated with that of its Director which has always been the case. The core of the community today is seventeen resident artists and their families, with Tom Blomefield as resident artist and Director. In addition there are over seventy non-resident artists who

come and go at will.

These artists are living in the nearby compound and working on the farm, and the community is given a broader local dimension by artists who come from Guruve twenty kilometres away to bring their work to Tengenenge, hopefully for sale. Isolation is further broken down by interaction between artists and other farm workers, and interaction between the artists of various cultures takes place at many levels, socially, and in terms of family relationships.

Tengenenge has had many exhibitions outside of Zimbabwe, but 1989 saw a consolidation of this outreach. In May an exhibition of humorous and satirical Tengenenge sculpture was shown at the House of Humour and Satire in Gabrovo in Bulgaria, the works being purchased for the permanent collection of the House, by His Excellency the former Ambassador for the People's Republic of Bulgaria in Zimbabwe, Cde Alexander Atanassov. Tom Blomefield accompanied this exhibition to Bulgaria. Also during mid-1989 a number of Tengenenge works were in an exhibition of Zimbabwean stone sculpture in Wageningen in Holland, held under the auspices of the National Gallery of Zimbabwe and the Foundation Beelden op de Berg in Wageningen. Tom Blomefield attended the exhibition and gave a paper at a Symposium on

Contemporary African Art organised by the Foundation. In Harare the Zimbabwe-German Society, in July of 1989, organised a very successful exhibition of Tengenenge sculpture. In Harare, in December of the same year an exhibition 'Mother and Child' was organised by His Excellency the former Ambassador of the People's Republic of Bulgaria in Zimbabwe. This was opened by the First Lady, the late Amai Sally Mugabe, the proceeds going to the Child Survival and Development Foundation of which she was Executive Chairperson.

Tom Blomefield, of necessity, has intuitively and empirically developed the skills needed to sustain Tengenenge: arts administration, art education, mining, and to a degree, art dealing. This has been an in-house development; learning from the needs of the artists, and the situations he has been faced with. At first appearance Tom Blomefield seems to have little control over life at Tengenenge which appears spontaneous and unplanned. After a time it is realised that the survival and future of the community is dependent on a number of complex decisions. These are put into practice rather than written down. These include the supervision of the mining operations by the artists and the Director, the selection of work for exhibitions, the loading of work and the arrangement of

transport for such work to Harare for local and overseas clients. All the artists become involved in these activities which underpin the communal nature of the community. This loyalty is in keeping with the loyalties within the artists' traditional social structures in which each individual is a member of society with many prescribed social roles, and communal duties.

In keeping with these loyalties there is communal governance at Tengenenge. Major decisions, with Tom Blomefield as final arbiter, are made by Blomefield in conjunction with the master artists of the community, and in the case of judgment of an individual, a tribunal of artists takes place. Young artists are encouraged to take responsibility. Barcari Manzi and Enoch Purumero, both sons of master sculptors, take on clerical and semi-managerial roles and, because of their fluency in English, show visitors around the community. Through the establishment of communal roles for the artists, Tom Blomefield minimises any conflict of interest between their traditional communal cultural allegiances and their roles as artists — self-employed people progressing through personal initiative and self-development. At the same time the new role is encouraged. Each artist is treated as an individual with a personal set of values, problems, ambitions and aspirations.

While Tengenenge has had one close association with a reputable private gallery in Harare, and receives strong support from the National Gallery of Zimbabwe, and other private galleries, formal association and affiliations are outside of its parameters of operation. Two attempts have been made to affiliate Tengenenge with larger structures, and both have been unsuccessful. Tom Blomefield sees Tengenenge itself as a community of individual artists, rather than an institution or a school which is financed and administered by a private company, Tengenenge (Pvt) Ltd. In the near future he hopes to establish a foundation to ensure the community its perpetuity in the future and contribute to its practical and material needs. Tengenenge receives strong support from individuals, and donor agencies are pledging support in various ways. These varieties of support for Tengenenge do not deny it its freedom of operation.

In the words of Tom Blomefield, 'Tengenenge could never be run by a bureaucracy, by memos and meetings and words on paper. Its administration must have a directly human dimension, and a dimension of understanding of the cultural and spiritual values of its artists which must of necessity determine its structure. Tengenenge is a living and growing thing. It is not just the art but the people who make the art. It is a tap roots community and my advisors are the people who know it best: my master artists. Administration is generated from within. However, we are now growing so rapidly that I have to spend some time away from the community, doing necessary administration in Harare with my secretary and travelling abroad with exhibitions. We certainly have outgrown our original structure, and we need administration, but this must come from a person who is capable of taking direction from within rather than to impose it from the outside.'

Although Tom Blomefield claims that art education at Tengenenge does not exist, he is an art educationalist in a very broad sense. He sees art education for his artists as part of the broader general education, the making of art as part of a broader learning experience through which the artists discover things outside of making art: attitudes to work, the value of money and and its uses, their way of social interaction and the development of professional relationships. Of his artists who have had little or no art education he comments: 'If some of us had never been to art school we would have become better artists. Art education, though it develops our basic skills, firstly introduces us to the ideas of

others, often in the form of reproduced images. Before we define our notions of art, and this is particularly important in an African artist whose culture does not accommodate the notion of art), we do not need to be influenced by the ideas of others. While not actually being directed at Tengenenge, the artists are given a sense of personal direction in their art. While they have conceptual freedom, they are constantly asked to question and define their reasons for making art and to objectify these reasons. An artist's clear conception of art and why he is an artist is necessary for the quality of his work.'

A visit to Tengenenge is a profound and moving experience. From the start an association with the artists has a remarkably human dimension. Nobody is a stranger at Tengenenge, but someone who can share for a short or long time, the life of the community. The human value of the artist as well as the artistic value of the art is immediately apparent to the visitor. Here cultural exchange is not a planned procedure but a spontaneous event. A more structured form of cultural exchange is the presence of overseas artists working together with Tengenenge sculptors. Within the last two years, writers, photographers, anthropologists, sculptors and academics from Australia, America and Europe

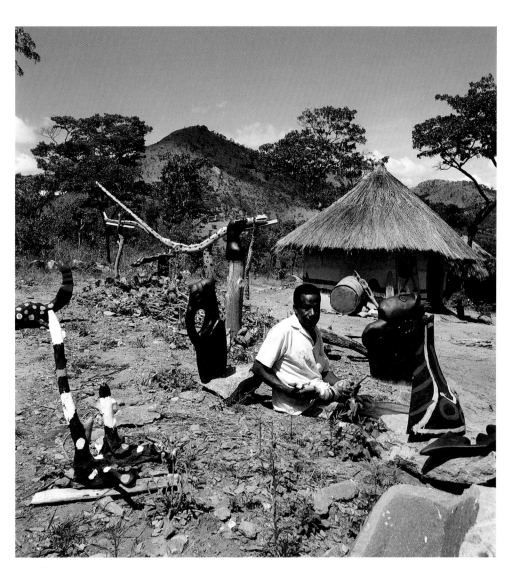

Barankinya Gosta

have spent long periods of time at Tengenenge. These artists and academics have developed cultural diversions in terms of the cultural practices of the community: learning to play the mbira, joining in the dancing, learning the languages of the artists. In turn they involve the artists in their way of life and cultural practices such as playing chess. The presence of these artists broadens the dimension of the already successful element of cultural assimilation within the community.

To walk among the sculptures, to develop a visual memory of each artist's work, to extend and develop this memory further to appreciate the different sculptures of each artist, requires concentration and effort. But this is, in itself, part of the process of art education. This is the process of art education encouraged by the best museum to its visitors — identification and classification of objects and an appreciation of cultural context. In the sense that most of the artists are living and working within the community, Tengenenge is a living museum in the best sense of the word. On the other hand it observes the traditional museum role of conservation and preservation. Part of the archives of Tengenenge are the half-finished, abandoned pieces of early sculpture which lie on the ground

in an old mining shed, overgrown with grass and weeds. These, like archaeological remains, allow the fragment to tell much about the whole, the stark and stylised shapes showing early hesitancy in exploring the three dimensional potential of the stone. Here also is shown the opening up of the stone to allow space to become a property of the sculpture, and the experimentation which allows the abandonment of the work in the cause of taking up a new idea. These fragments resemble those of some ancient culture, they speak of preliterate civilisations in which the signs and symbols of art have some glyphic significance. These early pieces allow a chronological art historical study to be made of Tengenenge, for an aesthetic for the work of the sculptors to be established, for the closeness of cultural origin of early work to be established. It is significant that in October of 1989 Tom Blomefield was invited to attend and speak at a seminar for museum personnel arranged by the National Museums and Monuments in Harare. Delegates at the seminar, senior museum staff from museums in Zimbabwe and Lesotho, were taken to Tengenenge and saw, in its informal structure and development, some relationship to the developments they were trying to make in their own museums. They saw the

human dimension of Tengenenge as making it a living museum of a most unusual nature. Today Tengenenge has enough historical substance and international significance to interest scholars, and a number of public art museum directors and curators are visiting the community with exhibitions in mind.

Notions of style, form and subject matter have never been impressed on Tengenenge artists. If the artists choose to represent the beliefs of their parent cultures in their work, or their belief in the spiritual intervention in everyday life, it is because they subscribe to those beliefs, not because they are meeting the European market's expectations of African art. The making of sculpture at Tengenenge is not sustained by market expectations alone. While the artists delight in selling their work, and indeed some make considerably more income from the sale of one piece of sculpture than they would through a year's employment as a farm or domestic worker, it is not the commercial aspect of their activities which necessarily makes them wish to sculpt. The physical proximity of the stone gives them a primacy of relationship to their material, the digging out and selection of their own stone gives them a sense of its origin, and an understanding of how its

natural properties can suggest subject, and other aesthetic potential. At Tengenenge there is little regard for the Western expectation of the art object to be a thing of beauty. Subject is not confined to the aesthetically pleasing, and it is not determined by preconceived notions of art. Although the Tengenenge artists do not know what expressionism is, expressionism has never been new to them; it forms part of the African approach to collective observances, such as dances, and communal expressions such as feasts, celebrations and funerals. As these events are unpredictable so is Tengenenge sculpture. At times the subject of Tengenenge sculpture remains indefinable, fully understood by the artist alone.

Often it appears at the confluence of imagination and reality and is indicative of the overall spiritual dimension of the artist's existence. Like the play on words which the best writers achieve some of the best sculptors at Tengenenge play successfully with form. To many Yao sculptors such as master sculptor Josia Manzi, surrealism seems a natural form of expression. The definable function and placement of human features and limbs seems to limit their possibilities, and often these are placed where they are least expected. Yao sculpture makes it possible for ears to have mouths, for eyes to hear and for mouths to see. Breasts have no sexual discrimination, they are the property of both man and woman and are seldom limited to two per person. In Yao sculpture imagination supersedes orthodoxy. Similarly in Yao sculpture, possibly because of the folkloric tradition of animal fables, the natural world is inhabited with variations of the known inhabitants — birds with human features, inbred animals and composite creatures which are neither animal nor bird.

At Tengenenge sex and age are no barrier to the making of art. Children, such as Edmore Kefala, as young as four years old, are working with stone in the way that European children might work with clay or plasticine. Old men of eighty such as Angolan Kakoma Kweli are discovering their creative potential through making sculpture. In his sculptures Kakoma Kweli invests the inscrutable appearance of the Mkishi mask with the dignity of his own years, and his sculpture could be hundreds of years old. Young sculptors from Guruve, proud of their Christian beliefs, are giving their sculpture a Messianic twist. Staycott Tawa's *The Bible* allows the beatitudes carved on to stone to have runic significance, and the words God is Love to be a fresh discovery. Wanda Luka, a young Shona sculptor from the compound, presents the world in the form of its madness, staring-eyed figures, searching in vain for sanity and reason. Shekey Chimbumu restores reality, using the lighter side of stone to make fun of the human condition.

Despite its isolation from the main-stream of Zimbabwe's artistic development, Tengenenge has considerable capability for its own artistic development, and the art of Tengenenge in a self-generative way is on occasions more progressive than the art to be found in Harare. Dependent on the use of natural materials for daily living, for building huts and making fireplaces, for making furniture and beds, sculptors at Tengenenge are developing a use of these materials in their art, a paradigm perhaps for the fact that at Tengenenge art is an extension of daily life. An example is seen in the work of Barcari Manzi, son of master sculptor Josia Manzi who works in stone but also in other materials. His *Lady* is a figure of painted wood and metal, with the contours of a Greek statue and the appearance of a scarecrow in a British field. Standing at the entrance of the old mining shed, the home of Tom Blomefield, she is a gracious hostess, inviting guests to join in the hospitality of the community.

His *Stunt Man*, of painted wood and

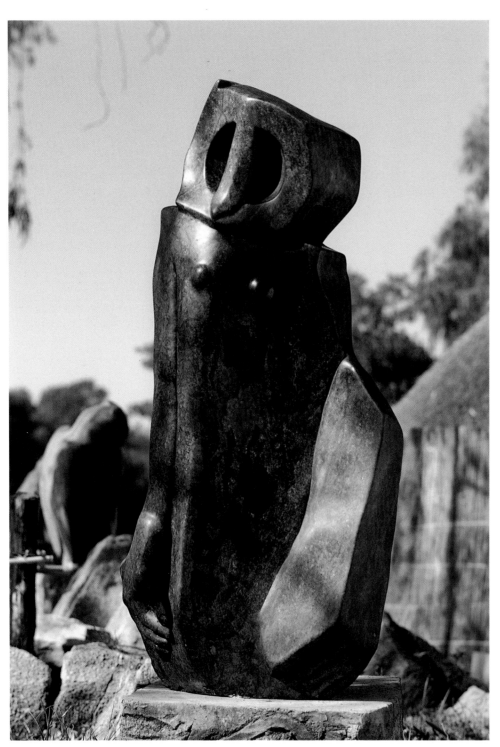

Tom Blomefield, *Owl Woman*, picture courtesy Chapungu Sculpture Park

metal, might be called *Effigy to Rambo*. Kesias Ngwalati's *Puppets* which, when manipulated, dance to the rhythm of Thomas Mapfumo and other popular Zimbabwean musicians gives a sense of theatre to the shebeen and a heightened drama to the relationship and activity which develop in that urban environment.

The paintings of the children of artists, which developed during 1989, are a new phenomenon, but they are also the result of Tom Blomefield's original philosophy of a simple provision of a place where artists are able to work, and have materials at their disposal. Here, under the mulberry tree, outside the mining shed, young boys are painting — having been given brushes, PVA paint and newsprint and particle board. These are not the painstakingly realistic paintings of the average five year old, where the cat is identified by every whisker. Perhaps frustrated by the slowness of carving and its repetition (in which they are also already engaged) these children paint quickly, depicting their view of the world, the mountain of Mwari which rules over Tengenenge, the cat and the elephant in abstract terms. The images become apparent through their use of light and colour.

Here too the women are painting, using the imagery of their own bodies, in somewhat radical terms, turning them-

selves inside out as it were to display their conception of their internal organs. The involvement of women in the art, the making of which may be in traditional conflict with the cultural stereotype of their role, stresses the importance of creativity as a dimension of life which keeps the community together.

The making of art at Tengenenge is broadening its parameters without the need of an art school. The use of found objects and recontextualisation are words applied to such developments, usually formally taught in the international art arena, but at Tengenenge art does not develop through words but through intuitive processes, and a greater awareness of the world around.

Tengenenge is a community of people and a collection of individuals who happen to be artists, with a cultural background and richness not usually evident in more sophisticated and less isolated communities. It is a community where social, racial and cultural harmony are present and essential. If Tengenenge's cultural dimension is broadened from time to time by artists from overseas who live and work in the community, it is the African quality which remains, after the guests have gone, and gives it its strength.

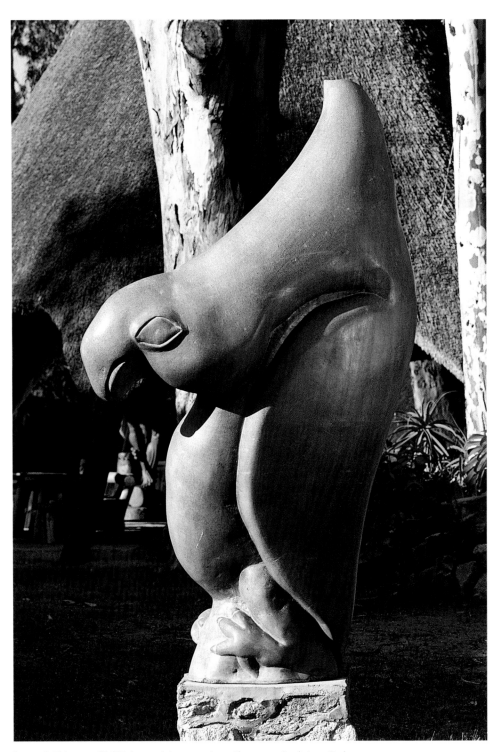

Sanwell Chirume, *Old Vulture*, picture courtesy Chapungu Sculpture Park

CHAPTER SEVEN

THE SCULPTORS SPEAK

SANWELL CHIRUME

Sanwell is a Shona sculptor who had no need to leave Tengenenge to extend the range of his subject. He has lived at Tengenenge all his life and it is difficult for ourselves, and even for his fellow sculptors, to understand his thinking. His sculpture seems to be the imaginative product of a view of life which has nothing to do with where he lives, what he has been taught and what he believes. Nor does his personal experience seem to have much bearing upon his work. The real world means little to Sanwell, nor does the spiritual realm as represented by the Shona. All these factors have been subjugated by an imagination which is far from culturally determined. Sanwell's life has been confined by this imagination and he has never left it to experience the world at large and reality as we know it.

It is hard to establish this imagination's origin or its future direction. This is not an imagination kept in check by reality or common sense, nor is it influenced by the ideas of others. In a sense, it is a feral imagination, wild and rebellious, abiding only by its own laws. His sculptures are a collection of its figments, a concretisation of the shapes and forms it conjures up in its wilder moments. These are shapes and forms which nobody else could have created — chaotic, turbulent and restless. At their most extreme his sculptures might be seen as the product of an unconditioned mind. They are like scrambled words, the products of an invented language, or the incoherent ramblings of delirium.

Subjects stem from an imagination which cannot be contained by traditional Shona beliefs, or Sanwell's belief in Jesus wearing white who walks down the high street of neighbouring Guruve to converse with the *mhondoro*. Sanwell does not present a spiritual explanation of the works of the real world but a surreal one. To him it seems the world was not created by design but by accident and default. It is full of surprises, and devoid of logic. He turns the world around, into an event which cannot be explained, a topsy-turvy world full of the unexpected where mouths are used for smelling and noses for eating. Expressionism has never been new to Tengenenge and in particular to Sanwell. He pushes the subject to its emotional extremes and presents it in a state of catharsis. Shape and form cannot altogether convey Sanwell's feelings and thoughts — so often the message is not clear, and emerges distorted and garbled.

Sanwell is one of the most articulate of all the Shona sculptors and if his subject defies description by its physical presence, description by Sanwell will unlock its meaning. His sculptures reflect his vocabulary and turn of phrase, sometimes rich, exotic and ornate, and sometimes economic, carefully chosen and concise. He is a teller of stories and his sculptures reflect their meaning.

Sanwell's sculptures are like fragments of subjects pieced together by his descriptions. Their meaning is made manifest in words. But language cannot altogether describe the impact of his sculptures. For example, the animal power of his *Dog*, a panting, heaving mass of stone, spent from the chase; or the shining spread of girth and loin of his *Beast* drawn to full length and height, ready to roar, attack and devour. Nor can the subject be sufficiently explained by the title; one or two words are not sufficient to convey the free association of thoughts and imagined creatures, incidents and events which constitute the statements made by his sculptures.

Sometimes Sanwell's fantasies are surprisingly literal; they broaden the context of logic and impart a new meaning to common sense. His N'anga can see into the future, a talent assisted by eyes extending beyond the face to meet events still to come. When he depicts his idea of metamorphosis he insists we see it take place. His *Pig* has reached the moment of indecision as to

whether it is man or pig. A pig-like nose is about to renounce its snout-like form; soon it will never grunt again. His *Jesus Head* was possibly a stone shattered to pieces by a fall to the ground. By means of some power within itself it has regained at least a partial resemblance to its original shape. A drooping pair of much treasured moustaches remain intact. According to Sanwell, the head was given to Jesus by a man with whom He was having lunch. As the man was late for lunch, Jesus threw the head on to the ground, in a rage. The equally enraged head picked itself up from the ground, reassembled its shattered components and looked down to its face to make sure its moustaches still remained and had possibilities for growth!

For Sanwell it seems not enough for a subject to remain a sculpture. It seems to want to crawl out of the stone, to become flesh and blood, to smile and grimace and to live and exist outside its form, shape, surface and texture. Material can be constraining; sometimes the subject demands to be set free of the stone, and exist as words only. Sometimes Sanwell seems to have too much to say. His sculptures are overcrowded with meaning, and his words trip over themselves in their rush to be heard. Recently it has occurred to Sanwell that things can be left out of a sculpture and

thus establish their meaning. This he calls *Chimbungu* — the invisible. His *Mountain* is a bare-faced rock, with no indication of the 'history or geography of things' which Sanwell says he conveys through his other work. We have no idea where this mountain is, how old it is, or what has lived on it. But here is an indication of the invisible at work, of something animate within the rock, peering through the stone to see what is going on in the visible world.

These sculptures are the product of a mind of strange makeup and thoughts, far removed from the normal conditioning of upbringing and belief. His sculptures generally do not do what is expected of them, nor are they endowed with recognisable features.

What seems possibly to be an elephant, munches a bunch of flowers with its nose and sniffs the blossoms through its mouth. His *Bird* seems discontented with its present existence and is occupied with thoughts of new forms and bodily changes. His *Buck's Head* has no eyes or ears but seems aware of the world around it.

Sanwell's statements are largely savage and are of considerable ferocity. His sculptures attack established beliefs and values, turn order askew and make monsters of myths. High on the mountains of the Great Dyke, these

sculptures could descend on the world and terrorise its inhabitants. They are the protectors of Tengenenge from the real world.

Sanwell comments: 'My head was too hard for learning, it only becomes soft when I make art. I don't want to be on a square level. My art comes from myself, my body, my head and my strength.' Sanwell is aware that he is making art, but only art as he understands it. If this is far removed from our understanding of art we must accept it, and appreciate him as one of Zimbabwe's most original sculptors.

BARANKINYA GOSTA

Barankinya is a Chewa sculptor at Tengenenge whose wooden, mask-like sculptures appear to have been left over from a performance of the *nyao* dance. The facial features, the dramatic projection of the forehead and lip, the narrow nose, the white eyes which seem lodged in the wood or bored into it by a rapacious insect, are those of the Chewa mask. As in the masks, the carving in the sculptures is naturalistic. Abstraction and stylisation are apparent in the painting of the sculptures. The paints used by Barankinya are white, red and black — colours of religious significance to the

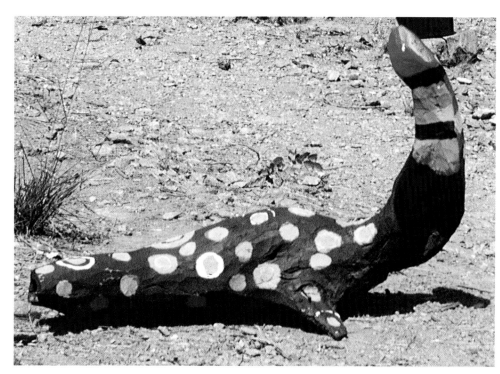

Barankinya Gosta, *Water Creature*

Chewa. These are bright colours, brighter than the high colour on the tall grass at Tengenenge, and the sun in the evening sky. Even in the evening light they transmit a glare, and darkness does not prevent them glowing incandescently into the night.

Barankinya remains close to his parent culture. It is possible that he sees both the ritualistic and art significance of the Chewa masks, and has observed and even experienced the power they have outside of their objecthood as well as appreciating their beauty. Indeed this power is conveyed in his sculptures. However, Barankinya's carving, unlike the carving of the Chewa masks, is not governed by any religious tradition. The painted markings do not have any religious meaning. The *nyao* dances today no longer present a believable rationale for the existence of the Chewa and the Maravi, nor depict the way of life and system of belief which elevated the *nyao* dancers to a position of spiritual prestige. Their relevance is largely academic to the life of the Chewa today. However Barankinya's sculptures make an important cultural statement in their comment of the importance of the dance to one individual, and the way in which Tengenenge allows him to accommodate its relevance into his daily life and work.

Barankinya's conversation is fast, his mind skim-reads many situations yet absorbs the details. He works quickly. As other artists would dash off a painting, he makes a sculpture.

His *Mamba*, his largest sculpture, seems to uncoil before our eyes. Bands of red clutch at the throat of the black form, squeezing out life and soul. On the front of the Mamba are markings which fling themselves around the body making way to a large open mouth. This is the mouth of an old man, extended beyond full width with laughter. The old man is delighted that the spirits have returned to admonish the snake for killing without reason. On the back of the snake is a red form which, although painted on to the wood, seems suspended in space. According to Barankinya this is the ghost of a victim of the mamba, senselessly

killed, which has come back to haunt it. Perhaps the old man knows that the mamba will finally be victimised with its own bite, to die at the flick of its own tongue, and to turn in on itself and become its own victim. Around the mouth of the old man the wood is appropriately gnarled and wrinkled. Cracks assume the lines of an ageing face, and the deepening seams of a skin which no longer breathes easily.

Barankinya's is sinuous painting. The bands slip and slither around the mamba; they could slide away to make their own way through the grass and find their own victim. In the half darkness they gleam on the form, taking on the appearance of tribal markings standing out from the mamba like angry weals. The red band locked around the neck,

never to be prised away, will prevent the snake from biting once more and claiming another victim.

His *Young Girl* is made far older than her years by the age of the wood. The grain of the wood assumes the form of pitted skin, and paint cannot hide her wrinkles and lines. To the Chewa white signifies age and the wisdom of years, and appropriately there is a band of white across her eyes. Red rests on the side of her face like a vivid weal, the paint looks inflamed and sore to touch. The other side of the face is like a burntout landscape, a facial wasteland, devoid of feature and mask-like. If this girl was once young it is hard to realise it. His *Campini Head* is a well known mask image in the *nyao* dance. Here it stares vacantly, a satire on human folly.

Barankinya's sculptures have no special place or space at Tengenenge. His *Mamba* takes one by surprise at the kitchen door, waiting, ready to spring. His *Girl* rests her face by a barbed wire fence, and his *Campini Head* lolls against a wall. Yet, in a sense, where they are conveys what they are. Here are sculptures which do not need the trappings of display. In a sense they need to be separated from his cultural background by distance of time and place, and his work speaks of the power of belief and the efficacy of faith.

TAPFUMA GUTSA

Tapfuma Gutsa is the product of a formal art education at the City and Guilds School in London (1982–1985). He is extremely visually literate, and well acquainted with international sculptural practice, in particular with British sculpture. As much an intellectual as a sculptor, he has an academic interest in art and in particular a theoretical interest in its social function. Although he has been educated outside Zimbabwe he is both appreciative and critical of his Shona cultural heritage and traditional spiritual practices. Through his art, Gutsa speaks on behalf of well-educated young Zimbabweans in any field rather than just on behalf of his fellow artists. His dilemmas are their dilemmas, his inherent contradictions are their contradictions, his problems are their problems and his solutions are also theirs.

In his art he is trying to reconcile and resolve the differences established through his education outside Zimbabwe, and his relationship to his own culture in a manner which is consistently innovative and experimental. Much of his work has an affinity with the large-scale, site-specific, mixed media installations made in Europe. If he uses stone, it is part of this larger plan, and there is little similarity between his work and that of the other Zimbabwean stone sculptors.

Gutsa is no maker of income-producing objects but of art which performs a social role. He sees the artist as a contributive member of society, an effecter of social change and an architect of social planning. He is committed to making social comment and, through his art, to voice solutions to social problems. His work contains references outside his culture, and at the same time he explores his relationship to that culture. He is critical of Shona sculpture in Zimbabwe. He feels that it has become too set in its ways, and that a hastily established tradition has limited its possibilities, closed off its options and stunted its development. He feels that it has become too culturally dependent, that it brings Zimbabwean sculpture to a standstill, and refuses to acknowledge post-Independence change. To him, the stone sculpture's importance as a cultural statement diminishes in the face of social and spiritual change in Zimbabwe, and this importance can be reconstituted only if sculptors address these changes in their work.

His relationship with his own culture, since returning to Zimbabwe from the United Kingdom, takes the form of a social experiment with an appropriate input of fieldwork. He has chosen, for some time, to live and work

in Murewa where he grew up with his family. Here, an ancient mountain presides like an elder over his people. Gutsa surrounds himself with natural forces and phenomena. He taps his cultural roots and his resulting disenchantment with Shona stone sculpture stems from his observations of the current state of Shona spirituality. Like an artist who stands back from his own work and looks at it critically from several viewpoints, Gutsa stands back from Shona ontology. If he does not like what he sees, he does not, like some artists, destroy what he sees, but he retains what is reasonable. He knows he cannot start again from scratch. He feels that long-established Shona beliefs have become inhabited by false gods. There are certain spirit mediums, cult figures who fake possession and attribute hallucinatory and fantastic explanations to inexplicable events which merit scientific explanation. Because of the ways people have worked the system, some laws have lost their values. Some sculptors have become similarly devious; Gutsa says: 'They take a piece of stone, hit it and call it a water spirit, when they do not believe in the power of the water spirit.'

Gutsa comes from a protest generation, but his protest is not necessarily generational. He feels God to be the product of man and sometimes custom-made, but he acknowledges that He is a necessity. He is not trying, through his art, to destroy Shona beliefs or Shona culture but he is trying to discuss his own beliefs which are not necessarily of Shona origin. He believes that there is a new rationale for the explanation of events within traditional society which does not have recourse to supernatural or mystic explanations. That a spiritual explanation for the workings of the real world is a belief, collectively or personally held, does not mean it is the only explanation. A belief is not a proven fact, and faith cannot be explained.

Yet if an explanation is a proven fact it cannot destroy a belief, and Gutsa feels that it is the traditional beliefs of the Shona which have established moral order and social structure and institutions. 'In their genuine form, the spirit medium, the *mudzimu*, the *vadzimu* and the *mhondoro* are the conscience of the tribe,' he says.

Each sculpture Gutsa makes is a test of his reactions to his culture and the questions it poses. Gutsa is a self-made sculptor. His art stands on its own merits and its quality has never been established by dealers. He has had no European mentors. Yet he is a prophet not without honour in his own country. He has had a one-person exhibition in the PG Gallery

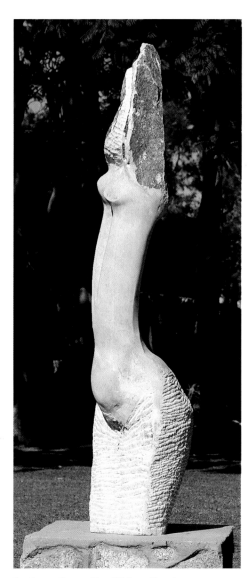

Tapfuma Gutsa, *The Wish to Fly*, picture courtesy Chapungu Sculpture Park

of the National Gallery of Zimbabwe, and in 1987 won the Nedlaw Prize at the Annual Exhibition.

Tapfuma Gutsa could have established his career in the United Kingdom or Europe. Instead he has chosen to return and work in Zimbabwe. In so doing he has helped to establish a new direction for Zimbabwean art — sculpture which can be culturally specific and yet cross international boundaries. His work is far removed from most stone sculpture in Zimbabwe but he feels it is more genuinely Shona than that of many of his Shona colleagues and more honestly so. 'Through my work I am trying to create a code, like the rosary. There was a science once known to the Shona, through which a rationale or a rational explanation was provided for so-called irrational events such as the weather. Through my work I am trying to remind the Shona people of the rational explanation of things, rather than the fantastic or supernatural.'

Gutsa's *Arch* is a thrust of ten stones, precariously balanced with possible runic significance and mathematical meaning. Here he creates sculpture which seems part of nature, perhaps reminiscent of the British sculptors, Hamish Fulton and Richard Long. Like beliefs which can be shattered, this *Arch* appears to be waiting to break and fall to the ground

to destroy itself in the manner of a fallen idol. The *Arch* was made at Murewa and reflects the shadow of the mountain and points to its shape and form. It became a landmark in Murewa — 'people knew it had something to do with them'. Gutsa would like to straddle the mountain with a larger arch to create an indelible landmark with its foundations in nature.

Doom, a wooden bird, blackened and charred, hovers over two old tins resembling the burnt-out relic of a vast bird. It is only when the flames flare over the tins that the bird becomes a victim, and a ritual is acted out. Here is the bird in Zimbabwe bursting into a thousand feathers when hit by a car, and in a broader sense the statement concerns the vulnerability of nature in the face of things man-made. Here is a site-specific installation, and a performance piece, European in sensibility and African in its concerns, and specifically Zimbabwean in its preferences. It raises the question of cultural dependence against cultural authenticity, and answers are satisfactorily established.

These two of Gutsa's sculptures have decidedly British leanings. He cites their affinity with the work of Moore, Chadwick and Armitage, intimidating only in size, creating a naturalistic dialogue between themselves, their public and their environment. He attempts, with

success, in these works to establish the same dialogue. But Gutsa's sculptures do not attract by their scale or, like those of the British sculptors, by their bulk or their imperiousness. Gutsa's sculptures are free of association, a random encounter with elements which make sudden sense as art, and create, through their relationships, something new, something worth saying and worth listening to. Gutsa gives historic value to stone sculpture in Zimbabwe which has always appeared far older than its years. If it does not speak necessarily about what he feels Zimbabweans believe now, it speaks about what they have believed for centuries, and in this sense is culturally authentic. If they listened to Gutsa the stone sculptors of Zimbabwe could have their minds and ears opened.

His work anticipates the establishment of a regional art school in Zimbabwe where artists could be introduced to new media, rigorous and informed criticism, quality control and selectivity, and professional standards. Gutsa's sculpture is an example of what such things can do to the quality of a work of art.

If artists are seen to be romancing the stone, all love affairs must end, rather than drag on, lost of meaning and relevance. To Gutsa, how to look and what to look for next are not enough.

He makes demands on what we feel and what we think, and helps us to define our relationship to society. He feels that historically Zimbabwean sculpture speaks on the part of the societies it represents, but that the audience does not listen. Shona sculpture is largely unrecognised by the Shona people. They are hardly aware of its existence, and are unaffected by what it has to say and its meaning to them. This he feels is not because they do not want to know about it but because they do not know about it. He urges a support system in Zimbabwe to take art to its own people, to make art meaningful to them. He also urges the sculptors to take issue with things relevant to Zimbabweans today rather than produce what has been heard many times before. He feels that like poets, playwrights and novelists, Zimbabwean sculptors should be doing something about their culture but until they realise what this culture is, the sculpture will never be truly indigenous.

'In my own sculpture, the shapes and forms I produce are not the means to the end, but the means to an under-standing of my thoughts and philosophy.'

MAKINA KAMEYA

Makina Kameya was a Mbunda from Angola who migrated to Zimbabwe in the l960s to find work. He worked at Tengenenge all his life and died there in February, 1988. At the age of seventy he was the oldest resident sculptor. Luminous of eye, tattered of dress and eloquent of phrase, he was a work of art in himself — an original and of inestimable value. Now lost to us he will never be replaced, and his work will never compensate for that loss.

Makina's work has a strong sense of its cultural origins, and the richness of Angolan art. Form and imagery can be found in the masks of the *Mkishi* dancers who celebrate the presence of the Mbunda god, *Kalunga*, in the lives of all Mbunda. Although Makina sculpts only the head and torso, it is not difficult to imagine the entire dancer's body, teetering on his stilts, as if in drunken celebration of the work of his creator *Kalunga*. Makina creates facial form through a series of dots and dashes. As appropriate to a mask, nothing is given away, but one cut can speak volumes. Yet there is no indication of the man behind the mask; we have no idea of the dancer before the dance or after the performance is over. Like most mask-makers it seems that Makina thought two-dimensionally, and

our view is confined to the front of the face. His sculptures differ by the slightest of suggestions; their statement is collective rather than individual. In their setting at Tengenenge they suggest a row of dancers, masked and ready to perform. However, their similarity does not detract from their impact. It makes the point that they are all by Makina, and in this case that statement is more important than the art.

Makina was protected from the real world by Tengenenge and his personal god, *Kalunga*, for the last twenty years of his life. If he had left Tengenenge he may not have endured separation from it, for Tengenenge provided protection and gave him the entree to the spiritual realm. Certainly he would not have found a replacement for Tengenenge, and it is doubtful if the real world would have found a place for him.

To Makina his art was an extension of *Kalunga's* existence and a reason for living. Makina sculptured because he wanted to create, not because he wanted necessarily to make art. The only way he knew how to create was to make sculpture. If he had been able to write, he may not have made sculpture; if he had been able to dance he perhaps would not have carved. His sculpture expressed what he could not put into words and the steps that he had not

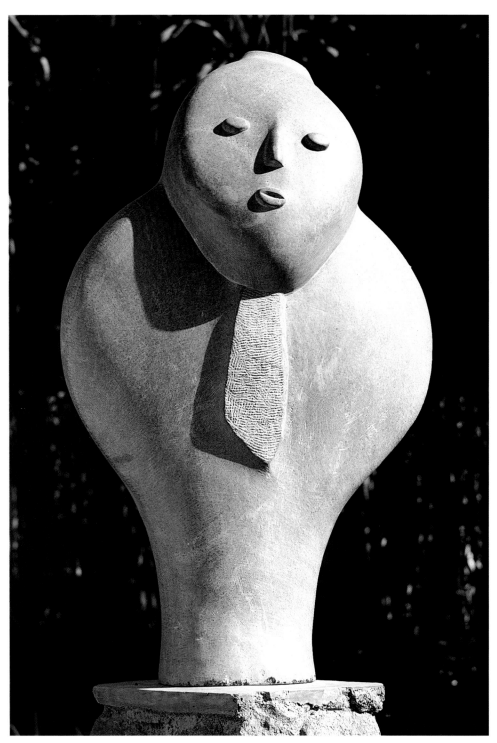

Makina Kameya, *The Story Teller*, picture courtesy Chapungu Sculpture Park

been taught. To Makina his art was a language more important than words. It was his way of speaking and addressing the world with confidence. If Makina had been deaf, dumb and blind, he would still have made sculpture. Through his art he would have seen, heard and felt the world around him and learned to experience its pleasure.

Kalunga was a guiding hand for Makina, being both the force behind Makina's work and, as Makina believed, the audience for it. These sculptures brim over with joy and his love for *Kalunga*, and we share in their bounties.

Ironically Makina was destroyed by an act of his own creation. A large sculptured head fell on his pelvis and legs creating difficulties from which he never recovered. Ceremonies have been held at Tengenenge to establish the spirit of Makina in his rightful place with *Kalunga*. His sculptures remain on earth, and in so doing the presence of Makina also remains.

WAZI MAICOLO

Wazi Maicolo was a Yao sculptor from Malawi who lived and worked at Tengenenge for twenty years. He died at the age of sixty in May, 1987, after a short illness which was as

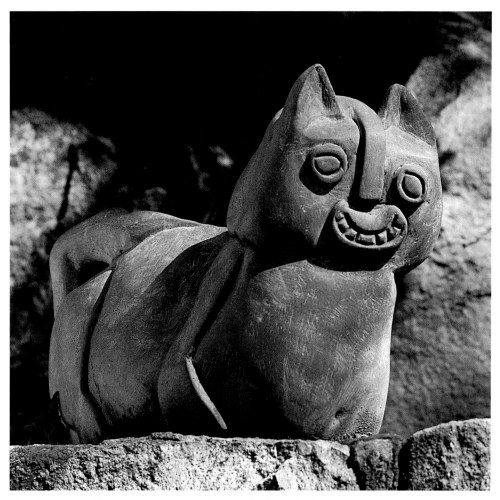

Wazi Maicolo, *Old Lion*, picture courtesy Chapungu Sculpture Park

confusing to him as tc those who cared for him. His retrospective exhibition at the National Gallery of Zimbabwe was in a sense a memorial service — a public recognition of the work of one of Zimbabwe's most original sculptors.

Ironically it is fitting that Maicolo, known as Wazi, gained the respect and recognition he deserved after his death rather than during his lifetime. He cared little about public recognition of his work. It was only his uncle, Amali Mailolo and Tom Blomefield, together with a few close friends and peers, that he took into his confidence about his sculpture. Although Wazi was proud of his art he never presumed recognition and did not understand the pride that others took in it.

Wazi began to sculpt out of curiosity. This was not curiosity about the meaning and function of art, which did not interest him, but curiosity about his beliefs. Wazi's beliefs about the interaction of Yao and Chewa spirits with the mortal realm were fraught with superstition and fear. In particular, he was afraid of the Chewa *mfiti* which he believed descended to the grave to eat the dead, and assumed visibility and invisibility at will. It was through his sculpture that Wazi, with increasing confidence, came to terms with the idea of the indivisibility of the mortal and spiritual realm, and established his links with the visible and invisible worlds. It was his partially imagined relationship of the spiritual realm with the earthbound which sometimes constituted the subject matter of his sculpture.

Sometimes seeking refuge from these fears, Wazi turned for the subject to Yao animal fables handed down by the Yao elders. Often he would repeat these stories himself. An excellent mimic, he would capture the crow of the cock, the roar of the lion, and the cry of the jackal. In recounting these stories he would turn himself into the characters, creating a scenario and giving a one-man performance. His recounting of these fables can be likened to an animated cartoon, or a silent film overlaid with sound and running at high speed.

In a sculptural sense Wazi would embellish these stories with creatures of his own making. These original creatures were often sightless and inanimate, giving away nothing of what they represented. Perhaps the outcome of Wazi's increasing restlessness with the

real world and its inhabitants was that these creatures appeared to be in a trance — not of this world and uninterested in its activities. As he developed as a sculptor, he made little distinction between the real world and the spiritual realm. Spirits became to Wazi as familiar as the animals he observed at Tengenenge and the characters of the Yao fables, and his sculptures became a composite of all three. When Wazi was concerned with the natural order of things he was not always faithful to that order. He was more interested in creating a new order, dismissive of evolutionary principles and genetic propriety. His was an animal kingdom of strange couplings and amazing company. Collectively, his sculptures resemble an experiment in inbreeding, distinctly unselective. The attraction of opposites produced startling progeny. A head of a jackal rests on the shoulders of a roebuck, the ears of a civet cat are cocked at the world from the head of an antelope. The spirit of a hare inhabits the body of a lion. Undecided as to what animal they are or whether they are spirit or animal his sculptures generously accommodate all options.

His talent for mimicry is reflected in his sculptures. Some creatures imitate the actions of the real world's creatures with parody, exaggeration and considerable humour. Yet Wazi's work has its darker side. At times, his imagination reached down to an underworld of sinister inhabitants, possible rejects from the spiritual realm who leer at the natural orders of things and aspire to plot its overthrow. Here is a region where affliction and disability have their rightful place. These creatures seem like an accident of birth, with dreadful mutations. Here cocked ears compensate for vacant and sightless eyes, one limb performs the function of four. Hands and feet remain unformed stumps. Some creatures are like children's toys filled out with stuffing, to be dragged around the nursery and carried by the ear. Others address us with insane grins and lolling tongues.

Wazi provided the drama at Tengenenge community. Collectively, his corpus of work resembles a loosely-constructed plot, each character acting out their role. Wazi's scenario had an effective setting in an old mining shed at Tengenenge. Major figures took centre stage, others waited in the wings for their turn. Wary of the real world these creatures lurked in the shadows and with reticence avoided the eye. It almost seemed that they were posing as sculptures during the day only to emerge at night as shadowy figures devouring what they could find, including each other, and howling at the stars in the sky.

Wazi followed the stone's angularities and avoided its curves. Hence his creatures present a sharp-faced, sharp-eared, sharp-eyed and possibly sharp-tongued view of the world. All eyes and ears, Wazi's animal kingdom perhaps sees things we cannot see, hears things we cannot hear and knows things we cannot comprehend. Wazi's sculptures are the product of a mind of mordant wit and conceptual dexterity. If we cannot reach his conclusions about his work we may be able to reach our own.

His sculptures prove that consistency of medium, means and even theme do not exclude originality in art, and that good art is not necessarily the product of clearly formed ideas about art and formal art education. While Wazi was afraid of the spiritual realm, his sculptures indicate that he could not resist a little dabbling. Like the occasional table tapper of the participant in the seance he establishes communication with the spiritual realm and we are glad to be part of his audience. We wish Wazi well in the kingdom of his creation.

AMALI MAILOLO

Amali Mailolo came to Tengenenge from Malawi twenty years ago. Today he remains on Tengenenge farm. He has not worked consistently as a sculptor but each piece is worthy of consideration. He approaches each sculpture as if he is making sculpture for the first time — it brings a sense of individuality to his work, and a marked sense of variety.

Amali's sculptures are essentially perceptual, intelligible observations of the inhabitants of the real world, recognisable and reassuringly familiar. They are couched in his memories of Lake Malawi, chafed by the wind, soothed by the sun and laid to rest by the night. In his work he considers the relationship of the subject to its environment; the way in which environment affects behaviour, determines the means of survival, and lays down the guidelines of the battle between man and nature. In short, he deals in ecological matters.

His human figures, substantial, assertive and drawn to their full height, speak of his respect for the Yao, who during the nineteenth century were slavers and traders, strong in physique and physical prowess. These figures appear to have Yao blood coursing through their veins; they are ready to

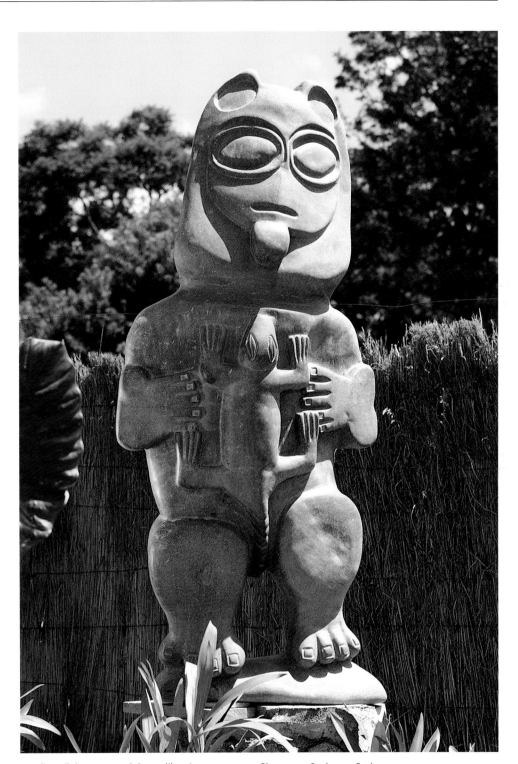

Amali Mailolo, *Man and Crocodile*, picture courtesy Chapungu Sculpture Park

pillage and plunder and establish their dominance by force. They seem to have had a life before art, and to lead a life outside art — they are made of flesh and blood rather than stone. They speak most eloquently and at some length in body language — the physical stance, the pelvic thrust, the clench of a fist and the protruding buttock convey their character and make their statement. Human forms pose in the manner of the best Greek statuary. The body becomes an art object to be admired at the level of its beauty alone. They seem poised to run effortlessly, and to win the race. They are action-packed sculptures, suffused with energy and full of movement. They seem naturally nude, clothing would rest uncomfortably upon them and detract from their beauty. The classic shapes and contours employed have been constant since the ancient Greeks and we enjoy their familiarity.

In *Man and Crocodile*, his largest and most impressive piece, now in the permanent collection of Chapungu Village, man and crocodile are in an obvious state of sexual entanglement. Man is the dominant partner, massive, aggressive and assured of his prowess. The relationship between man and crocodile is explicit but in no way offends. The man is strong enough to capture ten crocodiles and displays

enough sexual energy to violate each one. The crocodile is not an object of pleasure but the victim of sexual attack, possibly indecent. This is Amali's revenge on the crocodile which devours man in Lake Malawi. He reverses, with graphic savagery, the role of the ravager and the ravaged, and makes variations on the theme of bestiality. The man bears the splayed crocodile on his body like a cross, pierced and bleeding. The force behind the attack is revealed when the back of the figure is seen, suffused with virility, all jutting buttock and arching back, an armature of muscle and sinew built upon by layer after layer of flesh. Here the subject is not limited to one man's attack on a crocodile but has wider implications. It speaks of the victory of man over nature, and suggests the roles can be reversed.

Amali's *Malawi Birds* appear ready to take off from Lake Malawi. Their bodies are like giant fuselages to be supported by wings outstretched in the air like huge propellers. The birds' eyes are large and blank as if blinded by ground lights. Once in the air these birds could be steered on a set course and guided to their destination. Amali's sculpture, in particular *Man and Crocodile*, reveal much about the way they are made and the artist who made them. They speak as much of the act as the art

of carving; of the strength of the hand and the power of the tool, and the resistance of the stone. Here is evidence of the artist's considerable strength, his sustained effort and power of concentration and a high degree of patience. They tell of the work that goes into a sculpture, and what that work involves.

Amali's sculptures are secure in their objecthood, reassuringly there, and unmistakably sculpture. Yet they still pose the question: is there life before art? It is as if these sculptures have come about by natural causes and that sculpting is an act of nature rather than of man. They follow closely the contours of the human form and if Amali is the most realistic of all the Tengenenge sculptors we see this realism as essential to his art.

DAMIEN MANUHWA

Damien Manuhwa is one of the few Shona sculptors to recognise, through his work, that Zimbabwe is a new and developing country whose history is still to be shaped by future political and social ideological changes. Personally affected by the transition and social changes which accompanied Independence in 1980, Manuhwa has

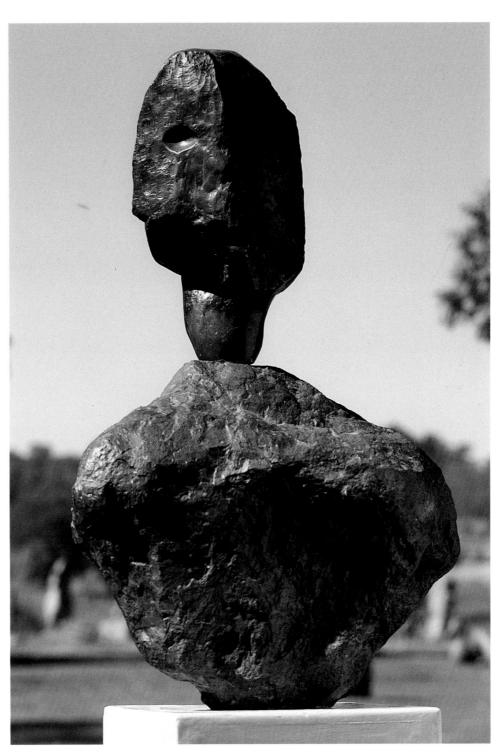

Damien Manuhwa, *Creation of a Woman*, picture courtesy Chapungu Sculpture Park

since responded in his work to the social consequences. Prior to this time his work had been concerned with traditional Shona beliefs and customs, but after Independence he began to see the constraints of sculpture in this context. Although he remains faithful to the traditional material and means, his subjects deal with contemporary issues.

Manuhwa extends the scope of stone sculpture in Zimbabwe to make a social statement but makes us aware of the possibilities of political intervention in the art, which up until now has enjoyed freedom of speech. If the sculpture of the Shona is to be held in esteem by those of its own culture these possibilities cannot be ignored. Manuhwa's work since Independence is atypical of that of his colleagues. He is not afraid to take issue through his art, and the reality of his work is unmistakably contemporary. His most telling expression of this kind is *Unity*. Here the subject is expressed through a formal analogy. Two pieces of stone are effectively joined to become one in sculpture. They represent those opportunities afforded to people after Independence to become united, working together towards common goals. A clutched hand rises from the stone as if holding a flag, issuing a call to arms, or presenting a manifesto. A head devoid of feature or indication of sex represents

man united. This sculpture, small of stature, should assume monolithic proportions, and a place in the public eye. This would allow as many people as possible to be drawn into its concerns, allow it to sway a crowd and impart its meaning to the casual observer. As Manuhwa comments: 'Although we became independent, Independence gave us the opportunity to become united, to work together without conflict.'

There are other isolated instances of stone sculpture in Zimbabwe making a comment on the issues and events arising out of Independence. In *Breaking Free*, by Sylvester Mubayi, a human form struggles to break through a massive piece of stone. It is seemingly manacled by the material, and freedom seems a remote possibility. However, Manuhwa's platform is seldom shared by other sculptors, and he must be commended for this highly personal stance. Manuhwa sees himself largely as an interpreter of his culture to the outside world, but he is concerned that his work or Zimbabwean sculpture in general is not encouraged to address the Shona people. However *Unity* addresses their need and captures the spirit of Independence for Zimbabwe which has a profound meaning for everyone. He is ideally suited to make public sculpture which will shape social consciousness on a large scale, and it is

hoped that such opportunities will he provided for him.

Damien Manuhwa's early work relates strongly to his childhood spent in the rural areas tending animals. Here he was able to see the similarities of form, feature and habit between animals and man. In some of his works he makes us realise how close we are to the animal kingdom, and in this way he brings us closer to nature. His *Antelope Woman* shows a female antelope, well-endowed and full of figure. She displays her large breasts with pride and seems to anticipate with delight the time she will become fully woman. At the same time, in his early work, he speaks with an essentially human voice. His *Rich Man* appears awed with the enormity of his wealth and weighed down by his responsibilities. Here he reminds us that the Shona put more emphasis on social honour than material gain. This work has moral overtones and issues a warning. In *Creation of a Woman*, a female head springs from the bowels of a piece of stone. It is distorted of form and foetal of feature. It is possible that this child was born before he or she was ready to be presented to the world, and that the Creator had run out of inspiration.

Both aspects of Manuhwa's work are valuable. On the one hand, his post-Independence work looks at a society

whose cultural values are being shaped by social issues and political beliefs. His earlier work represents those who lay claim to their traditional cultural loyalties in the face of change, and retain their traditional beliefs. Collectively, his work represents the feeling that the two ways of thinking are not incompatible and that one system of beliefs can contain aspects of the other.

Manuhwa, today, sees the sculpture of the Shona as constrained by exclusively spiritual concerns. He has moved on in his art to reflect a different and more contemporary Zimbabwe. He has opened up possibilities for the future of stone sculpture in Zimbabwe which will not make it any the less Zimbabwean than it was in the past. It appears he is considering both the future of his country and its art.

JOSIA MANZI

Josia Manzi is of Yao origin and has always lived and worked at Tengenenge. He was born in Zimbabwe, and feels that although he is descended from his parent culture he cannot claim to be part of it. His relationship with that culture is tempered by detachment and objectivity. He regards himself as an onlooker at the Yao dance.

To Josia the Yao dances, the *nyago* and the *ben*, are a form of theatre and a

spectator sport. His sculptures follow the forms of the dances but stop short of following the steps. There are in his mask-like heads, implications of characters, and of caricatures, but never revelations and the Yao secrets are kept safe.

On first appearance, Josia's sculptures do not have the feral quality of other Tengenenge art, which seem ill at ease in the real world and uncomfortable in the presence of man. Although meticulous of finish and impeccable of technique, these sculptures have a sense of the anima of the artist, and the fact that the Yao beliefs have not altogether lost their hold. They convey that, at Tengenenge, what is felt is more important than what is seen or observed, experienced or heard. In this sense they are truly Tengenenge sculptures.

Generally, Josia seems on good terms with the real world and at ease with its inhabitants. Some of his sculptures lovingly represent this relationship, and are naturalistic statements about the world around him. But often it is his terms rather than our terms which matter, and it is his view of things rather than ours which is depicted.

To Josia the real world is not always a serious place. Its destiny is often shaped by quirks and follies and events which go off course and which cannot be steered

back to their original direction. Josia is not averse to tinkering with the natural order of things, to turn the real world and even the spiritual realm on its lighter side, to recount an amusing incident, or play a practical joke on our sensibilities. He delights in establishing surprising relationships between man and spirit, animal and man, and man and nature. He takes license with accepted notions of reality and his sculptures are a play on orthodox ideas of form. In some of his sculptures, the anatomy develops new and often disturbing relationships. To Josia it seems natural for breasts to develop from thighs. Yet to the onlooker it seems surreal and a subversion of orthodoxy. Josia's surrealism does not have the bite and expressiveness of other Tengenenge sculptors, but it has an African sensibility and a hint of Yao origin. In a sense he turns the Yao dancing into the theatre he believes it to be, a theatre verging on the absurd.

Josia invests nakedness with propriety and makes us feel it has always been man's natural state and that clothes have never been invented. Like the painted nude his naked forms are to be admired and appreciated. Smooth and well-rounded his sculptures are stone made flesh: firm, toned, glowing and smooth. His nude figures are proud of their appearance and they have nothing

to hide or to be ashamed of. Josia's stones have no sense of origin; they are sleek and smooth, well-cared for and even pampered. Each day they are carefully polished and retain a high gloss. His recent use of the natural surface in his sculpture is more a device than a respect for the natural qualities of the stone. His *Monkey and Owl* and his *Mirror* seem like giant cameos — the smooth, carved figures of the animals, the bird and the human face carefully inlaid into the stone and offset by their natural setting.

Josia can be a sculptor of incidents, each work conveying the circumstances which create the predicament for the subject. In *Baboon Stealing the Mealie Guard's Child* the baboon is caught in the act, surprise on his face, defensively clutching the child. Here is a tussle in stone which is never resolved. His *Fighting Man* is punch-drunk with aggression. He sees the world as his assailant and engages in combat with empty space. The winner is never revealed. His *Rhinoceros* is a stone which seems to swell before our eyes, well turned out, riding its pedestal with amazing grace. His *Bird* is full-frontally nude. The tails of a frock coat which stream down its back are an apology for feathers. In *Woman* a hand modestly covers an area where a breast should be.

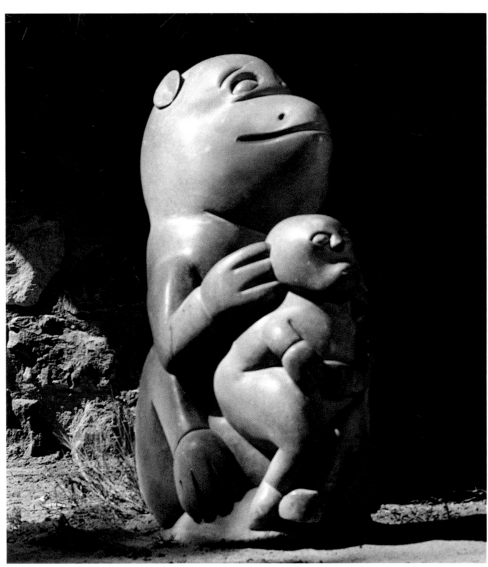

Josia Manzi, *Baboon Stealing the Mealie Guard's Child*, picture courtesy Chapungu Sculpture Park

The breast has been removed from its original position and relocated on the thigh, and pokes fun at the world with its nipple. Josia poses new possibilities for the human form, and new ideas for creation which do not disturb or shock.

Josia has never left Tengenenge, has little idea of education and is without any concept of art education, or training by others. What is usually gained from the instruction of others, often experts, Josia has taught himself.

Josia like Amali, another Yao sculptor at Tengenenge, does not include our view of the real world in his art, and does not always help us to understand his world. His relationship with his parent culture's spiritual realm is not always easy. If ill at ease with the spiritual realm he will turn to the real world to relax and enjoy its lighter side. We cannot predict the outcome of Josia's sculpture; we tend to end up with a totally different impression to our first. His is the art of surprise, and if Josia plays a practical joke he will always have the last laugh.

JORAM MARIGA

It has become fashionable to say 'without Frank McEwen', but today it has become necessary to say also 'without Joram Mariga'. The origins of

any movement in art, or groups of artists are often hard to determine. It is particularly the case with stone sculpture of Zimbabwe, when oral history or memory rather than documented fact can come closer to its genesis. While Frank McEwen can be seen as the catalyst for the Workshop School, many of the sculptors associated with the school actually worked in the rural areas, were self-motivated and brought their work to McEwen for comment and criticism only.

Before McEwen arrived in Zimbabwe, Joram Mariga, a sculptor and employee of Agritex, living in Nyanga, started to carve in soapstone. He was encouraged by Mrs Pat Pearce who lived in Nyanga and who developed, with her daughters, an informal supportive association with the National Gallery in its early days. Mariga knew of the historic association of stone with Zimbabwe culture, understood its properties and knew where it could be found and how to mine it. His initial approach to stone came from his knowledge of carving wood; he whittled it with a penknife, and turned, for inspiration, to the human figure. Then, without encouragement from anyone, he turned to the Shona beliefs, which initially he expressed in representational terms. At this stage he did not know that sculpture could be a

vehicle for abstract ideas, or that it could depict things imagined. However, as he developed as a sculptor, his conceptualisation of subject developed a more spiritual dimension. His subjects came from images of cultural importance to the Shona, the basis of his beliefs. In fact the act of sculpting almost became a ceremony through which those beliefs were venerated.

Mrs Pat Pearce took Joram Mariga's work to Frank McEwen at the National Gallery, and McEwen met Joram and encouraged him to continue carving. A man of infinite patience, Joram Mariga did not mind the time it took to carve, and he gradually discovered what other tools might be used. Soon others associated with the Workshop School and from outside it joined him in Nyanga: the late John Takawira to whom he was related, the painter the late Kingsley Sambo, Crispen Chakanyoka who came from Guruve and who was the impetus behind Tengenenge, then Moses Masaya. They were all inspired by Nyanga stones which already had the natural appearance of sculpture. It was in Nyanga that the sculptors first became guided by the shape of the stone, and developed the idea that stone suggests and contains subjects. It was in appreciation of the artists' creative response to the stone that Frank McEwen's wife, Mary,

established Vukutu in Nyanga, where artists could live and work.

Today, a conversation with Joram Mariga establishes a chronology for the sculpture. His conversation is a mass of dates and names. He establishes oral traditions for stone sculpture in Zimbabwe. He is an oral historian of skill, and a generous and reliable informant. He speaks slowly and considers seriously the implication of what he says because he realises its importance. His words tell of a depth of understanding of events, and a consideration of their historical meaning. His comments about the other artists and the events which he was involved in give this chronology a human dimension and make it far more than a series of facts and figures.

Joram Mariga shares some historical events with Tom Blomefield, the founder and director of the Tengenenge Sculpture Community. He still proudly wears the black cloth, given to him by Blomefield, to appease his ancestors. His wearing of the cloth creates a ritual around which their close friendship was based. He attributes to the cloth the symbolic significance it has to the Shona, and its value means much to him.

Until recently Joram lived in isolation with his wife in Nyanga — his existence only recognisable by a small sign reading 'Sculpture Village' on the left-hand side

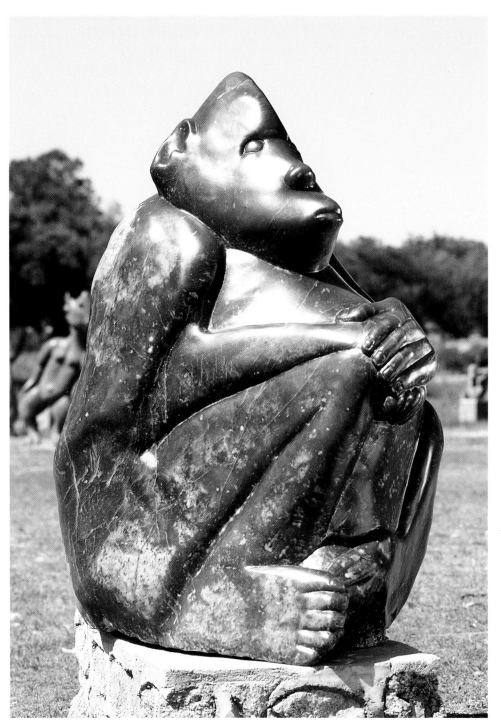

Joram Mariga, *Chief Chirorodziwa*, picture courtesy Chapungu Sculpture Park

of the road to Juliasdale. Here, nothing had changed for years, and this reinforced his links with the past. It is the past which remains important to him, despite many recent changes in his life. It is those early days of sculpture which have never been recorded but about which he can tell much. In his studio in Nyanga, where his sculptures were modestly mounted on wooden logs, it was apparent that his art was as important as his historical significance — art which was then sadly seen by few people. It was he who worked in the widest variety of stone: leopard rock, peroxinate, and the purple lepidolite which shines like a prism and resembles amethyst. Joram sculpts to bring out the colours in the stone, and gives small sculptures a jewel-like appearance. His *Rock Rat* in lepidolite is as much like a rock as a rat — oval in form and pebble-like in shape. The rat merges with the rock and is difficult to distinguish. His *Calabash Man* (Highly Commended, Zimbabwe Heritage Exhibition, National Gallery of Zimbabwe, 1989) is hunched within the stone, with a large head which speaks of the wisdom that dominates all of his thinking.

Notwithstanding the initial encouragement of Frank McEwen, Joram Mariga has established the direction that stone sculpture in Zimbabwe has taken. He has allowed his culture to take over

his art, and has given this culture an imagery of his own, as have many sculptors since, of both Shona and non-Shona origin.

The National Gallery of Zimbabwe gave Joram Mariga a one-person exhibition in 1989. This exhibition, much of which was purchased for the permanent and overseas collections of the National Gallery of Zimbabwe, revealed that art does not have to change to establish its quality, and that the development of an artist can take place in many different ways. Although encouraged to work on larger stones, the sculpture of Joram Mariga retains its original character. His is partly the sculpture of metaphor. The eagle, to Joram, represents a messenger to his ancestors and it is apparent in his sculpture that these ancestors are not very far away.

Now living in Harare, with his wife, Joram Mariga is enjoying the quality of life appropriate to someone of his historic importance, and the quality of his art. If, despite these changes, he seems fixed in time it is to his credit, and it is the reality of Nyanga which still directs his art.

MOSES MASAYA

It is because Moses Masaya is a Shona that he makes sculpture. His art reinforces his beliefs and assures him of their reality. To Masaya a Shona sculpture must have 'details of Shona ways about it' and reflect Shona beliefs in order to truly qualify as Shona sculpture.

Masaya lives in Seke, a large, crowded town south of Harare. At first glance, Seke may seem far removed from traditional Shona ways. Here houses brush against each other and cross each other's paths, and hens bring the farm-yard indoors. Tape decks, television sets and glass cabinets are more in evidence than beds, and children overpopulate small gardens. Yet to Masaya, blessed with the richness of his Shona beliefs, material culture means little.

To Masaya, Shona spirits are not selective in their associations. The interaction of the spiritual realm with the natural world is the rightful experience of all men, rather than the privilege of the few. His sculptures, which often depict the closeness of man and spirit, support this view and present its reality in concrete terms. In *Spirit Protecting a Woman* it is not clear who is being protected. The spirit appears to be sheltering the presence of a woman,

perhaps uncertain of its relationship with the mortal realm. A womb-like shelter in the back of the sculpture indicates the spirit's previous dwelling.

Masaya's sculptures speak of the length of an experience of sadness and the short life of the experience of joy, of how sorrow remains with us and joy fades all too quickly. He feels sadness is a more profound experience than joy. His work speaks of the origins of sorrow and of sorrow as an aspect of the human temperament. His subjects ache to talk, to be relieved of their loneliness and feelings of isolation. His female faces for which he is best known are melancholy Modiglianian faces, which grow longer and sadder before our eyes. They have mouths which have never learned to smile and never will, and eyes washed with tears. Perhaps their sadness was always there, it will remain behind when they are gone and yet accompany them to the after-life.

From his sculptures, it would appear that Moses Masaya has not always lived in Seke, but has also observed the life of the rural Shona. In *Baboon Woman* a woman is shown changing into a baboon as a punishment for stealing mealies. Reduced to an animal, she will no longer have the thoughts and feelings of a woman, or the gracefulness of her sex. She will inherit instead the lumbering

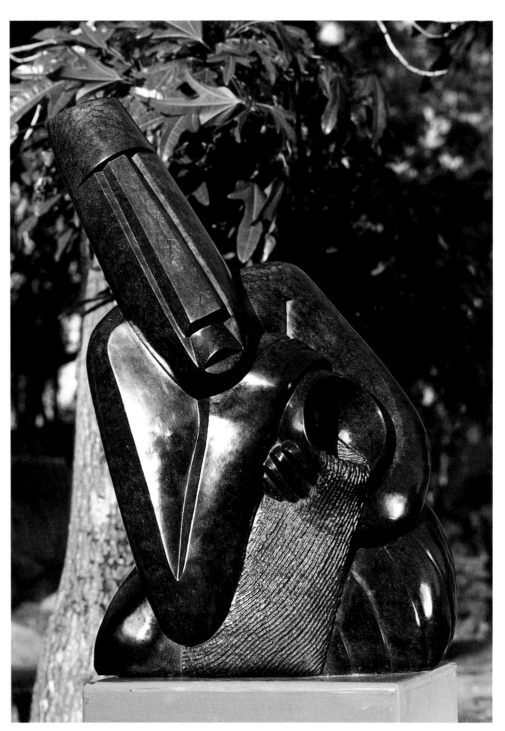

Moses Masaya, *Beer for the Spirits*

gait of the baboon. The baboon on the other hand seems to have inherited the facial features of the woman, perhaps showing that womanhood has not been left completely behind. His *Lion* is a compact statement — all mane and haunches. Yet its long and womanly face shows the humanity of the lion, and states perhaps that it is king of both beasts and man. If this *Lion* was invested with the power of *mhondoro* perhaps it would prowl the streets of Seke and protect its earthly inhabitants from harm.

Moses Masaya's sculpture comments on the retention of beliefs suited to the rural way of life for many urbanised Shona. Tape decks and television sets cannot remove people from the persuasions of the *n'anga* or the efficacy of spirit mediums. His sorrowful sculptures are perhaps a lament for the fact that he is not suited to life in Seke. He refuses to let his beliefs be crowded out by a preoccupation with material culture. Through his work we witness the sincerity of his beliefs and are, perhaps, led to question the sincerity of our own.

BERNARD MATEMERA

Bernard Matemera is one of the few Shona artists who have always lived and worked at Tengenenge. He has been able to develop independently of other Shona artists and his work is not characteristically Shona. Nor has it been influenced by the work of any non-Shona artists around him. His sculpture visualises his early established and highly original view of life which has not been changed by outside influences. His sculpture reflects the generosity of Shona ontology and accommodates beliefs in a manner best suited to the individual. His work is far from representative of Shona beliefs and customs and observances which are well established.

Central to Matemera's sculptures is the notion that sexuality is a spiritual force, partly providing a spiritual explanation of the real world, all part of the larger plan devised for African man, and the shared preoccupation of the mortal and spiritual realm. Matemera's sculptures speak of the culture of sex, of the way in which sexual desire, activity and fulfilment determine the structure of human relationships and establish the power of one over another. His view of sexuality is far from stereotyped. He plays sexual politics and is a staunch advocate of sexual rights. He opens up the options

of sexuality. He sees sexual pleasure not only as the privilege of man and woman, or the thin and the rich, but of children and animals, the misshapen and the grotesque. He opens up the prospect for sexual pleasure and extends the potential for coupling. Overall his sculpture states that sexuality is not only the pleasure of the few but the right of the masses.

Matemera deals in pleasures of the flesh. To him sexuality means a healthy appetite, to be nourished with opportunity and spiced with variety. His sculptures speak in a highly suggestive body language. He is the creator of sculpture in the raw — huge naked figures with breasts, buttocks and bulges, charged with a sexual energy and all at odds with their massive proportion and bulk.

Matemera's area of Tengenenge is a playground for all shapes, sizes and conditions of man and of spirit. He encourages all of us to throw off our clothes and join in the games. We are asked to reshape our notions of beauty and engage in a number of erotic pursuits, to enter a world of romping and rolling, of games for the flesh and playtime for lust.

Matemera is not only absorbed with the act of sex and its execution but with its major consequence — reproduction. Each new sculpture seems the result of sexual activity, the creation perhaps of

spirit and man or animal and woman. Such an absorption may be the result of the barrenness of his first wife and a wish fulfilment on his part. In his sculpture he is obsessed with the procedure of reproduction. In his *Family Group* children lie in their mother's arms in a foetal position, as if they have left the womb with reluctance and still long for the life they had before birth.

His female figures have breasts which are ready to lactate, nipples eagerly waiting to be sucked, and stomachs swollen and distended. His *Elephant* explores aspects of her new female body, and greedily drinks her own milk. In *Nipple-Eyed Head* eyes protrude with the fullness of breasts and culminate in nipples waiting to be sucked. In *Foetal Figure* the figure takes pleasure in her own flesh, enjoys the curves of her breasts, the heaviness of her thighs and the amplitude of her buttocks, and the presence of an inviting mouth in the soft folds of her stomach.

Within Matemera's sculptures there is a wide distribution of the properties of man, animal and spirit. His *Rhinoceros* ponders on the various uses of its horn. Already it seems that metamorphosis is imminent, and that bodily changes will soon take place. The *Anteater*, with bulbous eyes and womanly lips, is absorbed with eating its own flesh and

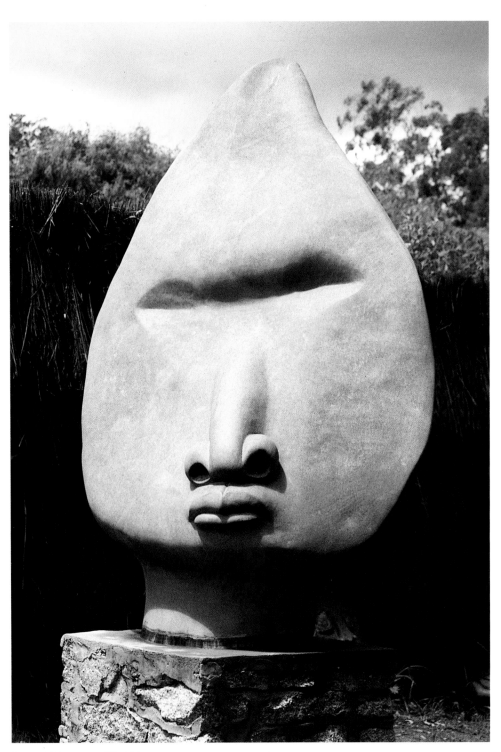

Bernard Matemera, *Blind Man*

exchanging its neck for another. For his *Blind Man* each day begins with night and ends in darkness. He gropes for sight and never finds it, his eyes like a vacant lot are never used. There are hints of transexuality here, unusual in Zimbabwean sculpture. His male figures are of womanly proportions; they are round of thigh and buxom of buttock. His female figures have the aggressive stance of the male. His children share both male and female characteristics. Well-developed at birth they are endowed with the capacity to enjoy future pleasure. To leave Matemera's sculptures is like waking from a dream, and it is from Matemera's dreams that the subject often comes. Sometimes his dreams are peaceful dreams, sometImes nightmares, and it seems that we wake in fright. Then we find comfort in the world outside art.

It is possible that Matemera was more aware of the day he was conceived than the day he was born and that he witnessed the joyous event with a great deal of pleasure. His sculptures comment that if sexual activity is an act of love as well as an act of pleasure, then it is also a thing of beauty. His forms are never crude and the suggestions made never overt.

There is in these sculptures an unspent power and a reserve of energy. They speak both of the force within them

and the force behind them. They are the product of great strength of mind as well as strength of the hand; of a strength of will as well as a strength of physique. They are indeed a celebration of the monumental. Yet there is a sense of innocence about Matemera's creatures. Their games are only just commencing and there are new and pleasant things to be learned. Theirs is the freshness of new experience, the joy of the first encounter and the timidity of the first move. They share with us our primal feelings and turn Tengenenge into a Garden of Eden.

RICHARD MTEKI

To Richard Mteki, a Shona sculptor of some standing, the sculpture is realised before it is made, and it never leaves him when it is sold or taken away. Like the Chewa's earthbound spirit, the *mfiti*, the sculpture may steal into Mteki's head uninvited in the night, and awaken him in the morning, impatient to be translated into stone. Alternatively it may appear before his eyes during the day, demanding to be carved from the waiting stone.

If the subject appears to Mteki as if in a dream, his realisation of it is no hazy recollection but a total recall, and a fully-formed impression. Here is a decisive rendition of shape and form, a use of recognisable images which are as clear to us as if we had dreamed them ourselves. In a sense, it is as if Mteki is possessed by his sculptures, being their permanent host.

God and *Mwari* are one to Mteki, inhabiting both heaven and earth. Each has a dwelling place in people, animals, birds and nature. To Richard Mteki and his brother Boira, God and *Mwari* are 'moving art', never remaining in one place, changing how and where they live at will.

His are small compact sculptures; the breadth of their statement is larger than their scale. In them it seems that the real world offers its hand to the spiritual realm of the Shona and gently guides it through its operations. Here he comments that the spiritual world is in need of worldly guidance, of education in ways of the mortal realm, and of dialogue with its individuals.

Mteki is a consummate depicter of age. In many of his heads, the lines are deeply etched like furrows in the skin. Eyes are closed as if by the weight of memory, stockpiled over the years. If these subjects want to sleep through the present and spend their waking hours in the past it will be a long vigil. Many of Mteki's stones resemble human forms before they become sculpture. Heads, torsos and limbs are apparent in the natural form of the stone. The stones are like solid slabs of flesh, muscle and sinew.

His *Twins* comprise a massive body, generously accommodating two heads with one hand prepared to do the work of four, and no doubt one heart which beats in the place of two. This work expresses the inseparable nature of twins. On occasions his work speaks of youth before age. His *Head* is pillowed on a bed of uncarved stone, sleeping peacefully, perhaps dreaming of the sculpture it has become. Here the stone seems soft and mottled, the lines like creases in a baby's skin, the features awaiting full formation, and forehead awaiting the presence of hair. His *N'anga's* eyes are closed after a long day of magical deeds. Perhaps he has run out of magical cures and needs some time to restore his powers.

His *Zimbabwe Bird* is now at the National Sports Stadium in Harare. This is a massive bird which, nonetheless, rests lightly on its huge base as if preparing to fly. It fears to leave the high civilisation it represents, to cease to be a symbol of that civilisation and become a real bird. It may explore that civilisation from the sky and then perhaps rest on a pillar of the Western Entrance of Great Zimbabwe. All beak and massive talons, this is a bird of prey, ready to tear to shreds the smaller

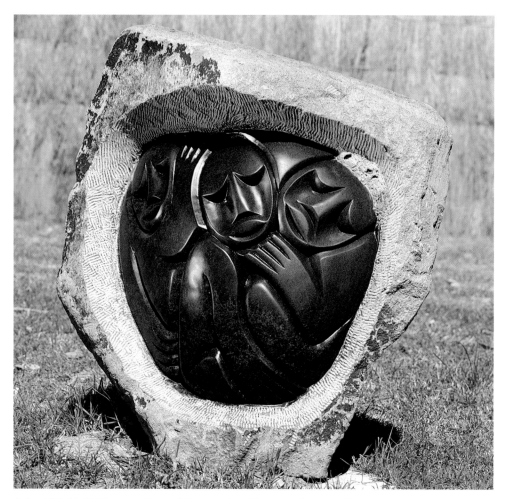

Richard Mteki, *Children in a Cave*, picture courtesy Chapungu Sculpture Park

species, and claw its way through the sky.

However, Mteki's sculptures are generally peaceful. They do not disturb our thoughts or minds and, instead, encourage repose. In many of the heads it is as if a peaceful hand has passed over the brow, shutting the eyes for sleep.

Mteki sculpts with ease and seemingly little effort. The result is easy sculpture, restful, and filled with a gentle spiritual presence. His subjects share their response with the viewer, and leave us refreshed to face life outside art.

THOMAS MUKAROBWA

The history of stone sculpture in Zimbabwe, and indeed the history of the National Gallery of Zimbabwe, is in a sense the history of Thomas Mukarobwa. Thomas Mukarobwa was the first member of the National Gallery Workshop School. Encouraged to paint, and then to sculpt, by Frank McEwen, he has worked at the National Gallery since 1957, first as an attendant and today as Assistant Marketing Officer. For Thomas Mukarobwa his sculpture speaks for him. It speaks of his growing up in Nyanga, of his life in the bush where rocks and stones assume the shapes of animals, and animals the shapes of rocks and stones. It is these experiences that make up his visual

memory and today that memory remains unimpaired.

Thomas Mukarobwa may possibly feel that he is a creation of Frank McEwen, but it was Thomas who was one of the first to initially create in McEwen a realisation of the anecdotal wealth of traditional Shona culture, the descriptive power of folklore and custom and the way it could be realised in art. While he feels strongly that Frank McEwen contributed to his education, he also contributed to the education of Frank McEwen, taking him to Nyanga and showing him the natural ways of the bush.

It was his uncle who trained his eye to see the movement, and ear to hear the sounds, which are not visible or audible to many men in the bush; to observe the ways in which man adapts to survive, and the part that nature plays in that survival.

Thomas Mukarobwa began to paint before sculpting. He had seen the Old Masters' paintings in the National Gallery and was amazed that they were done by hand. His paintings, in bright colours, in a narrative sense, evoke nature's powers of description. They are an expressive rendition of the movement of nature, or the way that, at Nyanga, the elements seem to alter the composition of nature and its colour.

His sculpture reveals the closeness

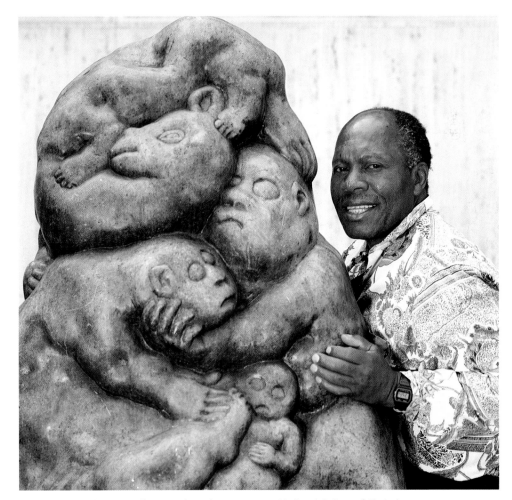

Thomas Mukarobwa, *Family Dreaming*, picture courtesy National Gallery of Zimbabwe

of man to animal and animal to nature in the Nyanga area. Of all the sculptors working in Zimbabwe, he perhaps becomes closest to the natural world and its inhabitants, which sustained the existence of the country through time. There is an historic dimension to his sculpture in its representation of the times in the area when 'people wore no clothes, smelt naturally and lived with animals'.

There is a primal feeling about his work, a closeness to the core of subject and its essence. The life in his sculptures comes from both the stone and himself. He feels that what he sees in the stone is something that someone inside him sees, and that person is transferred into the stone. His sculptures initially appear to be stones rather than sculptures — stones from the bush seemingly untouched. Gradually features emerge, turning into faces, and forms assume the shape of bodies. Then life is found in the stone, often life spontaneous and always life abundant. In *Love of Togetherness in the Rock* (Award of Merit, Zimbabwe Heritage Exhibition, National Gallery of Zimbabwe, 1989) the rock resembles an animal, and the animal a rock. Perhaps the animal is growing out of the rock while living within it. *Sitting Quietly in the Bush* (Zimbabwe Heritage Exhibition, National Gallery of Zimbabwe, 1989)

depicts a hardly discernible figure, surely unseen by those it observes. Thomas Mukarobwa's view of nature includes its human element: the men and animals which make their home in the bush. He sees the survival of animal, man and nature as interdependent, and it is this interdependence that he responds to in his sculpture.

However, to Thomas Mukarobwa the bush is inhabited by a spirit world from within, and without, Shona culture. This spirit world is not seen or heard but is present in the movement of the bush. It is this movement which he is now trying to put into his sculpture to give the natural world of the bush a greater spiritual dimension.

At all times his sculptures are reminiscent of the landscape, of the rocks and kopjes around Rusape, and the way in which these rocks and kopjes seem gnarled with age, like trees, and speak of early days. This landscape, like his sculpture, still remains the same today.

Times have changed for Thomas Mukarobwa. He has travelled and met with kings, but his visual memory remains intact and in a sense uncorrupted. The fact that his sculpture has not changed, reveals also in a more personal sense the way of life he values most. Together with Joram Mariga, Thomas Mukarobwa's

Shona beliefs establish the world around him, and his culture, and as with Joram Mariga's culture, establishes the direction of his art.

NICHOLAS MUKOMBERANWA

Nicholas Mukomberanwa is the elder statesman of stone sculpture in Zimbabwe. After twenty-four years of sculpting, and an award for his outstanding contribution to Zimbabwean sculpture by President Robert Mugabe in 1986, he has the respect of his colleagues and peers, and his work is held in high esteem outside Zimbabwe. Today his platform is secure. His work addresses his own countrymen and those outside Zimbabwe with confidence, and his work is recognisable to both. Through his work he persuades his audience of the value of traditional Shona beliefs and observances still of moral and social benefit to Shona society today. His is no simplistic view of Shona spirituality, couched in superstition, but a profound commitment to the age-old ordinances of the Shona and its relevance today.

Unlike many other sculptors, Mukomberanwa speaks from personal experience rather than recounting what he has heard or been told. To him beliefs must be personally held rather than

customarily observed. Over the years, his work has shown a sense of the increasing spiritual support which has sustained his art. He is not afraid to share his spiritual experiences with his audience, and to convey through his work the highly personal relationship he has with the Shona spiritual realm.

When Mukomberanwa's own son drowned, seemingly without a struggle, Mukomberanwa believed that the water spirit, *nzuzu*, was responsible for his death. His *Water Spirit* is a flowing piece of black serpentine which like the flow of the water has no discernible beginning, middle or end. A series of undulating curves create movement. Through these curves, Mukomberanwa suggests the source of the spirit, the water reaching like an unseen hand to claim its victim.

A number of his sculptures physically explore the relationship between spirit and man. In *My Spirit and I*, subject and spirit share a third eye, and faces and features are fused together. The spirit is represented by a semi-carved image of the man. This spiritual doppelgänger, although less defined, supports the human form and gives it strength. It reflects Mukomberanwa's belief that the 'spirit is stronger that the man even though it is less defined'. *Spirit of Peace* similarly fuses the features of spirit and man. This shows a levelling of realms and

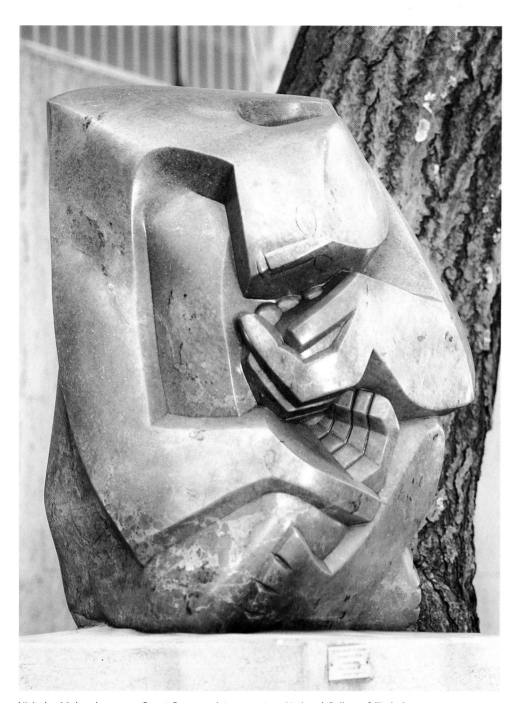

Nicholas Mukomberanwa, *Street Beggar*, picture courtesy National Gallery of Zimbabwe

a bridging of the gap between mortality and immortality. The sculpture shows the approachability of the spiritual realm, and the possibly permanent relationship of man and spirit.

Mukomberanwa sees the observance of Shona traditional beliefs as a way of preserving social order and maintaining moral values. Pivotal to this preservation is the power invested in those who through their positions in society become social institutions, for example the Old Aunt (Vatete), the Chief, the Medium and the Mediator. It was through these people that families were held together, young girls were advised before marriage, and conflicts resolved through a disinterested system of arbitration. These figures are often the subject matter of Mukomberanwa's sculpture. For centuries those assuming these roles have laid down unwritten laws and Shona society has survived through their dictates. Mukomberanwa presents these figures often ravaged with age. The stones seem eroded by time and take on the fragility of ageing flesh. They seem spent of their power and devoid of strength. This is perhaps a paradigm on the part of the artist for the historic role of these institutions in the lives of many urbanised Shona today.

Mukomberanwa's view of power is that it is ambiguous. He speaks of its benevolent force, the weight of its responsibility and the manner in which it can corrupt. To his Mediator power has become an affliction, a wasting disease which eats away flesh and drives away the spirit. Here the colours of verdite assume the mottled tones of ageing skin and raddled flesh. The uncarved surface of the stone takes on the fragility of folds of skin hanging loosely over bones which might break at the touch. Here the stone seems pitted and pockmarked. While one side of the head is lifted high and speaks of pride of position, the other falls away as if the stone has some massive fault like a crevasse. The face seems eaten away by some terminal illness. This mediator is too tired and possibly too ill to arbitrate and his judgment is no longer relevant.

His Old Aunt (Vatete), comes from the same middle period of 1985. Here an ageing stone seems to have lost its strength. This old aunt is spent of advice, no longer in touch with the needs of young girls and unable to come to terms with their morality. She is waiting to shed a mortality as old as her wrinkled skin and perhaps regain her power as a mudzimu. Her hooded eyes, the preserve of old age, eat into the world, picking at what they are offered and little nourished by what they see.

Mukomberanwa's relationships with his subjects appear to be of long standing. His heads, like the best portraits, do not flatter but tell the truth. If they were portraits they would speak of many hours of sitting, of lengthy conversations and perhaps some time spent living with the sitter.

In his latest work, Mukomberanwa seems to withdraw from intimacy with his subject. Here the sculpture is austerely geometric, coldly black with no warmth of texture. The black serpentine used has no life or warmth of its own. Cold to touch, it takes on a man-made appearance — a newly discovered material with an assured technological future, to be worked by machines rather than the human hand. It suggests that in Zimbabwe the stone itself may have been asked to say too much too soon, and that possibly it has run out of things to speak about. Instead of the material, it is now Mukomberanwa who is speaking, like the able politician, persuasive, and winning the audience to his cause through his polemical skills. Here Mukomberanwa is new to the subject, and surveys it from the standpoint of his own personal feelings. His Chief is a cold, hard profile of black serpentine. He has reached the height of his power, and is not yet affected by the wear and tear of high office. He has assumed command over his own people, and intends to

retain that command. Here is power at its zenith, and not its decline. The Chief is a figure of arrogance and of self-assurance who wears his regalia with pride.

Mukomberanwa investigates not only the makeup and character of those who have acquired or inherited power, but the nature of power itself — the effects of high office and the loneliness and isolation of those who have reached the top. His subjects do not always communicate easily with their audience. Austere and remote, they seem symbols of power rather than actual holders of office. In an exhibition they rest most suitably on a high pedestal and convey the remoteness of high office to ordinary men. These rulers seem dictatorial, issuers of edicts rather than initiators of dialogue and unable to rule by conciliation.

As much as his work is culturally specific, the issues dealt with and matters raised have a wider implication and a universal theme. They speak of the strength and ambition which have commanded armies and won victories, conquered nations and established their downfall. Although his statement is highly personal, his sculpture is essentially public art, addressing a wider audience than the subject implies.

Mukomberanwa's sculpture is not so much characterised by a wide range of subject or the exploration of new ideas, but exploring a theme such as power with increasing maturity, the wisdom of years and a new profundity. His work is like a classic novel, to be picked up and put down and returned to with fresh insight. His subjects and themes may remain unchanged but he has far from exhausted his comments about them. His sculptures indicate that if a thing is worth saying it is worth saying more than once and in many different ways. The views of subject presented are many-sided, and from fresh considerations of established institutions and age-old practices, new truths are arrived at. He resists change for the sake of change, and as a response to the needs of dealers and the marketplace. As one of the most established and successful Zimbabwean sculptors he can say what he likes. He can afford the luxury of working in his own time with a subject of his own choice. If he explores a subject by making several sculptures until he reaches his conclusions about it, that is his own prerogative. At this stage of his career as an artist he feels it is his right and his duty to take issue with things, and he would like his sculptures to remind the young urbanised Shona of the sense of their age-old institutions.

Nicholas Mukomberanwa speaks clearly and drives home each point with conviction and we listen to, as well as see, what he has to say. As much of his sculptures demand to be looked at, their message can be clearly heard. Just as his work represents unwritten laws, he lays down his own and expects them to be obeyed. He establishes contemporary credentials for the traditional beliefs of the Shona and makes them more than academically respectable. In this way he gives fresh meaning to Frank McEwen's vision and does not, like Tapfuma Gutsa, see it as a runaway dream. He is proud of his beliefs and through his art conserves their strength and establishes their meaning.

Prior to joining the National Gallery Workshop School, Mukomberanwa was taught to carve at Serima Mission, and encouraged to believe in the Christian notion of art as uplifting, addressing a public, not necessarily to please or entertain but to convey some moral principle or truth. Mukomberanwa's sculptures are uplifting. We leave them as if leaving a church, somehow purified, cleansed of our imperfections and wider in our understanding of things.

Mukomberanwa's work has now reached the height of its power, commanding rather than inviting respect. We do not always come easily to his work. It demands the attention of our eye, ear, mind and spirit.

In 1989 Nicholas Mukomberanwa

received the Award of Distinction and the Directors Award of Distinction in the Zimbabwe Heritage Exhibition at the National Gallery of Zimbabwe. The award winning sculpture was *Street Beggar*. Here the decorative aesthetic of Chiweshe stone is subdued by subject, and the material seems almost incidental to the idea. The austerity of a mass of planes, angles and shafts of shadow do not detract from the human dimension of the work. Here the beggar's hands reach out for the support he hopes to receive, but they appear also to provide for him the support which his sightless eyes cannot. Despite the mass and bulk of the sculpture the beggar's helplessness and the vulnerability of his state are omnipresent. In the same exhibition his *Woman Swimming* shows a woman swimming against the tide, her hair extended along her body by the current of the water. Here is the idea of the body in motion, buoyant in the water, sometimes swimming, sometimes floating.

Nicholas Mukomberanwa is now working in Ruwa, a rural area near Harare, with a number of young sculptors, including his sons. While benefiting from his example, these young artists are establishing their own direction. While their master has helped establish the standards of stone sculpture in Zimbabwe,

it is obvious that these artists will establish future standards which may be hard to live up to. The work of these artists is part of Nicholas Mukomberanwa's lifetime commitment to the art of Zimbabwe, and part of his contribution to its future.

JOSEPH MULI

Kenyan-born sculptor Joseph Muli has lived in Zimbabwe for the last twenty-nine years. His ebony sculpture conveys the dignity of the people of his own country, and a sense of cultural origin outside of Zimbabwe. However, his personal history and reputation as an artist are strongly linked with the history of Zimbabwean art, and his life has been involved with many events and personalities which have established that history.

Yet, although identifying and being identified with the development of Zimbabwean art, Joseph Muli's career has differed markedly from that of many Zimbabwean artists. There is a Dickensian pathos about his early life. Coming from a poor Kenyan family living outside of Nairobi (his father having three wives and twenty-nine children) he came to Nairobi to find work to support the family. He met and was brought up by an Italian

family living in Nairobi. His foster father was an artist involved in the carving of tombstones and their appropriate headstones. His first introduction to art was 'angels on tombstones', and the carving he learned from his foster father was the Italianate carving which gives hard stone its decorative and flamboyant appearance, far removed from its natural properties.

From an early age Muli was encouraged by his foster father to think of art as a career — a career which would be essentially self-directed and not dependent on galleries and mentors. He was able, prior to coming to Zimbabwe, to do many things which Zimbabwean artists rely on galleries to do — to determine and establish the market for his work, to arrange exhibitions and their promotion, and to understand the importance of the correct critical appraisal in establishing standards for an artist's work. Coming to Zimbabwe after his foster parents' departure for Italy (his own parents prevented him from going with them), he worked with Canon Edward Paterson at his Nyarutsetso Art School (1964–1968) in Harare. The meticulousness, the sense of finish and the attention to detail which characterises his work may have developed during his time with Canon Paterson.

His sculptures today, made from

the root of the ebony, are impeccably finished and polished but there is more to them than their outside appearance. At their best they show an understanding of the lonely, the lost and the displaced; perhaps reflecting the artist's cultural displacement and the personal loss he felt when his foster parents returned to Italy. In these ebony sculptures there is a sense of physical balance as in the balance of works in a carefully fashioned line of verse. His *Family*, which was in the Zimbabwe Heritage Exhibition of the National Gallery of Zimbabwe in 1989, is carved from one single piece of wood, emphasising the closeness of the family and the unbreakable ties of kinship. Here the material is like the womb, and the children the embryos within it. The length and slender quality of the ebony underpins the plight and physical condition of *Fugitive Mother and Child*; the curve of the wood, the flight of the mother and the child. Within these wooden sculptures there is a sense of preparation of the wood which is almost a veneration of the material, and the fact that nature perhaps tarnishes rather than enhances the wood's appeal.

His *Scheming*, also, in the Zimbabwe Heritage Exhibition of 1989, is one of his few pieces of stone sculpture. Here the two faces carved on the one piece of stone, at times appearing as one face, at

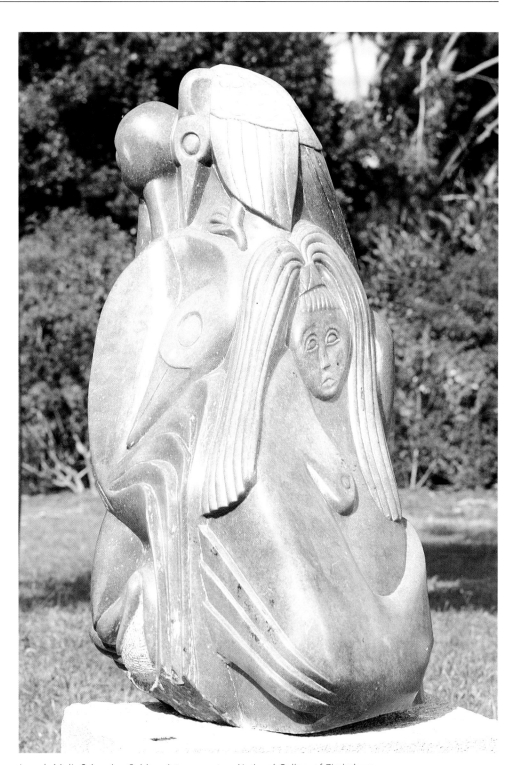

Joseph Muli, *Scheming Spirits*, picture courtesy National Gallery of Zimbabwe

times as two, demonstrate the closeness of conspiracy, the need for likeness of mind and spirit for the plot to be worked out, and the secret to be kept. Yet in evading the world the 'schemers' seem to be avoiding each other's gaze, perhaps thinking their private thoughts about their mutual resolutions.

Joseph Muli has lived through the history of Zimbabwean art, as an artist, man and observer, as well as a contributor to the welfare of the artists of Zimbabwe. One of the founder members of ZAVACAD — the Zimbabwe Association for Visual Artists, Craftpersons and Designers — he is today its Chairman. He works for two days a week as a volunteer in the National Gallery Market, evaluating the work of young artists, marketing it for them, and discussing it with them. When asked to comment he replies: 'I want to give to Zimbabwean artists the support my foster parents gave to me, to provide them, through myself and the ZAVACAD executive, with some leadership, in particular for the young artists in the rural areas such as Guruve.' He comments: 'The negative side of the current market forces are, to a degree, cultural manipulation of the younger artists. They say their culture is in their work because their culture is expected to be in their work. A title alone cannot make a statement about culture, the

statement must be in the meaning of the work and above all in what it means to the artist!'

Joseph Muli's work is possibly an eye witness to the history of the art of Zimbabwe, yet he has on many occasions stepped out of that history to establish the direction of his own career. Whatever role he plays his value to the development of Zimbabwean art is apparent.

HENRY MUNYARADZI

Henry Munyaradzi's sculpture puts our minds at rest. We are secure in the knowledge that we are looking at art, and our appreciation of the sculpture is an appreciation of an art object as much as a cultural statement. Hence, we are more at ease with his work than that of many other Zimbabwean sculptors. Here possibly is the reason for Henry's popularity and wide appeal among collectors outside Zimbabwe. Henry's sculpture engages us in an aesthetic discourse with which we are familiar through our appreciation of Western art. It accords with our culturally determined view of an art object as a precious thing and a thing of beauty, pleasing to the eye and easy on the mind. We are not asked to consider why he made the work, but how he made the work, why

he chose the stone, what tools were used and what formal decisions were made. Through Henry's sculptures we are led to believe that stone was created to be made into art, and that stones are art objects in their own right and things of beauty. To Henry, stone primarily has an aesthetic appeal. He is absorbed with its properties of beauty, of the varieties and tonal qualities of its colour, and the sculptural quality of its natural form. Henry approaches stone as if it were already a work of art. He does not tarnish its beauty, but leaves its sculptural qualities intact, adding on the finishing touches.

Unlike some sculptors, Henry does not think for the stone but allows the stone to think for itself. He does not see the subject within the stone but within the shape and form of the stone. If the stone is already a work of art, it does not stop short of extending the possibilities of this work. He further defines the subject by smoothing and polishing, and through the use of illustrative lines carved into the stone. These lines add an anthropomorphic character to objects of nature. Vertical lines and circles endow trees and flowers with facial features. The lines lend a human character to natural forms and individualise the subject. Often these illustrations on the stones are the subject's most

distinguishing feature, and make for highly imagist sculptures. Like Paul Klee, Henry takes a line for a walk but he reins it in after the first steps. Through Henry's use of ideograms it is possible to read his sculptures two-dimensionally and to see him as a graphic artist, using a far less ephemeral material than paper.

Without the incision of lines and circles, Henry's birds would be composite creatures or bird forms only — academic investigations of the form of a bird, or the relationship of beak to head, of wing to torso. With the incision of lines and circles they become not only species of bird but individuals of the species, of definite gender and age, and responding to particular circumstances. His *Fish Eagle* becomes a fish eagle rather than a mass of abstract forms through the introduction of a baleful eye. Once the eye is seen the shapes form into wings ready to soar into the sky. His *Heron* rests comfortably on shoulders narrowing down to the tapering stone. He appears as if contemplating the world on one leg from the perspective of greedy eyes.

Even the wildest of Henry' animals invite us to reach out and touch. His *Lion Cub* will never learn to roar and is far removed from the ways of the big cat. His *Lion* is truly the king of beasts with a flowing mane of uncarved stone. Here huge slabs of stone are folded into the

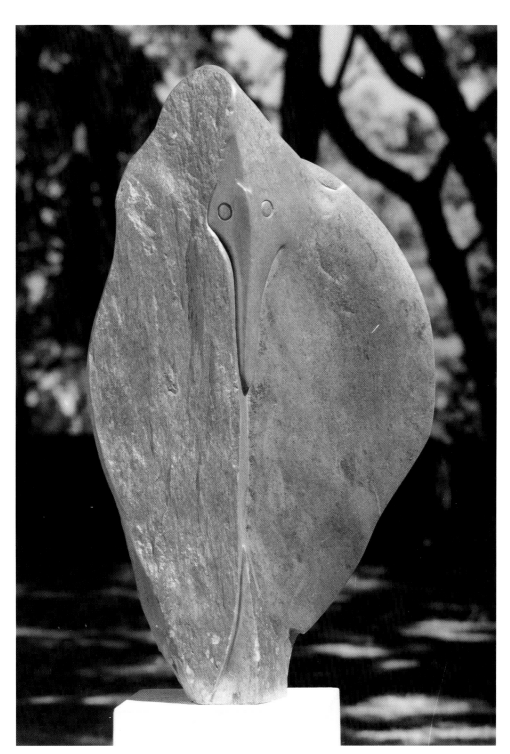

Henry Munyaradzi, *Heron*

form of the lion, and the surface becomes a coat which seems to ripple before our eyes. This is no feral cat but a well-kept animal which has benefited from human care. His *Mudzimu Bull* has settled down for the night in soft folds of flesh, ears like curls slicked down on his forehead. His *Python* speaks of the harmless nature of the reptile in comparison with others of the species. If this python were to bite, it would be a gentle flick of the tongue rather than a poisonous bite of the fang. It invites touch rather than recoil, it would uncoil to embrace rather than to kill, or rush to wrap itself around an object of its affection rather than its enemy. In *Monkeys Playing*, a mother monkey shelters a child only recognisable through its small beady eyes. Once these eyes are big and fully rounded the monkey will reach adulthood and leave the shelter of the mother and establish a life of its own.

These are animals of winning ways, inviting protection, preservation and conservation. They would enjoy the comforts of hearth and home, to be indoor pets, pampered by loving owners, well fed and regularly groomed. Similarly Henry's natural forms, his leaves, trees and plants would be indocr plants, watered and nurtured with the prospect of steady growth and life in the hothouse.

Henry draws a strong distinction between life and art, and seldom represents the reality of things. His view of nature is more on the side of art than life. His sculpture presents natural forms as if designed and fashioned only by art, subservient to the dictates of style.

Henry's interest lies in the artistic potential of natural things, rather than the spiritual realm. It seems quite in order that he should be converted to Christianity which, unlike Shona ontology, ascribes spiritual attributes to many born on earth of flesh and blood. Henry's Apostolic Church encourages the reading of the Bible as a narrative but does not consider preaching from the Bible as an essential tenet of doctrine. Hence, Henry sees biblical events as stories with moral overtones and depicts them thus in his sculpture. If he refers to Shona beliefs in his work it is because he recognises their truth to the non-Christian Shona who believe in them, but not because he necessarily believes in them himself. For example his *Spirit in the Rock*, in which the face of the spirit rests in a bed of uncarved rock, stems from his under-standing of the Shona's belief in a spiritual realm which is not necessarily his own.

His conversion has resulted more recently in sculptures in which stone is illustrated two-dimensionally in the manner of children's Bible stories. Here Christian symbols take on an iconographic meaning. They are displayed with simplicity and conviction as if the work of a true and unquestioning believer: His is a Christianity of childhood memories, of the Christ child, cradles, shepherds, wise men and doves, and Samaritans rather than of wicked kings and last days. In *Family*, the stone is carved as if out of stained glass, imparting a holiness to an ordinary family and blessing them with the spirit of God. In his *Good Samaritan*, two figures emerge from the same stone, the Samaritan behind the man he has helped along the way, and the Samaritan bids farewell to his friend.

Henry speaks little about his work. Through seeing it and touching it we feel our way to the subject and establish its meaning for ourselves. He allows us to say what we feel about his work and feel what we like about it. Our feelings about the work are as important to Henry as they are to ourselves, and perhaps more so. An affection for Henry's work is understandable. It reaches out to touch us by its warmth. His animals demand care, his plant forms nurturing. Our affection is long lasting, and this is part of the caring and sharing that is the basis of Henry's reason for making sculpture.

JOSEPH NDANDARIKA

If Joseph Ndandarika was to present his credentials to *Mwari* the Shona's Great One in the Sky, they would be impeccable, and warmly received. As one of the most spiritually developed of all the Shona sculptors Ndandarika is held in high regard by his peers, and like the elders of the Shona who are so often his subject, he demands a hearing and speaks with wisdom. Joseph Ndandarika's spiritual connections are well-established and close to home. His great uncle was a *n'anga*, his sister was possessed by a *mudzimu* (family spirit) and he is acquainted with several well-known *mhondoros* (tribal spirits).

Ndandarika has been close enough to those spiritually possessed to know them on their human side. He portrays those with spiritual connections as part of the natural world and the natural order of things, with physical flaws and human limitations. Despite their spiritual powers these people are afraid of their mortality and are subject to human failings and the vagaries of the real world. In particular his work complements his great uncle the *n'anga* as a man as much as a spiritual force.

In his sculptures, Ndandarika makes acculturation, urbanisation and social change appear events of the far future for the Shona of Zimbabwe. His works and their titles convey a feeling that these things have never happened in Shona society and perhaps never will. Ndandarika's subjects have their origins in centuries-old established beliefs which cannot be taken lightly. These beliefs may be disregarded or dismissed by urbanised Shona but they are not easily replaced. His subjects are of considerable ancestry and respectable lineage and they lend to his sculpture a strong sense of cultural authenticity. His work seems to stem from a long tradition of Shona sculpture, which we know does not exist but which he makes seem possible, and he imparts to Shona sculpture a history far older than its years. His subjects are old before they become sculpture and his stone has had a life before carving. His *Too Old to Walk* is based on his late uncle who died at the age of a hundred and twenty. A large head sinks wearily into massive shoulders, arms extend into large and lifeless hands divested at last of their magical powers. The sculpture conveys the respect he had for his uncle as a man, a victim of the real world's circumstances — temporal, ageing and impermanent. His *Counsellor Listening* has heard too much of what has been said and knows there is nothing more to say. He slumps on the ground, waiting to speak but knowing that he will never

have his turn, and that if he does he will never he heard. In *The Family* two ageing figures sit together, raising the past from the dead, and putting it to rest again. They reminisce about things gone by with the wispy memory of old age, and the limited vision of old, tired eyes, and sink back gratefully to their younger days. These are the elders of the Shona, bent over with the weight of their responsibilities, with flaccid bodies and heads enlarged to accommodate the vast repository of wisdom which history, observation and years of cultural practice has given them. They have nothing to do with today and hardly know the existence of the present. These subjects are the victims of the spread of old age, too heavy to lift their bodies from a sitting position, large hands extending from arms like the roots of some ancient tree. The matters they ponder are appropriately weighty and large of scale. His subjects show a sense of kinship, a close relationship which includes physical similarities but suggests something more — a sharing of experience and perhaps a growing old together. He extends the Shona family beyond the nucleus to accommodate his great uncle, the old aunt and the medium. Mortal and spiritual qualities are found in each person represented. Man and spirit live under the same roof and share the

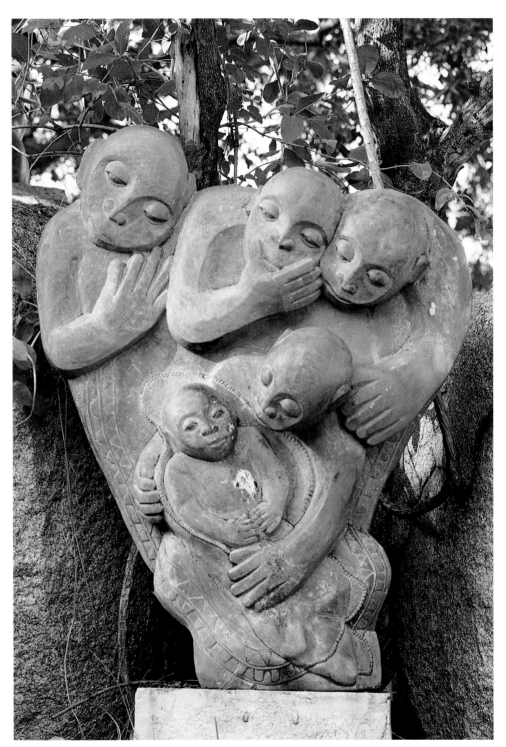

Joseph Ndandarika, *The Birth of Chaminuka*, picture courtesy Chapungu Sculpture Park

same table.

His sculpture speaks of labour and considerable effort. The material makes more demands on him than he on it, and what he wants is not easily arrived at. His stones are massive and obstinate, reluctant to give up their natural forms and become sculpture. These stones are grey and drained of colour like flesh of blood, or are flushed with pink like the tint of the sun. The stone seems as old as the hills in which it once resided, and leaves the quarry with difficulty.

Ndandarika reminds us that the traditional beliefs of Shona rural society have never altered, nor have they been modified and re-thought, nor removed from their matrix to suit the needs of the urbanised Shona. Through his sculpture, Ndandarika speaks of the conviction of his beliefs and their reality to him. He carves as a consequence of his feelings and thoughts, and his memories of his uncle. He is assured of his welcome to the spiritual realm and, through his sculpture, prepares himself to be ready.

LOCARDIA NDANDARIKA

Locardia Ndandarika, who has been making sculpture and pottery for nineteen years, is more concerned with making art than establishing her position as a woman through her art, or seeing

art as a basis for feminist polemic. The quality of her art today is, however, perhaps a measure of the independence as an artist which has occurred since her divorce from master sculptor, Joseph Ndandarika, and a statement of her new-found individuality. Working initially with her husband, Locardia has continued to sculpt and indeed has taken up welding, and returned to pottery she made as a child. Her self direction is based on an innate curiosity; a curiosity about the way different kinds of sculpture and art allow her to say new and different things. Without ever having been to art school (apart from one year at the BAT Workshop of the National Gallery) her work indicates what benefits she would have gained from an excellent art education, moving, as she does, from media to media, quickly, developing new executional skills and looking at new ways to treat materials.

It is possible that because Locardia Ndandarika is a woman that she does not feel tied to a tradition of stone sculpture which was established by men, and feels a freedom within her work that she would not feel if she were a man. Her work in stone shows an appreciation of the material, not unlike that of the late John Takawira, a feel for its ruggedness and a refusal to be seduced by its decorative qualities.

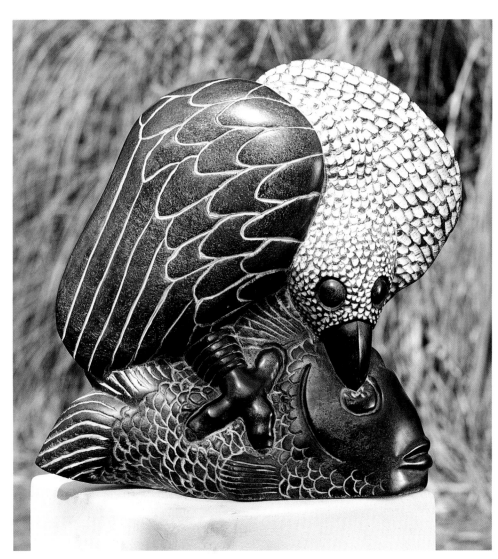

Locardia Ndandarika, *Eagle*

Her *Spirit Owl* (Award of Merit, Zimbabwe Heritage Exhibition, 1989) allows a mass of barely carved stone to be seen as feathers. Eyes appear as if bored into the stone. Here is a sculpture which not only shows physical strength but inner strength, on the part of the artist, which is required to develop that strength — a strength of mind and character. *Spirit Owl* has the feeling of sculptures to come, of increased maturity on the part of the artist, of moving on to things of a grander scale. It reveals an enjoyment of making art and a taking on of new challenges.

Her welded metal sculpture, by contrast, has a sense of containment, and a sense of the indefinable order which creates a good sculpture within the medium. While her stone sculpture makes a discernible cultural statement her metal sculpture reveals an appreciation of art which has nothing to do with things cultural, but with matters of style and the properties of the material.

Locardia Ndandarika may be establishing a direction for women artists in Zimbabwe, largely through reputation rather than intention, but she is also establishing new directions in Zimbabwean art, directions which will also, hopefully, be followed by men.

AGNES NYANHONGO

It is difficult to look at the position and the work of Agnes Nyanhongo without reference to the broader social and cultural issues evident in post-Independent Zimbabwe. Agnes Nyanhongo is one of the few leading women sculptors in Zimbabwe. She is not necessarily concerned with being known as a woman artist because of any female approach to sculpture; for example, the use of a small stone, or the reliance on decorative qualities. Feminism is also unknown to Agnes Nyanhongo, but in wishing to be a successful artist to show the potential of women she is perhaps adopting a feminist stance. She feels that since Independence women have been given greater opportunities in Zimbabwe. There is less distinction between women's and men's work, and less division of labour within the family. The active work of the First Lady, the late Sally Mugabe, was perhaps indicative of this. The fact that male sculptors admire the work of Agnes Nyanhongo may also be part of a broader change of attitude of men to women.

While Agnes develops as an artist and is treated by men as their peer, she has not divorced herself from the traditional role of the Shona woman, that of wife and mother. Married to sculptor

Joseph Munemo, she has two small children. Her ideas about pregnancy and birth are eloquently expressed in *Foetus* in which she expresses feelings which are exclusively female, hopefully in a way that men can understand. The piece reveals by its title, preoccupation with feelings of impending motherhood and birth. *Foetus* is the artist's idea of a stage of development in her body before her first baby was born — of the heaviness of what she was carrying, and the feelings of discomfort before and during labour. To Agnes one of the problems of pregnancy was not knowing what was going on inside her body. She could not watch the growth of her child or know what it was going to look like, or what sex it was going to be.

Through helping her father, sculptor Claude Nyanhongo, Agnes came naturally and without question to sculpture. Yet it was her conscious decision to become a sculptor herself. She studied for three years at the National Gallery BAT Workshop and saw that experience as improving her technique and, most importantly, broadening and deepening her understanding of art. She learnt what being an artist meant in society. Her time at the Workshop made her think three dimensionally; to think of subject and its sculptural form spontaneously. *Balancing Rocks* in the permanent collection of the

National Gallery of Zimbabwe comprises three pieces of stone like the Balancing Rocks at Epworth, close to Harare, which seem to be precariously joined together, ready to fall apart from each other at a touch. This is the art of illusion, a reference to the Balancing Rocks themselves which Agnes feels seem to be joined together by history, and the piece speaks for the historic presence of stone in the country.

Refugee Mother and Child (Award of Merit, Zimbabwe Heritage Exhibition, National Gallery of Zimbabwe, 1989) is based on the sculptor's observation of women and children at a refugee camp. Here the stone communicates subject as much as the title and content. Its natural contours suggest the protection of the mother for the child. The eyes on both are sightless. Feeling that they have no place in the world they both seem oblivious to it — seeing nothing and avoiding its presence. The African quality in the work is unmistakable but the feelings it conveys are universal and applicable to many similar situations.

Agnes Nyanhongo's relationship to her work and her material are highly personal. They are both the outcome of her personal experience, her sexuality, and the situations she has faced and been involved with. This she shares in common with many women sculptors

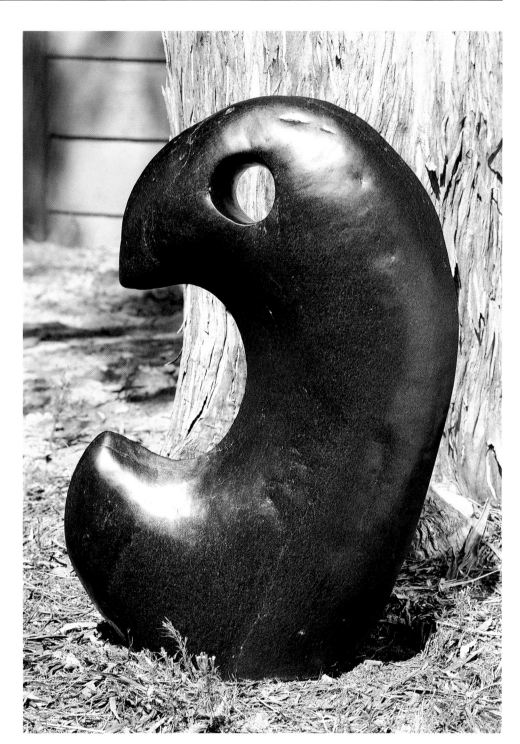

Agnes Nyanhongo, *Foetus*, picture courtesy Chapungu Sculpture Park

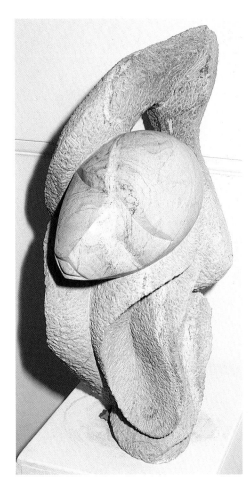

Brighton Sango

outside Zimbabwe. Her involvement with the culture is highly subjective, and her work portrays how her culture affects her personal and private circumstances. Her work seems to portray her 'coming out' as a woman, an extension of a highly feminine mystique which as a young woman maturing she is now able to understand, and locate and interpret it from a cultural perspective.

It is hoped that through the example of Agnes Nyanhongo other Zimbabwean women will be able to see art as part of their overall self-expression — a way of expressing an individual and collective world view, and reflecting the changing position of women in Zimbabwe.

BRIGHTON SANGO

'I prefer to stand back from Shona culture, to look at it critically both in my life and in my art. Some forces at play in Shona religious practices are not beneficial to the Shona. Certain individuals are harnessing Shona beliefs to evil and destructive ends.' Brighton Sango is one of the most successful young Shona sculptors but being Shona is not necessary to his art. Indeed there is nothing that is recognisably Shona about his work.

His criticism extends to the sculpture itself: 'I feel that a tradition has been established too quickly, and this tradition prevents artists from moving on and exploring new things. The sculpture has become too set in its ways. It needs some changes in expectations and more possibilities for development. In my work I am exploring issues applicable to all sculpture, not only stone sculpture in Zimbabwe. I am talking about things of interest to all men, not only to the Shona.'

Sango's work uses the power of pure abstraction to convey profound emotion. Without the use of recognisable images, Sango allows form to portray feelings recognisable to all men. His sculptures speak of the fragility of human feeling. They help us to trace the source of emotions and to understand the reasons for their existence. Sango's work can be very personal; it can express his emotional reaction to a particular situation, which is often complex and, at times, contradictory. The viewer is charged to recognise his or her own emotions within Sango's sculpture or to reflect on how he or she would have reacted in a similar situation. In *Shy Defensive*, the sculpture withholds the inner feelings of the artist. Here stones huddle together, moods and feelings appear withheld. This is an introspective sculpture, revealing little about the

subject and less about the artist.

Sango has chosen to live and work at Raffingora, near Guruve. This is not because he has been recalled to his rural cultural roots, but because he wants to be near accessible stone. Clean of cut, his stones have the appearance of oversized gemstones — prisms of light which, if smaller, could gleam on the finger or glow from the neck. They dazzle the eye and seem to alter their colour. His sculptures speak of skills of the hand, of the power of the tools which carved them. His stones are hard and resistant. If parts are too hard they are left uncarved, but speak of decisions on the part of Sango. These sculptures always seem new. They speak of departure points, of new thoughts and explorations, of future possibilities rather than of what has come to mean successful sculpture in Zimbabwe.

Sango's sculptures benefit from light and careful display, and are essentially indoor works. They are generally small, and compact of form. They speak only of the surface of Sango's intensely personal and private feelings. These are the haiku of Zimbabwean sculpture and not its epic verse. It is the simple phrase rather than lengthy rhetoric which conveys the subject. They belong to the age of reason and there is no sense of romancing the stone. They

are not expressive sculptures but they make us wonder what can be expressed that has not been expressed before. They tell of age-old and universal feelings in age-old ways. They speak on behalf of the artist's private thoughts but do not reveal all that is thought.

If Sango is dismissive about a spiritual explanation for the workings of the real world, what is felt about his work cannot always be explained in worldly terms. His work conveys the spiritual if not the cultural side of Sango; it speaks of feelings which are not explicable in worldly terms.

If Sango's work is not culturally determined, it is still essentially African in its concern with mass and concern for the properties of the material. Possibly without knowing it, Brighton Sango has already established a new direction for Zimbabwean sculpture. Already his work is considered to be different, but how different the future will determine.

BERNARD TAKAWIRA

*I*f you are going to be a sculptor you are expected to be completely uneducated. You are almost expected to have a tail to be authentic.'

Bernard Takawira is all things a Zimbabwean sculptor is expected not

to be — educated, visually literate by international standards and well-travelled. As well as being a distinguished sculptor he has been a gallery director, held an exhibition of his own work in New Zealand, and organised an exhibition of work in Sydney, Australia. Hence, he is well qualified to discuss both the art of others and his own art.

He sees stone sculpture in Zimbabwe as governed by historic expectations rather than forging new directions. 'We are still involved in making spirit something or other. We still make what Frank McEwen expected us to make. Our development now should be self-development, not development as our mentors saw it. As we are developing an international audience for the sculpture we should respond to the needs of the audience. Our sculpture should become more liberal, more Western, and more versed in the international language of art. Artists are travelling to London, to Sydney, to Boston, and they cannot remain unaffected by contact with other art. In this way, sculptors are becoming removed from their origins and they are no longer so close to their cultural roots. We are now becoming capable of looking at the more universal aspects of spiritual expression. We should speak of these aspects in the language of international art rather than in the

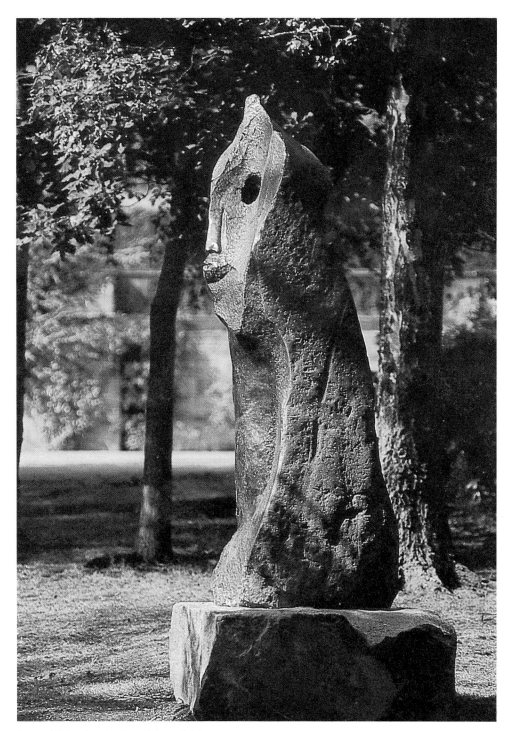

Bernard Takawira, *At One with my Spirit*

language of our own culture. The tradition established by our sculpture today is not so much spiritual, but material — stone, and the means employed — carving. When we started we were more realistic. The symbols and images we used were more readily identifiable as symbols from our own culture. Today our images and symbols have a more general association, and meaning is not couched in cultural reference. Our presence is now more international than Zimbabwean and we have to live up to it. Many sculptors are still too culturally dependent. International art has references outside the culture of the artists and we must seek to establish these references in our art.'

Bernard Takawira's comments give sculpture a sense of future possibilities which do not destroy its integrity or the strength of its original associations. If his comments seem removed from the origin of the sculpture and uncommitted to its original ideals it is because he, through his personal experience, has moved on from these positions.

Takawira feels that young artists try to establish their signature before their reputation. 'They virtually sign their name before they finish the sculpture. They try to force their reputation on the market-place before it is ready to be established. There is a great deal of sculpture being

made. It is inevitable to feel that you are going to be knocked down by the rush, so you make more sculpture in the hope that you will be recognised and still not be lost in the crowd. Young sculptors should spend more time making an honest assessment of their relationship with their own culture. They should be thinking of the meaning of things outside their culture, and voicing their thoughts through their work.'

Takawira has spent much time in assessing his relationship with his own culture, and establishing his position regarding his traditional beliefs. He has a profound and deep understanding of, and commitment to, the Christian faith, but still chooses to draw his subject matter from traditional Shona sources. He feels that his early work was not capable of realising the force and complexity of his ideas, and he expressed them in a manner that was too simplified. He does not see what is wrong with taking these ideas again and giving them a more sophisticated realisation. As one idea leads to another, one sculpture leads to another. The problem he feels is that: 'You can make up to ten sculptures and then you begin to make a sculpture that looks like the previous sculpture. There has to be balance between producing and absorbing. The difficulty is that so much sculpture is simply a matter of producing, and the absorbing of new ideas is forgotten.'

Bernard Takawira's views are very much of the present with an eye towards the future. He presents what he feels are the realities of the situation for stone sculpture in Zimbabwe today, and the realities which hopefully will establish its future direction. Those who make, and those who love, the sculpture may not recognise or wish to come to terms with these realities, but Bernard Takawira has much to say that appears to be true and which deserves consideration.

JOHN TAKAWIRA

John Takawira, who died in November, 1989, was an 'epic' individual, grand and gestural, and his sculptures have a similar eloquence. Large-scale emotions sweep through his work, and he was a master of rhetoric. To Takawira. sculpting was an act of compulsion, the result of an unpremeditated impulse. He was driven to sculpture by some force outside himself and his sculptures reveal the power of that force. His carving appeared guided by some unseen hand which urged the tools across the stone and finally laid them to rest. His sculptures reveal thoughts and feelings of considerable intensity. If some of his sculptures seem the result of an act of rage, and he shatters the world with his violence and unleashes his fury upon us, we will weather the storm.

The stone was Takawira's doppelgänger — massive and powerful. It was the natural shape of the stone, its surface and often rugged texture that suggested the subject. If Takawira's imprint on the stone is slight it does not make him any the less of a sculptor. If he was a poet, lost on occasions for words, he allowed the stone to speak for itself with natural eloquence and considerable strength. Each act of carving was highly selective and carefully considered like the careful choice of words before the sentence is completed. His sculptures are the reflection of much thought before action, as much as the act of sculpting.

Much of his stone came from Tengenenge, where nature has always been considered art. Often his work appears sculpted by nature, the consequence of natural forces of considerable violence. His are craggy, rugged sculptures — stones which defy contact with the human hand and which are still part of the kopjes and mountains which tower over the veld and give Zimbabwe its majesty. To look afar at John Takawira's sculptures is to observe the forms of the mountains of the Great Dyke which protect Tengenenge from the

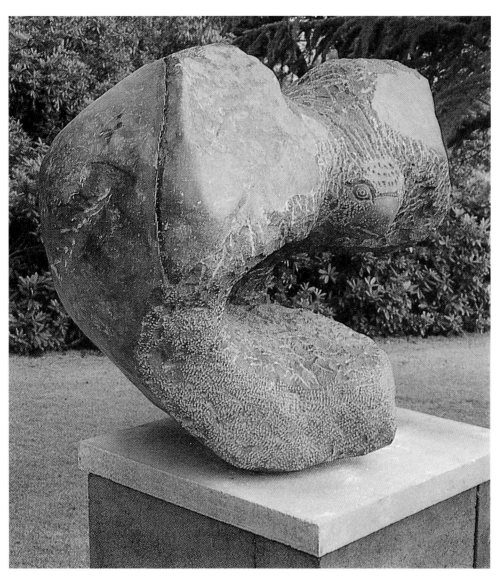

John Takawira, *Chapungu Landing*

real world and which reach towards the spiritual realm. On close inspection they become sculpture, and reveal the massive but careful sweep of the artist's hand.

Takawira acted in the interests of his material. He was guided by the stone and allowed it to make decisions for him. His sculptures seem older than their years, having the appearance of archaeological finds with geological significance. They appear timeless and speak of the long history of Shona beliefs.

Yet Takawira's personality could not be shut out of his art. His sculptures reflect the strength of that personality, flamboyant and commanding, compelling attention. They stand out in a crowd, dominating our thoughts, and not easily fading from memory.

Unlike his brothers, Lazarus and Bernard, John Takawira was not contained by Christian beliefs, nor by Shona ontology. To him *Mwari*, the Shona's Great One in the Sky was a personal god, greatly interested in John Takawira, rather than a disinterested philosophical principle. He was part of *Mwari's* personal creation, and *Mwari* was part of his. 'I must think about *Mwari*, see him, give him personality, otherwise I cannot believe in him.' Perhaps Takawira became his own *mhondoro*, possessed by his spiritual self, and imparting this possession to

his sculpture.

Apart from his personalisation of *Mwari*, there was nothing new about Takawira's beliefs although his approach to them was highly individual. Through his sculpture he gave Shona beliefs fresh meaning and new reasons for their existence, and he reached out to give these reasons and meanings a universal relevance. In his work he opened up new possibilities for metamorphosis and spirit possession, and gave a new significance to the spiritual engagement with the real world.

His *Chapungu* established his belief in the spiritual powers of the Bataleur eagle. Here a massive wingspan opens before our eyes. This eagle could soar not only above the viewer but the world. It is higher than the mountains and mightier than the sky, ready to swoop on its prey in the natural world and carry it off to the spiritual realm. His *Grandmother* looks at the world with the tenderness of a mother looking over her children. She has brought them up her way but now she knows they are old enough to lead their own life and have no further need of her.

Takawira spoke in symbols and metaphors and his sculptures articulate his language. He spoke of things we cannot understand and explained the reasons for their existence. Yet, although his presence is readily felt in his art he did not always push himself forward. He stood back and made way for the creator of all things, seen and unseen. In his work, he allowed himself to be guided by *Mwari* as he saw him, indicating the strength of his belief in a personal god of whose creation Takawira and his art are a part. In fact Takawira's sculptures could be part of the original scheme of things and the work of a divine hand.

LAZARUS TAKAWIRA

Lazarus Takawira, the youngest of three Takawira brothers, cannot be contained by the success of his older brothers, Bernard and the late John. His reputation is personally established and his work is easily recognisable. Lazarus Takawira cannot separate his life from his art, and his sculpture is primarily a form of self expression. Rather than exploring his relationship to his Shona culture through his sculpture he explores the relationship of his Shona culture to himself, and records how he sees the significance of traditional Shona beliefs and observances to his own personal experiences. His Christian beliefs are profound, but if observance of a Shona belief is applicable to a personal situation he will represent it in his sculpture. His sculpture puts his personal life on public display. It largely depicts his reactions to events which have taken place in his life, in particular his relationships with other people. To emphasise that his work is self-referential, he will often incorporate a self-portrait into the stone which he sees as his signature.

His sculptures are often a cathartic response to events of some complexity. *My Recent Problem* defies description of the problem. The stone has been carved with tremendous energy and a brute force. There is a maelstrom of forms, and a confusion of mass and planes. This was Takawira's response, prior to marriage, of the attraction of a girlfriend to another man. Rather than fighting the other man he fought the stone. Unconsciously working through the problem in his art he reached the solution.

In a sense, Lazarus Takawira's sculptures are a response to Nicholas Mukomberanwa's comment: 'You must put your own history into the stone rather than present the history of the stone only.' His sculptures not only tell the viewer much about the artist, they objectify his relationship with himself and make him look at his problems as he would those of another person, in particular, recurring problems he cannot control or master. There are some occasions when Lazarus Takawira stands

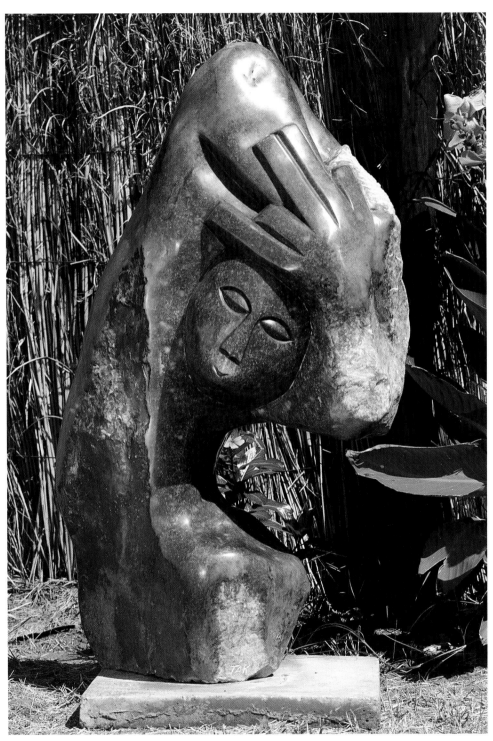

Lazarus Takawira, *All My Problems*

back rather than comes forward. His *Eye Witness* observes a crime through a gouged-out space in the stone which appears to take in many things at once. A fully defined eye appears oblivious to anything that is going on. His *Man Changing into a Buffalo* allows metamorphosis to take place before our eyes: the smooth skin of the man contorts into the wrinkled skin of the buffalo, the lidless eyes swell and bulge from the stone, the head is massive and fleshy.

Recently his sculptures have become less anecdotal, and more concerned with the exploration of pure form rather than the depicting of subject. As he has matured, it is possible that his reactions to events have become less emotional, that he has begun to handle his problems personally and he no longer needs to work them through his art. His *Zimbabwe Bird* in green serpentine presents an abstracted realisation of the character and form of all birds, possibly a paradigm for the way in which the Zimbabwe Bird has become a national symbol to all Zimbabweans. A preoccupation with pure form is an objective he shares with his brother Bernard, and it points to a possible new direction in Zimbabwean sculpture.

Lazarus Takawira is a large man like his brothers Bernard and the late John, and his emotions and feelings have

previously been on an appropriate scale. If his sculptures are small and compact the impact of a statement about his personal feelings is not reduced through the size of his art. Perhaps having said too much too soon, today his work says little about subject but a great deal about developing notions of pure form and aesthetic sensibilities. It raises the question of whether there is any need for statement in art and speaks on behalf of form with increasing sophistication.

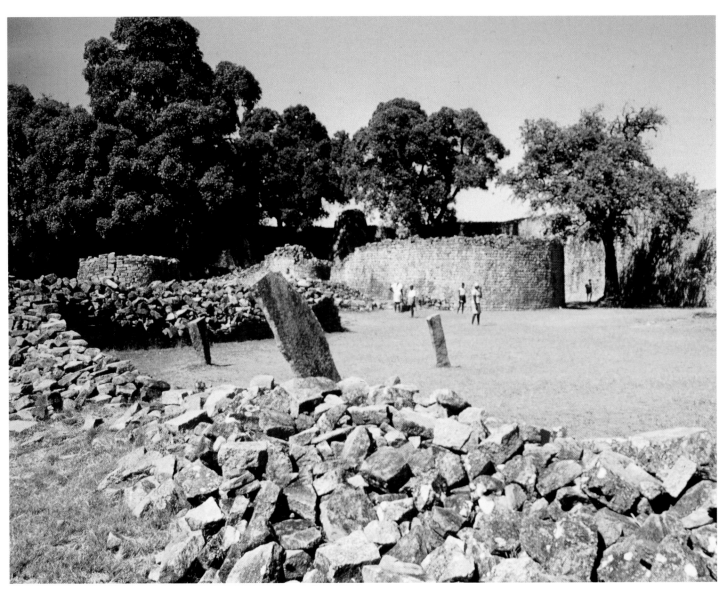

Great Zimbabwe, photograph courtesy Ministry of Information, Zimbabwe

CHAPTER EIGHT

VISUAL CULTURE IN EARLY HISTORY

The stone sculpture in Zimbabwe and other aspects of the visual arts in the country have no direct aesthetic or cultural origins within historic aspects of visual expression in Zimbabwe. However, they might be seen as the latest manifestation of a continuity of the visual realisation of cultural concepts of the people living in what is now known as Zimbabwe since the Late Stone Age. This visual realisation is also indicative of settlement patterns since that time. From the rock paintings of the Late Stone Age; from Early and Late Iron Age pottery; from Great Zimbabwe, its soapstone birds, and contemporary and later smaller *zimbabwes*; from objects associated with Shona material culture and the *musha*, the domestic environment of the rural Shona; much can be learned about the people who created these things, and the societies to which they belonged.

In terms of Great Zimbabwe and the other *zimbabwes* and the Shona *musha*, a spatial analysis of both the built environment and designated space can tell much about the inhabitants. The use of space is a cultural variable. Societies everywhere divide up their spatial environment into a number of discrete areas where they allow a limited range of things to happen.[1] In the case of historic Shona settlements, Shona prose, poetry and proverbs can provide an analysis of

their social dynamics, and the people's cosmology.[2]

Indeed the organisation of space reflects values, and the way the space is divided up reflects the cosmology of the people concerned.[3]

It is the intention of this chapter to not only consider some major aspects of the way that cultural concepts have been transmitted through cultural sites by some inhabitants of Zimbabwe since the Late Stone Age, but to establish how these sites can provide information about these concepts, what they were, who conceived them and how they were conceptualised. From these factors it is possible to establish how the cosmologies of the people involved affected their everyday lives and attitudes.[4] The chapter concentrates in particular on cultural sites which are accessible in Zimbabwe today: the rock paintings of the Late Stone Age many sites of which are both well preserved and accessible; Great Zimbabwe, easily visited; the Shona *musha*, which in the rural areas can remain the same in terms of spatial organisation and the built environment, as it has been for hundreds of years; and objects from Shona material culture which are either used as they have always been used in the *musha*, or preserved and conserved and put on public display.

Although the stone sculpture in Zimbabwe today has no historic links with traditional modes of object making, apart from a commonality of means (carving) and material (local stone), it does, like these sites and objects, tell much about the cultural conceptualisation of the society to which the people involved belong.

Even during pre-Independence days, cultural sites and objects with cultural relevance were subjected to preservation and conservation by the National Museums and Monuments Commission. Much information has been documented and classified by the National Archives. Since Independence, the government has associated itself with Zimbabwe's past and sees recognition of the past, in particular its cultural expression, as a national heritage and part of Zimbabwe's national consciousness.

What might be termed the visual culture of Zimbabwe is as rich and varied as that of many other African countries. It does not, however, as it does in many of these countries, manifest itself in objects with a largely spiritual function.

Much of Zimbabwe's visual culture contained on cultural sites is not portable. It must be visited in situ. It remains in its original context, which explains its cultural relevance. Any book which considers the overall dimension of the

contemporary art of Zimbabwe must take into account the best-known cultural sites as expressive manifestations of the historic visual culture of the country. The art and these sites are aspects of the cultural practice of people of various ethnic, cultural and linguistic groups which at various times have lived in that area.

The rock paintings of the San artists (bushmen) of the Late Stone Age are the earliest and some of the best-known and most accessible cultural sites in Zimbabwe. In his book *The Painted Caves*, Peter Garlake describes in detail 38 sites that can be visited, and there are over 2 000 additional sites.[5] Archaeological evidence is inadequate to interpret the exact meanings of the paintings. Information cannot be calculated from carbon dating as it can for Late Stone Age pottery, and dating of the paintings can only be arrived at through evidence of human occupation in the caves[6] in which they appear.

Garlake considers that the paintings were probably produced between 10 000 and 2 000 years ago.[7] Certain aspects of their subject matter indicate that they were the work of a hunter-gatherer society which belonged to the Late Stone Age. Four painted fragments of granite from caves in Zimbabwe can be dated 8500 BC, 7500 BC, 3000 BC and between 3000 and 2000 BC.[8] These fragments,

however, cannot indicate exactly when the paintings were produced. While the Zimbabwe paintings belong to a broader tradition of rock art in Southern Africa (in Namibia, Lesotho, Natal and the Cape)[9] which share a common cultural system, the paintings in Zimbabwe have, according to Garlake, different characteristics,[10] but he acknowledges them to have the characteristics of a San bushman culture.

While the paintings have undeniable artistic properties, and some information about their meaning and social significance can be gained from an analysis of the conventions employed by the artists, a purely aesthetic analysis limits their meaning. Looking at the paintings as art, without consideration of their content and meaning, the fact that the outline rather than the composition and form of subject best represents the subject indicates considerable drawing skills on the part of the artists.[11] The paintings are two-dimensional, there is no indication of perspective[12] and the cave wall is not used as space[13] or background. The conventions are strict enough to allow an artist to establish his own style. It is not possible to establish whether a painting was done by one or more artists, although it is obvious that the conventions were used with more skill by some artists than others.[14]

Garlake points out that in hunter-gatherer societies, the development of skills was open to all,[15] and it is possible that the paintings were made by those with considerable skills rather than those with lesser skills.[16] The conventions decreed the way that subject matter was portrayed, but they do not provide an interpretation of the subject, and an explanation for the meaning and purpose of the paintings. Nor do they suggest who the artists actually were as individuals or what the paintings signified to the society represented by the artists.

To establish the relationship of the art to society we have to turn to aspects of the artists' cultural practices outside art, and to their cosmology. It is generally agreed among archaeologists and anthropologists that the paintings cannot be read literally, or seen as realistic art, and that they had no magical function in the societies represented by the artists.[17] If they cannot be read literally, then the subject is a metaphor for an abstract state of mind on the part of the artist or the society he or she represents.

It has become scholarly practice, because of the lack of evidence in the dating of the paintings, to base an interpretation of the paintings on anthropological studies of the northern Kung San of Botswana and Zambia.[18] Professor J.D. Lewis-Williams, Professor

of Cognitive Archaeology at the University of the Witwatersrand in South Africa, pioneered these studies through his analysis of ethnographic reports on the Kung, and the findings of a field trip to Botswana in 1975 with Dr Megan Biesele. The Kung are San, but Lewis-Williams feels that the Southern African rock paintings are concerned with a physically induced state of trance among dancers which releases a stream of energy and potency in the dancer which enables him to heal, and among other things make rain. Among the Kung this state of trance is known as *!kia*; those in trance are supposed to possess a form of supernatural energy known as *n/um*.[19]

Lewis-Williams believes that trance is explained by a group of metaphors dealing with human and animal behaviour. Initially Lewis-Williams believed that the dying animal was the major or principal trance metaphor in the paintings. Garlake feels that other trance metaphors exist in the paintings, and believes that the many metaphors in the Southern African paintings, and some in the prehistoric paintings of Zimbabwe, are metaphors for trance. He sees various aspects of the Zimbabwe paintings as being symbolic of trance, and the energy and potency associated with trance. He sees figures with distended stomachs as being symbolic of potency, the lines surrounding

numerous figures as being descriptive of potency, and the large nebulous, almost indefinable shapes that seem to float on the walls of caves such as those at Zombapata near Guruve (sometimes interpreted as beehives, bees themselves being a symbol of potency) as powerful symbols of energy. He also sees the rows of dots along the back of many of the figures as representing the sensation of boiling which arises in the spine when the trance is approaching.[20]

Lewis-Williams points out that the death of an animal resembles a man in a trance.[21] He sees death as a metaphor for trance.[22] Lewis-Williams sees certain metaphors which link the natural world and the social world as depicting trance, and sees the dying animal and the trancing man as sharing similar disorders — sweating, hyperventilating, gasping for air and bleeding through the nose.[23] Professor Thomas Huffman also believes that the trance metaphor exists in the paintings of Zimbabwe in which animals do not appear. He sees erect hair, a feature of dying animals, as a metaphor for trance, and also attenuated figures which represent the sensations of trance.[24]

Conceptual animals such as the rain animal play a large part in the rock art of Zimbabwe. While in trance the medicine man believes that he captures one of

these animals and when it is killed its milk or blood comes down as rain.[25]

The trance is seen as the most important ritual in bushman society, capable of repetition by its practitioners. The trance is physically induced and the person in trance has the power to heal, to control social tensions (social ills being thought of as the origin of all illnesses, including physical illnesses, among the small-scale San society in which social harmony is essential). According to Peter Garlake many people — half the men and a third of the women in any group — have the ability to *!kia*, to go into a trance and to cure.[26]

Professor Lewis-Williams argues for the paintings having been done mostly by people who have been in a trance, although not in a trance at the time of painting.[27] Professor Huffman feels that the artist can also convey images out of the context of the memory of a trance which are culturally powerful.[28] While in a state of trance, the person engages in out-of-the-body travel and hallucinations. The hallucinogenic composition of geometric forms is known as entoptics, which are produced by the stimulation of the central nervous system. These are cross-cultural reactions to hallucinogenic states produced by physical stimuli or mind-altering substances, such as drugs which can be culturally interpreted.[29]

Anthropological studies show that the San do not see going into trance as being possessed by spirits, and that the San do not believe in ancestral spirits as Bantu-speaking people do. When the San are in a trance they feel that they are actually channelling themselves out of their bodies, and they perceive their real selves as being part of that vision. Those in trance feel that they are receiving their potency from the rain, or animals, or God. Professor Lewis-Williams believes, in addition to representing what is seen in trance, that the paintings represent the symptoms of physically induced states and hallucinations which are associated with trance.[30]

Lines trailing from the arms and the legs might, according to Dr Lewis-Williams, suggest illness being expelled from the body through healing by the person in trance.[31] Those in trance had no wish to go berserk while in trance as they had to concentrate on their healing. While entoptics are included in the paintings, it appears to the scholars that the artists were able to depict the imagery of trance, or hear about it from others and document their descriptions.

Peter Garlake and Professor Lewis-Williams believe that the act of painting was another means of communicating the experience of trance outside the trance itself.

Robert Burrett, an archaeologist who trained under Professor Thomas Huffman at the University of the Witwatersrand, comments that the caves in South Africa were big and that this could indicate that a number of artists worked on one painting, and that the caves in Zimbabwe were smaller, indicating that perhaps only one person had worked on a painting. He sees no individual styles in the paintings, and sees the rock art as being socially controlled. He does not believe that the San groups, further south, came to Zimbabwe but that the San who painted the caves had the same cultural system as the San of more southern regions. He feels that the animals in the paintings are important symbols, like the lamb in Christian imagery.

However strict the conventions of the rock art in Zimbabwe are, they allow for a metaphorical interpretation of the spiritual beliefs of the artists. Trance is depicted as the central activity which sustains belief, and anyone can go into trance. Trance underpins the egalitarian nature of the society of the artists and the paintings inform us that the artists were an integral part of their society — that the making of art was a democratic rather than an elitist activity. In a pre-literate society, language is visual and the means of communication in that society

are signs, symbols and metaphors, the meaning of which is collectively recognised. The rock art of Zimbabwe is part of this language and the research currently being done is enabling it to be read, not in Eurocentric terms, but in terms of the beliefs and customs which sustain the religious practices of the people. They focus on the *shaman* as performing the most important role in an egalitarian society but because of that egalitarian society, the role of the *shaman* is open to anyone who goes into trance, and all are able to go into trance if they wish.

Like stone sculpture in Zimbabwe, the cultural references of the paintings lie outside art itself, and they provide valuable information about other aspects of cultural practice of the societies they represent. The San paintings of Zimbabwe play their part in both shaping and reflecting the culture of the San. There are many accessible and well-preserved sites in Zimbabwe today which offer all who visit them an opportunity to grasp an important cultural dimension of one of the most significant periods of Zimbabwe's pre-history.

Although much has been written about how the rock paintings depict the cosmic vision of the artists' society, and the social and spiritual significance of the paintings has been well documented,

to date there has been little appreciation of them as art. The rock paintings of Zimbabwe are great works of art, the flowering of an innate artistic talent over a period of thousands of years. These are the earliest, and undoubtedly some of the best, examples of the art of Zimbabwe.

An appreciation of the paintings as art does not require an interpretive understanding. This appreciation is based on the ability to know how to look, rather than what to look for. Their descriptive powers can be appreciated without a knowledge of their symbolic associations.

The paintings depict much activity but this does not make them appear crowded, rather it underpins, at a literal level, the activities and inter-related activities which sustain the social organisation of the bushmen and the living out of their cosmology. From the paintings it is obvious that the bushmen were a nomadic hunter-gatherer society.

These are true paintings of the African bush and its former inhabitants. The paintings make a safari into prehistory, to provide a close and revealing view of a variety of animals. Despite exaggeration and distortion of form, and some anatomical licence, there is a realism about the animals in the paintings; black and white rhino, kudu, antelope, duiker,

among them.

Belonging to a society of hunters, the artists were trained in the observation of animals at close quarters. The animals, apart from what are termed mythological animals, are recognisable. Some are drawn in outline, some are painted in silhouette, and others executed in fine detail. From the paintings, the inter-dependence of man, animal and nature is apparent. The paintings also illustrate the natural surroundings of the terrain of the bushmen. Varieties of organic forms resemble trees, roots and bulbs, and a richness of vegetation in the area may be assumed. Here, as with the animals, close observation of nature by the bushmen is apparent.

Among the San artists there is a decisive use of line, and a control of tools, remarkable in untaught artists. The colours used range from monochrome to polychrome, and there are degrees of shading and variations within the colours to give the figures and animals depth. The pale background of the cave walls and ceilings highlights the vibrancy of the colours and their earth tones, although the overpainting or superimposition on many of the paintings makes the compositions a little hard to define. The faded figures, which seem to haunt these paintings, give them a sense of centuries of history.

The social role of art in Zimbabwe began with these paintings, and it possibly has not been as important since their time. However, painters today are looking at their society in much the same way — depicting its activities in paintings which have many layers of meaning and leave interpretation open to the viewer.

Much of Zimbabwe's history has been written on the basis of archaeological evidence, Portuguese documents and oral traditions. It is not as simple to understand the dynamics of archaeo-logical sites as it is of living settlements.[32] An archaeologist will study what is left on the ground.[33] Even if a site is completely excavated it will not produce enough physical evidence to show all the things which have happened there. Unlike that of a living settlement it is not possible to determine the actual size of an archaeological settlement.[34] For example the stone walls at Great Zimbabwe only mark the edge of the palace area.[35] In using contemporary Shona ethnography to construct an historical model (ethnography being used to construct models about the past, but not to provide answers about the past),[36] Professor Huffman says that there is a certain level of analysis which can be used to analyse the past — micro-analysis is not appropriate. What is appropriate is macro-analysis based on historical

principles, which underlies the way cultures function, irrespective of where they are in space, time and place.[37]

Shona society has altered considerably following the arrival of the Ndebele and the influences of the colonial period. Certainly, with the advent of a centralised government, tribal chiefs do not wield the power they used to.

Huffman says that in order to understand cultural behaviour a world view must first be established, and in the case of the Shona this can be done through religion. Hence he believes that cognitive factors can play their part in archaeology, and in an archaeologist's understanding of cultural change.[38] Professor Huffman, in his writing, is concerned with spatial analyses of Shona settlements, in particular Great Zimbabwe, the organisation of space being a reflection of certain cosmological principles of the Shona. His model for this analysis is the ethnography of the Venda of the Northern Transvaal. He comments: 'The Venda are a particularly appropriate model for the social distinctions in Shona settlement and aspects of class distinction, including sacred leadership and divine kingship. Many Venda clans came from Zimbabwe, and Venda settlement is a variation of the Zimbabwe culture pattern rather than the southern Bantu pattern, and some

aspects of Venda court art are based on that of the Shona. The Venda also share similar cultural attitudes and adopt cultural practices similar to the Shona speakers rather than the southern Bantu. Venda chiefs, unlike Shona chiefs, continue to live in large settlements, and maintain institutionalised bureaucracies such as those which prevailed at Great Zimbabwe.'[39] As the Venda were not defeated by any major invasions in the early nineteenth century, their degree of centralisation and associated cultural practices are less changed today than those of the Shona.[40]

In his book *The Shona and Zimbabwe 900–1850*, Dr David Beach comments that 'archaeological tests in the past have given the impression that the country was inhabited by pots rather than people'.[41] This may be the case, but in a sense it is the right impression because it is largely from the pottery that people, in particular the linguistically based cultural groups, can be defined and delimited. Pottery can also establish the movement of groups of people. Pottery styles are part of a national culture. Providing the makers and the users of the pots were the same, a mapping of the distribution of a particular linguistic group can take place.[42] The stylistic features of pottery can identify the cultural group. Pots indicate that the people of the Late

Iron Age were settled food producers, and they define the parameters of archaeological cultures known as the Harare culture, Leopard's Kopje and so on.[43]

The cultural significance of the Leopard's Kopje culture to the development of Great Zimbabwe, considered in terms of the archaeological culture, was one which can determine a group of people who made the same kind of pottery and shared the same kind of beliefs. The Leopard's Kopje culture established in AD 980 a settlement now called K2, at the confluence of the Shashi/Limpopo rivers. This was a settlement in which the spatial organisation was originally in keeping with central cattle patterns — the men's meeting place was associated with cattle byres, and men were buried in cattle byres — but in which a spatial organisation was developed independent of these patterns because of increasing trade with the East Coast and Indian Ocean which gave an added dimension to the economy.[44] A large midden found at K2 replaced the cattle byre, and the refuse found in the men's main assembly area was indicative of the increase in the size of the decision-making group of the community, and the beginnings of an institutionalised bureaucracy. This indicated an expansion of the political power base of the

leader.[45] In the twelfth century the midden had engulfed the cattle byre, and it can be assumed that the cattle were moved out and became secondary to the economy of the ruling elite.

According to Professor Huffman, K2 was abandoned to allow a new settlement to be established in order to accommodate a growing population, and new concepts in spatial organisation emerged in keeping with the physical separation of the king and the ruling class from the commoners, and the growth of an institutional[46] bureaucracy. This meant larger assembly and meeting places and burial places on the hill rather than near the cattle byre.

It was indicative of the emergence of the association of leadership with mountains which is mentioned in Shona prose, poetry and proverbs, an essential spatial dichotomy which is related to social distinction and class significance. Here class distinction was apparent through the spatial organisation and designated spaces of the new settlement, Mapungubwe. Stone walls separated the ruling class and the elite from the ordinary man. A residence on the hill belonged to the king;[47] a separate ascent to the residence was made for his wives.[48] Huffman comments that the move of the K2 people to Mapungubwe was based on the fact that they were so wealthy

that they had changed the way they lived to support an institutional bureaucracy, and they needed to reorganise their living space.[49] Mapungubwe was suited to their new cosmology and allowed that cosmology to be realised rather than to be merely a theory. There was a hill on which the king could ritually seclude himself.[50] There was wealth enough from Indian Ocean and East Coast trade to support the bureaucracy, which in turn stressed the remoteness of the king.

Mapungubwe was abandoned in the thirteenth century, for reasons still to be established; the ecology being unable to support the growing population being one theory.[51] Great Zimbabwe, a similarly spatially organised elite centre, emerged immediately after the decline of Mapungubwe, but it was not inhabited by people originally from the Leopard's Kopje culture but by a related group of people from the plateau.

Great Zimbabwe was one of a number of contemporary and future historic Shona settlements, centralised states or polities, exacting tributes and engaging in trade with other territories. The principal ones were Great Zimbabwe from approximately 1250–1500; Torwa, around Bulawayo, 1450–1650; Mutapa 1490, gradually declining from 1650 to the 1800s; and Changamira (Rozvi states) 1690–1830.[52] Linked by similar settlement

organisation and social and class implications, Great Zimbabwe and the other settlements provide a lengthy cultural continuity for a long period of Shona history. Today, Great Zimbabwe represents a peak of Shona civilisation hidden to a degree under earth, refuse and rubble, a civilisation which cannot be completely understood until accurate excavation and restoration take place. Much valuable archaeological data was destroyed at Great Zimbabwe in 1902 and some inaccurate restoration has been carried out since that time.

Until extensive restoration and excavation have been completed, we are left with parts of the whole.[53] While the physical presence of Great Zimbabwe as it stands today is a social statement and has human implications, the meaning and function of the monument is not entirely implicit in that presence. It is only when the excavation and restoration are accurately completed that we can gather from the built environment of Great Zimbabwe who lived there, and how the civilisation survived and functioned during its lifetime.[54] Since colonial times, Great Zimbabwe by its very existence has exercised political functions firstly with the colonial regime, and then the government of Zimbabwe since Independence.

In the colonial period, there was

government pressure not to acknowledge that Great Zimbabwe was built by the Shona, although genuine archaeologists reflected this in scientific literature. Since Independence, the conservation and preservation of Great Zimbabwe is in keeping with government policy.

Great Zimbabwe is the most well-known and culturally significant of the Shona polities. It parallels periods of architectural and creative development in other areas of Africa — Nigeria, Ethiopia — although it developed independently of these achievements. Great Zimbabwe was a city of over 18 000 people with a ruling elite, a ritually secluded king, economic wealth, and a settled urbanised population.[55] There was great social and economic distinction between the ruler and the ruled, articulated through the spatial dichotomies of their settlement.[56] Great Zimbabwe was able to build up a material culture of a greater richness and variety than had hitherto been seen on the plateau. This included ornamental and decorative objects which had no function other than that of a prestigious means of exchange, a tribute payment, and a display of wealth on the part of the ruling class. It also allowed for the development of specialist skills of craftsmen who supported the state and in turn were supported by the state. Much evidence of this material culture

exists today. Great Zimbabwe was close to natural resources; stone was mined on the spot, while gold and mineral deposits were further away.[57]

The first manifestations of Great Zimbabwe by the Shona-speaking Gumanye people were a series of isolated huts surrounded by stone walls made of local granite which separated the elite from the ruled, and the king from the elite.[58] The builders of the walls did not use mortar,[59] and as the walls were made from granite of an irregular shape, from the distance they seemed like part of the landscape. The walls have variously been considered architecture or magnificent manifestations of the stonemason's craft.

It is likely that the walls were part of an overall scheme of design. A.H. Whitty, in *Architectural Styles of Zimbabwe*, considers the addition of buttresses and platforms elevates Great Zimbabwe to an architectural conception,[60] but it has not yet been discovered how the walls were conceptualised. The walls must be considered as structures enclosing people, as well as skilfully built masses of stone. This construction was obviously considered in terms of human needs — basic and simple needs such as warmth and shelter, and more complex needs, such as social and class distinction, social interaction, and the administration of large numbers of people inside and

outside the walls. In the thirteenth century, a long wall was built around Great Zimbabwe.[61] Elite huts had larger living areas than huts for ordinary people,[62] and large and varied imported goods were evidence of wealth and Great Zimbabwe's stronger presence over trade routes.

The name Zimbabwe means court or home of a chief or royal residence.[63, 64] Production of objects associated with material culture assisted the king in exercising social control of the population outside of his walls. The economy of the ruling elite was basically a foreign-exchange economy based primarily on agriculture. A flourishing textile industry existed. Spinning and weaving were well known. Cloth was initially imported, in exchange for valuable ivory and gold. When produced locally it was used as a means of exchange. Efficient manage-ment of these resources meant the consolidation of wealth and the increase of the dependence of the ordinary people on the ruling class. Cattle were herded in outlying grazing areas. The wealth gained from cattle and export trade led indirectly to additions to the existing walls, greater privacy for the king and the ruling class, and huts inside the walls with larger and fewer rooms than those found in the huts in the village. This additional building meant

large-scale mobilisation of partially-skilled workers at least, and payment of some kind to the leader. Also found at Great Zimbabwe, and evidence of foreign trade supported by a sophisticated means of exchange, were imported objects such as glass beads, and Chinese celadon.[65]

To Professor Huffman, an analysis of the spatial organisation of Great Zimbabwe and other settlements is reflective of their social organisation, their class structure and unequal distribution of wealth.[66] It is the social correlate of Huffman's spatial analysis which, of all scholarship surrounding Great Zimbabwe, gives it its most human dimension.[67] From Huffman's analysis we gain some understanding of the people who lived behind the walls, and how they functioned as human beings and even as individuals, as well as components of a complex socio-economic system. This chapter accordingly devotes much time to Huffman's ideas. It is also his analysis which places human activity in an appropriate cultural context. To Huffman, Great Zimbabwe and other settlements are a visual realisation of a number of cultural and social concepts developed by the Shona, and linked to their cosmology.[68] Those manifested in their settlements, in particular in the way that space in terms of the built environment and designated space is organised, tell us much about

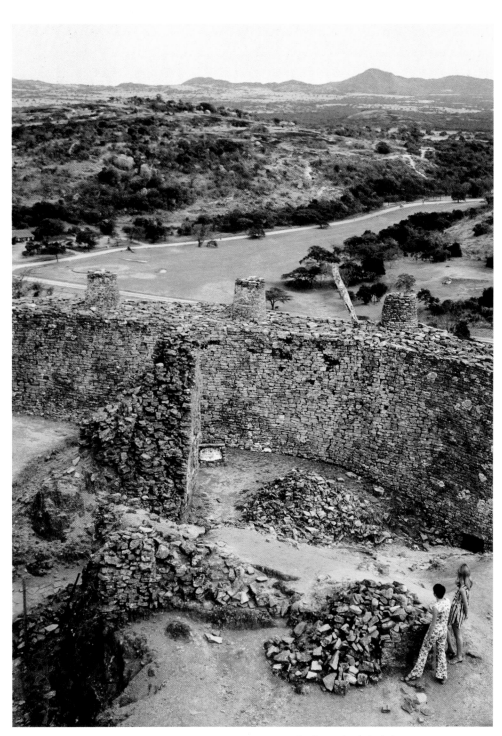

The walls of Great Zimbabwe, photograph courtesy Ministry of Information, Zimbabwe

the Shona themselves.[69] Huffman feels that a spatial analysis of Great Zimbabwe, including the relationships of opposites in keeping with Shona cosmology, such as high-low, hot-cold, east-west can accurately explain part of the human activity which went on.[70]

It has been established that the hill was the first settlement at Great Zimbabwe. The hill today is a ruin of turrets, buttresses and towers, all of which have a meaningful cultural association with height and power. Both Thomas Huffman and Peter Garlake believe that the Western Enclosure was the king's residence. Huffman says that sacred leadership is an anthropological concept[71] about the king's direct link with royal ancestors. The king, together with his senior sister, was in direct communication with those spirits who control the ecology and affect the world.[72] At Great Zimbabwe there was great ritual elaboration of the office and institution of the king. The king, because he was king, was respected by his people, but physically and in human terms he was ritually separated from them. Rather than directly seeing the king, a person would have had to go through several other people. It was not possible to see the king for just any reason at all, and it was possible to be refused an audience.[73] Once an audience

was actually given, the king may not actually have been seen, and a veil might have been drawn across the audience chamber. Many people may never have seen the king at all, and it may not have been known if he was alive or dead.[74] The position of the king was not hereditary and ancestral spirits played their part in the selection of the king.

The Eastern Enclosure is, in spatial terms, appropriately behind the Western Enclosure, designated a sacred space in terms of Shona cosmology. It was thought by Peter Garlake to be the home of the spirit medium.[75] Thomas Huffman feels that the spirit medium would be hidden from sight and only appear when the king desired an audience with him, but thought that he would be living somewhere in the area behind the Eastern Enclosure.[76] There is no firm evidence for this but, nevertheless, the Eastern Enclosure contained ceremonial and ritual objects rather than residential debris, and also six of the soapstone birds of Great Zimbabwe.

Between 1889 to 1891 some of the birds were removed from the enclosure. Professor Huffman believes that the birds were mounted on low terraces at the back of the enclosure facing what must have been a designated space for some aspect of ritualised communal activity. The birds are in reality carved composites

of raptors of no specified breed. They are essentially anthropomorphic realisations of birds, some have human as well as bird-like features. These are stylistic renderings of a raptor theme, and it is possible that they had some spiritual significance outside of their physical presence, and rather than being objects worshipped in themselves, were part of an overall concept with that significance. Garlake suggests that the birds were composite creatures with bird-like characteristics, and no realistic interpretation of species could be applied to them. While Garlake looks at the birds in terms of their physical appearance,[77] Thomas Huffman considers them from the viewpoint of the spiritual association of birds in Shona culture. He sees them as symbols of ancestors, and cites the role of the eagle as mediator and messenger between God and man.[78] He suggests that the six birds in the Eastern Enclosure represented ancestors of previous Kings at Great Zimbabwe.[79] If the Eastern Enclosure had been used for the propitiation of ancestors for such purposes as bringing rain, the birds may well have played some part in the related ceremonies. The seventh bird was found in the Western Enclosure inhabited by the king.[80] The eighth bird was found in the Phillips' Ruin (now called Lower Homestead), and was decorated with

crocodiles and symbols associated with Shona divination.[81]

While much attention has been paid to the spiritual and cultural significance of the objects found at Great Zimbabwe, little attention has been given to their art qualities and considerable aesthetic merit. In other culturally developed sub-Saharan African countries, an appreciation of objects with a spiritual or material function as art, without denying them their original function, is well recognised. Perhaps because the exact function of many objects found at Great Zimbabwe has not yet been determined, this extra dimension of appreciation has not yet taken place.

The most impressive and famous objects found, and those most relevant to the stone sculpture of today, are the soapstone birds. The birds, in today's terms, are undeniably sculpture. Standing on stone pillars, high above the ground, the birds have the unending length of Brancusi's *The Column*. They are monolithic in form; a skilled working of the mass of the stone is obvious. They work three dimensionally and are effective from the front, the back and the sides. There is a natural recourse to abstraction on the part of the makers, and a sense of direction appears to be given by the shape of the stone.

The use of soapstone is significant if modern stone sculpture in Zimbabwe is looked at as part of a longer historic process. While the carving technique is rudimentary, the execution is skilled. While few of the sculptors working in Zimbabwe today have made recourse to the Zimbabwe Birds for their inspiration, the birds indicate that today's sculpture is pre-dated by sculpture in the same media over five centuries old.

Scholars are inclined to see the meaning and significance of the birds as more important than an appreciation of their formal and art properties. But like the rock paintings, the birds must be recognised as an earlier form of artistic expression in Zimbabwe, and they are indeed Zimbabwean sculpture.

Thomas Huffman considers that the king lived permanently on the hill, in the Western Enclosure of Great Zimbabwe, while Peter Garlake, and Godfrey Mahachi, an archaeologist at the Queen Victoria Museum in Harare, feel that the king moved from the Western Enclosure to the Great Enclosure, a later construction but one of more ethnocentric merit, and suited to the king's increasing wealth through trade and the development of the economy. Professor Huffman, using the ethnography of the Venda to construct a model,[82] constructs a model for the Great Enclosure on the basis of the initiation ceremonies, which he substantiates with the findings of objects in the enclosure normally associated with initiation. Huffman's analysis of the Great Enclosure includes a structuralist designation of opposites to the spatial organisation: front/secular, back/sacred, male/female, separate entrances with horn decorations for men and grooves for women.[83] The gender-based entrance interpretation was indicative of the concepts of status and power in-built into the initiation, although anyone could be initiated. He uses the device of opposites to interpret the meaning and function of many of the enclosure's physical features and considers the male/female symbols at the back of the enclosure to be like those found on the Shona *hakata* dice, also expressed through binary notions of opposites. Garlake's approach to Great Zimbabwe's Great Enclosure is essentially descriptive, while Thomas Huffman's is interpretative and focuses on its possible human dimension.

Peter Garlake and Thomas Huffman present both complementary and contradictory views on Great Zimbabwe. Both appear to think that the architecture can provide a visual symbolism for the class structure of the society in particular, through aspects of the architecture which might be considered to have a symbolic meaning such as the

turrets, buttresses, pillars and terraces. Garlake also concedes that the various Shona beliefs, such as the totem, might provide an explanation for some of the physical features of Great Zimbabwe. Huffman uses Shona/Venda enthnography and the spatial organisation of the settlement to analyse the meaning of Great Zimbabwe, which he appears to see as an expression of Shona culture and an architectural structure with cultural significance. While Huffman stresses the communal associations of designated spaces, such as the Great Enclosure, Garlake sees little sense of community evidenced at Great Zimbabwe in terms of the organisation of the built environment and its designated spaces — no temples or shrines — and believes this to be in keeping with the Shona's highly personal and individual relationships with the ancestral spirits.

Professor Terence Ranger considers that many activities might have been carried out by only a few, but that performances of collective significance were crucial and points out that areas which were designated spaces and did not contain stone buildings might have been of that significance, including natural areas where the king was buried and where the spirit medium lived, and where the living king established relationships with the dead king.[84] Both

Garlake and Huffman are in agreement that Great Zimbabwe is a statement about political power and the wealth and the privilege of the ruling class, and that its function lies within that statement. From its physical appearance, Garlake considers that its walls, low and unfinished, are not suited to defence and that it symbolises domestic wealth and power rather than military power.

Similar constructions and settlements, smaller in scale, followed Great Zimbabwe after its decline. Some believe that the same dynasty which controlled Great Zimbabwe transferred its power to Khami. Hence, there was a continuation of the cultural traditions and political structure of Great Zimbabwe. At the time of Khami, during the second half of the fifteenth century, the Shona group in the north-east broke away to form the Mutapa state as a separate political entity retaining the same culture and political system as Great Zimbabwe and Khami. In the sixteenth century the Portuguese attempted to colonise the Mutapa state, and were eventually overthrown by the Rozvi, the ruling dynasty of the Changamire state.[85]

The rock paintings as art, and Great Zimbabwe as architecture, are as impressive as anything to be seen in Africa. Both are representative of societies educated in their own way

about the world around them and their world view.

An aspect of the visual realisation of other cultural concepts indigenous to Zimbabwe, which has been naturally conserved and preserved and which is an essentially living tradition with historical significance, is the rural Shona's built environment, and its associated functional objects which are known as Shona material culture. From this environment, and in particular its spatial organisation, much can be learned about Shona cosmology and the customs and observances which sustain it, a central aspect of the subject of the contemporary sculpture of the Shona.

The Shona pole-and-daga hut and the village structure probably has not changed radically over the years in rural areas. Some functional objects to ensure survival and fulfil domestic needs have been passed down for centuries and are still in use, others have been and are still being made from age-old materials, by traditional means to accepted formats. The traditional arrangement and positioning of these objects in the Shona hut remains, and assigns to them a wider social and cultural significance.

The concept of the home to a rural Shona bears little relationship to the building or space which houses the Western nuclear family. The notion of

home to a rural Shona can be extended to a number of buildings and space which serve the needs of a number of families under the control of the senior member of the patriline or a patriarchal figure. The generic term to express this built environment and its designated spaces is *musha* and to the Shona this environment and its spaces rather than the actual living space means the home.

A *musha* can be used as an analogy for some of the Zimbabwean settlements of the past — the way the entire settlement is organised, the organisational principles behind houses, and the other aspects of the built environment, the role of kinship, status and age within the concepts of organisation.[86] The implications of the *musha* demonstrate the importance of the extended kinship system to the Shona.[87] If the *musha* is used to describe the home of the nuclear Shona family rather than the extended family, it does not mean that all the family and rooms of the home are under one roof,[88] and the rooms are not interconnected as they are in a Western home. Much of Shona domestic activity or interaction takes place out of doors. The *musha* of today has an outdoor area or *dare* where people meet around an open fire, a laundry or line for hanging out clothes, a chicken coop, a grain store, a kitchen and an ablution block.

The home thus comprises a number of free-standing buildings, discrete structures which allow for the privacy of members within the family and the separation of the sexes that such privacy implies. The architectural structure of the *musha*, although stereotyped, reveals human values, human needs, and the social dynamics within the nuclear or extended family, and to a degree the economic functioning of the family. The *musha* tells a great deal about the Shona family, its communal values, its love of conformity, and its culturally specific customs, and conduct. Within the *musha* there is a designated boundary, and the boundary signifies the end and the beginning of the natural world; concepts of nature versus culture are very prominent in rural Africa. Several *misha* may be grouped together to form a *kraal* and the public spaces are swept every day. The *musha* is not the limit of the territory of the people, merely the limit of the built environment. People have fields to cultivate and land to hunt in. Shona and Venda chiefdoms are tied to land and if a potential chief moves away he loses the right to leadership.[89]

Traditionally the *musha* is not as cluttered as the Western home, with things incidental to daily use. However, Western material culture has made inroads into the *musha*, in the form of

cabinets of ethnocentric glass intended for display only, pieces of bedroom furniture which are both for use and status, as are tape recorders and the radio. But these factors have not taken away the traditional way of living, or compartmentalised the way of life in the way that the Western life is compartmentalised. They have not destroyed traditions. The majority of objects used in the *musha* are those which have always been in use, and a discussion of Shona material culture may be confined to these objects and their wider social and cultural implications.

While social relationships in a Shona *musha* are sustained by communal values and loyalties, kinship ties and economic needs, they are also sustained by communal rituals and ceremonies which require associated objects for their practices and performances.

Because of the personal nature of Shona religion, there is comparative lack of ceremony; there are not so many objects associated with religious practice as there would be for example in Ife, Yoruba or Benin society. The objects with a spiritual rather than a material function include *hakata* dice, and *tsvimbo*, walking sticks, also axes with ritual significance, and knives and headrests. While these objects do not have the power to represent spiritual forces, nor

are they used to venerate spirits, they have their place in ritual and ceremony, and often symbolise, if not actualise, power outside their objecthood. The *hakata* are small wooden or iron carved objects which are used by the n'anga in a combination of throws to predict the future, and diagnose illness. Each piece has its own design hollowed out of the material, and each design has its own significance.[90] The combination of throws is four, eight or sixteen. The *tsvimbo*[91] is an elaborately carved walking stick, which cannot be referred to merely as a walking stick. It has a carved handle which displays considerable carving skill. The *tsvimbo* is usually used by the medium in his or her dance and has belonged to an ancestor whose spirit possesses the chosen host. The *tshombo*[92] is an axe, taken beyond its function to be carried in the dance. The wooden pillow or *mutsango*[93] resembles the armrest of a chair or depressed table, supported by an intricately carved base. Although similar in form the *mutsango* is individualised by a design, in relief, carved on the support which in form often resembles the female breast. These headrests were evolved during the days when the older men of the village were expected to keep their heads above the ground while sleeping. They are passed down patrilineally and possess a ritualistic significance in the

ceremony for that ancestor spirit. Headrests for both men and women can be carved from one piece of wood. While the form of each headrest is similar, with various degrees of support at the base, the individual decoration on the body may be indicative of the highly personal nature of the headrest. In addition to wooden headrests, wooden stools are used. These stools are low-lying and mushroom-like in shape, and not unlike the headrests.

The range and scope of Shona material culture is not great compared to that of some parts of the world. The traditional needs of the Shona have been simple, and the functional capabilities of the objects have been great and varied. What was not necessary for use was not produced, and the fact that there is not a wide variety of objects does not detract from their interest and aesthetic value. Indeed, it is admirable that the life of the rural Shona has been sustained by such few objects. This speaks much of the function and practicality of the existing objects and their versatility. The Shona are not interested in creating what is new and original; it is what provides the impetus for them to create which interests them, and indeed this is evident in their sculpture. Many makers of objects, as well as makers of sculpture, claim to have been host to a *shave*,

or inspired by dreams, hence their knowledge of their work is inherent rather than taught.

The production of objects for Shona material culture today outside the home might be called a cottage industry. Some people work from their homes for a wider market, using natural materials and traditional means with their own methods of production. Works are marketed through co-operatives, or through stalls on the side of the road. While mass production and replication of traditional objects are inevitable, many objects are made as they have always been made, and maintain their traditional use and function. A thriving part of this cottage industry is the making of *gudza* mats, handwoven mats from bark, coloured with natural dyes.[94] The making of *gudza* mats is a social activity in keeping with the communal aspects of village life. Large groups of people are involved in collecting the inner bark of the trees, which is softened and made into the piece ready to be woven. The *gudza* mat is used for many purposes — clothing, beer filtering, and as maize containers.

It is not within the scope of this book to describe every aspect of Shona material culture, for example, spears, musical instruments, calabashes and gourds, and aspects of cicatrix and

personal adornment. It is, however, relevant to a book focusing on stone sculpture in Zimbabwe to say that notions of sculptural form were a traditional development of the Shona, as was the idea of each object as an individual object, although similar in type. The Shona traditionally have been attracted to the use of natural materials: stone, wood, earth dyes, grass and, earlier, clay. They adopted their own means of working these materials of which carving was one. Hence there is a strong sense of cultural tradition about the stone sculpture of the Shona, which can only be appreciated in the context of some discussion on Shona material culture, its production and function.

It is interesting to note that European artists in Zimbabwe are using techniques and materials used by the Shona. Potters are using skills of hand-building and open-firing rather than the kiln, and textile artists are using hand-weaving and natural dyes.

It is the intention of government to see that old traditions of object-making do not die out and that traditional objects are conserved and preserved. The aesthetic traditions of the Shona are seen to be a paradigm for the traditional Shona way of life. While proposed houses of culture are thought to encourage the local production of objects in a traditional manner, and create an interface between traditional and contemporary modes of object-making, culture is essentially a way of life and it cannot be institutionalised or determined by what is held in cultural institutions. The presentation of objects from traditional material cultures, whether they are institutionalised or otherwise, makes it possible for the traditional cultural practices and the contemporary practices to meet on equal terms, and for both to be recognised for what they are worth. If traditional objects are now ascribed as art with market values and are removed from their functional role, it does not detract from their cultural authenticity. The presence of these objects, and their preservation and conservation in Zimbabwe reinforces the links between the contemporary Zimbabwean and his or her parent culture.

It is essential that stone sculpture in Zimbabwe, which shares a commonality of material and means with many traditional objects, is not seen as a totally isolated phenomenon but as a new aspect of creative expression in Zimbabwe, an expression which has existed since the beginning of human kind. If the stone sculpture in Zimbabwe stops short at having a relationship with people of its own culture and society, its true meaning as an indigenous expression of Zimbabwean art is not fulfilled. The sculpture of the Shona is as much a part of Shona cultural expression as the material objects of the Shona, and it should be treated as such by those who present it to the public and establish its presence. Until all this takes place, stone sculpture in Zimbabwe is not truly Zimbabwean art.

Ndebele material culture is more recent than that of the Shona. Apart from recent traditions of basket-making, it is of historic significance through ceremonies and dances which still take place, such as the *impi* and *indlamu* dances, and special festivals such as the *inxwala* and the *ukuchinsa*,[95] and objects are used in association with such events. The Ndebele adopted a number of Shona cultural practices, and the built environment of the Shona hut. What is specifically Ndebele, apart from basketry, is a reminder of the militaristic nature of the Ndebele. Elaborate weaponry, in particular shields and spears, official and personal armoury, are the most culturally meaningful objects in Ndebele society. Contemporary Ndebele art has never emerged as a movement, although the realist paintings by the pupils at Mzilikazi School in Bulawayo represent a contemporary tradition which is not altogether culturally determined. Ndebele

material culture and art do not form a substantive part of this text, but it is part of the visual culture of Zimbabwe and must be given due recognition.

The people known as the Ndebele settled in western Zimbabwe in the early nineteenth century, in the area around Bulawayo, now a province of Zimbabwe known as Matabeleland. The Ndebele people initially were a multi-cultural group of various people sharing a common language, Nguni, a Bantu-speaking people. Two chiefdoms were formed into large scale kingdoms at the end of the 17th century. In 1816 and 1819 these underwent military defeat and ensuing political breakdown.

These disturbances, which took place under Shaka Zulu's rule of Zululand, were known as the 'mfecani' or 'great crushing', or 'grinding'.[96] The Ndebele were part of the Khumalo community which was led by Mzilikazi, one of Shaka's generals,[97] when the Khumalo joined the Zulus. Mzilikazi soon began to use his new position to amass his personal wealth and that of his people, an affront which led Shaka to take military action which led to the defeat of the Khumalo at the battle of Mhumane.[98] The outcome of this was the flight of Mzilikazi and the minority of the Khumalo, well trained and disposed towards fighting. They fled Shaka's

kingdom in 1822 and crossed the Limpopo River, and eventually settled in the Rozvi state of the Shona by the 1840s.[99] While adopting some aspects of the Shona culture the Ndebele were able to uphold their previous identity through a system of militaristic dominance. The Ndebele community consisted of, in part, a large number of regimental villages which housed young soldiers who also used to make raids. Those Shona who did not pay tribute to the Ndebele were raided.

Ndebele ritual and ceremony centred around consolidation of the status of the leader, firstly Mzilikazi and, secondly, Lobengula. This allowed for costumes, regalia and other trappings of power. In the ixwaba ceremony, Mzilikazi was conceptualised as a warrior as much as a leader; the high point of the ceremony was the throwing of a spear, to indicate the direction of the Ndebele's warfare and military strength. After this the young officers threw their spears on to the ground as a token of their allegiance.[100] The spear known as the assegai, was used for stabbing rather than throwing, and they were based on those originally brought from Natal. Spears were also given to soldiers when they had graduated from military training.

Ndebele material culture today has

little relevance to the former Ndebele way of life, yet it symbolised a way of life, socially and militaristically which was very different to that of the Shona. Its functions were abstract and symbolic rather than concrete: the upholding of status, the evocation of power, and the wealth of the leader. Perhaps the role of the leader might be compared with the divine kingship at Great Zimbabwe, but with the difference that the Ndebele king was very visible to the Ndebele people. In keeping with these concepts the Ndebele material culture was less a necessary part of life compared to that of the Shona.

The cultural sites of those who have inhabited Zimbabwe since the Late Stone Age are many and varied. They speak of many different cultural traditions in Zimbabwe and the presence of many different groups. They also speak of shared attitudes, and some have a symbiotic relationship. The cultural traditions associated with these sites were once dismissed but are now seen as part of the national heritage and part of the rich cultural endowment of Africa.

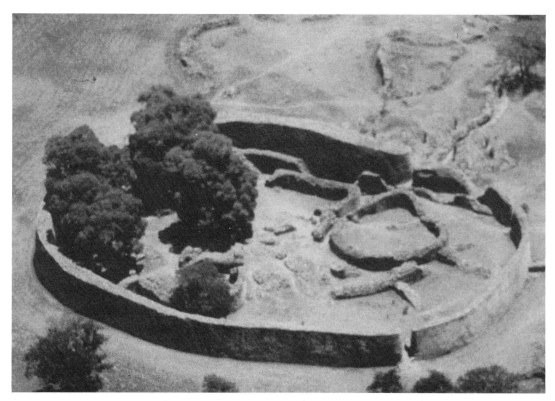

Eleven-metre-high walls surround the Great Enclosure, Great Zimbabwe Photograph courtesy Ministry of Information, Zimbabwe

Thomas Mukarobwa, *Suggest Paintings: Adam and Eve*

CHAPTER NINE

VISUAL ARTS SINCE THE NINETEENTH CENTURY

In the nineteenth century the advent of a white presence in what is now Zimbabwe — explorers, naturalists, miners and hunters — established, without intention, a tradition of white painting which flourishes in Zimbabwe today. These earliest works were essentially pictorial and topographical records of the experiences of the artists from the viewpoint of their various professions, or illustrative extensions of diaries beloved by Victorian travellers. Although these people did not consider themselves to be first and foremost artists, they created a genre of white Zimbabwean painting sustained during colonial times which at its best did not romanticise or prettify the African landscape, nor enoble or patronise the African, but accurately and realistically portrayed both.

From the journals of these artists comes an honest view of Africa: the flies, mosquitoes, heat and disease which afflicted writers. In these paintings, the African landscape remained as wild and untamed as it actually was then and largely is now, and things appeared not in terms of European expectations of Africa but as they were to the African. These were the days before the camera, and the paintings and drawings took the place of photographs and sometimes maps. Much of the illustrative work was

done in tandem with publications or journals of travel, and the detail and accuracy of the work was reflective of the artists' professional skills. A number of the artists were asked to join expeditions of exploration or were sent to Africa at the behest of organisations such as the Royal Geographical Society of London. If the paintings and drawings were more informative than artistic, the information was given in real terms, conveying much of what the camera conveys today.

One of the major early artists was John Guille Millais, who spent six months sketching and hunting in Zimbabwe in 1893. Millais was a hunter and a naturalist who observed the country and its flora and fauna with the eye of a naturalist rather than that of a romantic painter of his time. His animals were not always in a 'chronic state of charge'[1] but presented with the realism that the sportsman and naturalist, from close observation and professional experience of the fauna, understood[2]. Millais captured his prey on paper or canvas with the accuracy of a sports-man's eye and a gun shot at close range. His was no softening of the landscape to suit British taste, no subduing and muting of colour or the washing away effect used by the watercolourist. In these paintings, the African grass was

baked by the sun and flushed by the sunset, the kopje grey and wrinkled with age, and the tension of the balance of the rocks was shown.

Perhaps the best known of the artists was Thomas Baines, explorer, naturalist and artist, who as a chronicler accompanied various expeditions, as a photographer would do today. These expeditions included the Zambezi expedition by Livingstone in 1858. Baines' art was in reality an extension of the fieldwork he undertook in his other professional capacities, and in 1887 he was awarded a Fellowship by the Royal Geographical Society.

In 1861, he arrived at Victoria Falls (Mosi-oa-Tunya) with the explorer James Chapman, to make oil paintings, water-colours and sketches, some of which are now found in the National Archives in Harare. Baines spent much time at the Victoria Falls with a sextant, but his paintings have far more than topographical value. With measured accuracy and attention to detail, his works convey with realism the flow of water, the wetness of the spray, the transparency of the spume, and the crashing and rising of the torrent. The paintings not only embody the appearance of the Victoria Falls but also their sound. Today, the artistic merit of Baines' work is measured equal to its

documentary worth, and in 1960 the seriousness of his work was recognised in a one-person exhibition held at the National Gallery of Zimbabwe in Harare.

When what was to be known as Rhodesia was settled rather than explored by whites, there was little of the explorer's curiosity or the naturalist's sense of discovery to encourage the kind of chronicle-like painting characteristic of the latter half of the nineteenth century. There was little interest by the white settlers in exploring in reality, or on canvas, the distance, space and vista which are part of the Zimbabwean landscape. Art was not a priority in a country where an artist could not support himself, and energy was channelled into the more important things: the establishment of farms, the building of towns and the adjustment to a new way of life. However, from 1913 onwards, amateur art societies were established: the Institute of Allied Arts in 1913, the Salisbury and District Art Club in 1923 which became affiliated with the Rhodesian Society for Fine Arts in 1927. The nostalgic paintings which emanated from these societies had an essential Englishness. Rather than expressing this by sentimentalising the landscape and subduing its harshness by watercolours and washes, the artists returned home for the subject. In these paintings was a diminished sense of scale, the softer light of the British landscape, the grass greened by the rain rather than dried of colour by the sun. Here was a domestic countryside of hedgerows and roses, seen from the window by the warmth and comfort of the hearth. These paintings were essentially a postcard from home; Sunday paintings, and a relaxation from the harsh practicality of establishing a life in a new country.

It was these amateur art societies which virtually sustained painting in those early days until the opening of the National Gallery of Zimbabwe in 1957. Inclusive and unselective, exhibitions by these societies did not impose standards and did little for the pursuit of excellence and the quality of the art. Exceptions to the rule were two painters to whom Africa, rather than England, became home, and whose view of the landscape was not illustrative or modified to suit British taste.

Like Thomas Baines, British painter Robert Paul came to painting as a result of his other professional skills. Paul arrived in Zimbabwe in 1927 as a trooper of the British South Africa Police mounted patrol. He was employed to chart the land as a result of the skill of his sketches made on horseback. He retired in 1951 to devote himself to painting. He largely painted the Nyanga district of the Eastern Highlands of Zimbabwe. Nyanga is moody terrain, with unpredictable changes in temperature. There are inexplicable changes in light, form and colour, which do not altogether follow the patterns of weather or the cycle of nature. Paul's paintings were able to capture not only these changes but the moment of change — the point when the clouds appeared wrenched apart to show the sun, the sheets of rain which seemed sown like fine gauze on to the hills, granite rocks which follow no pattern, and light which ventures timidly over the horizon and then boldly envelops the day. It was Paul's split-second timing on canvas which makes his paintings memorable, and while his idiom remained European his art remained essentially African.

Thomas Papenfus looked at the African landscape through a surveyor's eyes. His paintings concentrate on the details of the landscape: the different grasses and their colours, the terrain of the mountains and the distances between, trees, the stance and attitude of the animals.

Although the eyes of both artists were trained to see the landscape from the point of view of their professions, they were able to translate these visual terminologies with remarkable skills,

vision and effect, into art. There is in both their work an expression of a personal relationship with the landscape. It is as if they were included in their own paintings, their feelings about landscape being based on personal experience. Initially lacking an audience, both painters continued to paint, and today their work has wide respect in Zimbabwe and beyond.

The opening of the National Gallery of Zimbabwe, and its early years, established visual arts practice as a serious and professional activity. These years marked a period of economic growth, population increase and urban expansion in Zimbabwe, and a number of established artists in their country of origin were new settlers. Overseas exhibitions organised by the first Director of the Gallery, Frank McEwen, encouraged a familiarity with international directions in art, and local conservatism began to break down. Locally, artists benefited from contact with artists from abroad. Standards evolved and complacency and parochial attitudes towards art began to lessen.

In 1958, the year after the Gallery opened, the Annual Exhibition was established. Here artists from the three countries in the Federation of those days (Southern Rhodesia, Northern Rhodesia and Nyasaland) entered their work, which was subject to rigorous selection and criticism. This was an indication of McEwen's obsession with standards and critical appraisal. For amateur artists, the Gallery encouraged the production of work of a larger scale to meet the dimension of the space, and necessarily work in media other than watercolours. It also encouraged people to consider their art as more than a pastime or leisure activity, and to subject their art to an impartial public and professional scrutiny. The fact that the Annual Exhibition was established during colonial times was a credit to the Gallery, and Frank McEwen. Equally important was that the Annual Exhibition was held within the precincts of an august public institution. It informed the public of the seriousness of art and the professional status of the artist. Hence the artist began to be held in more esteem by the community at large. Many of the people submitting work to the Annual Exhibition had little or no formal art education. However, the exhibition imposed upon them the notion of standards, selectivity and criticism which are often the product of art education. It also fulfilled needs and expectations which had not been fulfilled before, and instilled the appropriate kind of competitiveness in the artist and a concept of achievement which had nothing to do with commercial success.

The Annual Exhibition allowed for exposure of the work of a number of new citizens, work which had its roots in international practice and the visual expression of their home countries. It encouraged the painter to employ the use of abstraction and symbolism to convey the Zimbabwean landscape, and this broadened the expressive scope of this genre. However, it cannot be said that a school of Zimbabwean landscape painting arose out of these conditions, because the traditions through which the Zimbabwean landscape were expressed were too broad and varied for one style to emerge. The natural environment of Zimbabwe is ever present, and although it does not prevent painters from working in other genres, most painting by white Zimbabweans has a relationship to its colour or light even if it is not used as the subject.

In many paintings by white Zimbabweans it is as if the artists have been initially concerned with light, a colourless phenomenon which is built into the paintings like a material, and which appears to intensify various aspects of natural colour — the yellow of the tall, summer grass, the sky sometimes a choleric purple. It is the light, although colourless, emanating from these paintings, which has an African sensibility whether or not landscape is the painter's

subject matter.

The war in Zimbabwe took its toll on composition and form in paintings by whites. They reacted to the war by reflecting its tensions rather than its incidents in a highly physical way. To many in the war little happened but people constantly worried about what might happen as though it had already happened! Painters reflected the war as a mental state rather than a physical event, and they were not far from the truth as it was represented to people who were not involved in the incidents of war. In these paintings, it was as though emotion was in-built into the paint.

While some painters, through their paintings, endeavoured to leave themselves out of the war, one of Zimbabwe's leading abstract painters, the late Marshall Baron, endeavoured to share his feelings, presenting the viewer with a vortex of paint which spoke of a conflict of emotions, and a sense of irresolution. His were aggressively surface paintings, images with an expressive charge stopped short of meaning, and denying the viewer the subject.

Since the war and the advent of Independence for Zimbabwe, white artists have continued to paint the Zimbabwean landscape as if it was hardly inhabited by man, yet these paintings are not devoid of human interest. Even if

man is not represented in these paintings, the paintings speak of the challenge the landscape offers man, of the distances to be crossed, of the physical barriers of the mountains, and of the altitude and the elements. In many of these paintings there is a sense of the emptiness of the landscape, of vast tracts of space, of a feeling that nothing has happened and that nothing ever will happen.

If depicted, the figure is often a lone figure, walking down a road which seems to come from nowhere and lead to nowhere, a figure without a sense of destination. It is a landscape where things are explained by their absence rather than their presence. In these paintings there is the feeling of the heat after the rains, the sweatiness of the ground, and the air redolent with moisture.

It is significant that the majority of Zimbabwe's white painters, working today after Independence, are self-taught or received art education outside Zimbabwe. Seldom have white painters in Zimbabwe shared the experience of working or learning together, although the Pachipamwe Workshops held in Zimbabwe in 1988, 1989 and 1990, offered artists the chance of such a shared experience. These factors, and also the fact that there are comparatively few white painters in Zimbabwe, have

meant that they have never been thought of as a school, and have invited little comparison. While a number of painters share a preoccupation with the Zimbabwean landscape and environment, each expresses a very different response to what he or she sees and experiences.

The late Jean Danks details a very small section of the landscape which although abstracted, minutely analyses the structure and form of the trees and rocks. Her paintings stem from close observation of the landscape, and familiarity with small areas of it. In her paintings, rocks and trees are defined by changes in colour and tone. As with other white Zimbabwean painters there is nothing pictorial about her work, and no attempt to impose upon the landscape a beauty which is in the mind of the beholder only. To Danks and other Zimbabwean painters, the visible world of Zimbabwe is contained in the land-scape. In their highly textural paintings, there is a sense of the feel of the landscape as well as the sight of it: the hardness of the granite rocks, the smoothness of the bark, and the slipperiness of the leaves after the rain.

The paintings of Ann Linsell Stewart, now resident outside Zimbabwe, have a sense of the landscape stretched like a giant canvas over the earth, and of the relationship of houses and people to

the distance within the landscape. The subject is perhaps more recognisable in her paintings than in those of other painters, and she deals with the familiar. In *Ploughed Field* the paint appears raised from the canvas to convey the furrows which have been ploughed. Here the ploughed field is parched and dry, and the furrows are like cracked lips. A figure seems poised to begin a never-ending walk on a road which comes from nowhere to what, to us, is the outline of a farm. Here paint is restricted to a palette of earth colours; the earth is reflected in the sky — pale ochre, devoid of its natural blue. These are the colours of Africa — the light brown dust appears in the paintings to rise from the ground and envelop not only the figure but the viewer as well. Linsell Stewart's paintings portray Africa as those who live there know it, not as it is perceived by those from the outside. They speak of the drought, the heat and the rains which govern the life and create the essential human predicament of those who live in the African rural areas. These paintings involve us in the struggle of man, black and white, to live in these conditions, but they generalise rather than particularise this predicament. Often without a subject they tell a story and involve us in the plot.

In South African-born Henry

Thomas Baines, *Victoria Falls*

Thompson's paintings, the Zimbabwean landscape, abstracted and minimalised, has the required sense of space and sparseness. The placement of one or more figures in the landscape apart from giving the paintings a sense of scale, reassures us of a human presence and reminds us of our relationship with the landscape, and of our closeness to the natural world. Henry Thompson sees the barrenness and emptiness of the African landscape as an essentially European

perception. He feels that to the rural African the landscape is full of incidents and events which are part of his life, but in his paintings detail is not used to convey these sensibilities. Without actually being depicted, the presence of the African is implicit. There is a sense that the landscape belongs to the African rather than the European. While his *Winter Landscape* is devoid of human occupation, the long grass is full of an unseen living presence. Henry Thompson

is obsessed with the African light which heightens and defines colour as opposed to the European light which mutes and softens colour. His colours are the bright blues, yellows and reds of Zimbabwe, and his forms and shapes have the clear definition that the African light provides. Thompson's work is never of a particular landscape; rather he conveys the atmosphere of all Zimbabwean landscapes — the harsh light, the distance and the colour. To the viewer here is landscape as it is truly experienced by those who live in rural Zimbabwe. Here is the visualisation of one who has lived in the bush, and who values what is left of its natural state.

Indian-born Thakor Patel's paintings are well respected both inside and outside Zimbabwe. In his paintings, which are abstract in the purest sense, a series of unassociated images gain significance through their placement in compositions of considerable subtlety and extreme beauty. Patel's untitled abstract works seem remote from subject. While the images used are recognised shapes, they are devoid of specific identity. Patel considers the use of a form (never an object) in one painting and then, in another, recontextualises the form; things become new when they are seen in a new way and they are changed by placement. 'If

something remains in the same place it does not change, if something is moved it does, even though it remains the same thing.' In his paintings, Patel takes poetic licence with images and their known associations. It is painting and poetry which to Patel 'legitimise the power of the imagination to create a black rose, a dry sea and a burning sky'[3], to make things do what nature never intended them to do, and convey these new associations with conviction. Patel comments that if he shows his paintings in the United States no one would ever know that he was an Indian painter. His work is essentially acultural, sharply delineated, and brightly coloured; forms appear as if seen in the African light, which in turn seems to emanate from his paintings. In these paintings, space has its own identity and significance. It surrounds not only the images and forms contained within it, but also seems to surround the viewer. We feel as if we are inside and outside the space in Patel's paintings. We also feel that we are looking through them to the outside world. Patel's recent paintings include three in which sculptural forms, avoiding subject, convey a third dimension in the two-dimensional world. Here, the artist is trying to portray the material (stone) and the form (sculpture) without referring to any particular sculpture. Paint takes on

the surface qualities and texture of stone. Overall, Patel's images, as much as they cannot be defined, seem to exist outside the paintings, and to be part of our world as much as that of the artist. Without conveying subject or meaning these paintings have much to say and they are easily understood.

Helen Lieros is one of Zimbabwe's leading painters, and her work is widely acclaimed both inside and outside the country. She was born, of Greek parents, in Gweru in the Midlands of Zimbabwe, but her art education took place in Europe. In her career as a painter she has divided her time between Zimbabwe and Europe. 'I used to think that I was of either an African or Greek background, but now I don't know. Today I am still trying to find my roots and I feel I have no roots.' In a sense, Lieros is a cultural exile: in another sense, she represents, through her work, the best of two cultures. This is reflected in the imagery of her paintings — a symbiosis of the African and the Greek, and in the use of colour which comes from both an African and a Byzantine source. Lieros does not consider herself a landscape painter, but her paintings are full of the space and forms of the Zimbabwean landscape. Like the paintings of Henry Thompson, her paintings appear brighter than they really are, and perhaps are made so by the

clear light which intensifies colour in Africa. At the same time, the hues used — reds. yellows and blues — have an association with Byzantine art.

In her current paintings, the light and colour of the African landscape, without specifically representing that landscape, appear to be haunted by some ancient Greek statuary, perhaps a paradigm for the shifting location of Lieros' identity. Here shapes slowly form the outline of an African mask: more solid forms accentuate the insubstantiality of the Greek imagery which appears to float on the canvas, disembodied and detached. There is a sheen and gloss about these paintings. The material qualities of paint absorb Lieros: in particular, its textural possibilities. In many paintings, paint is built up to create a three-dimensional quality, oozing from the canvas as if still wet. At times, colour (with the texture of material) seems draped on the canvas, the paint carefully arranged in folds. While the paintings are indicative of considerable drawing skills on the part of the artist there is nothing illustrative about them, and they have no sense of narrative. However, while they tell us little of the subject, they tell us much about the artist, her origins, her moods and her emotions.

Lieros feels that Zimbabwean painters use their isolation to good effect. 'We do not have outside influences and are not persuaded like artists in Europe to subscribe to prevailing fashions. Although painters in Zimbabwe have a close relationship we retain our individuality, and rather than looking to other art for our direction, we are doing more self-analysis to try to establish who we are.'

Teaching black African students at Ilsa College in Harare, Lieros prepares them for their O levels. She feels that young, black African painters are more preoccupied with colour than shape, possibly because colour plays such an important part in their lives, and has a role within social dynamics. These painters, she considers, are not trying to merely depict things but to discover their deeper significance. Rather than learning history, or reading Shona or English literature, these young Africans express themselves through their art. The painting is like an essay or composition: the putting down of their thoughts is a visual language, translating thoughts into visual images.

She says: 'I think young African painters today do not want, like the sculptors, to belong to a tradition, they want to be an individual and say "look now I am me, see me through my art". It is possible that in ten years time the paintings in this country will be of more interest than the sculpture.'

A parallel to the development of white Zimbabwean painting in its early stages was the work of black Zimbabwean painter, Kingsley Sambo (1932–1977), which presages the realistic work of a number of black Zimbabwean painters today. Sambo started painting at Cyrene Mission, and his early work shows a sense of space crowded to its limits to accommodate all the detail necessary to convey the subject. As urban Zimbabwe is crowded with African life, so are Sambo's paintings. The paintings are full of a rhythmic application of paint, and the physical expressiveness of people who establish contact and social relationships. Sambo's paintings are full of the vivid colours loved by the African. There is the human interaction at many levels in a small space, characteristic of African life in the urban areas. As well as living in Harare, Sambo moved into the rural areas, and his paintings of the rural areas indicate the casual yet structured social dynamics of rural African life.

His subjects also speak of the patience and endurance the African must undergo, waiting in the queue for the bus. Although Sambo's paintings do not depict the darker side of African life, or convey a message, they must be considered as social realist. They are both impressionistic and expressive in the way

Thomas Papenfus, *Agaramogora*

that only black African painting can be.

While white painters in Zimbabwe remain individualistic, a more unified recent tradition of black African painting has been established at the Mzilikazi Art School in Bulawayo. The school was established in 1963 by Alex Lamberth, who in 1974 waged an unsuccessful campaign for the establishment of a Fine and Applied Art College for Africans in Bulawayo, justified by the following comment: 'It seems almost unbelievable that in the whole of Rhodesia, with its enormous and rapidly increasing African population … there is not one academy or school for the teaching of fine and applied art. '4

The Mzilikazi Art School is as much a community centre as an art school, which allows underprivileged and disadvantaged black Africans from urban Bulawayo to establish their relationship with, and their role in, society through artistic expression. Training in figurative painting and sculpture allows these young people to produce a more permanent and enduring record of what is taking place around them.

The painting and sculpture at Mzilikazi, the artists' feeling that they are members of the community, the social dynamics and interaction which sustain community life, bring people together.

The paintings and sculptures at

Mzilikazi may be described as social realism and social criticism. They focus, in part, on incidents such as road blocks and unemployment, which fragment the community structure. These are paintings of life as the artists know it and see it, and in this way they bring Zimbabwean art into the area of social comment. They place the viewer in the middle of the action and in a sense allow their social problems to be shared.

The paintings at Mzilikazi are small paintings, with many people and much action crammed into a limited space, reflecting the high density of population in the urban areas. There is no dramatisation of the events taking place, and there is a feeling of philosophical acceptance of disturbances to the community as though they are a part of everyday life — a life which cannot be changed or improved upon. The paintings show a competent handling of special issues such as the matter of human scale and the urban environment, unusual in African art.

As a community centre, the influence of Mzilikazi extends into the community. Evening classes are given to adults; classes are given to students in neighbouring schools and to handicapped children. Hence the interaction of the artist and the community takes place in more ways than the practice of art.

Tuition at the school is free and students are accepted on the basis of aptitude.

The school reinforces its social contribution to the community by offering students opportunities for education and employment, on leaving. In a climate of high unemployment in Bulawayo, students are steered towards self-employment, to establish new or to join existing cooperatives thereby generating an industry for art in terms of their own resources. Thus, job creation as an aspect of employment for students is a priority of Mzilikazi. Works are offered for sale and profits ploughed back into the school.

One of the strengths of Mzilikazi is that it has actually produced a school of painting — the collective statement expressing the importance of the subject. Here the outreach is to an audience of the same culture as the artist. Mzilikazi art is not political but nonetheless it contains a political statement in that it is a cry for a solution to social problems, and addresses issues and events of recognisable interest to black Zimbabweans in their own terms. As with the Tengenenge Sculpture Community, the provision of art education at Mzilikazi has a wider significance in that it assists the cultural, social and economic development of students and does not separate art from life. Here is art

education which affords art its proper place in the community. If these paintings appear an essay in photo-journalism the artists see with the eye of the camera, and what we receive is a chilling document, through children's eyes, of the problems which create disadvantages and lack of privileges in urban Bulawayo.

Many contemporary Ndebele artists have a more spontaneous relationship with their culture, be it urban, traditional, or rural, than that introduced by Europeans. There is within Ndebele culture much art-related practice with cultural relevance. In particular there is the decorative painting of the Ndebele houses, by the women. For example, when the bride comes to the house of the bridegroom for marriage, the house is decorated. Certain motifs will show the wedding, and some symbols are in themselves designs. There are certain compositional rules — white and black outline the symbols and motifs which are in bright colours: red, orange, yellow, blue and green, deemed culturally appropriate for weddings.

Baskets for everyday use have now, in a commercial sense, become art objects. These are woven from sisal which is grown on the river banks. The baskets largely display diamond motifs.

In the beerhalls in Bulawayo, often

frequented by rural Ndebele, cultural traditions are expressed through decoration to make the rural Ndebele feel at home.

Gateways to Ndebele homes which, in part, establish the social dimension of Ndebele domestic life, are sculptural in form and are often decorated in geometric designs.

Many Ndebele artists are conscious of the art-related activity within their traditional culture. Dumisani Ngwenya, one of the best known Ndebele artists, and a member of staff of the National Gallery of Zimbabwe, uses the images and symbols with cultural value within both Ndebele and Shona culture in his paintings and prints. He feels that through this use of symbols and images he establishes for Zimbabwean art a direct relationship with Zimbabwean culture. With the use of geometric symbols his paintings and prints have a strong sense of design, veering towards the abstract, but yet their cultural significance is recognisable, not only to the artist but to those from either culture.

Taylor Nkomo, a graphic designer with the National Gallery of Zimbabwe, is a well-known Ndebele painter, sculptor, designer and print maker. His references are not specifically cultural; his paintings are essentially a scenic interpretation of

the Matopos Hills near Bulawayo. Setting the rocks and trees against a white background, the starkness of the Matopos is apparent in the paintings. Taylor Nkomo feels that there is a tradition imposed upon Shona sculptors, rather than the artists creating their own tradition. He does not see his painting as being particularly 'Ndebele', but as the response of a landscape painter to the environment around him.

Many of the artists living in Bulawayo are white, responding to Western traditions of art to which they were exposed at art school, and perhaps translating their vision of these traditions into an exploration of their relationship to the African landscape, or local social issues.

Berenice Bickle heightens the voluptuousness of the sexual experience through her use of colour: rich reds, glowing yellows and incandescent purples.

Many Bulawayo artists (together with Harare artists) have attended the Pachipamwe Workshops which, in accordance with the ideals of the founders of the Triangle Workshops in America — South African Robert Loder and sculptor, Anthony Caro — see artists working together intensely for two weeks. The cross-fertilisation of ideas results in the mixing of media, and

the crossing of the boundaries of classification. Here at Pachipamwe, influence is seen at its best, leading not to imitation but to experiment and innovation.

If the stone sculpture of Zimbabwe is considered today to have become an industry rather than an art form it is refreshing to find sculptors, in particular in Matabeleland, working in other media, whose interests are not overtly commercial.

The Weldart Competition, established at the National Gallery of Zimbabwe in 1977, and the presence in Zimbabwe of Professor Melvin Edwards, a metal sculptor, who is Head of Fine Arts at Rutgers University in the United States, together with the fact that a number of urban areas in Harare and Bulawayo abound in scrap metal, has encouraged sculptors to work in welded metal. Largely, these sculptors, black and white Zimbabweans, explore the expressive rather than the technical possibilities of the metal.

Metal sculpture, internationally, has become a movement of sculpture born of other movements — minimalism — abstraction — constructivism — and to some extent it has become repetitive and academic.

Metal sculpture in Zimbabwe has remained outside the mainstream and

has developed a vernacular vocabulary. The work of Zimbabwe's metal sculptors has a sense of innovation and experiment, and is free of influences. These sculptors apparently see no limitation to the potential of their material. In the Zimbabwe Heritage Exhibition at the National Gallery of Zimbabwe in 1989, there was no specific category or section of sculpture, and awards were given for sculpture in metal, wood and stone.

Adam Madebe and David Ndlovu, both Ndebele and resident in Bulawayo, have been associated with the Mzilikazi School, and their experiences in life drawing have a direct bearing on their metal sculpture. In the work of both sculptors, the human body seems the matrix of physical power. Here the previous existence and identity of the metal gives way to the manner in which it is used to express human form. While the figures made are not representative of individuals, it appears they are based on the artists' perceptions of a particular person, and indicate that they might have been based on a study of the actual human body. The use of material in their work seems almost incidental to the purpose of the work, which appears to be to convey the way the human form is constructed, and the strength that the construction allows. They both use the metal as though to cover the human

form like a massive suit of chain mail, and nudity is conveyed with no sense of impropriety.

The sculpture of Arthur Azevedo, born in Harare in 1935 and still living in the city, sees pieces of found metal objects, which have an existence in their own right, take on a new identity through a new association. These sculptures convey the fact that existing metal objects often remind us of something else far removed from the purpose and function of the object.

While the objects used have little association with their previous function and existence, there is little change in their condition. It is not the external appearance of the object that is changed to bring about its new associations, but the imagination and vision of the sculptor.

Azevedo sees the potential associations of his objects prior to commencing the sculpture, and it is through his way of viewing the material, that the subject is reached. His sculptures encourage us to see those associations for ourselves, to appreciate the powers of suggestion of metal, and to extract from form a measure of content. His work has a residual association with the biomorphic forms of the British sculptors: Armitage, Chadwick and Moore. His African animals for which he is best known, capture the movement of those animals and their ability to move quickly over long distances, and the importance of speed and motion to their survival.

The appeal of the natural material, however, remains residual in the minds of Zimbabwe's artists.

The tall etiolated figures of Kenyan sculptor, Joseph Muli who has worked as an artist in Zimbabwe for twenty-nine years, gives wooden sculpture in the country an established history. These sculptures are universal in statement, in their expressions of sorrow and grief, but speak also of the dignity of the African and his pride of race and heritage in whatever situation he might be placed.

The work, in wood, of July Nyengera assesses the classical heroism of the Greek and Roman statue, but gives to Zimbabwean art a political slant which is unusual but not untoward.

Gerard Dickson's humorous, large-scale wooden sculptures give the African subject a European idiom, and African folk culture a lighter side. Each of these artists' work establishes their individual direction, and speaks well for the future of Zimbabwean art.

The wooden sculptures of Morris Tendai poke the fun of the fair at Zimbabwean popular culture. Tendai's wooden figures appear to act out the drama of the narrative conveyed. The bases on which the sculptures are placed assume the floor of the stage, groups of wooden figures take up the dramatic pose for the actor, and are obviously engaged in some kind of dialogue and conversation. They appear like puppets with strings, perhaps to be manipulated by the viewer, or moved at will like pieces of a chess set. Tendai was a carpenter before he became a sculptor, and his work has a sense of the joinery that is part of carpentry, and the whittling away of the wood. Tendai adapts part of Western popular culture to an African idiom, but he does not neglect local concerns and issues, such as famine and baby dumping. He turns sculpture into an aspect of Zimbabwean popular culture easily read by those in the beer hall, or at the dance or the shebeen. He thus extends the outreach of Zimbabwean sculpture and, like Azevedo, Madebe and Ndlovu, makes a case for Zimbabwean sculpture rather than exclusively Zimbabwean stone sculpture.

Zephania Tshuma is a sculptor in wood and reinvents traditions to allow them to be interpreted through contemporary associations. In wood he has created the crucifixion as an event of today — Jesus, a man of our time, in running shorts.

Tshuma lives in West Nicholson, outside Bulawayo, and for three years he took a course in building. His wooden

Robert Paul, *Inyangani*

sculptures have a sense of construction, of building up, which may be an outcome of that training. As well as reinventing tradition, Tshuma invents folklore which possesses the moral statement characteristic of the fable. His stories in wood have a macabre twist and they express a sense of the darker side of fantasy.

Perhaps the situation of Zimbabwean art today is best expressed in the work of Richard Jack. Whether it is painting, or sculpture, Jack's work has a cultural richness. His art is not African in its sensibilities, but one cannot avoid its African qualities, which lie deeper than a European's mere observance of things African. The fact that his work is art, is not altogether important to him, it is a

means of communication which could just as easily take place with words. Jack's work incorporates a variety of established traditions in Zimbabwean art. His stone sculpture, which although very much his own and not consciously African, nonetheless relates easily and disarmingly to the tradition of stone sculpture. In his landscape paintings human beings are used as a metaphor for the fact that man is very much part of his environment and, like other white Zimbabwean painters, this indicates what he feels about the landscape's effect on man and man's reactions to it. Many of the materials used in a developing country have been well used or over used. These materials are used both in his paintings and his sculptures. Here

is the idea that traditional or accepted cultural significance is not the only cultural significance, and a statement that culture can survive development and change.

Richard Jack works in isolation and his work is not often seen in Zimbabwe. Yet young sculptors are unconsciously following in his direction, through some kind of instinct which seems to be part of a broader collective consciousness in Zimbabwe, a consciousness which cannot yet be classified or defined.

The established presence of these artists in Zimbabwe, and their growing recognition outside the country, in no way diminishes the importance of stone sculpture in Zimbabwe, but it does reflect the variety of social and cultural traditions, and directions in international practice which are now influencing the art of the nation.

While it is not in the scope of this book to establish a detailed chronology of visual arts practice in Zimbabwe, it does establish the cultural pluralism which is part of the freedom offered to the individual in post-independent Zimbabwe.

Chapungu Sculpture Park

CHAPTER TEN

PRIVATE PATRONAGE OF THE ARTS

In the 1960s, the aim of Frank McEwen and Tom Blomefield was to create a market for stone sculpture inside and outside Zimbabwe, and to impress upon the sculptors' audience their genuine belief in the seriousness and cultural authenticity of the art. At this stage, it was the market response to the art rather than the artists' response to the market which made the art successful. As the sculpture was new, the potential market had little expectations of the sculpture, and there was little commercial pressure placed upon the artists. Its presentation by McEwen and Blomefield in Zimbabwe, and particularly abroad, applied appropriate conditions of connoisseurship: discriminate and definite group exhibitions, scholarly promotion, and good catalogue introductions. Appreciation of these conditions was manifested in exhibitions held under the auspices of the National Gallery of Zimbabwe at the Musée Rodin and the Musée d'Arte Moderne, both in Paris, in 1971 and 1972 respectively.

After Frank McEwen's departure from the National Gallery in 1973 until Zimbabwe's Independence in 1980, the National Gallery's directors did not give the sculpture the serious attention afforded to it by McEwen, although the permanent collection was built up (albeit without much historical significance) and

the sculpture garden at the back of the Gallery was established. The sculpture, rather than being supported largely by the Gallery, was sustained by private galleries who were marketing rather than promoting art (with the exception of The Gallery Shona Sculpture which opened in 1970).

During the 1970s the Tengenenge Sculpture Community continued to establish a presence for the sculpture in South Africa and further afield, and in Harare in its own gallery. At that time, the opportunities for professional representation of Zimbabwean sculpture, as it would have taken place in galleries in Europe, were few and far between. The marketing, presentation and promotion of the sculpture was directed by a tradition established by the sculptors rather than the gallery directors which was not always in the interests of either. The sculptors, out of economic necessity, were concerned with the short-term benefit of sales rather than the long-term benefits of representation and promotion. They did not envisage an exclusive relationship with any one gallery and when there was more than one gallery, out of a monetary need, would offer their work to all galleries. After the departure of McEwen, the sales of sculpture by the National Gallery of Zimbabwe and the private galleries was

in the nature of a business transaction and an end in itself.

Today, the more favourable socio-economic climate, thirteen years after Independence, has led to a more professional representation of artists. The existence of more galleries, and a demand equal to the supply of works from both the local and overseas market collectively, meant that galleries had to move away from the artists' established tradition to work in the interests of both the sculptors and the galleries. While measures of quality control of the sculpture are sometimes still inadequate, and young artists are thus encouraged to make more art rather than better art, galleries are working towards more serious long-term representation of artists and, more importantly, looking towards representing the sculptors as individual artists rather than as members of a group. Artists themselves are beginning to see the benefit of an exclusive relationship with one gallery which works in their interests, and to see the benefits of long-term representation and promotion as well as immediate sales.

The overseas market for sculptors, neglected after McEwen's departure, has become well-consolidated through the National Gallery, the private galleries and the Ministry of Education and Culture. A contentious issue currently being debated

is whether or not the best work should be kept in Zimbabwe or sent outside the country.

There are five private galleries in Harare which work in highly individualistic ways to serve the interests of the artists and meet the demands of their essentially European market.

It is perhaps fitting that the emphasis today of The Gallery Shona Sculpture, Zimbabwe's oldest private gallery, is in the words of the Director, Roy Guthrie, upon conservation, documentation, and the building-up of a permanent collection which includes early work. Such an historical emphasis is in keeping with the duration of the gallery's operations (since 1970) and is significant to its historical achievements.

The Gallery Shona Sculpture was established as African Art Promotions in 1970. Its original directors were Mr and Mrs Arturo Larrondo from Buenos Aires, who managed the gallery for three years. From the gallery's inception, work was bought from major artists, and as the National Gallery of Zimbabwe, after Frank McEwen's departure in 1973, had little focus on sculpture, The Gallery Shona Sculpture was often the only outlet for the work of major artists. It was the exhibitions held by the gallery in public venues and established galleries, from 1973 until the early l980s, which

created an ongoing international presence for the sculpture.

Guthrie comments: 'Much of the work we did in those days should ideally have been done by the National Gallery.'

These exhibitions took place despite lack of foreign currency, and other economic difficulties, and at times with little margin or opportunity for promotion, advertising or contextual presentation. This meant that the work had to stand by itself, and its full cultural significance was not always realised.

The establishment of public venues was also difficult, as Guthrie comments: 'The motives of a private gallery are always suspect particularly in official circles.' Today the role of The Gallery Shona Sculpture is changing in appreciation of the new dynamic of the National Gallery of Zimbabwe under the direction of Professor Cyril Rogers. This is a dynamic which includes the promotion of all aspects of Zimbabwe's art outside Zimbabwe, often in participation with the Ministry of Education and Culture.

In 1990 The Gallery Shona Sculpture organised a very successful exhibition of the work of master sculptor Nicholas Mukomberanwa, at the Sydney Opera House. The exhibition had an historical and developmental dimension through including works from private collections, and was very well received in the

Australian press. This exhibition followed his one-person exhibition earlier in the year at the Chapungu Village.

Also in 1990 The Gallery Shona Sculpture held an exhibition in Stockholm which then travelled through small centres in Sweden, and went on to Norway, Denmark and Finland.

An exhibition was put together for the Yorkshire Sculpture Park in England, held from July until November 1990. From its permanent collection at Chapungu village, The Gallery Shona Sculpture provided a large selection of sculptures of an appropriate size and scale for display in an extensive outdoor area. This was the first time that pieces of such magnitude have been seen outside Zimbabwe — thirty tonnes of sculpture were sent by sea and eight tonnes by air.

It is possibly because of its early support for the major artists that The Gallery Shona Sculpture today has retained the loyalties of major artists such as Henry Munyaradzi and Nicholas Mukomberanwa, although they are not contracted, and are free to sell their work from home and through other galleries. The retention of work and the purchase of work for the permanent collection is seen by Guthrie as part of his long-term promotion and representation of his artists. The collection enables an artist to

see his progress in terms of his career and his development in terms of changes of style and formal approaches, and is of great assistance to scholars. The collection is also a constant reminder to artists of The Gallery Shona Sculpture's constant support and encouragement of their work. The combined permanent collections of The Gallery Shona Sculpture and the National Gallery of Zimbabwe creates an art/historical base for consideration of the sculpture, and permits a critical and comparative assessment of work to be made over a period of time.

The Gallery Shona Sculpture is to be found in Msasa, an industrial suburb of Harare. The gallery extends to a large outdoor sculpture garden which leads to a lake. It is part of a large complex of businesses known as Chapungu Village and is a tribute to the entrepreneurial skills of Guthrie. Chapungu Village gives a sense of the scale and scope of the Guthrie enterprise and a feeling that there is nothing that cannot be achieved and that there is still much to come. It provides a natural setting where sculptures seem to become the things they represent: creatures of nature hiding in the rocks or resting on the ground in the shade of trees; birds and beasts of every species; and every kind of human being. Here Bernard Matemera's figures

turn nature into a personal playground, and Henry Munyaradzi's *Lion* claims its territory from the banks of the lake.

The spacious lakeside grounds of Chapungu Village provide the opportunity for young sculptors and some master sculptors to work within their traditional environment. Many of the young artists come from industrial areas where working space is at a premium, and they welcome this chance to work more comfortably.

It is clear from the range and scope of The Gallery Shona Sculpture's permanent collection that the gallery has had an historic monopoly on the best work of a number of artists, including many from Tengenenge, to which The Gallery Shona Sculpture has given strong support without establishing a formal relationship. This collection speaks of the power of money and its exercise of the dynamics of Zimbabwean art. Although Guthrie insists that he is not in competition with the National Gallery of Zimbabwe it is obvious that his collection rivals that of the public institution. It is Guthrie's intention to further enhance and substantiate this collection by commissioning artists for further major works.

In the days of African Art Promotions, works were bought outright from the sculptors. Average selling prices for major pieces ranged from Z$30–Z$60 and the

average monthly income of the gallery was approximately Z$300 and the monthly turnover would increase accordingly. Works are bought outright, and prices are established without consultation with the artist, not at a 'set mark up' but according to the value of the work in the eyes of Guthrie. In accordance with his conviction about the worth of the works the prices are high. If the works are sold on commission, prices are mutually agreed between the artist and Guthrie. Guthrie believes in the merit of a contract, and compliments Roy Cook, the director of the Matombo Gallery, on his meaningful and sincere promotion of artists through the setting up of contracts. However, he sees the danger of contracts as curtailing the freedom of artists, and possibly encouraging the production of second-rate work. He feels that the artists should be fully aware of the implications of a contract and, having signed it, should honour it.

Guthrie is of the opinion that Nicholas Mukomberanwa and Henry Munyaradzi, among other artists, will be known in international art circles in the future as French Impressionists are today. He persuades us both to share that conviction and believe that he will play a large part in ensuring that success. However, concentration on the establish-ment of a permanent collection for The

Gallery Shona Sculpture imparts a new element of seriousness and historical interest to the sculpture, and adds to the gallery a cultural dimension which is not directly connected with its highly successful commercial operation. It also establishes the fine arts value of the sculpture. This collection and its recent scholarly documentation by Professor Helene Nelkin, together with that of the National Gallery of Zimbabwe, is an exercise in connoisseurship that the sculpture badly needs. It will impart notions of excellence to artists which are far removed from commercial gain, and ideas of worth which are not associated only with money. It will assist the argument that the best works should be left in Zimbabwe, and will create, in Zimbabwe, an awareness of the sculpture as part of the country's national heritage.

Roy Cook, the Director of Matombo Gallery in central Harare, sees the measure of seriousness of his local operations as a recipe for the success of his gallery's operations overseas.

The new building for his gallery is crowded but not cluttered, and there is a sense of the artists' individual presence as much as a group or a movement. Similarly, Cook speaks of his artists as individuals as much as belonging to a movement or a group. Cook's presentation of his artists' work focuses on their individuality. His brochures contain contextual essays and biographies of each of the artists he represents, and overall there is a strong feeling of the Matombo stable. Cook's relationship with his artists embraces his concern for their careers, their long-term goals and their individual recognition. He sees his success in terms of movement towards the attainment of his long-term objectives. He sees his role as a gallery director in an international sense rather than as a dealer, and despite the difficulties of establishing such a position in Zimbabwe he has made several radical moves in this direction.

The majority of artists represented by Cook are under contract. This has gone against tradition, but the artists have come to see contracts as a necessity if they are to be treated as individuals to be represented and promoted, and their work sold. Cook comments: 'A gallery overseas will only offer an artist a one-person exhibition if the artist has had a long-term relationship with an existing gallery in Zimbabwe. If I go overseas without a contract I am simply selling the work rather than promoting the artist, and an established gallery will not take me seriously or associate our gallery with its long-term plans. If I do not contract the artists I cannot justify, in business terms, the time and money spent in promoting their careers.'

Cook feels that there is something positive in the relationship he has established with his artists, as the contract has been mutually agreed upon. Largely, the contractual relationships have been successful, and he tries to make his artists see the advantage of these relationships.

However, while he makes financial provision for his artists when he is overseas 'there is always the problem that someone is jangling cash around and wants a piece and offers something just a bit over the odds, and in this sense that person dishonours my relationship with my artists.' Essentially, the contract requires the artists to offer work only to the Matombo Gallery on an exclusive basis. It is not, however, binding in other ways. It allows the artists to sell their work to private collectors, and encourages the artists to have a relationship with the National Gallery of Zimbabwe.

'One of my concerns, tied in with my concern to seriously promote the artists' work,' comments Cook, 'is for their work to be represented in the Annual Exhibition at the National Gallery of Zimbabwe. If I am talking about my artists' credentials in the Zimbabwean art world overseas, it would seem strange to the overseas gallery director if the artists' work has never been seen in the

prestigious Annual Exhibition.'

Cook acknowledges that it is possible for an artist to move on from his gallery, but few have done so. He has recently organised an exhibition for Sylvester Mubayi in London, although he is also keen to establish the presence of the individual artist in Harare. Without having had the space at the old Matombo Gallery to provide this presence, he has organised exhibitions at the Standard Chartered Gallery in John Boyne House, Harare. The business arrangements are a blueprint for any local one-person exhibition organised by the Matombo Gallery. The first option is that the artist prepares for the exhibition and determines his or her selling price.

The Matombo Gallery meets the artists' ongoing financial needs while the exhibition is being prepared, and provides the organisation, promotion and backup. For this, the gallery takes twenty-five percent commission. The second option is that the artist, when preparing for his or her exhibition, sells the work to the gallery in the normal way and the gallery reserves it for the exhibition. The gallery then provides the usual organisation, promotion and backup, and pays an additional twenty percent to the artist for works sold at the exhibition.

Works are purchased for the Matombo Gallery in two ways. Work may

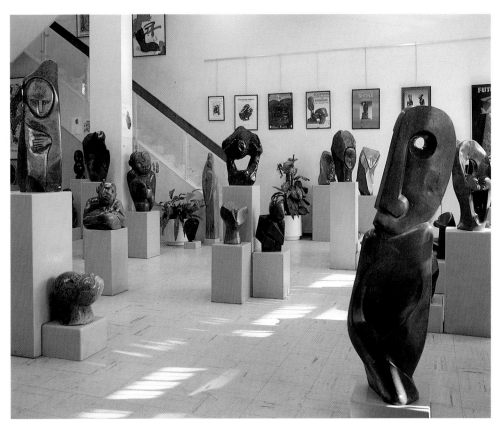

Matombo Gallery, Harare

be bought outright from the artist, which the artist prefers, or on a commission basis, which is 'better because it eats up less of our capital and secondly allows us to give a better price to the artist.'

Cook would prefer to move towards a commission arrangement but currently is effecting a compromise, providing both a down payment and an after-sale payment for each piece. The new premises allow space for individual exhibitions, and reinforce the gallery's emphasis on the work of the individual artist. At the Matombo Gallery 'The admissions policy for sculpture is more inclusive and broad-based than it would be for an overseas exhibition. The nature

of my clientele is usually people who would not normally look at art, and they like to see a lot of art. This pushes me to show more work than I should, rather than less.'

Cook is not above selling a minor work of an artist, while the artist works on a major piece. 'If such work being sold gives the artist a measure of independence financially (in the absence of grants and scholarships) and other means of support, and he can then make a piece in which he can really express himself, I feel the situation is justified. It is also a way of introducing the artists' work to the public.

'We are working in an environment

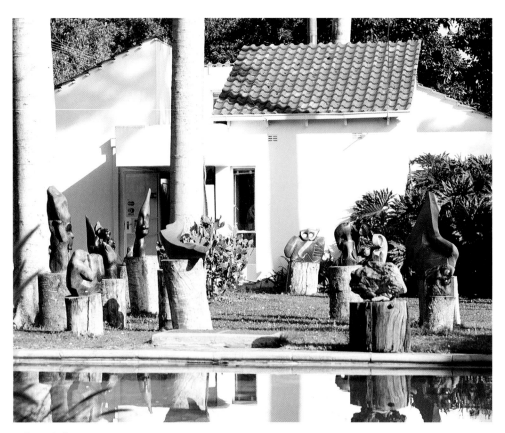

Vukutu Gallery, Harare

where for historical reasons the artist has been working on a day-to-day basis. I want to move towards how things are done overseas. In an artistic sense, I am concerned with the total freedom of the artists, and the contractual arrangements are business arrangements which allow the artists to exercise that freedom and allow the gallery to use its energies to assist, in a long-term sense, the artists' careers.'

Cook has thus established a new direction for stone sculpture in Zimbabwe, and if this trend is followed by other galleries it may well benefit the future state of the art.

In 1987, Russell Schneider, an enterprising young American executive in the computer business, came to Zimbabwe and collected the sculpture of Damien Manuhwa. This sustained his interest in Zimbabwean stone sculpture and in the same year he established a gallery in Boston in the United States, called African Influence in order to hold changing exhibitions of individual Zimbabwean stone sculptors. 'Because of the business associations between Zimbabwe and the States, it was not difficult to start a gallery dealing with African art. In a sense it was an extension of the business we were doing here.'

In any business venture in the United States it is necessary to have a support

system, a pipeline of supply and people who advise. In Zimbabwe, Schneider had an across-the-board relationship with private galleries and individual artists, and he obtained the advice of experts in the field of stone sculpture in Zimbabwe. His frequent visits to Zimbabwe included a buying spree of sculptures purchased for full-scale one-person exhibitions. He felt that such a purchasing policy gave him an overview of each artist's work, and allowed him to present it in exhibitions to its best advantage.

In Boston, Schneider had to create the market for the sculpture, but he was not worried about the limitations of galleries in Harare. He commented: 'To promote the work as a generic art form will take away from its collector appeal. To create the market I have promoted the work of each individual artist. This panders to the collector's mania for specialisation. Also if your changing exhibitions are individual rather than collective the work has a sense of development and a newness which a collective exhibition cannot provide.'

Prior to starting the gallery, Schneider saw an increasing interest in the sculpture internationally. Through his visits to Zimbabwe he saw the prices accelerate tenfold in three years. It is possibly true to say that when any market grows in size and has to rely on a

product of which there is a finite supply, the larger the demand, the poorer the quality of work at the bottom of the scale. Hence, on this premise, Schneider confined himself to the most well-known artists and, at the behest of his advisors, the best quality work. His concentration on individualism was followed through at trade fairs where 'each artist's works are clearly defined; there is information on each artist, separate display, and emphasis on the style and individual character of each piece.'

Before opening the gallery, Schneider made a video in Zimbabwe, a documentary message to enhance the credibility and integrity of the work.

In exhibitions, he stressed the contextual background of the sculpture. 'We are promoting a serious art form which is not just art for art's sake, but art from within cultures and a representation of other aspects of cultural practice.'

He saw the originality and selectivity of the sculptors' work, to be seen in Boston, as an advantage. 'Anyone's perception of the value of anything has to do with how rare they perceive it to be. In Zimbabwe, people are subjected to a proliferation of work; it is everywhere and that has debased its value.' He saw promotion as bringing a large measure of success to exhibitions outside Zimbabwe. In economically advanced countries where

the social sciences are well developed, an appreciation of the cultural worth of art is possible. The problem in this respect is that Zimbabwe is a developing country; it has become, to a degree, Westernised but not to an extent where it is greatly interested in the social sciences. In addition to people being exposed to work of poor quality Schneider did not feel that the Shona people look towards a cultural interpretation of their work and they are not ready to do so. He also felt that, historically, the object in Zimbabwe has been utilitarian and functional and the country was not at a stage when an object was also appreciated as art.

Schneider's role as director of the African Influence Gallery, in addition to his purchasing work, was the planning of its direction, the establishment of its goals, and the timetable of implementation of these goals. He aggressively pursued corporate sponsorship in the cause of the national credibility of the work. However, his reference to the sculpture as a product stopped far too short of his thinking of it as a product only. His marketing techniques were a mixture of high technology and the human touch. Advertising, promotion and telemarketing were features of these techniques. It was his aim to place articles in leading art journals. 'You have to have ten or twelve

advertising messages to make an impact, as involvement in these journals requires a high profile of patronisation,' he said.

In highlighting the work of individual artists, Russell Schneider, like Roy Cook, is establishing a direction and future for the sculpture which has not previously been taken. It is traditional for a gallery in America to individualise its artists through exhibitions and promotion, and for galleries to have one-person exhibitions. In following these traditions in a country outside Zimbabwe, Schneider established a new direction for showing Zimbabwean sculpture overseas which could well be emulated by other galleries in Zimbabwe.

African Influence Gallery no longer exists, but Russell Schneider is still very much involved with stone sculpture in Zimbabwe through the African Influence Company.

The Vukutu Gallery is hidden from the commercial bustle of Harare in the residential suburb of Milton Park. Here the sculpture is truly outdoor sculpture, mounted on logs, surrounded by trees, grass and plants. Vukutu's operations are discreet and less commercial than the other galleries in Harare. Vukutu clients are comparatively few, but they are well-known and wealthy and Vukutu affords them the screening and privacy that they desire. Here they enjoy the atmosphere

of a private salon rather than a gallery. The directors of Vukutu do not think of the gallery in commercial terms. Olivia Burdett-Coutts comments: 'As a commercial gallery we do not believe in being overtly commercial. We don't have to make money and we don't believe we should be doing this to make money. We believe that we are promoting art, and working entirely in the interests of the artists. We do not select works which we know are going to sell, we select works that we know are good. We believe that good art gives stone sculpture in Zimbabwe a good name. I don't believe in the democratisation of art, and I believe that good art is the opposite of democracy. Art is not just a matter of opinion and if it is bad art it is not art.'

While work is sold at Vukutu, Vukutu also operates as an art foundation, and there is a sense of patronage of the arts and philanthropy rather than commerce. Indeed, a number of the works on display are from the private collection of the co-director, Bill Burdett-Coutts, a former Harare stockbroker.

Vukutu is part of the history of stone sculpture in Zimbabwe and all those involved, including the Burdett-Coutts and sculptor John Takawira (before his death), knew Frank McEwen personally. McEwen's philosophy and artistic principles are upheld by the gallery. Vukutu today is the Harare presence of the Vukutu community of Nyanga, started as an extension of the National Gallery of Zimbabwe by Frank McEwen and his wife, Mary. After Frank McEwen and Mary divorced and she returned to America, Vukutu was bought by Bill Burdett-Coutts, but remained, for some time, an extension of the National Gallery as it was originally. Olivia Burdett-Coutts comments: 'I think Frank felt that he could have more control and provide better guidance if his artists were all together rather than being spread out all over the Nyanga area.'

At Vukutu as many works are rejected as selected. The criticism of Olivia Burdett-Coutts, a trained art historian, is informed and rigorous as was the criticism of the late John Takawira. Olivia Burdett-Coutts comments: 'If we reject a piece we will maintain our own standards. People who have money to spend do not always have money to think.'

As an art educationalist she feels that selection and rejection are part of an artist's education. 'If you want to learn to be an artist you have to learn to see in inverted commas, and by giving criticism you are encouraging the artists to see with a more refined eye.'

Olivia Burdett-Coutts has no formal relationship with her artists and she does not tie them in any way to Vukutu. She has a warm personal friendship with many of them and this, she feels, is why they allow their interests to be represented by her without any formalised structure, and why they maintain their loyalty.

Much of the work shown at Vukutu is of historical significance. Olivia Burdett-Coutts sees Vukutu's role as an art museum as much as a private gallery. The collection of Bill Burdett-Coutts allows an artist's development to be seen. The early works are valuable for their historical importance. All works are dated. The eye of John Takawira could accurately date any early work of an artist. Before his death in 1989 he spent much time working at Vukutu teaching young sculptors and criticising their work. It was John Takawira's policy never to praise an artist while he was learning. His comment was: 'If my rejects are put on the market, and they are sold, the next piece I make will be worse, because I was praised for what was bad.'

Recent moves at Vukutu have been made to purchase stone deposits. Olivia Burdett-Coutts bought the first of many mines near Guruve in 1985. Artists can now choose their stone freely, although they pay for the labour and the transport costs.

At Vukutu, purchasers are encouraged to collect what is considered best by the gallery. Olivia Burdett-Coutts comments: 'I know people who have begun to collect, but they are collecting bad things. Rejects are easier to collect than good works. They are not strong; they do not require an effort to be appreciated. In fact, in terms of art the public is eighty years behind the times and artists are ahead of their time!'

Thus speaks one of the directors of Vukutu which is an educational institution, a private gallery, an art museum and a resource for artists rolled into one.

The newest gallery to be established in Harare is Stone Dynamics, run by two young Zimbabweans, Stuart Danks and Jonathan Hoisie, both sons of well-known painters. Appropriately, the gallery's policy is to support the works of the directors' contemporaries, young Zimbabwean sculptors, whose work they feel is 'less ethnic, more abstract, and reflects a more Western concept of cultural form than that of the older generation of artists. They see the exploration of sculptural form as an end in itself. The sculpture of the younger artists is more perceptual; they sculpt what they see rather than what they think about, and there is less explanation needed for their work than that of the older artists.' Indeed the highly polished stones at Stone Dynamics have a strong sense of *objet d'art*, which is intensified by their gallery display and lighting.

The concern of Stone Dynamics appears to be with both immediate sales and long-term representation. But at the same time, the gallery has a very personal and open relationship with its artists which it believes ensures their loyalty. 'Artists are free to exhibit their work elsewhere, but we are always pleased when they come here first, which it appears they often do.'

Stone Dynamics has the open face of youth; the directors are pleased to discuss the details of their business arrangements and equally pleased to let the artists know who has bought the work and, when possible, to introduce them to the client.

Appropriate to a sales gallery, Stone Dynamics offers efficient customer service. It is responsible for packing and freighting works, and organising clearance with customs. Their relationship with the client does not end with the purchase of the work, but only when it has been satisfactorily delivered, locally or overseas.

'We have nothing to hide,' says Stuart Danks. The gallery will either purchase work outright from the artists at a price satisfactory to both, or a commission of twenty-five per cent will be taken. The work of more-established artists will be kept for a year before it is sold; the less-established artists will have their work at the gallery for two months.

'Artists are not contracted. Freedom is a cultural concept for the artists, they do not like to be bonded. This may stem from their colonial past when the African was restricted and told what to do by the European.' As such, the operations of Stone Dynamics are in keeping with the spirit of independent Zimbabwe. Sales skills are backed up by considerable entrepreneurial flair. Before establishing a presence overseas, the gallery has tried to consolidate its presence in Zimbabwe. Exhibitions have been held at the Bulawayo Trade Fair and at the Victoria Falls Hotel to attract 'those who fly straight from Johannesburg to Victoria Falls and never even come to Harare.' A third director, based in Bulawayo, looks after the Victoria Falls operations.

Situated in Samora Machel Avenue, in the centre of Harare, strategically close to the well-known Monomatapa Hotel, the Stone Dynamics gallery welcomes clients who 'walk in off the street'. The gallery is gradually making contact with the middlemen of the market place — the interior and commercial designers, and architects who endeavour to place sculpture in their clients' projects.

Danks and Hoisie have a sensitivity

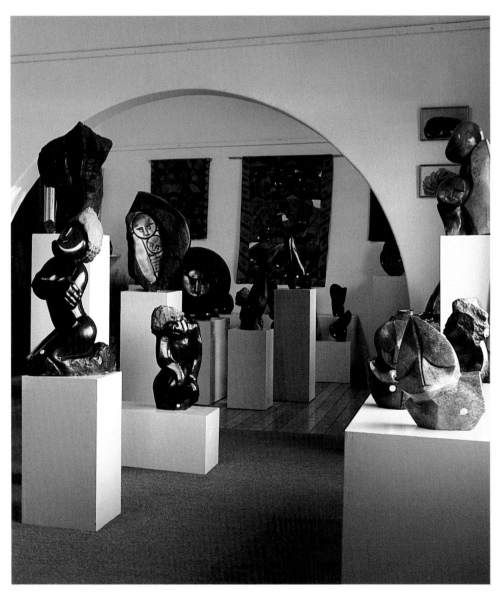

Stone Dynamics, Harare

to their artists' needs which is over and above the selling of the artists' work.

A new gallery in Zimbabwe is a welcome event, and it would seem in this competitive climate the activities of Stone Dynamics are complementary to those of the other galleries in Harare.

Gallery Delta was established in 1979 by the painter Helen Lieros and her husband Derek Huggins. 'At Gallery Delta we try to exhibit art as art.' Here art ceases to be an industry and at times it is not income-producing. There is little feeling of 'turnover', and commerce does not seem to enter into the arrangements between the owners and artists. Nonetheless, Gallery Delta admirably serves the needs of Zimbabwe's painters. It does not aim to make a considerable profit. If an artist is considered to be worth exhibiting, the quality of his or her work rather than exhibition sales will determine whether he or she exhibits again. While other galleries can be somewhat monopolistic in their selection of work, at Gallery Delta this process is more democratic. Here the selection is by the directors, Helen Lieros and Derek Huggins, and a committee of artists. Unlike other galleries, the client base is constant, hence changing exhibitions can take place to meet clients' needs. The media represented includes etchings — 'In Europe artists are surviving through

graphics,' says Derek Huggins — and sculpture is represented in exhibitions rather than sold off the shelf. Delta clients include architects and professional people in Harare.

The continued presence and success of the gallery indicates that there is a developed art public in Harare, and that the successful career of an artist does not always depend on sales. Here is a venue in Harare for the promotion of art as art, rather than art as an income producing object.

The proliferation of sculpture to be found in Zimbabwe will probably make it necessary for more galleries to open in the future. A partial solution to the problem of selling an ever-increasing volume of work is the opening of galleries for the stone sculpture outside Zimbabwe, notably in America. However, this also means that these galleries establish a monopoly of clients that limits the opportunities of the Harare-based galleries exhibiting in that country. With this type of gallery there is a strong trend towards scholarly presentation of the work, which allows room for accurate interpretation and education of the client. Gallery directors coming to Zimbabwe seek information as eagerly as they seek art.

In Zimbabwe, galleries are now concentrating more on the interpretive side of exhibiting, on seeing the value of providing information to the sales of the sculpture. Galleries are also seeking to represent individual artists, and there is less emphasis on exhibiting the sculptors as a group, which has overtones of mass production and curio art.

On the other hand, shops which sell curios, ivory, jewellery, leather goods and safari suits with great success, also include sculpture with their merchandise — albeit, the sculpture is not of a very high quality. Even the best galleries, however, fall down slightly in terms of the historical presentation of exhibitions. Works are seldom dated, and it is often not possible to trace works in private collections to give full developmental recognition to an artist in an exhibition.

Artists are often given little information about the ownership or destination of their works, and moves are being made by ZAVACAD to have an official petition and code of conduct which structures a fair and equitable relationship between artist and dealer, establishing, at the same time, what happens to an artist's work after it is sold. In more developed countries, for example Australia, galleries are brought together in a formal association which establishes a code of ethics. It is timely for such an association to be established in Zimbabwe.

A well-known figure in the Zimbabwe art world has said that there are 'good artists and good dealers, and failed artists and failed dealers'. It is usually the good artists who gravitate towards the good dealers, and the failed artists who gravitate towards the failed dealers.

Steps have not yet been taken to monitor those who come to Zimbabwe and wish to deal extensively in art.

While ZAVACAD is looking for premises to act as a members' sales outlet, amongst other things, there is no indication that sculptors wish to form themselves into cooperatives as many craftpersons have done. Government or university-funded galleries could provide an alternative to private galleries, and these galleries would not be wholly dependent on sales to support the promotion of their artists' careers.

Much is now being written about the cultural origins of the subject matter of the sculpture, but still there has been little attempt to provide informed critical analysis which would enable the client to make an accurate judgment of the quality of the work. Many sculptures are bought because they are by a particular artist with a good reputation, and not all works conform to the same standards within an overall corpus. Despite these limitations the prices of Zimbabwean

sculptures are soaring both inside and outside Zimbabwe. Critical appraisal may assist the more realistic establishment of the worth of a sculpture and it is possible that the projected establishment of the Regional School of Art will encourage critical analysis to develop. This may make young artists see art not merely as an aspect of cultural production with a largely economic rationale, but develop in them notions of good art that they can pursue in the cause of standards of excellence. The galleries themselves are now also in a financial position to encourage these standards, through greater selectivity, the provision of scholarships to the Regional School, the organisation of cultural exchanges, and perhaps — as Chapungu Village does — provision of adequate working space and comfortable working conditions for artists.

In the past the press in Zimbabwe concerned themselves, largely, with the 'exploitation' by galleries of the artists which, in terms of the reputable galleries, has now become an historic issue. Newspapers and magazines now carry regular articles on art, and art critiques, and the National Gallery of Zimbabwe is soon to embark on a new publication, *Southern African Art*, which will deal with art of the SADCC region.

In a purist sense, patronage of the arts is a benevolent gesture in which the patron assists the artist without expecting any financial gain. This was established in the days of the Greeks and Romans, and later, the Renaissance. However, even the early patrons usually expected some kind of return for their support, namely the making of art to be housed in their church, palace or home or in a public place. Hence the early patronage became a kind of employment for artists, and the patron had some control over artists' activities, and the direction that the art took.

Zimbabwean art is contemporary, and the nation does not have any history of patronage from church, state or from noble families. Historically, in Zimbabwe the strength of private patronage, rather than institutional patronage for art has come from individuals: Frank McEwen in his role of a private person, with a strong personal commitment to the artists of Zimbabwe, and Tom Blomefield, whose professional role has been coupled with a strong measure of private support. Just as private people have acquired art for their own collections, Tom Blomefield is currently actively building up his collection to give it a contemporary, as well as an historic dimension. Roy Guthrie, Director of The Gallery Shona Sculpture, has for some time lent his personal patronage to artists in a variety of ways.

In a country such as Zimbabwe, where artists do not as yet benefit from grants, stipends from government, or scholarships, and cannot be employed as teachers as they are in more developed countries, the role of the patron is more vital and has a broader meaning. Because the Zimbabwean artist has many needs which require to be met to foster their remarkable intuitive talent, patronage at its best has a holistic character. The patron can look after the artist's economic needs, his promotion, his education, and his social welfare.

Zimbabwe is a rapidly developing nation. The quality of its art is developing with other areas of quality growth, and so is the status of the artist, but the quality of life of the artist sometimes lags far behind. Today, when market forces and economic demands are encouraging more and more young people to make art, in particular stone sculpture, existing galleries are not able to represent each artist in terms of individual long-term promotion. As a possible sign of the times in Zimbabwe, companies and corporations, multi-national and national, are turning to the kind of patronage of the arts which has been well developed in other countries. It is refreshing to find that this patronage is not entirely to reinforce the image of the company or corporation concerned, or a subtle means of promotion, but a genuine philanthropic

gesture, and one of many gestures of patronage that these organisations are making. Certainly patronage can be part of corporate or company policy or service, but it is also a pleasingly human aspect of their activities.

The four main organisations in Zimbabwe which are, in the purest sense of the word, patrons of the arts, are the Nedlaw Group of Companies, Mobil Oil Zimbabwe, Cairns Holdings, and BAT.

Exclusively concerned with art education, BAT funds the BAT Workshop associated with the National Gallery. The Nedlaw Group of Companies' funding of the Zimbabwe Heritage Exhibition at the National Gallery of Zimbabwe each year, until 1990, had an educational as well as a promotional dimension because the exhibition provided artists with notions of quality and standards which have nothing to do with commercial expectations.

Each aspect of patronage is creatively and sensitively in touch with the needs of the artists of Zimbabwe. The organisations' philosophy of patronage is not paternalistic or culturally imperialistic. Within each organisation there is a personal commitment of the person involved in organising the patronage.

The longest standing and one of the most imaginative aspects of corporate patronage for the arts of Zimbabwe has come from the Nedlaw Group.

The founder Chairman of the Nedlaw Group is Norman Walden. He is a man of missionary stock, born in a mud hut in the Congo, in a village called Baringa, which has lent its name to the Baringa Group of Companies which became involved in support of the art in Zimbabwe in 1986. Walden has a deep appreciation of the African's need to maintain ties with cultural roots, to retain an African identity and to maintain a sense of personal equilibrium in a rapidly developing nation. In 1980, at his suggestion, the Nedlaw Group lent their patronage to the Annual Exhibition of the National Gallery of Zimbabwe. This not only gave a financial reward to the winning artists, it allowed international jurists, distinguished artists in their own right, to come to Zimbabwe to select the best work for awards. In their selection the jury applied standards of excellence which had nothing to do with the commercial appeal of the work or its appeal to commercial taste.

In 1986, The Baringa Group of Companies lent their patronage to the Baringa Exhibition, an exhibition of two dimensional work of Zimbabwe's artists, and also of ceramics and textiles. The patronage of both groups of companies has been, in a sense, an investment in both the art of Zimbabwe and the artists of Zimbabwe; an investment without

any commercial rewards, and one of benevolence without any sense of paternalism or colonialisation of the arts. The Baringa Exhibition has made the statement that Zimbabwe should be recognised for its art and not just its stone sculpture. This statement speaks of the diversity of the art of the nation, of its cultural specificity and universal significance, of opportunities for changes of direction, innovation and experiment.

It has not been the wish of the Nedlaw, or Baringa Group, to make their presence felt through this patronage. The recognition they have required has been of Zimbabwe's art and artists, and not of themselves, and this is to their credit.

Mobil Oil is a multi-national corporation represented in Zimbabwe. Patronage of the arts and other aspects of human endeavour is part of Mobil's world view, and one of its means of getting to know the country in which its presence is established, and identifying with the local community's needs. Support for the art of a country in which it is represented appears to be part of an overall commitment to the liberal education of that country's people.

Mobil's presence in Harare is enhanced by its building, Pegasus House, perhaps the most striking in Harare. A structuralist composition of red and black, the building seems like a giant

New Delta Gallery

mirror, which reflects the busy life outside its doors. Once inside, the art predominates, to make the commercial operations of the corporation seem almost incidental to its cultural activities.

The Chairman of Mobil is David Seaman — a Scot by birth. He has had a long and distinguished career with the corporation. For him, life at Mobil is far more than a product, and has always been so. He cites his experiences in Ghana where Mobil's support for art had a strong educational base. Mobil has been involved for fifty years with the Faculty of Art at the University in Accra, and students from the university decorated the Mobil building. Similarly, in Harare, there is a strong identification of Mobil's support for art with the building. David Seaman comments: 'We thought the best way to give the building a cultural character was to have the best art selected through an art competition — democratic and open to all artists — and to have an exhibition of the winning entries at the National Gallery of Zimbabwe, the most prestigious venue in Harare.'

The first Mobil art exhibition was held in 1988. Odette Enslin, an artist of repute in Zimbabwe. and for some time art teacher at Chisipite School, was the coordinator of the exhibition. Work which was not purchased by Mobil was then offered for sale at an exhibition at the Sheraton Hotel.

Although the patronage of art is a corporate service of Mobil, there is no written policy in concise terms. David Seaman says: 'Needs among artists, as among any people in such a rapidly developing country, change, shift and move on, as do directions in art. What is new in art one year, the next becomes a tradition, and possibly history the next. Any such policy for our patronage of art must be flexible and open-ended enough to recognise these changes, which are all positive.'

Mobil succeeded Nedlaw in 1990 as the patrons of the Zimbabwe Heritage Exhibition at the National Gallery of Zimbabwe, and Professor Rogers comments that it is envisaged that other major corporations in Zimbabwe, such as Mobil, will be future patrons of the exhibition for a period of five years each.

Cairns Holdings is a Zimbabwean group manufacturing a range of products including wines and spirits. Its patronage is both 'in-house' and to the 'community'. For its employees it provides professional training, opportunities for O and A level education and other such facilities in study areas, and books.

The making of wine and the making of art are considered to have a similar creative dimension to Tim Johnson of Cairns Holdings who was specifically in charge of wine operations, and who is now the managing director of the company. The two are married together by a competition for the design of wine labels for Cairns' Mukuyu Gallery range of wines. The competition culminates at the National Gallery of Zimbabwe when the winners are announced at a gathering where artists, and many friends of the group, drink wine in praise of art.

It is Cairns' idea to show its appreciation of Zimbabwe through, in Tim Johnson's words, 'giving patronage without being patronising.'

Tim Johnson had observed in Australia and the United States the use of art for wine labels, and felt the idea

could be used in Zimbabwe to give a strong Zimbabwean identity to the product. He comments: 'We did not want a glass of wine with some grapes around it, but something that was fundamentally good art, which showed the calibre of the art as much as the calibre of the wine. If the label related to the colour of the wine and the bottle that was good enough.'

Prior to 1989 the successful entrants for the competition have won prizes of scale, but since 1989 the rewards have been entirely democratic, each artist receiving the same amount of kudos and money. 'There is possibly too much emphasis on 'sell and win' among Zimbabwe's artists' comments Tim Johnson, 'and we wanted to encourage the notion of equality with success'.

The judges for the Zimbabwe Heritage Exhibition are the first selectors of the labels, Cairns Holdings having the final judgement. In Tim Johnson's words: 'The art of this country is young, it is part of the nation's development, but in terms of the security and well-being, there is still far more development to take place. What we are doing creates a little circle, a flow of money going out, a flow of work, and an expansion of talent.'

The winning artists receive further promotion when their work is purchased and hung in the premises of the Cairns Holdings' wineries in Marondera. The wineries receive many visitors, some from overseas, and this offers further exposure to the artists' work.

The support for the visual arts of the nation afforded by BAT Zimbabwe focuses on one of the most crucial aspects of its development — art education, but BAT's notion of art education is broad and generous enough to accommodate funding for artists' materials and cultural exchanges. BAT has supported the Workshop since 1982 and in Professor Cyril Rogers' words, 'it is far more than just a commitment on paper or a signature on a cheque' — it allows the educational policy of the Workshop to be in the hands of Gallery staff with the necessary expertise. The corporate conscience of BAT sees, of necessity, some of the profits of the company being ploughed back to benefit the community it serves. BAT's philanthropy has wide terms of reference, and includes sport and awards for sporting achievements, a demonstration of a concern for the ecology, and assisting rural development.

BAT sees the educated art student as making a contribution to the economy. Students at the BAT Workshop who successfully pass O and A levels have developed professional skills as artists which enable them to join the work force in fields such as commerce and industry.

They are helping to solve the severe employment and manpower problem currently confronting Zimbabwe. It is anticipated that BAT students will soon have their own accreditation after graduation through assessment by internal and external examiners. Over the year's BAT has improved the facilities at the various Workshop premises, and its generosity has allowed for a greater intake of students.

With the prospects of the Regional School of Art and Design, an institution such as the BAT Workshop which introduces students to the notion of art education without taking away from them their freedom of expression, is most important, and it allows self-development, and encourages the self-discipline, essential in the professional artist.

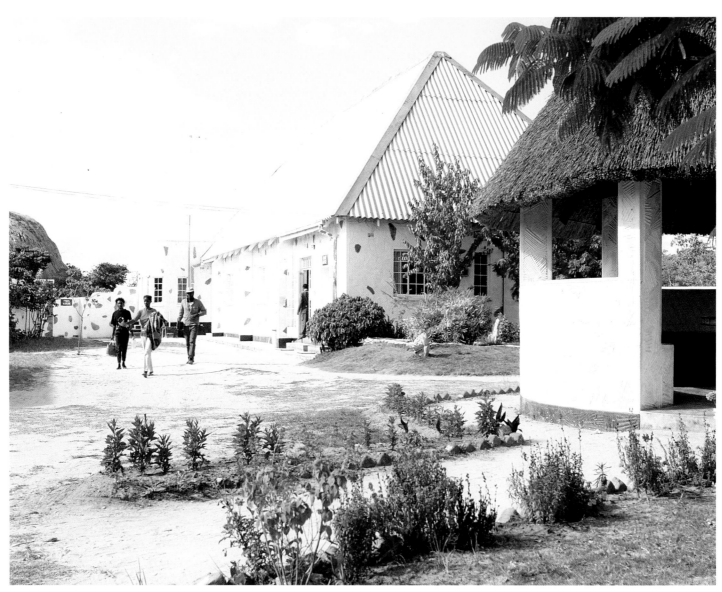

A culture house, Murehwa

CHAPTER ELEVEN

GOVERNMENT'S POLICIES FOSTER ART

In many socialist countries the artists are supported by the state but, in turn, it is necessary for their art to reflect socialist ideals, and it is often used by the state to propagate those ideals. Much socialist art is populist: posters and murals, which by their very nature are seen by a wide and varied public, rather than an 'art audience'. These, through realistic imagery, identify the people as 'heroes of the revolution'.

In Zimbabwe, at this early stage of the new nation's development, the artist is not supported by the state, although cultural exchanges which allow artists to study abroad are endorsed and often initiated by government. However, it is the enlightened policy of government, through its Ministry of Education and Culture, to allow the Zimbabwean artist the freedom of expression which has traditionally been the best vehicle for his remarkable intuitive talent. This talent is the result of the development of formal and non-formal traditions of art education in this country, established, initially, by Canon Paterson at Cyrene Mission and Father Groeber at Serima Mission.

The Ministry of Education and Culture has not made any moves to date to nationalise the art of Zimbabwe; to impose a directive upon artists to produce art in sympathy with the prevailing ideology. The government's policy on the visual arts has been formally stated in the First Five Year National Development Plan (1986–1990): 'In order to democratise the acquisition of artistic skills, and access to the arts by the great masses of the people, facilities for training in, and presentation of, the visual arts will be built, improved and reorientated.'

Less formally but no less publicly, Professor Cyril Rogers has outlined the cultural policy of the ministry in his prologue to the catalogue for the Zimbabwe Heritage Exhibition in 1986: 'The formation of a division of culture within a major ministry of government has enabled government to express a coherent policy on cultural matters. In essence the policy has three facets to it: a) the peoples of Zimbabwe must be made aware of their splendid cultural heritage and rediscover the traditional art and beauty which was theirs; b) with access now to the cultural and artistic heritage of the whole world rather than just a part of it, the educational system, formal and non-formal, must draw upon this universal heritage to enrich the present life of the people; c) the cultural richness of the past, and of the present, must be understood and enjoyed, to enable all of our people to participate to the maximum in planning the future egalitarian society of Zimbabwe.'

The Ministry of Education and Culture is responsible for funding two parastatal bodies concerned with the visual arts of Zimbabwe. These are the National Arts Council and the National Gallery of Zimbabwe. Both have been set up by separate Acts of Parliament to administer the arts of Zimbabwe; in the case of the National Arts Council, the visual and performing arts; and, in the case of the National Gallery, the visual arts. The Ministry of Education and Culture formulates policy for the visual arts, and provides the philosophical and ideological framework for the support of the arts. The two parastatals provide the structure which gives a practical dimension to this framework. Although the National Arts Council is the umbrella organisation which provides funding for, and monitors, the administration of numerous arts organisations, including the Zimbabwe Association of Visual Artists, Craftpersons and Designers (ZAVACAD), the ministry has assumed a coordinating role in the establishment of the Joint Cultural Action Programme (JCAP), in which various arts organisations and institutions, concerned with the arts in the areas of visual arts, music and dance, among others, work together and share each others resources and information.

The ministry appears appreciative of

the pioneering work of the reputable art dealers in Harare to establish the presence of the art of Zimbabwe, inside the country and abroad, over the past thirty years. It is however aware of the danger of exploitation of the artist by the dealer, and has encouraged ZAVACAD to prepare a Draft Petition and Code of Conduct to ensure a fair and equitable relationship between reputable galleries and art dealers and artists.

While the Ministry of Education and Culture provides the philosophical and ideological framework for the support for the arts in Zimbabwe, the two parastatal bodies — the National Arts Council and the National Gallery of Zimbabwe — provide the structure through which this ideology and philosophy are put into practice.

A new National Arts Council (to replace the National Arts Foundation) is the centre-piece of the cultural super-structure, and an Act (No. 27 of 1985) has been passed to bring it into being. The National Arts Council is a parastatal organisation empowered by an Act of Parliament to administer the arts in Zimbabwe through the Ministry of Education and Culture.

The National Arts Foundation was originally established in 1971 by a government statute. Its objectives, set out in an Act, were philosophical and educational, to make the public aware of

the development of cultural activities in the country.

While the objectives of the National Arts Council remain in sympathy with those of the National Arts Foundation, their emphasis and operating strategies differ.

The Director of the National Arts Council is Dr T. Mahoso, PhD, a distinguished art historian and poet. The philosophy and ideology of the council as Dr Mahoso sees it is to 'encourage the essential Africanness of art in Zimbabwe, which was suppressed during colonial times, and to see that the cultural dynamics of Zimbabwean society are exercised in an essentially African way.

'African life provides a rich source of culture for the arts. The material is available but rather than being used locally it has been taken, studied and borrowed by other people. People from the outside appreciate the richness of the source and know how they can use it. It is not enough that Zimbabweans know how to dance, know how to sing and know how to sculpt. These resources need to be organised and developed further.

'There are several kinds of endowment given to an artist, those from socialisation, those from formal education, and those from professional training. All these things are important

to an artist's development, and cultural policy should take them into account.

'Traditionally, those who were considered artists in Shona society were integrated into the society, and the economy, and art was considered a means of production. In colonial times, art was separated from the means of production, and the artist was not seen as a worker but as some kind of oddity. Today, it would boost development if the artist was integrated into society and into the economy. Most successful artists made it the hard way struggling on their own. Possibly because of this, their art has little relevance to society. As workers must evaluate their place in the work-force in terms of their own culture so artists must evaluate their role in society in cultural terms.'

The National Arts Foundation did not have African representation, nor did it have a member of staff who could speak one of the local languages until 1981 when the first Shona-speaking African joined the staff. This situation, Dr Mahoso feels, established a structure which was outside the interests of the arts in Zimbabwe. Today the black African, Shona-speaking presence of the council is such that the council has become more accessible, and an increasing number of artists and arts associations want to be associated with

it in a long term sense. Dr Mahoso comments: 'You don't want a situation where the people who control the structure (the administrators) have no relationship with the people who control the content (the artists). The content is to some extent determined by the structure.'

The statute of the National Arts Council requires that before making a financial commitment, the council should receive expert opinion. Part of the structure of the council are three specialist panels, each made up of three NACZ board members, and as many professional members as they wish to co-opt. In the cause of working for the national interest of the arts in Zimbabwe, the council has been decentralised and, in particular, focuses on arts activities at a grass roots level.

The Parliamentary Act provides for a centralised administration which is divided into ten provinces each with six to eight districts. Harare and Chitungwiza are counted as provinces. As of 1989 National Arts Council funds are given only to provinces which are responsible for funding and supervising districts, and to officially recognised visual and performing arts organisations, such as ZAVACAD. It is envisaged that in the near future the NACZ funding will be given only to the provinces, which will undertake responsibility for the districts,

and hence the provinces will be given greater autonomy from the central administration. There is one representative from each province on the board of the council which appraises the activities of the council from a rural point of view. As Dr Mahoso comments: 'We are moving into an area of the encouragement of local initiative.

'Because of the structure of the economy and the long-term traditions of doing things, black Zimbabwean artists have seldom treated their own population as their source. For art to be deep and profound there is no need for it to be a mystical conceptualisation of things, as Europeans expect from African art. To an extent, the dealers have subsidised the subject matter of the sculpture. We are trying to encourage artists, including sculptors, to address people of their own culture through our biggest project, the building of culture houses.'

The first of these culture houses has been established at a major growth point at Murehwa. While the culture houses will institutionalise the culture of each area, it will be remembered that cultural expression does not only depend on cultural institutions. Dr Mahoso hopes that the presence of the culture houses will serve to draw together the cultural practices of each area which may, before,

have been fragmented and isolated, and establish a greater sense of community for those engaged in cultural production and practices. They will also centralise and make permanent various aspects of the documentation of culture of the area, in particular oral history in conjunction with the National Archives of Zimbabwe. This will be done on both tape and video film so that 'body language', which is a significant explanation of that history, can be recorded.

Dr Mahoso feels that the function, role and structure of each culture house should be determined in part by local needs and initiatives, and where possible, those needs and initiatives should be considered in the construction and concept of each culture house. Outside assistance which cannot be provided locally — for example a library — should also be provided.

The role of an urban culture house would differ greatly from that of a rural culture house. A rural culture house might be involved with the preservation and documentation of objects associated with traditional cultural practices and, while these practices may have become obsolete, the objects would serve as a reminder of their function within traditional society and make people aware of their cultural heritage. An urban culture house may bring together

arts practitioners and the manufacturers of the products in order to stimulate cultural production, for example, people working in light and heavy industry, and sculptors working in metal. The establishment of the culture house might also bring to the area someone who can improve the ecology related to cultural practice, for example someone who can improve the quality of raw materials such as clay and fuel for firing pottery.

It would appear that the original concept of the culture house in every district in 1987 was not only unrealistic but perhaps undesirable. Today only one culture house has been built, and the people themselves are asking not for culture houses but for the full utilisation of any existing facilities within their local area — such as church and school halls and public service training centre facilities.

The Ministry of Education and Culture has issued a directive conferring on the National Arts Council powers to register all artists and art dealers, and to clear artists and art dealers coming into the country and going out of the country. There is a proposed amendment to Act No. 27 of 1985 to empower the Arts Council to monitor the art being taken out of the country and to prevent the best works from leaving the country. Dr Mahoso sees the moves 'not only for the

sake of documentation but also for the sake of direction — there must be some kind of accountability from commercial galleries, and one has to control one's cultural product without stifling it.' Prior to the issuing of this directive by government, the council had talks with various ministries and relevant artists' agencies, for example ZAVACAD, the Musicians' Union and the Zimbabwe Tourist Association. 'We need information about exhibitions going out of the country, prices, prices of consignment, the purchase and sale prices overseas. The success of regulation requires very intricate coordination between the relevant ministries. We must understand how this affects culture and we must understand how we affect their areas of work.'

To develop the endowments of artists, training is necessary. The council proposes appointing two assistant directors, one for visual arts and training, the other for project development. The latter will concentrate on arranging funding for training projects. The council would like to support artists through internships and grants — internships possibly at the Tengenenge Sculpture Community, the future Regional Art School and the National Gallery of Zimbabwe. Dr Mahoso comments: 'The Ministry of Scholarships feels at

the moment that scholarships for artists would be their responsibility, but we argue that within that structure there are not enough people with a professional interest in all of the arts.'

In terms of cultural policy Dr Mahoso considers that a cultural policy document should be popularised and easily understood by everyone. It should be structured to define the relationship of the major ministries involved with culture, for example Education and Culture, and the Treasury. 'We are coming out of a tradition of separate development even for the Shona people. Prior to Independence, there were programmes run by the Ministry of Home Affairs which were not related to and not coordinated with those of other ministries, except in so far as the colonial regime sought to fragment and suppress the majority population.'

While the National Arts Council is in its infancy it is structured in such a way as to represent the immediate interests of Zimbabwean artists and also their long-term objectives. The structure of the council appears fluid and flexible, and conceived so as to include the professional interests of those it represents. While Dr Mahoso sees no need for all art to be propaganda, he looks to the time when Zimbabwean artists, in particular visual artists, make statements of more social

relevance than they are doing today. He feels that the origin of aesthetic value in Zimbabwe is not mystical or even strictly traditional but that it comes from the social dynamics and interaction within a contemporary society. It is obvious that the National Arts Council will act as both a foil and a balance for the activities of the private galleries and hopefully achieve, for the visual arts in Zimbabwe, an equilibrium that so far has not been reached.

The artists of Zimbabwe today, apart from those at the Tengenenge Sculpture Community, largely work in isolation. They value their individuality and, accordingly, galleries are moving towards the representation and promotion of individual artists.

Nonetheless an organisation exists for across-the-board representation of artists' rights, providing a structure that can embrace all of Zimbabwe's artists and focus on problems common to all.

ZAVACAD was officially recognised by the Ministry of Education and Culture in 1983. It is particularly important in a developing country, with a proliferation of artists whose intuitive talent is well-developed, to have an organisation of artists, run by artists, which can represent their needs, serve their interests, and see their situation from the perspective of artists. While Zimbabwean sculpture is

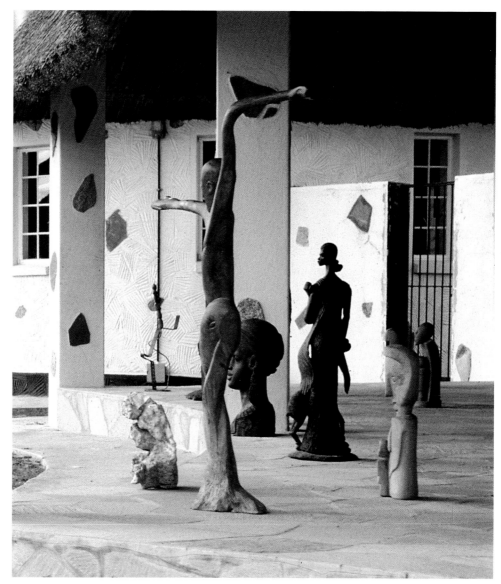

A culture house, Murehwa

known all over the world, few outside Zimbabwe are aware of the problems and difficulties facing the makers of that sculpture. Zimbabwe's young sculptors working in isolation, or in small groups in the rural areas, need an umbrella organisation run by an executive of more established artists, which can make their needs known at official level.

ZAVACAD is a protective national body for Zimbabwe's artists, with regional representatives in the rural areas where there are the largest number of artists: Guruve, Mutare and Masvingo. While ZAVACAD can have effective dialogue with government on matters of policy concerning the interests of the artists of Zimbabwe, it does not only concern itself with matters of policy. In a practical sense it takes a holistic attitude to its members, and is concerned with their careers as artists, their education and economic needs, their problems with transport, and the provision of tools and adequate working space. A more human dimension of its activities is its concern for its members' personal needs. Together with other art organisations, and the National Arts Council, it is investigating pension schemes and life insurance schemes for artists and their families. In addition to assisting in the promotion of the work of its rural members, ZAVACAD seeks to alleviate unemployment and improve the socio-economic standard of the rural areas from which its members come. Members living in Guruve, where the soil is dry and arid, have been able to purchase from the sales of their work, fertilizers in order to yield a good crop and improve the land.

ZAVACAD is actively seeking funding for premises in Harare. This will allow rural members, from time to time, to work closer to their urban sales outlets; and urban artists to work in less cramped spaces than their own backyards. It will allow an effective distribution centre for stone, which exists in abundance but which is not always accessible at an affordable price. It will provide exhibition space, be a valuable additional gallery in Harare and house the ZAVACAD administration, thus giving the organisation a stronger presence within the capital.

1989 saw two donations of tools and artists' materials for ZAVACAD members; one from DANIDA, the Danish aid organisation, and the other from the Victorian Society of Sculptors. Lloyd Orton, the vice-chairman of that society, has established an annual endowment of Z$100 for the most promising artist at the Annual Exhibition of ZAVACAD. Exhibitions such as that held in 1989 at the National Gallery of Zimbabwe establish the sales of artists' work thus strengthening the presence of the organisation.

Mindful of the lack of grants, scholarships and other educational endowments for artists in Zimbabwe, ZAVACAD involves its members in cultural exchanges instigated by government, donor countries and diplomatic missions. It sees these exchanges as part of the educational dimension of its work.

The ZAVACAD executive sees its work as complementary to that of the Ministry of Education and Culture, the National Arts Council and the National Gallery of Zimbabwe. It feels it shares the goals and objectives of these organisations, and in turn has their support.

The means of support for Zimbabwe's artists, other than that provided by the private galleries, is becoming more visible. Generally, it seems to be moving towards changing the nature of Zimbabwean art through the overall cultural, social and educational development of both the nation and the artist. The presence of the National Arts Council and ZAVACAD might lessen the hold the private galleries have on Zimbabwe's artists, but in a sense as these galleries plan for more long-term promotion and representation of artists this, in itself, lessens the hold, and works

more in the interests of the artists than the commercial gain of the galleries.

There is not, as yet, a vast arts bureaucracy in Zimbabwe which turns art into recorded minutes at meetings, and the visual arts have not as yet been subjected to the bureaucratic control which is characteristic of some Western countries. Within the structure of the support given to the artist in Zimbabwe, both officially and commercially, the artist is still allowed to remain an individual, and working outside that structure the artist is still able to have the support of that structure.

While the preservation of historic aspects of artistic expression is seen as a way of preserving cultural traditions, the support for the artist in Zimbabwe is largely support for the living artist. It is a flexible support which will withstand, accommodate and develop with the rapid changes which are bound to take place in Zimbabwe in future years.

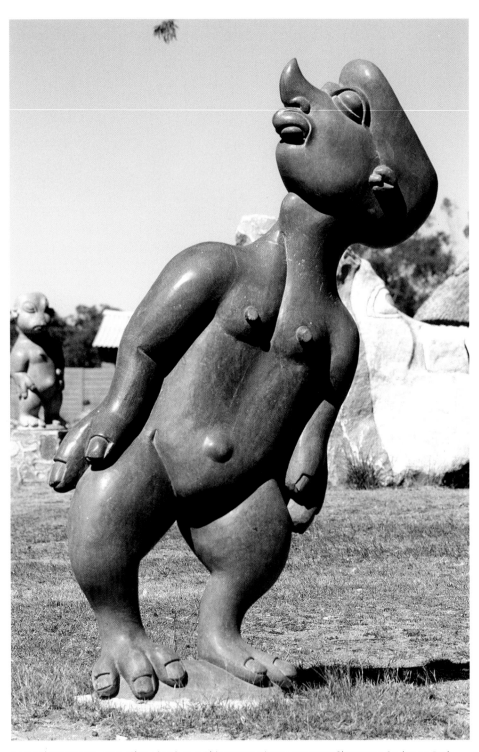

Bernard Matemera, *Man Changing into a Rhinoceros*, picture courtesy Chapungu Sculpture Park

CONCLUSION

The years since Independence have offered Zimbabweans prospects for political stability, economic growth and educational and cultural development. Indigenous cultural practices co-exist, seemingly without conflict of interest. The government acknowledges that traditional `cultural practices are part of the nation's heritage, and that contemporary cultural practice is part of the nation's future development. It actively supports the institutionalisation, preservation and conservation of the nation's heritage, and vests the National Gallery of Zimbabwe, a parastatal institution, with the authority to preserve and conserve the nation's art. Cultural minorities successfully assimilated into Zimbabwe retain their linguistic and cultural relationship with their parent cultures.

However much art is 'art for art's sake' it retains a relationship with society. The influences upon an artist are not merely educational, they are personal, spiritual, social, cultural, economic and political. Today the young artist in Zimbabwe has a higher standard of general education than his predecessors would have had thirty years ago. Overall he has an increased awareness, knowledge and sense of enquiry about the world around him, stimulated by the changes which are taking place in that world. It is inevitable that in this rapidly changing nation methods of art practice will broaden and pluralise. Many young artists are making statements which are a response to society, and search for the appropriate material and expressive means to make that statement. The historic use of natural materials by Zimbabwean artists, partly determined by lack of artists' materials, has taken a new turn. Artists are now working in wood and fibre, developing for these materials experimental and innovative aesthetics. Other artists are working in metal and using found objects.

It has been mentioned before that many artists today prefer to work in groups, as they initially did, rather than in isolation. Some of these groups have formed co-operatives which have an economic rationale. One of the most successful is the women's group of the Weya Training Centre. Here, in paintings and textiles which are essentially narrative and descriptive, the Weya women depict their view of the role of women in contemporary Zimbabwean society, and the cultural parameters which determine that role, both in urban and village life.

The painting of young black Zimbabweans is also developing its own direction. Black Zimbabwean painters have not banded together to make a political statement, and their painting is not necessarily energised or inspired by political thinking. Their movement towards social comment is because of their natural observation of the events going on around them, such as road blocks and bus queues, which are part of their own lives, and indeed part of black Zimbabwean urban culture. The painter Helen Lieros has commented that even if a black Zimbabwean painter is part of a school such as the BAT Workshop or Mzilikazi, he likes to think of himself as an individual artist, expressing what he feels in his own way.

While other art forms evolve and emerge, the stone sculpture in Zimbabwe still remains the art form for which Zimbabwe is best known and, indeed, is identified by. It is not possible to impose a direction on the future of the sculpture. What is predictable is an increase of interest in the sculpture outside Zimbabwe, generated in part by the number of people who come to Zimbabwe — some are already interested in the sculpture, some become interested in the sculpture and, through its purchase, promote the work in many ways, some formally, others informally. In America there are many plans to open galleries for exhibiting the sculpture, and these will be backed by the skilled marketing and promotion characteristic of that country. Government-to-government

cultural relations between Zimbabwe and other countries will also consolidate the sculpture's overseas presence. The National Gallery of Zimbabwe's exhibitions outreach programme expands yearly, and Gallery exhibitions outside Zimbabwe often travel from country to country. It is to the advantage of the sculpture that those people who come to Zimbabwe to buy the art are as interested in information about the sculpture as the sculpture itself. This trend will lead to appropriate conditions of connoisseurship and presentation for exhibitions.

There are, of course, dangers. One is that curios, 'airport art', and decidedly inferior sculpture will be presented under the name of Shona sculpture, which, although culturally inappropriate, has traditionally been accepted, and carries commercial and promotional weight. In fact, the more well known sculpture becomes, the more likely this is to happen. Another danger is over-exposure. The sculpture in a country such as America is a novelty, and it is all too easy for a novelty to become a fashion. It is significant that film stars and directors, actors, musicians and others are building up collections of the sculpture (in particular those who have been to Zimbabwe), and there is the possibility that the sculpture will become a cult rather than a serious collectors' item.

Collections in public art museums, in particular those with an African bias, are badly needed. Well selected, documented and curated collections will establish for the sculpture the seriousness it deserves. Whenever the sculpture is exhibited in or outside Zimbabwe, measures of quality control are essential. If this does not take place there will be little discrimination between serious stone sculpture and 'airport art'. Within Zimbabwe, as long as the market exists, stone sculpture will be made. Unless economic conditions in the country change radically and there are greater opportunities for employment, there will always be an economic rationale for making stone sculpture, and it will be looked upon as a means of employment by the artists. If a sculptor is commercially successful, there is little chance that he will experiment with other media, and the danger is that he will establish a formula for work which he knows will sell. There are, however, younger artists who, although economically dependent on their art, make art which rises above this criterion.

Agnes Nyanhongo is making sculpture which conveys a depth of human emotion which must be part of the artist's makeup. Fabian Madamombe, Kosmos Kamhiriri and Francis Mugavasi are romancing the stone in the best possible way. To them it is decorative,

and a thing of beauty. Their work, often the female form, is in praise of these qualities in the stone, and exceptionally pleasing to the eye. Garrison Machinchili, once a pupil of Tapfuma Gutsa, builds on notions of classicism in his torsos, and lets the uncarved stone take its place in the shape and form of the sculpture. These artists have an assured future, and it is to the credit of Roy Guthrie that they can work out of doors at Chapungu Village, freely and without constraint.

At Tengenenge, new artists emerge. Alice Sani's sculptures have the grace and elegance of her sex. Shekey Chimbumu's grotesque and humourous sculptures both frighten and amuse. Cubism appears to be the personal invention of Stella Faro. Plakey Barankinya's sculpture may be formative art, but she is well on the way to leaving her artistic childhood behind.

New communities of sculptors evolve, such as that of Luke Mugavasi at Guruve, near Tengenenge. Here the spiritual past is the spiritual present, and the sculptures establish the reality of age-old beliefs to the artists today. Here the making of sculpture is a holistic happening in conjunction with the ritual and ceremony to up-hold beliefs.

Bernard Takawira and Nicholas Mukomberanwa are both encouraging young sculptors by example rather than

by influence, and hopefully developing in them their own integrity as artists. The death of John Takawira in 1989 made those who love the sculpture aware of the mortality of the artists, and that a new generation of master sculptors must emerge to carry on what is best within the tradition. To retain the respect it has gained throughout the world, stone sculpture in Zimbabwe must retain its identity, and maintain its quality. It is hardly appropriate to make a comparison between Nicholas Mukomberanwa and Henry Moore. It is appropriate to make comparisons between Nicholas Mukomberanwa and Bernard Takawira, between Henry Munyaradzi and Bernard Matemera. These comparisons have yet to be made.

It is not only the sculptors who will establish the future of stone sculpture in Zimbabwe, it is curators, gallery directors, writers and scholars and, more broadly, it is social, economic and cultural factors in Zimbabwe and outside the country. It is hoped that all who become involved in the sculpture, professionally and personally, will work towards a future for the art which reaches towards the standards of excellence already obtained and still to be achieved.

The economic rationale for many Zimbabweans to make art has, in a sense, created an art industry, with the art work being considered as the products. Ideologically, in Zimbabwe art is seen as an aspect of cultural production and the artist as worker. At the same time there is much appreciation of Zimbabwean art as an aspect of cultural expression, and one which reflects and responds to Zimbabwean life and society.

While the government has made no move to nationalise Zimbabwean art or to issue an ideological directive to artists, it is making moves to keep what it terms 'National Treasures' in Zimbabwe, and if these treasures travel out of the country, on exhibition, to ensure their return. The National Arts Council is moving towards the establishment of grants, endowments and scholarships for artists, which will lessen the commercial aspect of their work and allow them to make art which is truly expressive of their contemporary and traditional culture. It is obvious that in future the art of Zimbabwe will not always be vocational. However, vocational necessity had often been the reason for the Zimbabwean to make art, and it is to be hoped that future support of other kinds does not stultify initiative. Already cultural exchanges, scholarships and grants are being given to artists to work and study in other countries. Conversely, overseas artists are coming to Zimbabwe to take up residence with the BAT Workshop of the National Gallery, and

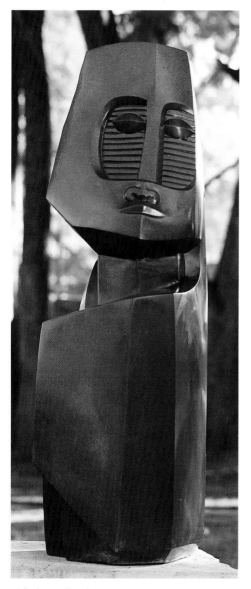

Nicholas Mukomberanwa, *Man in a Trance*, picture courtesy Chapungu Sculpture Park

the Tengenenge Sculpture Community.

The Regional School of Art and Design for SADCC countries will creatively engage existing traditions of Zimbabwean art. It will also establish new traditions, often cross-cultural, through the intake of students from other SADCC countries. It is possible that through the school, Zimbabwean artists will develop a broader cultural identity, consider themselves to be African artists, and possibly international artists. It is more likely that this will happen to painters and sculptors working in perhaps wood and metal, rather than sculptors working in stone whose identity is already firmly culturally located. Through the school, artists will begin to think of art as a product of education, as much as a gift and talent. They will see the making of art as part of a learning process. An aspect, if not the most important aspect, of the work of the school will be its provision, through its teacher training programme, of art teachers for secondary schools, fulfilling an obvious need.

Paul Wade, Director of Educational Services at the National Gallery of Zimbabwe, has commented that although many art teachers in Zimbabwe have had little or no art education, they are expected to teach up to A level, but do not have O levels themselves. It is important that the school teaches the teachers, in order to allow the teachers to teach the students.

What is needed among the sculptors today is a measure of self-criticism and judgment of their own work — this has perhaps been hampered by the esteem in which the artists of Zimbabwe have traditionally been held. It is all too easy for a young sculptor to think that because he makes sculpture he is a good sculptor.

The School of Art and Design will encourage artists to reach even higher standards of excellence. The school may, perhaps, dangerously separate art from life, the integration of which has partly led to the success and quality of Zimbabwean art. However, in a rapidly developing country, the holistic dimension of cultural life is breaking down, particularly in the urban areas and the cities.

While the artists of Zimbabwe will shape the future of the art of the nation, so will those who administer it. The National Gallery of Zimbabwe, the National Arts Council, and the Ministry of Education and Culture, will continue to be driving forces for the art. There is currently, among art education circles, a debate about talent and gifts as innate qualities. These qualities do exist among the sculptors in Zimbabwe.

The artists of Zimbabwe, through the School of Art and Design, are about to be blessed with endowments other than talent, in particular, formal education, professional training, cultural exchanges, and greater financial support. It will be up to those who are responsible for developing those endowments to see they enhance rather than repress existing talent and do not take away from Zimbabwe's artists the uniqueness that is undeniably theirs.

Education is also needed on the part of the art public in order that they can enjoy the art produced by their people in which so much of their lives is reflected. They can learn to enjoy art, and they need to know that it belongs to them as a nation and that it is not made for an elite section of society. So, whilst the artists and teachers and educationalists generally need training, the public also needs to learn about the value of art and art treasures.

FOOTNOTES

CHAPTER FOUR

1. Frank McEwen. 'Shona Art Today', *African Arts*, Vol. V, No. 4, Summer 1972.

CHAPTER EIGHT

1. Thomas Huffman, 'Expressive Space in Zimbabwe Culture', *MAN (N.S.)*, Vol. 19, pp. 593–612.
2. Thomas Huffman, interview with author.
3. *Ibid.*
4. *Ibid.*
5. Peter Garlake, *The Painted Caves*, pp. 65–94.
6. *Ibid.*, p. 4
7. *Ibid.*, p. 5
8. Walker, quoted in Thackeray, A.I., 1983, Dating the rock art of southern Africa, Lewis-Williams, ed.
9. Peter Garlake, *The Painted Caves*, p. 5
10. *Ibid.*
11. *Ibid.*, p. 7
12. *Ibid.*, p. 9
13. *Ibid.*
14. *Ibid.*, p. 10
15. *Ibid.*, p. 29
16. *Ibid.*, p. 10
17. *Ibid.*, p. 19
18. *Ibid.*, p. 27
19. *Ibid.*, p. 30
20. *Ibid.*, pp. 52–53
21. J.D. Lewis-Williams, *Believing and Seeing*, pp. 112–114
22. *Ibid.*
23. *Ibid.*
24. *Ibid.*
25. *Ibid.*
26. Peter Garlake, *The Painted Caves*, p. 30
27. J.D. Lewis-Williams, *Believing and Seeing*, pp. 112–114
28. Thomas Huffman, interview with author
29. J.D. Lewis-Williams, The San Artistic Achievement, *African Arts*, Vol. XVIII, No. 3, 1985, pp. 54–59
30. *Ibid.*
31. J.P. Lewis-Williams, *Believing and Seeing*, p.78
32. Thomas Huffman, Interview with author

33. *Ibid.*
31. *Ibid.*
35. *Ibid.*
36. *Ibid.*
37. *Ibid.*
38. Thomas Huffman, 'Iron Age Settlements and Origins of Class Distinction in Southern Africa', *Advances in World Archaeology*, Vol. 5, 1986, pp. 291–338.
39. Thomas Huffman, interview with author
40. *Ibid.*
41. David Beach, *The Shona and Zimbabwe, 900–1850*, Introduction, p. xvii
42. Thomas Huffman, interview with author
43. *Ibid.*
44. Thomas Huffman, 'Iron Age Settlements and Origins of Class Distinction in Southern Africa', *Advances in World Archaeology*, Vol. 1, 1986, pp. 291–338.
45. *Ibid.*
46. Thomas Huffman, interview with author.
47. Thomas Huffman, 'Iron Age Settlements and Origins of Class Distinction In Southern Africa', *Advances In World Archaeology*, Vol. 5, 1986, pp. 291–338
48. *Ibid.*
49. Thomas Huffman, interview with author
50. *Ibid.*
51. Thomas Huffman, 'Iron Age Settlements and Origins of Class Distinction in Southern Africa', *Advances in World Archaeology*, Vol. 5, 1986, pp. 29I–338
52. David Beach, *The Shona and Zimbabwe, 900–1850*, p. 36
53. Godfrey Mahachi, interview with author
54. *Ibid.*
55. Thomas Huffman, interview with author
56. *Ibid.*
57. *Ibid.*
58. David Beach, *The Shona and Zimbabwe, 900–1850*, p. 42

59. D.E. Needham, E.K. Mashingaidze, N. Bhehe, *From Iron Age to Independence, A History of Central Africa*, p. 17
60. A.H. Whitty, 'Architectural Styles in Zimbabwe', *Zimbabwe Environment and Design*, official journal of the Institute of Architects of Zimbabwe and the Institute of Regional and Urban Planners, 1st issue, Monograph 1, 1981
61. David Beach, *The Shona and Zimbabwe, 900–1850*, p. 43
62. *Ibid.*
63. Thomas Huffman, interview with author
64. D.E.Needham, E.K. Mashingaidze, M. Bhebe, *From Iron Age to Independence, A History of Central Africa*, p. 16
65. Peter Garlake, *Great Zimbabwe Described and Explained*, p. 59
66. Thomas Huffman, interview with author
67. *Ibid.*
68. *Ibid.*
69. *Ibid.*
70. *Ibid.*
71. *Ibid.*
72. *Ibid.*
73. *Ibid.*
74. *Ibid.*
75. Peter Garlake, *Great Zimbabwe Described and Explained*, p. 27
76. Thomas Huffman, 'The Soapstone Birds from Great Zimbabwe', *African Arts*, Vol. XVIII, No. 3, 1985, pp. 68–73
77. Peter Garlake, *Great Zimbabwe Described and Explained*, pp. 57–58
78. Thomas Huffman, 'The Soapstone Birds from Great Zimbabwe', *African Arts*, Vol. XVIII, No. 3, 1985, pp. 68–73
79. *Ibid.*
80. *Ibid.*
81. *Ibid.*
82. Thomas Huffman, 'Expressive Space in Zimbabwe Culture', *MAN (N.S.)*, Vol. 19, pp. 593–6I2
83. *Ibid.*

84. Terence Ranger, letter to author
85. P.O. Mazikana and I.J. Johnstone, *Zimbabwe Epic*, p. 49, (compiled by)
86. Thomas Huffman, interview with author
87. F. du Toit, *Musha — The Shona Concept of Home*, Official journal of the Institute of Architects of Zimbabwe and the Institute of Regional and Urban Planners, October, 1981
88. H. Ellert, *The Material Culture of Zimbabwe*, p. 9
89. Thomas Huffman, interview with author
90. H. Ellert, *The Material Culture of Zimbabwe*, p. 22
91. *Ibid.*, p. 27
92. *Ibid.*, p. 37
93. *Ibid.*, p. 18
94. *Ibid.*, p. 91
95. *Ibid.*, p. 47
96. D.E. Needham, E.K. Mashingaidze, M. Bhebe, *From Iron Age to Independence, A History of Central Africa*, p. 66
97. *Ibid.*
98. *Ibid.*, p. 69
99. H. Ellert, *The Material Culture of Zimbabwe*, p. 47
100. *Ibid.*

CHAPTER NINE

1. Millais, F.Z.S., *A Breath from the Veld*, Henry Sothern & Co., London, 1895, p. 121
2. Wood, Patricia, A General Survey in *Arts Rhodesia*, No. 1, 1978 Annual, p. 12
3. Arnold,. Marion, 'Four Zimbabwean Painters' in *Arts Zimbabwe*, No. 2. 1981/82, pp. 46–54
4. B.V. Project Development *Prode*, The National Gallery, The Establishment of an Art and Design School in Zimbabwe, feasibility study, October 1987, p. 181

BIOGRAPHY

SANWELL CHIRUME
(Shona, Zimbabwe)
1942 Born Guruve, Zimbabwe.
Training
Tengenenge Sculpture Community (informal).
Works Represented
Works represented in the permanent and overseas collections of the National Gallery of Zimbabwe.
Works Selected
Works selected for the Annual Exhibition of the National Gallery: 1988, 1989, 1990.
Awards and Achievements
1988 Award for Monumental Outdoor Sculpture, Zimbabwe Heritage Exhibition, National Gallery of Zimbabwe
1990 Certificate of Excellence, Zimbabwe Heritage Exhibition, National Gallery of Zimbabwe.
Selected Group Exhibitions
1988 Spirit and Matter, Le Forum, French Embassy, Harare
1989 Zimbabwe op de Berg, Foundation Beelden op de Berg, Wageningen, Holland
1989 The Spirit of Tengenenge, Zimbabwe-German Society, Harare
1990/91 Contemporary Stone Carvings from Zimbabwe, Yorkshire Sculpture Park, U.K.
1990 Stone Sculpture from Zimbabwe, Millesgarden Museum, Stockholm, Sweden
Public and Private Collections
Tengenenge permanent collection; Chapungu Village Sculpture Garden permanent collection; private and public collections inside and outside Zimbabwe.

BARANKINYA GOSTA
(Chewa Extraction, Mozambique)
1936 Born Kirimani, Mozambique.
Training
1966 Tengenenge Sculpture Community (informal).

Works Represented
Works represented in the permanent and overseas collections of the National Gallery of Zimbabwe.
Works Selected
Works selected for the Annual Exhibition of the National Gallery of Zimbabwe: 1988, 1989, 1990.
Selected Group Exhibitions
1971 Sculpture Contemporaine des Shonas d'Afrique, Musée Rodin, Paris
1988 Spirit and Matter, Le Forum, French Embassy, Harare
1989 Present and Future, Le Forum, French Embassy, Harare
1989 Zimbabwe op de Berg, Foundation Beelden op de Berg, Wageningen, Holland
1989 The Spirit of Tengenenge, Zimbabwe-German Society, Harare
Public and Private Collections
Tengenenge permanent collection; private collections inside and outside Zimbabwe.

TAPFUMA GUTSA
(Shona, Zimbabwe)
1956 Born Harare, Zimbabwe.
Training
1978–79 Driefontein Mission, Mvuma (formal)
1982–85 City and Guilds School, London School of Art. (Diploma in Sculpture) (formal).
Works Represented
Works represented in the permanent and overseas collections of the National Gallery of Zimbabwe.
Works Selected
Works selected for the Annual Exhibition of the National Gallery of Zimbabwe: 1976, 1977, 1978, 1979, 1980, 1981, 1982, 1985, 1986, 1987.
Awards and Achievements
1981 Award, National Gallery of Zimbabwe Weldart Competition
1982 Award, National Gallery of Zimbabwe Weldart Competition
1983 First Award, National Gallery of Zimbabwe Weldart Competition

1986 Award of Merit, Zimbabwe Heritage Exhibition, National Gallery of Zimbabwe
1987 Award of Distinction, Zimbabwe Heritage Exhibition, National Gallery of Zimbabwe
One-Person Exhibitions
1987 PG Gallery, National Gallery of Zimbabwe
Selected Group Exhibitions
1979 Joan Munn Gallery, London
1980 Standard Chartered Gallery, John Boyne House, Harare
1981 Gallery Delta, Harare
1982 Mall Gallery, London
1984 Creation for Liberation, Brixton, London
1985 New Horizons, Royal Festival Hall, London
1990/91 Contemporary Stone Carvings from Zimbabwe, Yorkshire Sculpture Park, U.K.
1990 Stone Sculpture from Zimbabwe, Millesgarden Museum, Stockholm, Sweden
Public and Private Collections
Chapungu Village Sculpture Garden permanent collection, Harare; private collections inside and outside Zimbabwe.

MAKINA KAMEYA
(Mbunda, Angola)
1920 Born Angola, died 1988.
Training
Tengenenge Sculpture Community (informal).
Works Represented
Works represented in the permanent and overseas collections of the National Gallery of Zimbabwe.
Works Selected
Works selected for the Annual Exhibition of the National Gallery of Zimbabwe: 1985, 1986, 1987.
Awards and Achievements
1985 Second Prize, Annual Nedlaw Exhibition, National Gallery of Zimbabwe

1986 Award of Merit, Zimbabwe Heritage
 Exhibition, National Gallery of
 Zimbabwe
1987 Award of Merit, Zimbabwe Heritage
 Exhibition, National Gallery of
 Zimbabwe
Selected Group Exhibitions
1988 Spirit and Matter, Le Forum, French
 Embassy, Harare
1989 The Spirit of Tengenenge, Zimbabwe-
 German Society, Harare
Public and Private Collections
Tengenenge permanent collection; Chapungu
Village Sculpture Garden permanent collection;
Nestle (Pvt) Ltd, Harare, permanent collection;
private collections inside and outside Zimbabwe.

WAZI MAICOLO
(Yao, Malawi)
1936 Born Malawi, died 1987.
Training
1966 Tengenenge Sculpture Community
 (informal).
Works Represented
Works represented in the permanent and
overseas collections of the National Gallery of
Zimbabwe.
Works Selected
Works selected for the Annual Exhibition,
National Gallery of Zimbabwe; 1973, 1974.
One-Person Exhibitions
1987 Retrospective, National Gallery of
 Zimbabwe.
Selected Group Exhibitions
1985 Contemporary Stone Sculpture from
 Zimbabwe, Irving Sculpture Gallery,
 Sydney (in association with The
 Gallery Shona Sculpture, Harare)
1986 Soul in Stone, Irving Sculpture
 Gallery, Sydney (in association with
 The Gallery Shona Sculpture, Harare)
Public and Private Collections
Tengenenge permanent collection; Chapungu
Village Sculpture Garden permanent collection,
Harare.

AMALI MAILOLO
(Yao, Malawi)
Born Malawi (date of birth not known).
Training
1966 Tengenenge Sculpture Community
 (informal).
Works Represented
Works represented in the permanent and
overseas collections of the National Gallery of
Zimbabwe.
Works Selected
Works selected for the Annual Exhibition of the
National Gallery of Zimbabwe: 1988.
Selected Group Exhibitions
1985 Contemporary Stone Sculpture from
 Zimbabwe, Irving Sculpture Gallery,
 Sydney (in association with The
 Gallery Shona Sculpture, Harare)
1986 Soul in Stone, Irving Sculpture
 Gallery, Sydney (in association with
 The Gallery Shona Sculpture, Harare)
1989 The Lighter Side of Stone, House of
 Humour and Satire, Gabrovo,
 Bulgaria
Public and Private Collections
Tengenenge permanent collection; Chapungu
Village Sculpture Garden permanent collection.

DAMIEN MANUHWA
(Shona, Zimbabwe)
1952 Born Rusape, Zimbabwe.
Training
1970 National Gallery Workshop School
 (informal).
Works Represented
Works represented in the permanent and
overseas collections of the National Gallery of
Zimbabwe.
Works Selected
Works selected for the Annual Exhibition of the
National Gallery of Zimbabwe: 1981, 1983,
1984, 1985, 1986, 1987, 1988, 1989, 1990.
Awards and Achievements
1988 Certificate of Excellence, Zimbabwe
 Heritage Exhibition, National Gallery
 of Zimbabwe

One-Person Exhibitions
1987 African Influence Gallery, Boston,
 Mass.
Selected Group Exhibitions
1971 Sculpture Contemporaine des Shonas
 d'Afrique, Musée Rodin, Paris
1981 Retrospective Exhibition of Shona
 Sculpture, Zimbabwe House, London
1985 Contemporary Stone Sculpture from
 Zimbabwe, Irving Sculpture Gallery,
 Sydney (in association with The
 Gallery Shona Sculpture, Harare)
1986 Soul in Stone, Irving Sculpture
 Gallery, Sydney (in association with
 The Gallery Shona Sculpture, Harare)
1986/87 International Contemporary Art Fair,
 Los Angeles Convention Centre, Los
 Angeles
1987/88 Chicago International Art Exposition,
 Chicago
1988 International Gallery Invitational,
 Jacobs Jaunts Convention Centre,
 New York
1988 Australia Art Expo, Darling Harbour,
 Sydney
1988 Spirit and Matter, Le Forum, French
 Embassy, Harare
1989 Solomon Gallery, Dublin
1989 Present and Future, Le Forum, French
 Embassy, Harare
1989 Zimbabwe op de de Berg, Foundation
 Beelden op de Berg, Wageningen,
 Holland
1990/91 Contemporary Stone Carvings from
 Zimbabwe, Yorkshire Sculpture Park,
 U.K.
1990 Stone Sculpture from Zimbabwe,
 Millesgarden Museum, Stockholm,
 Sweden
Public and Private Collections
Private collections inside and outside Zimbabwe.

JOSIA MANZI
(Yao Extraction)
1938 Born Zimbabwe.
Training
1966 Tengenenge Sculpture Community
 (informal).

Works Represented
Works represented in the permanent and overseas collections of the National Gallery of Zimbabwe.
Works Selected
Works selected for the Annual Exhibition of the National Gallery of Zimbabwe: 1968, 1981, 1982, 1987, 1989, 1990.
Awards and Achievements
1987 Award of Merit, Zimbabwe Heritage Exhibition, National Gallery of Zimbabwe
1990 Award of Distinction and Certificate of Excellence, Zimbabwe Heritage Exhibition, National Gallery of Zimbabwe
Selected Group Exhibitions
1985 Contemporary Stone Sculpture from Zimbabwe, Irving Sculpture Gallery, Sydney (in association with The Gallery Shona Sculpture, Harare
1986 Soul in Stone, Irving Sculpture Gallery, Sydney in association with The Gallery Shona Sculpture, Harare)
1989 Zimbabwe op de Berg, Foundation Beelden op de Berg, Wageningen, Holland
1989 The Spirit of Tengenenge, Zimbabwe-German Society, Harare
1990/91 Contemporary Stone Carvings from Zimbabwe, Yorkshire Sculpture Park, U.K.
Public and Private Collections
Tengenenge permanent collection; Chapungu Village Sculpture Garden permanent collection; private collections inside and outside Zimbabwe.

JORAM MARIGA
(Shona, Zimbabwe)
c. 1927 Born near Chinoyi, Zimbabwe.
Training
Informal, self taught.
Works Represented
Works represented in the permanent and overseas collections of the National Gallery of Zimbabwe.

Works Selected
Works selected for the Annual Exhibition of the National Gallery of Zimbabwe: 1989.
Awards and Achievements
1989 Highly Commended (2 works), Zimbabwe Heritage Exhibition, National Gallery of Zimbabwe
One-Person Exhibitions
1989 Whispering the Gospel of Sculpture, National Gallery of Zimbabwe. (Virtually all works purchased by the National Gallery of Zimbabwe)
Selected Group Exhibitions
1989 Zimbabwe op de Berg, Foundation Beelden op de Berg, Wageningen, Holland
1990 Zimbabwe Heritage (National Gallery of Zimbabwe), Auckland, New Zealand, during Commonwealth Games
1990/91 Contemporary Stone Carvings from Zimbabwe, Yorkshire Sculpture Park, U.K.
1990 Stone Sculpture from Zimbabwe, Millesgarden Museum, Stockholm, Sweden
Public and Private Collections
Private collections inside and outside Zimbabwe.

MOSES MASAYA
(Shona, Zimbabwe)
1947 Born Nyanga, Zimbabwe.
Training
1958 with Joram Mariga (informal)
1970–74 Vukutu Art Foundation (informal).
Works Selected
Works selected for the Annual Exhibition of the National Gallery of ZImbabwe: 1968, 1970, 1983, 1985, 1986, 1988.
Two-Person Exhibitions
1988 Standard Chartered Gallery, John Boyne House, Harare (with Norbert Shamuyarira)
Selected Group Exhibitions
1971 Sculpture Contemporaine des Shonas d'Afrique, Musée Rodin, Paris

1975 South African Association of Arts Gallery, Johannesburg, and NSIA Gallery, Durban
1981 Retrospective Exhibition of Shona Sculpture, Zimbabwe House, London
1985 Contemporary Stone Sculpture from Zimbabwe, Irving Sculpture Gallery, Sydney (in association with The Gallery Shona Sculpture, Harare)
1986 Soul in Stone, Irving Sculpture Gallery, Sydney (in association with The Gallery Shona Sculpture, Harare)
1988 Contemporary Stone Sculpture from Zimbabwe, Barbican Centre, London
1990/91 Contemporary Stone Carvings from Zimbabwe, Yorkshire Sculpture Park, U.K.
1990 Stone Sculpture from Zimbabwe, Millesgarden Museum Stockholm, Sweden
Public and Private Collections
Private collections inside and outside Zimbabwe.

BERNARD MATEMERA
(Shona, Zimbabwe)
Born Guruve, Zimbabwe (date of birth not known).
Training
Tengenenge Sculpture Community (informal).
Works Represented
Works represented in the permanent and overseas collections of the National Gallery of Zimbabwe.
Works Selected
Works selected for the Annual Exhibition of the National Gallery of Zimbabwe: 1967–1968, 1973, 1985, 1986, 1987, 1988, 1990.
Awards and Achievements
1986 Award of Distinction, Zimbabwe Heritage Exhibition, National Gallery of Zimbabwe
1986 Award of Honour (Lalit Kala Akademi) VI Triennial, New Delhi, India
1987 Award of Outdoor Sculpture, Zimbabwe Heritage Exhibition, National Gallery of Zimbabwe

1990 Award of Merit, Zimbabwe Heritage Exhibition, National Gallery of Zimbabwe

One-Person Exhibitions

1987/88 African Metamorphosis, National Gallery of Zimbabwe. (All works purchased by the National Gallery of Zimbabwe)

Selected Group Exhibitions

1988 Spirit and Matter, Le Forum, French Embassy, Harare

1989 ZImbabwe op de Berg, Foundation Beelden op de Berg, Wagentilgen, Holland

1989 The Spirit of Tengenenge, Zimbabwe-German Society, Harare

1990/91 Contemporary Stone Carvings from Zimbabwe, Yorkshire Sculpture Park, U.K.

1990 Stone Sculpture from Zimbabwe, Millesgarden Museum, Stockholm, Sweden

Public and Private Collections

Tengenenge permanent collection; Chapungu Village Sculpture Garden permanent collection; private collections inside and outside Zimbabwe.

In 1987 Bernard Matemera was invited to Yugoslavia to make a large sculpture at the Joseph Broz Tito Museum in Titograd. This has remained in situ.

RICHARD MTEKI

(Shona, Zimbabwe)

1947 Born Harare, Zimbabwe.

Training

Nyarutsetso Art Centre (informal); National Gallery Workshop School (informal).

Works Represented

Works represented in the overseas collection of the National Gallery of Zimbabwe.

Works Selected

Works selected for the Annual Exhibition of the National Gallery of Zimbabwe: 1965, 1968, 1981, 1987, 1988.

Awards and Achievements

1986 Zimbabwe Bird commissioned for Harare Stadium

1987 Work selected as gift for presentation to Nigerian President by President Robert Mugabe.

Selected Group Exhibitions

1981 Retrospective Exhibition of Shona Sculpture, Zimbabwe House, London

1985 Contemporary Stone Sculpture from Zimbabwe, Irving Sculpture Gallery, Sydney (in association with The Gallery Shona Sculpture, Harare)

1986 Soul in Stone, Irving Sculpture Gallery, Sydney (in association with The Gallery Shona Sculpture, Harare)

1987 International Contemporary Art Fair, Los Angeles Convention Centre, Los Angeles

1987/88 Chicago International Art Exposition, Chicago

1988 International Gallery Invitational, Jacobs Jaunts Convention Centre, New York

1988 Australia Art Expo, Darling Harbour, Sydney

1990/91 Contemporary Stone Carvings from Zimbabwe, Yorkshire Sculpture Park, U.K.

1990 Stone Sculpture from Zimbabwe, Millesgarden Museum, Stockholm, Sweden

Public and Private Collections

Private collections inside and outside Zimbabwe.

THOMAS MUKAROBWA

(Shona, Zimbabwe)

1924 Born Nyanga, Zimbabwe.

Training

1958 National Gallery Workshop School (informal).

Works Represented

Works represented in the permanent and overseas collections of the National Gallery of Zimbabwe.

Works Selected

Works selected for the Annual Exhibition of the National Gallery of Zimbabwe: 1958–1990.

Awards and Achievements

1982 First Prize, Annual Nedlaw Exhibition, National Gallery of Zimbabwe

1983 Third Prize, Annual Nedlaw Exhibition, National Gallery of Zimbabwe

1984 Prize, Annual Nedlaw Exhibition, National Gallery of Zimbabwe

1986 Invited Artist, Zimbabwe Heritage Exhibition, National Gallery of Zimbabwe

1989 Award of Merit, Zimbabwe Heritage Exhibition, National Gallery of Zimbabwe

1989 Highly Commended, Zimbabwe Heritage Exhibition, National Gallery of Zimbabwe

1990 Award of Merit, and Certificate of Excellence (2), Zimbabwe Heritage Exhibition, National Gallery of Zimbabwe

One-Person Exhibitions

1985 PG Gallery, National Gallery of Zimbabwe

Selected Group Exhibitions

1962 New African Talent, National Gallery of Zimbabwe

1963 New Art from Rhodesia, Commonwealth Institute, London

1968/69 New African Art, Museum of Modern Art, New York

1971 Sculpture Contemporaine des Shonas d'Afrique, Musée Rodin, Paris

1981 Art from Africa, Commonwealth Institute, London

1990/91 Contemporary Stone Carvings from Zimbabwe, Yorkshire Sculpture Park, U.K.

Public and Private Collections

Private collections inside and outside Zimbabwe.

NICHOLAS MUKOMBERANWA

(Shona, Zimbabwe)

1940 Born Buhera District, Zimbabwe.

Training

1959 Serima Mission (formal)

1962 National Gallery Workshop School (informal).

Works Represented
Works represented in the permanent and overseas collections of the National Gallery of Zimbabwe.

Works Selected
Works selected for the Annual Exhibition of the National Gallery of Zimbabwe, 1982, 1983, 1984, 1985, 1986, 1987, 1988, 1989, 1990.

Awards and Achievements

1984 Highly Commended, Annual Nedlaw Exhibition, National Gallery of Zimbabwe

1986 Invited artist, Zimbabwe Heritage Exhibition, National Gallery of Zimbabwe

1989 Award of Distinction and Director's Award of Distinction in Any Category, Zimbabwe Heritage Exhibition, National Gallery of Zimbabwe

1990 Certificate of Excellence (2), Zimbabwe Heritage Exhibition, National Gallery of Zimbabwe.

One-Person Exhibitions

1977 Goodman Gallery, Johannesburg

1981 PG Gallery, National Gallery of Zimbabwe (first invited artist)

1983 Commonwealth Centre, London

1983 Gallery 10, London (in association with The Gallery Shona Sculpture, Harare)

1987 African Influence Gallery, Boston, Mass

1989 The Gallery Shona Sculpture, Chapungu Village, Harare

Selected Group Exhibitions

1965 New Art from Rhodesia, Commonwealth Arts Festival, Festival Hall, London

1969 Contemporary African Art, Camden Arts Centre, London

1971 Sculpture Contemporaine des Shonas d'Afrique, Musée Rodin, Paris

1972 Shona Sculptors of Rhodesia, Institute of Contemporary Arts Gallery, London

1981 Art from Africa, Commonwealth Institute, London

1985 Contemporary Stone Sculpture from Zimbabwe, Irving Sculpture Gallery, Sydney (in association with The Gallery Shona Sculpture, Harare)

1986 Soul in Stone, Irving Sculpture Gallery, Sydney (in association with The Gallery Shona Sculpture, Harare)

1987 Contemporary Stone Sculpture from Zimbabwe, Africa Centre, Barbican Centre, London

1988 Spirit and Matter, Le Forum, French Embassy, Harare

1989 Present and Future, Le Forum, French Embassy, Harare

1989 Zimbabwe op de Berg, Foundation Beelden op de Berg, Wageningen, Holland

1990 Zimbabwe Heritage Exhibition, National Gallery of Zimbabwe, Auckland, New Zealand, during Commonwealth Games

1990/91 Contemporary Stone Carvings from Zimbabwe, Yorkshire Sculpture Park, U.K.

1990 Stone Sculpture from Zimbabwe, Millesgarden Museum, Stockholm, Sweden

Public and Private Collections
Museum of Modern Art, New York; Field Museum, Chicago; Museum of Mankind (British Museum), London; National Gallery of Botswana; Chapungu Village Sculpture Garden permanent collection; private collections inside and outside Zimbabwe.

JOSEPH MULI
(Wakamba, Kenya)
1944 Born Machakos, Kenya.

Training
Self taught.

Works Represented
Works represented in the permanent and overseas collections of the National Gallery of Zimbabwe.

Works Selected
Works selected for the Annual Exhibition of the National Gallery of Zimbabwe: 1974–1989.

Awards and Achievements

1985 Prize, Annual Nedlaw Exhibition, National Gallery of Zimbabwe

1988 Award of Merit, Zimbabwe Heritage Exhibition, National Gallery of Zimbabwe

One-Person Exhibitions

1974 Standard Chartered Gallery, John Boyne House, Harare

Selected Group Exhibitions

1964 Internal Affairs Exhibition, Rand Easter Show, Johannesburg

1971 Rhodesian Group Exhibition, Beira, Mozambique

1975 Contemporary Rhodesian Art, Harare, Zimbabwe

1975 Nedart Rhodesian Exhibition, Johannesburg

Public and Private Collections
Private collections inside and outside Zimbabwe.

HENRY MUNYARADZI
(Shona, Zimbabwe)
1931 Born Guruve, Zimbabwe.

Training
1967 Tengenenge Sculpture Community (informal).

Works Represented
Works represented in the permanent and overseas collections of the National Gallery of Zimbabwe.

Works Selected
Works selected for the Annual Exhibition of the National Gallery of Zimbabwe: 1968, 1981, 1982, 1983, 1984, 1985, 1986, 1987, 1988, 1989.

Awards and Achievements

1981 Second Prize, Annual Nedlaw Exhibition, National Gallery of Zimbabwe

1984 Third Prize, Annual Nedlaw Exhibition, National Gallery of Zimbabwe

1986 Invited artist, Zimbabwe Heritage Exhibition, National Gallery of Zimbabwe

One-Person Exhibitions

1975 Tengenenge Gallery, Park Street, Harare

1984 Commonwealth Institute, London

1985 Feingarten Gallery, Los Angeles

1987 The Gallery Shona Sculpture, Chapungu Village, Harare

1987 African Influence Gallery, Boston, Mass.

1989 The Gallery Shona Sculpture, Chapungu Village, Harare

Selected Group Exhibitions

1968 Tengenenge, for architects from the Carlton Centre, Johannesburg

1971 Sculpture Contemporaine des Shonas d'Afrique, Musée Rodin, Paris

1971 Museum of Modern Art, New York

1978 Tengenenge Gallery, Victory House, Johannesburg

1983 Africa Centre, London

1985 Kustschatze aus Africa, Frankfurt

1985 Stein Sculpturen aus Zimbabwe, Landertank, Vienna

1985 Contemporary Stone Sculpture from Zimbabwe, Irving Sculpture Gallery, Sydney (in association with The Gallery Shona Sculpture, Harare)

1988 Present and Future, Le Forum, French Embassy, Harare

1989 Zimbabwe op de Berg, Foundation Beelden op de Berg, Wageningen, Holland

1990/91 Contemporary Stone Carvings from Zimbabwe, Yorkshire Sculpture Park, U.K.

1990 Stone Sculpture from Zimbabwe, Millesgarden Museum, Stockholm, Sweden

Public and Private Collections

Chapungu Village Sculpture Garden permanent collection; private collections inside and outside Zimbabwe.

JOSEPH NDANDARIKA
(Shona, Zimbabwe)

1940 Born Harare, Zimbabwe.

Training

 Serima Mission (formal).

1962 National Gallery Workshop School (informal).

Works Represented

Works represented in the permanent and overseas collections of the National Gallery of Zimbabwe.

Works Selected

Works selected for the Annual Exhibition of the National Gallery of Zimbabwe: 1962, 1963, 1967, 1971, 1981, 1983, 1984, 1985, 1986, 1987.

Awards and Achievements

1981 Second Prize, Annual Nedlaw Exhibition, National Gallery of Zimbabwe

1985 Highly Commended, Annual Nedlaw Exhibition, National Gallery of Zimbabwe

1986 Award of Merit, Zimbabwe Heritage Exhibition, National Gallery of Zimbabwe

Selected Group Exhibitions

1963 New Art from Rhodesia, Commonwealth Institute, London

1964 International Art Exhibition, Lusaka, Zambia

1968–69 New African Art organised by Museum of Modern Art, New York (toured American cities)

1971 Sculpture Contemporaine des Shonas d'Afrique, Musée Rodin, Paris

1975 Shona Art Phenomenon, South African Association of Arts Gallery, Johannesburg

1981 Retrospective Exhibition of Shona Sculpture, Zimbabwe House, London

1985 Contemporary Stone Sculpture from Zimbabwe, Irving Sculpture Gallery, Sydney (in association with The Gallery Shona Sculpture, Harare)

1986 Soul in Stone, Irving Sculpture Gallery, Sydney (in association with The Gallery Shona Sculpture, Harare)

1987 International Contemporary Art Fair, Los Angeles Convention Centre, Los Angeles

1987/88 Chicago International Art Exposition, Chicago

1988 International Gallery Invitational, Jacobs Jaunts Gallery, New York

1988 Australia Art Expo, Darling Harbour, Sydney

1990/91 Contemporary Stone Carvings from Zimbabwe, Yorkshire Sculpture Park, U.K.

1990 Stone Sculpture from Zimbabwe, Millesgarden Museum, Stockholm, Sweden

Public and Private Collections

Private collections inside and outside Zimbabwe.

LOCARDIA NDANDARIKA
(Shona, Zimbabwe)

1945 Born Zimbabwe.

Training

Chapungu Village (informal); BAT Workshop School, National Gallery (formal).

Works Represented

Works represented in the overseas collection of the National Gallery of Zimbabwe.

Works Selected

Works selected for the Annual Exhibition of the National Gallery of Zimbabwe: 1987, 1988, 1990.

Awards and Achievements

1988 Certificate of Excellence, Annual Nedlaw Exhibition, National Gallery of Zimbabwe

1989 Award of Merit, Zimbabwe Heritage Exhibition, National Gallery of Zimbabwe

1990 Certificate of Excellence (2), Zimbabwe Heritage Exhibition, National Gallery of Zimbabwe

Selected Group Exhibitions

1971 Sculpture Contemporaine des shonas d'Afrique, Musée Rodin, Paris

1989 Present and Future, Le Forum, French Embassy, Harare

AGNES NYANHONGO

1960 Born Zimbabwe.

Training

BAT Workshop School, National Gallery (formal); Chapungu Village (informal).

Works Represented

Works represented in the permanent and overseas collections of the National Gallery of Zimbabwe.

Works Selected

Works selected for the Annual Exhibition of the National Gallery of Zimbabwe: 1985, 1987, 1989, 1990.

Awards and Achievements

1985 Award, Annual Nedlaw Exhibition, National Gallery of Zimbabwe

1987 Award of Merit, Zimbabwe Heritage Exhibition, National Gallery of Zimbabwe

1989 Award of Merit, Zimbabwe Heritage Exhibition, National Gallery of Zimbabwe

1990 Award of Merit, Zimbabwe Heritage Exhibition, National Gallery of Zimbabwe

Two-Person Exhibitions

1989 Standard Chartered Gallery, John Boyne House. Harare (with Joseph Munemo)

Selected Group Exhibitions

1989 Present and Future, Le Forum, French Embassy, Harare

1990 Standard Chartered Gallery, John Boyne House, Harare

1990/91 Contemporary Stone Carvings from Zimbabwe, Yorkshire Sculpture Park, U.K.

BRIGHTON SANGO

(Shona, Zimbabwe)

1958 Born Guruve, Zimbabwe.

Training

Tengenenge Sculpture Community (informal).

Works Represented

Works represented in the permanent and overseas collections of the National Gallery of Zimbabwe.

Works Selected

Works selected for the Annual Exhibition of the National Gallery of Zimbabwe: 1980, 1981, 1985, 1986, 1987, 1990.

Awards and Achievements

1987 Award of Merit, Zimbabwe Heritage Exhibition, National Gallery of Zimbabwe

Selected Group Exhibitions

1981 Retrospective Exhibition of Shona Sculpture, Zimbabwe House, London

1983 Standard Chartered Gallery, John Boyne House, Harare

1985 Contemporary Stone Sculpture of Zimbabwe, Irving Sculpture Gallery, Sydney (in association with The Gallery Shona Sculpture, Harare)

1986 Soul in Stone, Irving Sculpture Gallery, Sydney (in association with The Gallery Shona Sculpture, Harare)

1986 International Contemporary Art Fair, Los Angeles Convention Centre, Los Angeles

1987/88 Chicago International Art Exposition, Chicago

1988 International Gallery Invitational, Jacobs Jaunts Convention Centre, New York

1988 Spirit and Matter, Le Forum, French Embassy, Harare

1989 Australian Art Expo, Darling Harbour, Sydney

1989 Present and Future, Le Forum, French Embassy, Harare

1989 Zimbabwe op de Berg, Foundation Beelden op de Berg, Wageningen, Holland

1990/91 Contemporary Stone Carvings from Zimbabwe, Yorkshire Sculpture Park, U.K.

1990 Stone Sculpture from Zimbabwe, Millesgarden Museum, Stockholm, Sweden

Public and Private Collections

Private collections inside and outside Zimbabwe.

BERNARD TAKAWIRA

(Shona, Zimbabwe)

1948 Born Nyanga district, Zimbabwe.

Training

National Gallery Workshop School (informal).

Works Represented

Works represented in the permanent and overseas collections of the National Gallery of Zimbabwe.

Works Selected

Works selected for the Annual Exhibition of the National Gallery of Zimbabwe: 1969, 1973, 1980, 1983, 1985, 1987, 1988, 1989, 1990.

Awards and Achievements

1984 First Prize, Annual Nedlaw Exhibition, National Gallery of Zimbabwe

1985 Highly Commended, Annual Nedlaw Exhibition, National Gallery of Zimbabwe

1988 Award of Distinction, and Award of Merit, Zimbabwe Heritage Exhibition, National Gallery of Zimbabwe

1989 Award of Distinction for Outdoor Sculpture, Zimbabwe Heritage Exhibition, National Gallery of Zimbabwe

1990 Certificate of Excellence (2) and Award of Distinction, Zimbabwe Heritage Exhibition, National Gallery of Zimbabwe

One-Person Exhibitions

1980 Gallery Delta, Harare

1981 Gallery Delta, Harare

1986 Dowse Museum, Auckland, New Zealand

1988 The Gallery Shona Sculpture, Chapungu Village, Harare

Selected Group Exhibitions

1971 Sculpture Contemporaine des Shonas d'Afrique, Musée Rodin, Paris

1972 Shona Sculptors of Rhodesia, Institute of Contemporary Arts Gallery, London

1977 Gallery Delta, Harare

1981 Carlton Centre, Johannesburg

1981 Shona Sculpture, Zimbabwe House, London

1981	Contemporary Stone Sculpture from Zimbabwe. The Mall, London
1985	Contemporary Stone Sculpture from Zimbabwe, Irving Sculpture Gallery, Sydney (in association with The Gallery Shona Sculpture, Harare)
1986	Soul in Stone, Irving Sculpture Gallery, Sydney (in association with The Gallery Shona Sculpture, Harare)
1989	Zimbabwe op de Berg, Foundation Beelden op de Berg, Wageningen, Holland. (Bernard Takawira was invited to hold a workshop during the exhibition by the Foundation Beelden op de Berg)
1990	Zimbabwe Heritage Exhibition (National Gallery of Zimbabwe), Auckland, New Zealand, during the Commonwealth Games
1990/91	Contemporary Stone Carvings from Zimbabwe, Yorkshire Sculpture Park, U.K.
1990	Stone Sculpture from Zimbabwe. Millesgarden Museum, Stockholm, Sweden

Public and Private Collections
Chapungu Village Sculpture Garden permanent collection; private collections inside and outside Zimbabwe.

JOHN TAKAWIRA
(Shona, Zimbabwe)

1939	Born Chegutu, Zimbabwe, died November 1989.

Training
National Gallery Workshop (informal).
Works Represented
Works represented in the permanent and overseas collections of the National Gallery of Zimbabwe.
Works Selected
Works selected for the Annual Exhibition of the National Gallery of Zimbabwe: 1963, 1966, 1968, 1972, 1976, 1977, 1979, 1981, 1983, 1984, 1985, 1986, 1987, 1988.

Awards and Achievements

1981	First Prize, Annual Nedlaw Exhibition, National Gallery of Zimbabwe
1982	Consolation Prize, Annual Nedlaw Exhibition, National Gallery of Zimbabwe
1986	Invited Artist, Zimbabwe Heritage Exhibition, National Gallery of Zimbabwe

One-Person Exhibitions

1983	PG Gallery, National Gallery of Zimbabwe

Selected Group Exhibitions

1965	Commonwealth Arts Festival, London
1971	Sculpture Contemporaine des Shonas d'Afrique, Musée Rodin, Paris
1972	Shona Sculptors of Rhodesia, Institute of Contemporary Arts Gallery, London, 1989 Zimbabwe op de Berg. Foundation Beelden op de Berg, Wageningen, Holland
1989	Zimbabwe Heritage Exhibition (National Gallery of Zimbabwe) Auckland, New Zealand (during Commonwealth Games)

Public and Private Collections
Vukutu Gallery; Chapungu Village Sculpture Garden permanent collection; private collections inside and outside Zimbabwe.

LAZARUS TAKAWIRA
(Shona, Zimbabwe)

1952	Born Nyanga, Zimbabwe.

Training
Until 1974 informal, with John and Bernard Takawira.
Works Represented
Works represented in the permanent and overseas collections of the National Gallery of Zimbabwe.
Works Selected
Works selected for the Annual Exhibition of the National Gallery of Zimbabwe: 1971, 1972, 1973, 1974, 1975, 1976, 1977, 1978, 1979, 1980, 1982, 1983, 1984, 1986, 1987, 1988, 1989, 1990.

Awards and Achievements

1987	Commission for Old Mutual, Harare
1987	Commission of Water Spirit for Chapungu Village Sculpture Garden, Harare
1988	Certificate of Excellence, Zimbabwe Heritage Exhibition, National Gallery of Zimbabwe
1989	Award of Merit, Zimbabwe Heritage Exhibition, National Gallery of Zimbabwe
1990	Certificate of Excellence, Zimbabwe Heritage Exhibition, National Gallery of Zimbabwe

One-Person Exhibitions

1987	Standard Chartered Gallery, John Boyne House, Harare

Selected Group Exhibitions

1985	Contemporary Stone Sculpture from Zimbabwe, Irving Sculpture Gallery, Sydney (in association with The Gallery Shona Sculpture, Harare)
1986	Soul in Stone, Irving Sculpture Gallery (in association with The Gallery Shona Sculpture, Harare)
1989	Spirit and Matter, Le Forum, French Embassy, Harare
1989	Present and Future, Le Forum, French Embassy, Harare
1989	Zimbabwe op de Berg, Foundation Beelden op de Berg, Wageningen, Holland
1990	Zimbabwe Heritage Exhibition (National Gallery of Zimbabwe) Auckland, New Zealand, during Commonwealth Games
1990/91	Contemporary Stone Carving from Zimbabwe, Yorkshire Sculpture Park, U.K.

Public and Private Collections
Private collections inside and outside Zimbabwe.

BIBLIOGRAPHY

Arnold, M., 'Four Contemporary Painters' in *Arts Zimbabwe*, No.2, 1981/82

Azevedo, A., 'Experiences in Sculpture' in *Arts Rhodesia*, No. 1, annual, 1978

B.V. Development Prode, The National Gallery of Zimbabwe, The Establishment of an Art and Design School in Zimbabwe, feasibility study, October, 1987

Beach, D.N., *The Shona and Zimbabwe 900–1850*, Mambo Press, Gweru, 1980

Beach, D.N., *Zimbabwe before 1900*, Mambo Press, Gweru, 1984

Blackman, B. and Schoffeleers, M., 'Masks of Malawi' in *African Arts*, Vol. 5, No. 4, summer, 1972

Bourdillon, M., *The Shona Peoples*, Mambo Press, Gweru, 3rd revised edition, 1987

Du Toit, F., 'The Shona Concept of Home' in *Zimbabwe Environment and Design*, No. 2, October, 1981

Ellert, H., *The Material Culture of Zimbabwe*, Longman Zimbabwe, Harare, 1984

Garlake, P., *Great Zimbabwe Described and Explained*, Zimbabwe Publishing House, Harare, Revised, 1985.

Garlake, P., *The Painted Caves*, Modus Publications, Harare, 1987

Huffman, T.N., 'Archaealogy and Ethnohistory of the African Iron Age' in *Annual Review of Anthropology*, No. 11, 1982

Huffman, T.N., *Symbols in Stone*, Witwatersrand University Press, Johannesburg, 1987

Huffman, T.N., 'Iron Age Settlement Patterns and the Origins of Class Distinction in Southern Africa' in *Advances in World Archaeology*, Vol. 5, 1986

Huffman, T.N., 'Expressive Space in the Zimbabwe Culture' in *MAN (NS)* 19

Huffman, T.N., 'The Trance Hypothesis and the Rock Art of Zimbabwe' in publication of the South African Archaeological Society, Goodwin Series, No. 4, June, 1983

Huffman, T.N., 'The Soapstone Birds of Great Zimbabwe' in *African Arts*, Vol. XVIII, No. 3, 1985

Lan, D., *Guns and Rain*, Zimbabwe Publishing House, Harare, 1985

Lewis-Williams, J.D., *Believing and Seeing*, Academic Press, 1981

Lewis-Williams, J.D., 'The San Artistic Achievement' in *African Arts*, Vol. XVIII, No. 3, 1985

McEwen, F., 'Shona Art Today' in *African Arts*, Vol. 5, No. 4, summer, 1972

Murray, B. (ed), 'The Architecture of Great Zimbabwe' in *Zimbabwe Environment and Design*, No. 8, September, 1985

Needham, D.E., Mashingaidze, E.K., Bhebe, N., *From Iron Age to Independence*, Longman Zimbabwe, Harare, 1984

Plangger, A. (ed), *Serima: Towards an African Expression of Christian Belief*, Mambo Press, Gweru, 1974

Tindall, P.E.N., *History of Central Africa*, Longman Zimbabwe, New Impression, 1986

Wood, P., 'Rhodesian Art — a general survey' in *Arts Rhodesia*, No. 1, annual, 1978

Wylie, G., *Zimbabwe Crafts*, National Gallery of Zimbabwe, September, 1983

Zimbabwe Insight, National Gallery of Zimbabwe — 1978, 1; 1979, 1; 1980, 1; 1982, 1; 1983, 1; 1983, 2; 1984, 1; 1984, 2; 1985, 1; 1985, 2; 1986, 1

Catalogues:

Souvenir Catalogue of the Thomas Baines Exhibition, Rhodes National Gallery, 1960

Zimbabwe Heritage Exhibition Contemporary Visual Arts, National Gallery of Zimbabwe, 1986

Zimbabwe Heritage Exhibition, National Gallery of Zimbabwe, 1987